Peter Paul Rubens

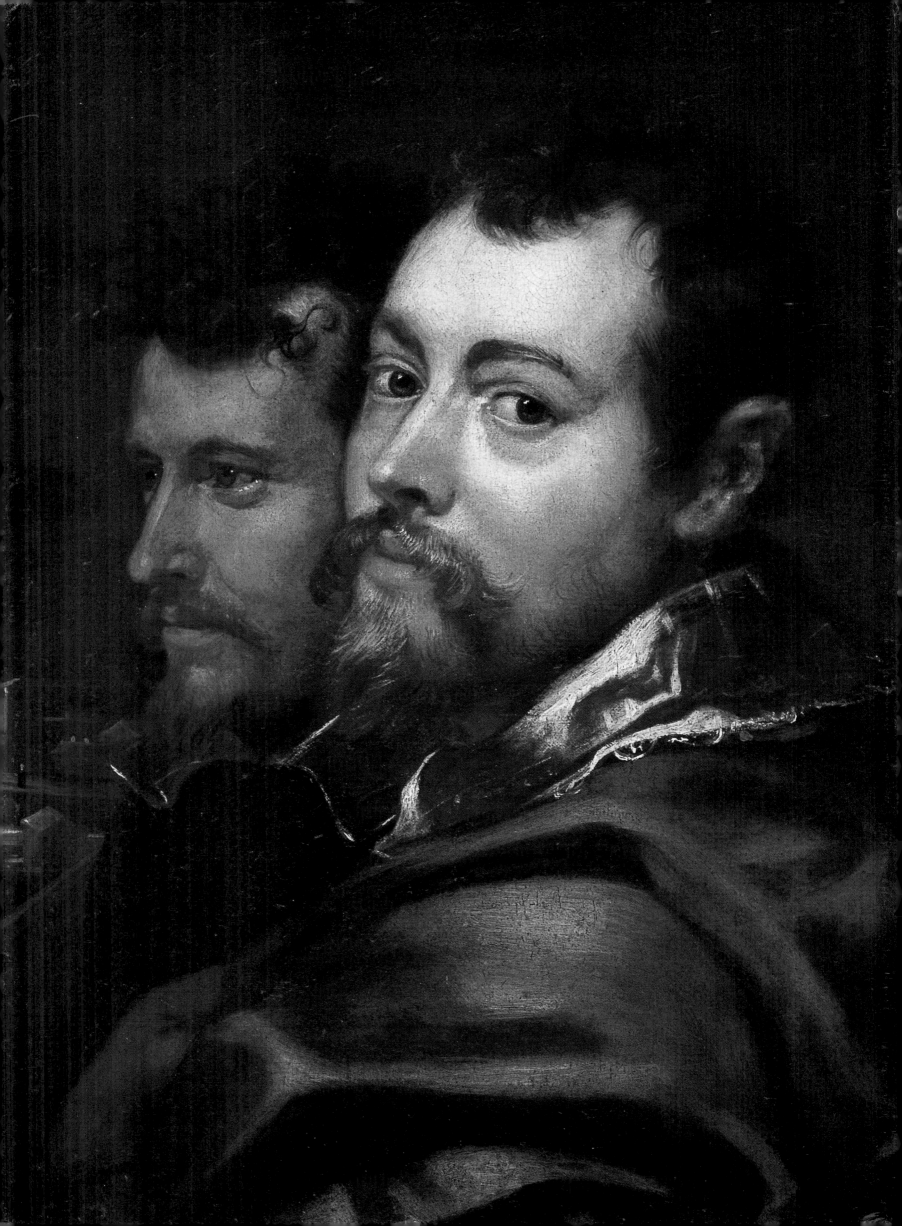

Peter Paul Rubens

MAN & ARTIST

Christopher White

Yale University Press
New Haven and London
1987

Designed by Faith Brabenec Hart
Filmset in Monophoto Plantin by
Tameside Filmsetting Ltd, Ashton-under-Lyne, Lancs.
Printed in Italy by
Amilcare Pizzi, s.p.a., Milan

Library of Congress Cataloging-in-Publication Data

White, Christopher.
 Peter Paul Rubens: man and artist.

 Bibliography: p.
 Includes index.
 1. Rubens, Peter Paul, Sir, 1577–1640. 2. Artists—
Belgium—Biography. I. Title.
N6973.R9W48 1987 759.9493 [B] 86-24565
 ISBN 0-300-03778-3

To Michael Levey, *amico per la pelle*

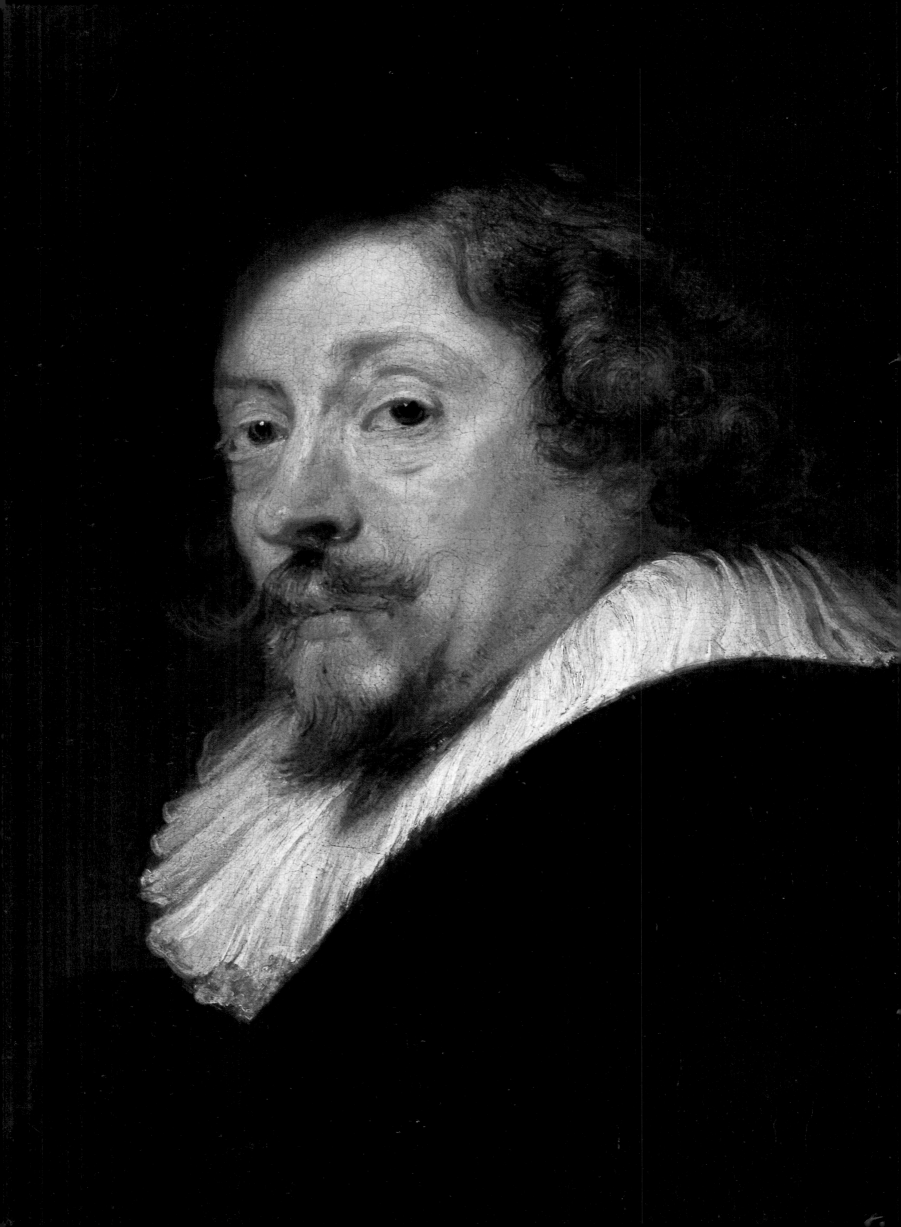

Preface

FACED with the daunting prospect of selecting one representative figure from the seventeenth century, I would eventually have little hesitation in choosing Rubens, whose life and work offer such eloquent testimony of both the spirit and the history of the period. Artist in the widest sense, who was involved in the creation of prints, sculpture and architecture as well as painting, Rubens was also a very well-versed scholar of classical art and literature, an enthusiastic collector of a wide range of art and artifacts, an active participant in the politics and diplomacy of the age and, as his extensive correspondence with an international group of friends and acquaintances shows, much engaged in the events and preoccupations of the day. He was, moreover, well travelled and, remarkably for an artist of the century, on intimate terms with many of the kings, princes and rulers of the major European countries. Possibly more than any other artist he could claim to be the *uomo universale* of his epoch. Conversely one can argue that much of his work, unlike that of many of his Northern contemporaries, cannot be fully understood unless it is considered in its social and historical context. The landscapes, portraits and many of the more popular religious and mythological subjects speak to us directly, but much else was created on special demand to meet contemporary needs. As the expression of a great artist, the most abstruse historical or allegorical subject will convey something to the modern spectator, but a full appreciation of Rubens' achievements can be gleaned only from a knowledge of the background against which it was created. In attempting a balanced general account of the artist's life and work, I have tried to present the man and his work as an embodiment of his times.

As anyone who has tried his hand will know, the arena of Rubens studies is not for lightweights, and the writer who ventures to enter must be aware that he faces three formidable obstacles. Apart from the width of his interests, Rubens was an immensely prolific artist who ranks as one of the most productive in the history of art. He was, moreover, extremely erudite in a wide range of subjects so that on his death a contemporary could, with justification, pronounce him to have been 'the most learned painter in the world'. He demands of his critics an advanced degree of knowledge. Stemming directly from these two facets of the artist, a vast body of critical literature has grown up, especially in recent times, which presents the reader with a bewildering diversity of opinions and hypotheses, covering such matters as authenticity, chronology and interpretation. In the vain hope of stepping safely through the minefield of *Rubensforschung*, I have concentrated on the documented and generally agreed aspects of the man and his work, regarding the more contentious issues as inappropriate for an introductory monograph. But I am conscious that I have strayed across the dividing line more often than I would like.

It seemed inappropriate to weigh down a book of this general character with a panoply of scholarly footnotes and, apart from providing the sources of direct quotations, I have confined myself to giving a list of the more important general

1. (p. ii) Detail of Plate 39.

2. (facing page) Detail of Plate 318.

works on the artist as well as references to more specialised studies under each chapter. In addition to offering recommendations for further reading, this bibliography should be regarded as a sincere acknowledgement of my very great debt to other scholars, without whose research this book would have been much thinner. If any of the latter should feel aggrieved that a contribution has not been recognised I can only hope that they will at least have some sympathy with the writer who foolhardily attempts to cover the whole field. For the record, the biographical sections of this book have been partly based on my *Rubens and his World*, published in 1968 and for many years out of print.

I would like to express my gratitude to a number of people who have kindly provided me with various items of information: Jacques Foucart, Julius Held, Hans Hoetink, Michael Jaffé, Evelyn Newby, Nicholas Penny, Julian Roberts and Gert Schiff. Both the dedicatee and Neil MacGregor took the trouble to read the manuscript and contributed a number of pertinent suggestions, for which I remain most grateful. I was very fortunate in the Press's choice of expert reader, whose constructive comments not only saved me from some errors but also served to improve the text.

More often than I care to remember I have been told that for one reason or another Rubens does not sell. I am, therefore, all the more grateful to John Nicoll of the Yale University Press for being prepared to fly in the face of publishing wisdom and accept this book for publication. Moreover, I am very appreciative of the immensely professional standards he brings to the task, which happens to coincide with the end of a harmonious and productive decade of collaboration over the publication of books by other authors. I would also like to acknowledge most warmly the care and devotion which Faith Hart has given to the preparation and design of the book. Anna Whitehead typed my manuscript most efficiently and expeditiously, and I must thank her for undertaking this task with such good humour despite being in the process of moving house.

3. (facing page) Detail of Plate 173.

Contents

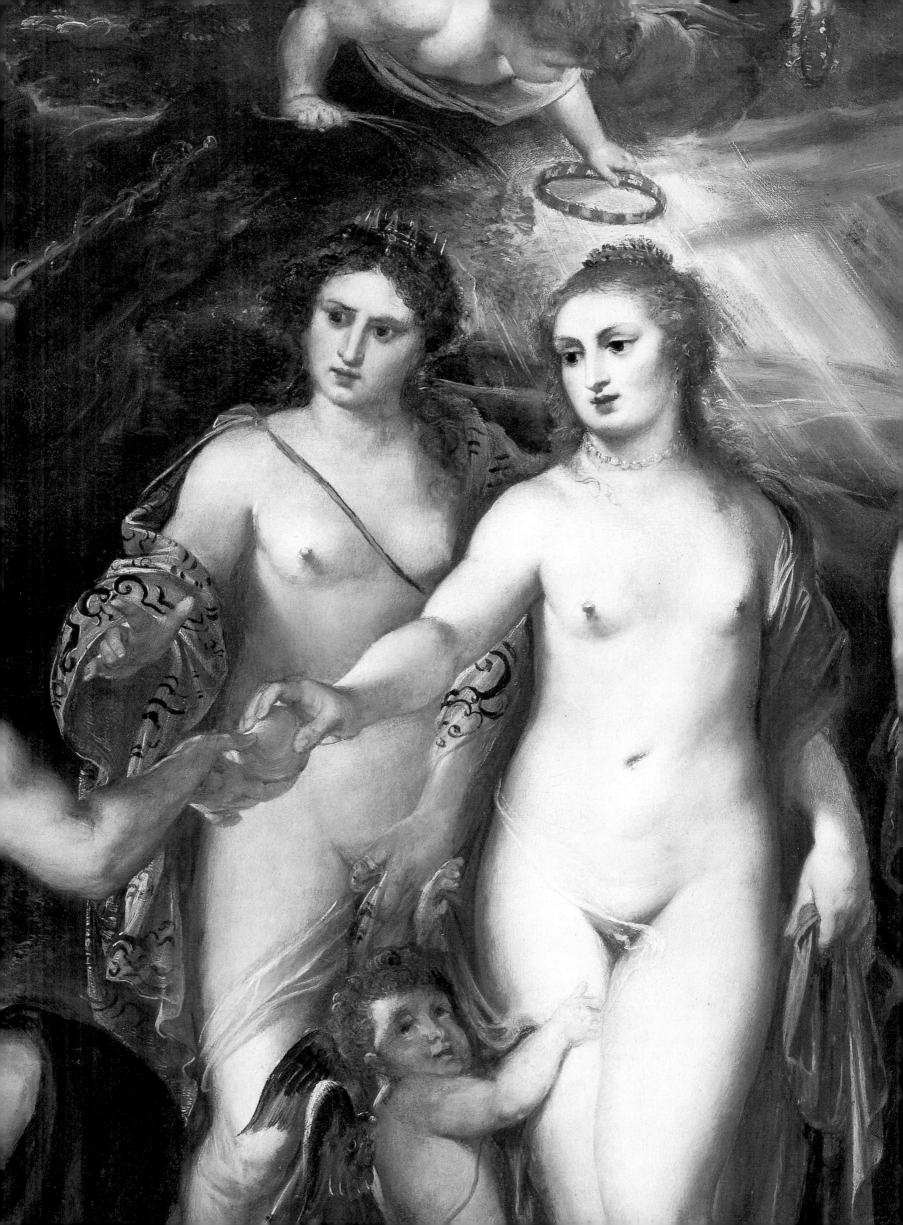

I

Birth and Education

If to live quietly in harmony with oneself means undertaking
only those things for which nature has given us particular talents
and the assurance of success in carrying them out, then one can
say that Rubens led the happiest life in the world.

Roger de Piles

THESE words written by one of Rubens' earliest critical admirers succinctly evoke
the special quality of the artist's life. But its eventual fulfilment could not have
been forecast from its sombre beginnings when both political storms and personal
misfortunes heralded his birth in 1577. His father, Jan Rubens, whose family
history in Antwerp can be traced back to the end of the fourteenth century, had no
sooner become a successful advocate and alderman of his home town and married
a certain Maria Pypelinx, the daughter of a dealer in tapestries, than war broke out,
in the name of religion but in the cause of politics.

It is often only in adversity that depth of character is revealed, and in no instance
could this have been truer than of Rubens' parents. Had political misfortunes not
overtaken Jan Rubens, we should probably remember him today as a worthy
citizen of Antwerp, as a successful advocate and a serious alderman, as a solid
respectable figure who had the honour of being the father of one of the world's
greatest artists. He would have been considered a man of parts. The painter's
mother, on the other hand, would probably have been no more than a name, and
we would have granted her respectability. But fate decreed otherwise, and for the
benefit of posterity a merciless spotlight was trained on the different characters of
Rubens' parents, revealing the weakness of one and the strength of the other. The
blood that ran in their son's veins was mixed with extremes of sterling fortitude
and easygoing intelligence. His ultimate strength of character could not have been
taken for granted, and possibly his genius was sparked by the very different
characteristics he inherited from each parent.

The submerged momentum of the Reformation in the Low Countries
intensified with the death of Charles V, who had been a powerful though respected
ruler. He was succeeded by his son Philip, whose championship of Spain and
Catholicism rapidly offended the Flemish nobles. The latter espoused the cause of
the Reformation largely for political purposes, and Protestantism spread rapidly
throughout the Low Countries, leading to widespread iconoclasm by 1566. Philip
swiftly retaliated, and the Duke of Alva carried out a relentless persecution in
Flanders. In the spirit of the times, Jan Rubens had previously become a Calvinist
in practice. Now, after a little specious pleading of his Catholic orthodoxy to the
Spanish suppressors, he had the wit to see that his home country was no longer a
safe place to live, and in 1568 he fled to Cologne with his wife and four children
(two boys and two girls). But there in another Catholic city his religious beliefs
caused further trouble, and under the threat of expulsion he adhered to his original
faith. He had made his gesture of religious independence, and that was sufficient
for him.

4. Detail of Plate 10.

If the weakness of his religious convictions led to convenient results, his sexual indiscretions were not so easily glossed over. In 1570 he became the legal adviser and confidant of Anne of Saxony, Princess of Orange, who had been left behind in Cologne by her husband, William of Orange, while he raised reinforcements in Germany for his battle against the Spanish. In this situation, the yielding character of Jan Rubens was no match for the ugly, pleasure-loving princess. By the spring of the following year the true nature of their relationship was sufficiently obvious for all to see, and the elder Rubens was arrested and imprisoned on a charge of adultery. The child conceived during the course of intimate evenings spent in the small town of Siegen, where Anne had moved from Cologne in 1570, was born in August of the following year.

In Germany the penalty for adultery was death, and, imprisoned in the dungeons of the Castle of Dillenburg, Jan Rubens gave way to despair. It was at this moment that his wife became a character in her own right and took centre stage. Having recovered from the news of her husband's betrayal, she took up her pen to plead on his behalf, addressing a heartfelt petition 'written without art or learning' to the prince and princess. To her husband, Maria Pypelinx wrote a letter of forgiveness, but she had hardly finished it when she received one, in a very different vein, from him. She immediately sent a reply, 'written this first of April between midnight and one o'clock,' which reveals her nobility of character, forgiveness and fortitude in the face of adversity.

> Dear and beloved husband, after I had written you the enclosed letter, the messenger we had sent to you arrived bringing me a letter from you, which gave me joy because I see from it that you are satisfied with my forgiveness, I never thought you would have believed that there would be any difficulty about that from me, for in truth I made none. How could I have the heart to be angry with you in such peril, when were it possible I would give my life to save you . . . Be assured then that I have forgiven you completely. Please God that may suffice to set you free. We should soon have cause to rejoice; but I find nothing in your letter to console me, for it has broken my heart by showing me you have lost courage and speak as if you were on the point of death. I am so troubled that I know not what I am writing. One would think that I desired your death since you ask me to accept it in expiation. Alas, how you hurt me by saying that. In truth it passes my endurance. If there is no more pity where shall I find a refuge? Where must I seek it? I will ask it of Heaven with tears and cries.[1]

And she added at the end, 'Say no more "your unworthy husband" for all is forgiven'.

After two years of pleading with the House of Nassau, Maria Pypelinx finally secured her husband's release on bail. But the strictest conditions were attached, including permanent residence in Siegen, where they lived half-imprisoned but happily reunited, and only in 1578 was Jan Rubens finally pardoned and allowed to live anywhere he wanted, except territory belonging to the House of Nassau and the Low Countries. The family lost no time in shaking off the dust of Siegen and returned to Cologne. During their time together in Siegen, their reconciliation had been celebrated with the birth of three sons, Philip, in 1573, Peter Paul, in 1577, and four years later, Bartholomeus, who died as an infant. When they departed from Siegen the drama was nearly over, but the scars remained. Just how much it meant to the two sons, only infants when they left for Cologne, is made clear by their avoidance of acknowledging Siegen as the place of their birth. The small town could have been no more than a name to them, but they did their best to eliminate it from their family history. Indeed, its hidden influence on Peter Paul probably did not stop there, and may well have given an extra fillip to his ambition.

Life in Cologne cannot have been easy, though straitened circumstances were probably softened by the happiness of family life. In later years Peter Paul Rubens was to recall, 'I have great affection for the city of Cologne, because it was there that I was brought up until the tenth year of my life'.[2] Their income had been

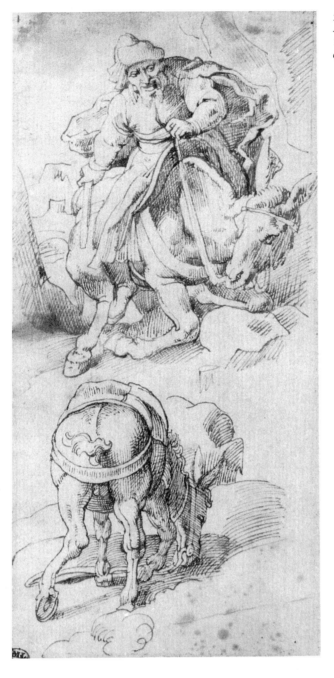

5. Rubens after Tobias Stimmer, *Balaam and his Ass, and the Ass of the disobedient Prophet*, before 1600. Pen and brown ink, 17.2 × 8.2 cm. Musée du Louvre, Paris.

sacrificed to rescue Jan Rubens, and to make matters worse he was once again ordered to go to Siegen to await the prince's disposition. After further entreaties from his wife, and further payments from the family fortune, Jan Rubens was pardoned absolutely and was able to take up his profession as an advocate again, attracting the esteem of Prince Charles de Croy. He had, however, only a few years of life left, and in 1587 he died in Cologne. In Siegen the family had belonged of necessity to the Lutheran Church, but sometime after their return to Cologne they returned to the Catholic faith, which became the religion of their children.

The widow soon went back with three of her surviving children, Blandina, Philip and Peter Paul, to her home town of Antwerp, from which she had fled some twenty years before. (The eldest son, Jan Baptist, who may also have been an artist, was last recorded as going to Italy in 1586.) Her financial situation must have greatly improved by this time, since she went to live in a house in the Meir, the main street in the centre of the city. Peter Paul continued his studies in a school run by Rombout Verdonck, situated in the cemetery behind the choir of the cathedral. There he met a boy, three years younger than himself, Balthasar Moretus, who was destined to be a lifelong friend and to achieve eminence as head of the famous Plantin printing house. A few years later Moretus wrote to Rubens'

brother Philip that 'he knew his brother at school' and 'I loved this young man who had the kindest and most perfect character'.[3] At school the boys learnt Latin and some Greek. On the syllabus were such books as Plutarch's *Education of Children*, and the *Aeneid* and *Bucolics* of Virgil. Then or later he became familiar with Ovid's *Metamorphoses* and Horace's *Odes*, as well as works by Livy, Seneca, Tacitus, Pliny, Philostratus and more modern writers such as Boccaccio. As his nephew said, Rubens was a student all his life.

Rubens did not remain in Verdonck's school for long, and at the age of thirteen his academic training was virtually over. It remains uncertain whether this early end to his schooling was due to his intellectual precocity or to financial stringency. During the course of his years of schooling, however, he absorbed a great deal. His familiarity with Latin was wide enough for him not only to draw on the literature

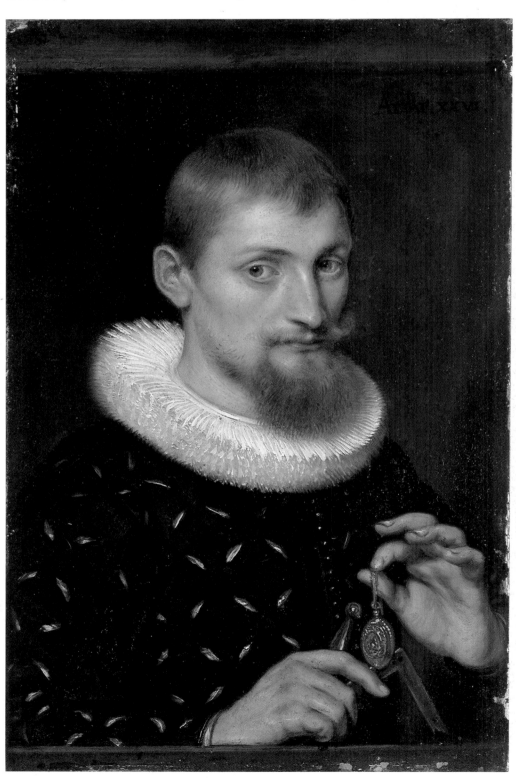

6. *Portrait of a Man*, 1597. Copper, 21.6 × 14.6 cm. Metropolitan Museum of Art, New York.

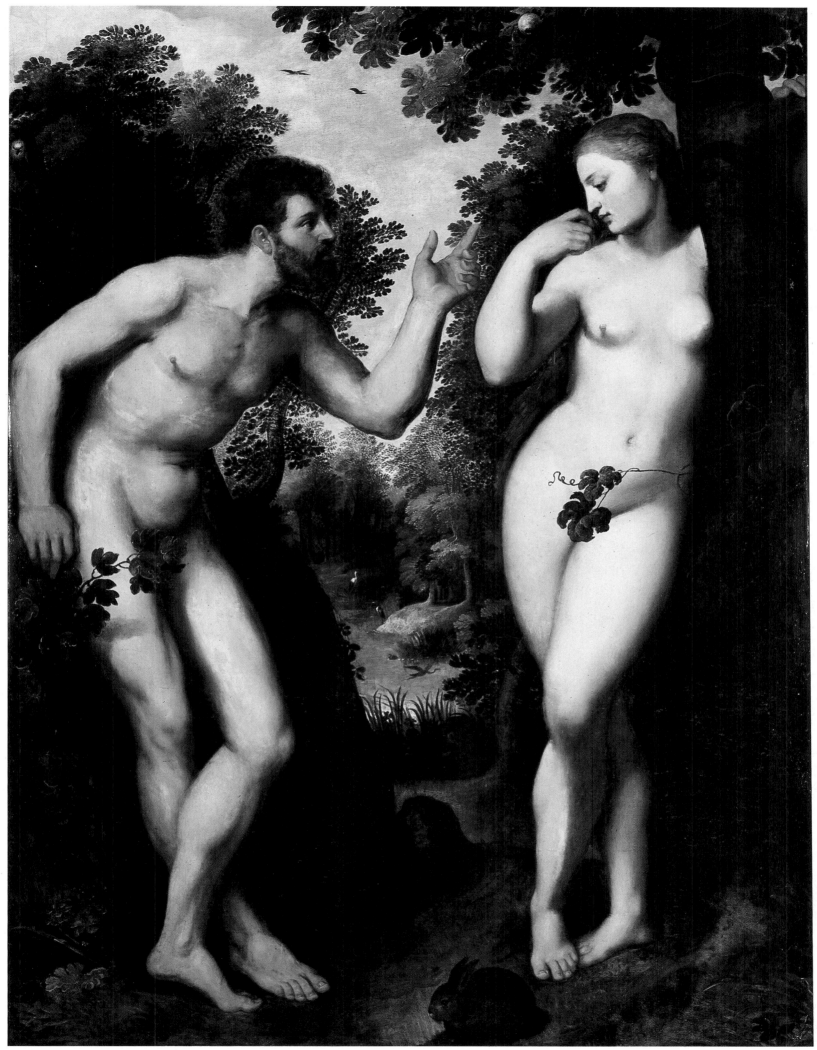

7. *Adam and Eve in Paradise*, before 1600. Panel, 180.3 × 158.8 cm. Rubenshuis, Antwerp.

for subject-matter without a moment's hesitation, but to understand subtle emotional nuances of the classical text he was illustrating. He was able to write the language fluently, although in his later years he protested his deficiencies. To Jan Caspar Gevaerts he wrote, 'My response in the Flemish language will be sufficient to show that I do not deserve the honour which you confer upon me with your letters in Latin. My practice and studies in the humanities have fallen so far behind that I should first have to beg permission to commit solecisms. Therefore, please do not put me, at my age, in competition with schoolboys.'[4] Despite such characteristic modesty, his letters were full of Latin quotations and allusions, and he was never at a loss for an apt phrase. His grasp and understanding of the language must have owed much to his brother Philip, who was an ardent classical scholar.

Latin was not his only foreign language, and, as his letters show, he wrote fluently in Italian but considerably less so in French. Italian, the language of diplomacy and increasingly of scholarship, became his favourite medium of communication (Plate 8). To his friends he preferred to write in Italian although when necessary was able to express himself in French. To his compatriots he communicated in Flemish. He must very quickly have acquired his cultural sophistication, for already in 1607 Caspard Schoppe or Scioppius, the well-known philologist, not noted for his warmth, referred to 'My friend Rubens, in whom I do not know what to praise most: his mastery in painting . . . or his knowledge of everything that concerns *belles-lettres* even more, or finally, that subtle judgement which goes along with such fascinating conversation'.[5]

When Rubens left school, according to his nephew, 'he was soon placed by his mother in the service of the noble lady Marguerite de Ligne, widow of Philip, Count of Lalaing, where he remained some time as her page'.[6] She was probably living at Audenarde at the time the young Rubens joined her court. His mother presumably had aspirations to make her son into a courtier, but he, a person with ideas of his own, quickly tired of the small enclosed circle, with its unsympathetic daily routine and strict etiquette. The leisurely atmosphere of a widow's court can hardly have been stimulating to a young and active man. By itself it was not a very important moment in the artist's life, but it gave him his first familiarity with court life, which was to play such an important part throughout his career, even though he took every opportunity to escape from it. His reactions to life at Audenarde foretold his future feelings about all the major courts of Europe.

The reasons that drove Rubens to ask his mother to remove him were possibly as much due to his growing desire to paint as to his dislike of life at Audenarde. He may have already tried his hand with a pen in a number of drawings of medieval tombs belonging to the Lalaing family, which, though a little thick and rigid, have his unmistakable personality about them. It is significant that his first known works are copies after other works of art of an earlier century. Many years later when travelling on a barge from Utrecht to Amsterdam with Joachim von Sandrart, Rubens recalled that in his youth he had made copies of woodcuts in Tobias Stimmer's Bible (Plate 5) and Holbein's *Dance of Death*, and at the same time expressed his admiration for Dürer and other German masters. For the whole of his life he retained a reverence for and a passionate interest in the art of the past, which was not only reflected in his own works, but can be seen in the copies he continued to make. There could be no better place for a young man to nurse a feeling for the past than the Lalaing circle, even if he quickly outgrew its narrow limitations.

The urge to paint was all-powerful and he returned to his mother's house in Antwerp clearly with the intention of becoming an artist. In the last decade of the sixteenth century the city still possessed a flourishing school of painting. From an older generation, Martin de Vos and Frans Francken were still alive and active. Nearer in time to Rubens were the landscape painters Paul Brill and Joos de Momper, and the landscape and flower painter Jan Brueghel, with whom Rubens was to develop a particularly close relationship. Rubens was at first apprenticed to

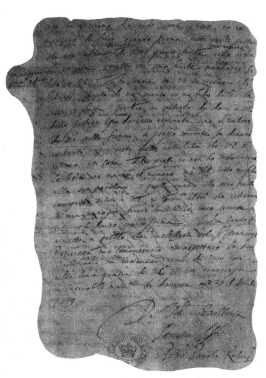

8. MS letter from Rubens to Sir Dudley Carleton, 28 April 1618. Public Record Office, London.

another landscape artist, Tobias Verhaecht, who was a distant relative (Plate 9). He can only have spent a short time in his studio, but before he moved on he would have learnt the basic method of composing and executing a landscape, which as a subject in itself and as a background to many of his pictures was to play an important part in his art. His early examples of fantastic scenery with high horizons are directly related to the late sixteenth-century tradition in Antwerp.

His next instructor was the portrait painter Adam van Noort, with whom he apparently stayed four years. Little is known of the master, and although it is not now easy to detect any trace of his influence, Rubens' accomplished execution of the portrait of a man (Plate 6) painted a few years later must owe something to his training. With his final teacher, Otto van Veen, with whom he probably worked from 1594 to 1598, he built up a much more tangible relationship, which went well beyond the mechanics of painting. Both men came from established bourgeois families and were conscious, Rubens acutely so, of the struggle to raise the position of the artist from that of craftsman still controlled by the medieval Guild of St Luke in the Netherlands to the gentlemanly status which was one of the legacies of the Italian Renaissance. With his cosmopolitan upbringing, Van Veen was well-educated and widely travelled. He knew Latin and its literature, and like many of his contemporaries latinised his name, to Vaenius. Compared with contemporary artists his much wider learning showed in his study of emblems, which later became the subject of a number of illustrated books such as the *Emblems of Quintus Horatius Flaccus* (1607), of *Love* (1608) and of *Divine Love* (1615), as well as several works on historical subjects. 'You are the first on our

9. L. van Panderen after Tobias Verhaecht, *Aurora*. Engraving. Ashmolean Museum, Oxford.

10. *The Judgement of Paris*, c.1600. Panel, 133.9 × 174.5 cm. National Gallery, London.

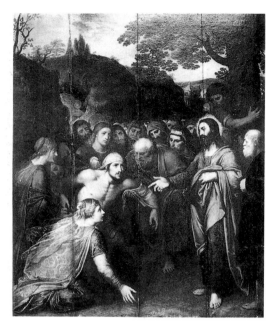

11. Otto van Veen, *The Raising of Lazarus*. Panel, 136 × 111 cm. Cathedral, Antwerp.

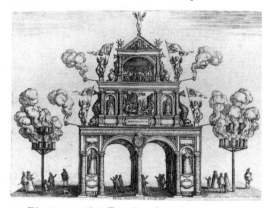

12. Pieter van der Borcht after Otto van Veen, *The Arch of the Spanish* from J. Bochius, *Pompae Triumphalis et Spectaculorum in Adventu et Inauguratione Serenissorum Principum Alberti et Isabellae* (Antwerp, 1602). Warburg Institute, London.

13. Marcantonio Raimondi after Raphael, *Adam and Eve*. Engraving, 23.9 × 17.6 cm. British Museum, London.

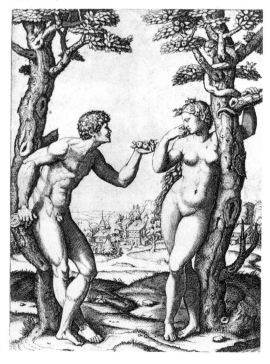

globe who has reconciled painting and the liberal arts'[7] was the opinion of no less than Abraham Ortelius. Roger de Piles, much of whose information came directly from Rubens' nephew, spoke of 'the same penchant for literature which they [Van Veen and Rubens] shared and which bound them in friendship'.[8]

After a basic education in both art and humanism in Liège, Van Veen had spent five years in Rome working as a pupil of Federico Zuccaro, and also acquiring a good knowledge of antique and Renaissance art. What he learnt in Rome had a simplifying and clarifying effect on the late mannerist style he had inherited. He subsequently worked at several European courts before returning to Antwerp with the stylistic attributes of a 'Romanist' (Plate 11). One of his public commissions was to participate in the decorations for the ceremonial entry of the Archduke Albert and his wife Isabella into Antwerp in 1599, for which he designed the Arch of the Spanish (Plate 12). Whether or not Rubens played any part in this event, he was to recall the occasion when much later in his life he was called upon to act as presiding impresario for a similar entry. Between Rubens and Van Veen there are a number of remarkable similarities both in the scope of their interests and in the pattern of their lives. But one essential difference divided master and pupil. Although he was a highly accomplished practitioner, Van Veen was no genius.

Having undergone the required pupilage, Rubens was at last able to become a member of the Guild of St Luke in 1598. Although he may have continued to work in association with Van Veen, he was now allowed to practise as an independent painter. He was also permitted pupils, and accepted his first, Deodat del Monte, the son of an Antwerp silversmith, whose oeuvre unfortunately remains undiscovered. Rubens had two years to fill before he set off to Italy, but from his mother's will, made when he was away, we gather that he was very active from the outset of his career. Referring to 'all the other paintings' in the house, she says that 'they are the property of Peter Paul who painted them' and with motherly pride describes them as 'beautiful'.[9]

Unfortunately, only one documented painting from this period exists today, the small portrait on copper of a twenty-six year old architect or geographer (Plate 6), whose profession is suggested by the set square and dividers he holds in his right hand. Painted in 1597, the year before Rubens became a guild member, it clearly reveals the artist's Northern origins as well as the emergence of a clearly defined personality of his own. Following a formula seen in fifteenth and early sixteenth-century Flemish art but later abandoned, the sitter is placed behind a ledge and holds up what is probably a watch in a gold oval case decorated with enamel, doubtless intended as a commonly used *Vanitas* symbol. Enhanced by the melancholy expression, the face and hands are beautifully refined, befitting the miniature scale of the portrait. Both the reddish flesh colour and the sensitive modelling foretell future achievements, in the same way that the intensity of gaze combined with the use of the illusionist motif of the watch held over the ledge establish the artist's ability to project his sitter. In later years Rubens may have been a reluctant portraitist, but his power in rendering personality is already clearly apparent.

Sometime during this period Rubens painted *Adam and Eve in Paradise* (Plate 7). Inspiration unquestionably came from Marcantonio's engraving after a design by Raphael (Plate 13), which probably represents the first of many acknowledgements to the latter by the young Flemish painter. But if the basic composition is a derivation, both the refinements to the original and the execution reveal Rubens' own hand, as well as a debt to the colour and figure type learned from his last master. As his nephew remarked, 'before his visit to Italy' Rubens' works 'had some resemblance with those of Octave van Veen'.[10] The small but significant alterations to Marcantonio's figures enhance the dramatic confrontation between the couple; the juxtaposition between heroic male body and sensuous female is heightened. The face of Adam, now bearded, can be read more clearly and his left hand, instead of holding out two apples, now points upwards in

8

an eloquent gesture with the index finger to the serpent in the tree. The lush wooded landscape, inhabited by birds and animals, engulfs the figures in an earthly paradise. It is unmistakably conceived in the Northern tradition of Jan Brueghel the Elder, suggesting that there could have been no inherent stylistic dissonance in a now lost painting recorded in a document. 'A piece by Octavio [van Veen] and Brueghel, first painted by Rubens . . . representing Mount Parnassus'.[11]

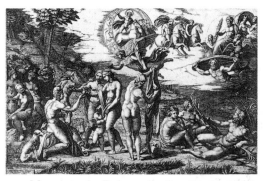

14. Marcantonio Raimondi after Raphael, *The Judgement of Paris*. Engraving, 29.8 × 44.2 cm. British Museum, London.

The *Judgement of Paris* (Plate 10), painted either just before or just after his departure for Italy, shows another blend of Italian figure motifs and Northern style. While the composition is developed from Marcantonio's print of the same subject after Raphael (Plate 14), the figure of Minerva is derived from Caraglio's print after Rosso (Plate 15). This dependence on Italian prints was a reflection of the works available for study in the studio of Van Veen, who followed the common practice of keeping a stock of prints and drawings. In this instance antique sculpture may also have played a part in suggesting the pose of Paris and the river-god and nymph in the background. Rubens' practice of using the works of other artists as a source for ideas, which he was to continue throughout his life, was not confined to Italian and antique art. Here the putti in the sky are close to similar figures in the work of Van Veen and suggest their continuing relationship after Rubens had officially left the studio. Compared with the *Adam and Eve*, he constructed the figures with greater independence from his models, evolving the precise iconography as he proceeded. Two preparatory drawings and an oil-sketch on copper as well as pentimenti on the panel itself disclose that initially the artist had chosen to illustrate the moment in the story before Paris had made up his mind, and that it was only at a very late stage that the artist opted for Paris's epic decision in favour of Venus, the consequences of which Rubens would have known from his familiarity with classical literature. As finally realised, Rubens' dramatic story-telling expressed through the strongly modelled figures in highly individual poses, made the more striking by their vivid flesh tints, leaves us in no doubt as to the outcome of the contest. Bright accents of mauve and red, which leap out from a prevailing pattern of blue, green and brown, show the artist striving for effect. It is quintessentially a young man's picture, done to impress by its verve and vitality of imagination. Whether painted in Flanders or Italy, this picture shows that Rubens was ready for a profounder confrontation with the art of the past.

15. Gian Giacomo Caraglio after Rosso Fiorentino, *Juno*. Engraving, 19.6 × 10.8 cm. Kupferstichkabinett, Berlin-Dahlem.

II

'Seized with a desire to see Italy'

RUBENS undoubtedly learned more than the rudiments of art in his home country, but, following the traditional recognition in the North of the superiority of the art of the South, education of a higher order began with his arrival in Italy in 1600. His nephew wrote later that 'when word got about that he was almost as good a painter as his teacher [Van Veen], Peter Paul was seized with a desire to see Italy and to view at first hand the most celebrated works of art, ancient and modern, in that country and to form his art after these models'.[1] Although it was a decision conforming to current practice, it was to have a fundamental effect on his future artistic life. Despite his Northern cultural background which went deeper than perhaps he would consciously allow, Rubens was to regard himself predominantly as a product of the Italian tradition. During the eight years he spent there, both his character and his art matured. From a formal and correct figure, he developed into a man of the world and a confident painter.

Accompanied by his first pupil, Deodat del Monte, he travelled south, if eighteenth-century writers are correct, via Paris, which, apart from Fontainebleau, could have offered little artistic education. Having arrived in Italy, he went, according to his nephew, straight to Venice. Even though the young artist has unfortunately left us no written record of his impressions of the city and its inhabitants, his painting speaks eloquently of his deep admiration for Venetian art, and his stay in the city provided him with his first opportunity to savour its painterly delights in any quantity. Writing of the Venetian experience in general, Bellori says that he studied Titian and Veronese above all others. Possibly at this stage of his visit his thoughts were more occupied with finding a position that would give him protection and financial support. Supposedly chance played into his hands when he found himself staying in the same lodging as a gentleman in the service of Vincenzo Gonzaga, Duke of Mantua, to whom he showed his pictures, and who in turn put them before the duke when he came on a visit to Venice in July. Gonzaga, 'a man very fond of painting and all the liberal arts',[2] was sufficiently impressed to take Rubens into his service. But since Vincenzo was a first cousin of the Archduke Albert, whom in the previous year he had visited in Brussels, where he now lived as joint ruler (with his wife, Isabella) of the Spanish Netherlands, it seems more likely that the swift offer of employment was the outcome of an introduction than the casual encounter related by the artist's nephew. The duke took Rubens into his service. He already had one Fleming attached to his court, and only a month after Rubens' appointment he was to add yet another, Frans Pourbus the Younger. Rubens promptly joined the duke's retinue and was immediately taken off to the handsome, grim city of Mantua, surrounded by swamps and flat land reminiscent of his native country. But if Mantua lacked the romantic character of Venice, it had much to offer in compensation.

Mantua was one of the capitals of the dozen or so small states that made up northern Italy at the time, and like its neighbouring rulers, such as the Este in

16. Detail of Plate 66.

Ferrara and the Farnese in Parma, the House of Gonzaga had a long tradition in the patronage of the fine arts. In the fifteenth century Mantegna had decorated one of the rooms of the medieval ducal palace with frescoes in honour of the Gonzaga family and in the following century Giulio Romano had added to the ducal residences by designing and largely decorating the Palazzo del Tè, both of which were closely studied by Rubens. Besides commissioning permanent adornments to the city, the Gonzaga family – Vincenzo no less than the others – avidly collected paintings, ancient and modern statues, tapestries, and even Chinese art, and owned works by artists of the calibre of Raphael, Titian and Correggio. In Mantua it was perhaps Mantegna's archaeological reconstruction of the ancient world, which, combined with the extensive finds from the Roman settlement there, made the deepest impression on the young Rubens. And he was to be the only Quattrocento artist to play such a dominant role in Rubens' education. Among the paintings by Mantegna in the duke's collection, the nine canvasses comprising the *Triumph of Caesar* especially caught Rubens' eye (see Plate 239). When the Gonzaga collections were sold to Charles I in 1629, the king's agent could write without hyperbole that 'they are, and will be acknowledged, the rarest pictures and statues that any prince has in Europe'.[3] At the time Rubens reacted to this news as if part of his cultural heritage was being dispersed and wrote unhappily about 'This sale which displeases me so much'.[4]

Poetry, theatre and music also flourished under the patronage of Gonzaga, and during his stay Rubens must have been intimately acquainted with the duke's master of music, Claudio Monteverdi, who, during three years, was occupied with composing his opera *Orfeo*. The duke rescued Torquato Tasso from a lunatic asylum and attached him to his court. He employed a celebrated troupe of actors who had performed in Paris at the court of Henry IV. Galileo visited Mantua at least twice during the period of Rubens' appointment. But Vincenzo was by no means an aesthete whose pleasures were confined to the fine arts and he followed in the Renaissance-princely tradition of collecting all kinds of exotica, as well as enjoying full-bloodedly the more sensual earthly pleasures of gambling and wenching. Mantua must have been a refreshing change from the austere court of the widowed Countess of Lalaing, and many years later, when the city fell to the Imperial troops, Rubens nostalgically recalled how he had 'served the House of Gonzaga for many years, and enjoyed a delightful residence in that country in my youth'.[5]

Gonzaga had the restlessness that goes with such wide tastes and was constantly travelling. Rubens had no sooner settled in his new occupation than he was taken in his master's retinue to Florence to witness the proxy marriage between his sister-in-law Maria de' Medici and Henry IV of France. The event was celebrated in truly sumptuous style, and the ceremony was followed by a banquet and a ball. It may be that an unmistakable small sketch of the bride, with her hair in the fashionable high dressing of the period, was made on this occasion (Plate 17). Some twenty years later Rubens recalled this scene when he came to paint the *Marriage in Florence*, which formed part of the series for Maria de' Medici's new palace, the Luxembourg. At the same time, he may have recorded a piece of personal history by including himself holding a processional cross in the background. In Florence Rubens took the opportunity of studying the city's artistic treasures, and probably made a number of drawings after works of art, proof that not all his time was spent in the duke's retinue. Even the hours of darkness were occupied by study, as is shown by the two copies after Michelangelo's youthful bas-relief of the *Battle of the Lapiths and Centaurs* (Plates 18–19), which he lit with a candle, first from one side and then the other. Rubens remained in the service of Gonzaga for the next twelve months, though from a chance remark in a letter written to him by his brother Philip, who was also in Italy, it is clear that he was not kept in Mantua but had the opportunity to visit other towns, either in Vincenzo's retinue or alone.

At the end of 1601 Rubens was at last given the chance to visit Rome. In July

17. *Maria de' Medici*, c.1600. Pen and brown ink, 6.5 × 3.9 cm. British Museum, London.

Gonzaga had written to the influential Cardinal Montalto, a nephew of the pope, asking for his protection for the painter Peter Paul, who was coming to Rome to make copies of paintings, while he, Gonzaga, pursued war in Croatia. For Rubens this commission killed two birds with one stone. He was able to serve his master and at the same time further his study of Italian art in what was the most important centre of both the High Renaissance and its ultimate source, the art of antiquity.

Before Rubens reached Rome he had already acquired some knowledge of antique sculpture. In Antwerp he could have studied it from engravings such as Galle's illustrations to Fulvio Orsini's *Illustrium Imagines*, published in 1598. During his stay in Mantua he had at last the opportunity to familiarise himself with a wide range of originals. But it was only in Rome that he could indulge in a truly searching study of antiquity, an activity which, since the early sixteenth century, had become *de rigueur* for any young artist arriving from the North. Like others before him, he lost no time in making copies of what he saw, which make clear that he visited all the major collections of antiquities then for the most part in the hands of clerics. (Cardinal Alessandro Farnese had, for instance, opened his outstanding collection to scholars as a *scuola pubblica* in 1589.) It seems likely that such carefully executed drawings as the several studies of the *African Fisherman* (Plates 21–2), seen from various angles, and the *Belvedere Torso* (Plates 23–4) were made on this first visit to Rome. His familiarity with the torso was immediately reflected in the figure of Christ in the *Mocking of Christ* (see Plate 36), which formed part of the altarpiece painted for S. Croce in Gerusalemme. Such copies, with their exact modelling and sensitive rendering of the outline, recall the drawings after the antique made by Hendrick Goltzius in Rome a decade earlier. The freer execution of the various studies of the *Laocoon* (Plates 25–6) suggest that these at least may have been made on his return to Rome in 1605, when, arm-in-arm with his brother, he became steeped in a study of ancient art and life. Despite their looser handling, these later studies are done with the same intention of reaching a full understanding of form and function of antique sculpture, which was to remain of such significance to Rubens.

But Rome was not only a museum of the art of the past. At the turn of the century a revival in activity took place with the arrival in Rome of artists of the calibre of Caravaggio and Annibale and Agostino Carracci, and their work was beginning to appear in the churches and palaces precisely at the moment when Rubens arrived. Unfortunately we have no records of any meeting or conversations with these artists, though it is clear from the copies Rubens made of their works and the effect they had on his own painting that he was keenly interested. In the case of Caravaggio his interest, as will be seen, went further. But in addition to native artists there was a steady stream of Northerners coming to Rome to complete their education in the same way as Rubens. Some chose to stay, and of these none was more influential for early seventeenth-century painting than

18. (above left) Rubens after Michelangelo, *The Battle of the Lapiths and Centaurs*, 1600–8. Black chalk with touches of grey wash, heightened with white, on brownish paper, 25.2 × 33.9 cm. Fondation Custodia, Paris.

19. (above) Rubens after Michelangelo, *The Battle of the Lapiths and Centaurs*, 1600–8. Black chalk, heightened with white, on grey paper, 24 × 34.7 cm. Museum Boymans-Van Beuningen, Rotterdam.

20. (following pages) Detail of Plate 38.

21. *The African Fisherman* (or the *Dying Seneca*). Marble with enamelled eyes and alabaster belt, ht. 118.4 cm. Musée du Louvre, Paris.

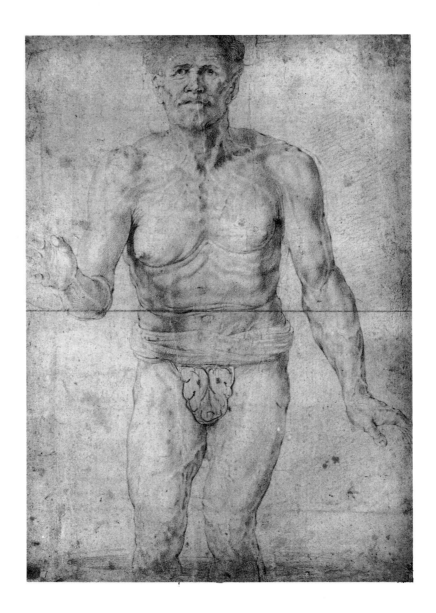

22. Rubens after the Antique, *The African Fisherman* (or the *Dying Seneca*), 1601–2. Black chalk, 46 × 32 cm. Hermitage, Leningrad.

Adam Elsheimer, the German artist from Frankfurt, who had travelled south to Venice in 1598 and on to Rome two years later. At Elsheimer's early death in 1610 Rubens responded to this 'most cruel news . . . which was very bitter to me. Surely, after such a loss our entire profession ought to clothe itself in mourning. It will not easily succeed in replacing him; in my opinion he had no equal in small figures, in landscapes, and in many other subjects.' Relations between the two men had not been confined to professional matters, and he was one of the 'friends whose good conversation makes me often long for Rome'.[6]

Copying the works of other artists very rapidly became a fundamental activity to Rubens. Part of artistic education since the Renaissance, it was not a new practice. Michelangelo, Raphael and Dürer, to name only the most famous, all made such copies. What distinguished Rubens from these was the extent that he did so, a fact already remarked on by writers in his own century such as Bellori, Samuel van Hoogstraeten and Roger de Piles. The inventory of his collection lists a large number of painted copies; over thirty after Titian, nine after Raphael and others after Tintoretto, Leonardo, Elsheimer, Pieter Bruegel the Elder and Anthonis Mor. Today, a sizeable proportion of Rubens' work consists of such copies, above all in the medium of drawing. His taste in the works he chose to copy was remarkably catholic, and although there is a bias towards Italy he also studied a considerable number of Northern artists.

In everything, Rubens was deliberate and his habit of copying had a specific purpose. Although a number of painted copies were carried out on commission from such patrons as the Duke of Mantua, by far the largest number were made for himself. In the first place they provided an artistic education, teaching him both the ideas and manner of execution of other artists. As already mentioned, he told Sandrart that he had copied Stimmer, Holbein and Dürer in his youth, and in this period other copies after Northern artists such as Jost Amman, Hans Weiditz,

16

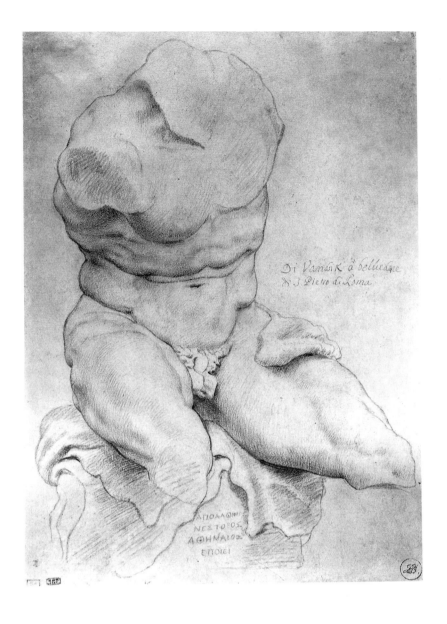

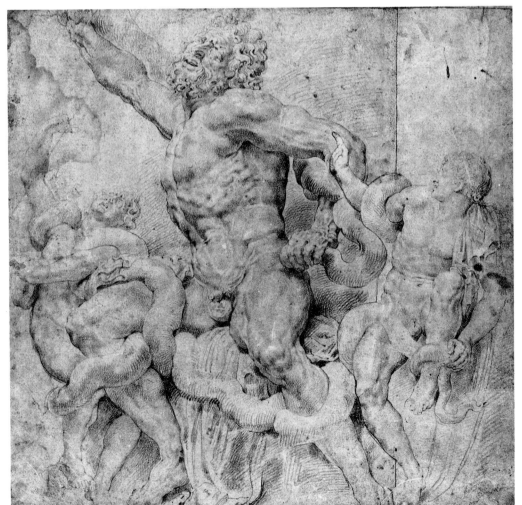

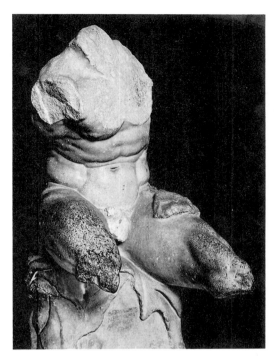

24. *The Belvedere Torso*. Marble, ht. 159 cm. Musei Vaticani, Rome.

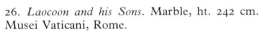

23. (left) Rubens after the Antique, *The Belvedere Torso*, c.1601–2. Black chalk, 37.5 × 26.9 cm. Rubenshuis, Antwerp.

25. Rubens after the Antique, *The Laocoon and his Sons*, c.1601–2. Black chalk, 47.5 × 45.7 cm. Biblioteca dell'Ambrosiana, Milan.

26. *Laocoon and his Sons*. Marble, ht. 242 cm. Musei Vaticani, Rome.

27. Rubens after Michelangelo, *Ignudo*, c.1601–2. Red chalk with touches of red wash, 38.9 × 27.8 cm. British Museum, London.

29. (right) Rubens after Michelangelo, *Ignudo*, c.1630(?). Red chalk with red wash, heightened with white, 32 × 19.8 cm. British Museum, London.

28. Michelangelo, *Ignudo*. Fresco. The Sistine Chapel, Vatican, Rome.

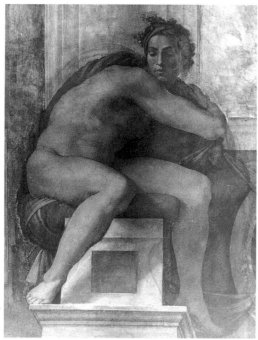

Israel van Meckenem, Hendrick Goltzius and Jacob Cobbe can be placed. In Italy the copyist was ever more active.

At the same time that he was educating himself, Rubens was also, as Bellori implies, concentrating on building up a record of works of art to supplement the available reproductive engravings. As a keen student of the art of the past and present, he required as much reference material as possible, and undoubtedly this interest made him continue to copy long after he was in need of any further education. To add to this material he employed assistants and possibly pupils in this work. Bellori reports that, despite the copies he made in Italy and elsewhere, and his large collection of prints, he employed after his return home a number of young artists in Rome, Venice and Lombardy 'to copy whatever seemed of quality'.[7]

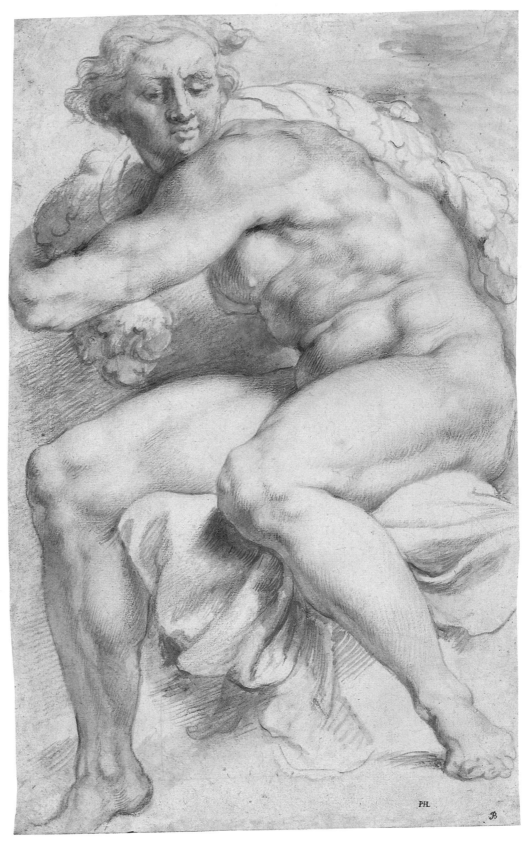

As much as Rubens admired the creations of others from the point of view of the connoisseur, he was even more interested in benefitting his own work. An outstanding feature of Rubens throughout his life is the degree to which he employed both the general and detailed ideas of others, sometimes without change but more often modified or developed. Identifying Rubens' sources, often varied and complex within one work, with individual limbs, as well as whole figures, derived from elsewhere, has occupied much scholarly ingenuity. The artist himself might well be surprised at the supposed variety contained within one work. And his practice did not go unremarked at the time. Samuel van Hoogstraeten records that 'Rubens was criticised by some of his competitors for borrowing whole figures from the Italians' to which 'he answered that they were free to do likewise if they found they could benefit by it. By this he indicated that not everybody was capable of deriving benefit from these copies.'[8] It was his talent to employ the art of others absorbed into his own personal language. As De Piles expressed it so eloquently, he used 'all that was most beautiful to stimulate his humour and warm his genius'.[9]

Rubens was entirely pragmatic in building up his museum of visual information. Where it was either possible or convenient he would copy direct from the original, but often he would work from an engraving or cast or some other reproduction or replica. On some occasions we can only suppose that he worked from memory. That his visual memory was of a high order is proved by his exact recollections twenty years later of the *Aldobrandini Wedding*, which he had seen after its discovery in Rome in 1606. Once Rubens had recorded the visual information in his copy, he remained completely free as to how he would use it. Sometimes the original figure or composition ended up after a series of studies moving further and further away, becoming in the end a mere echo of its former

30. Rubens after Leonardo, *The Battle of Anghiari*, c.1600–8. Black chalk, pen and ink with brown wash, heightened with white and grey, 45.2 × 63.7 cm. Musée du Louvre, Paris.

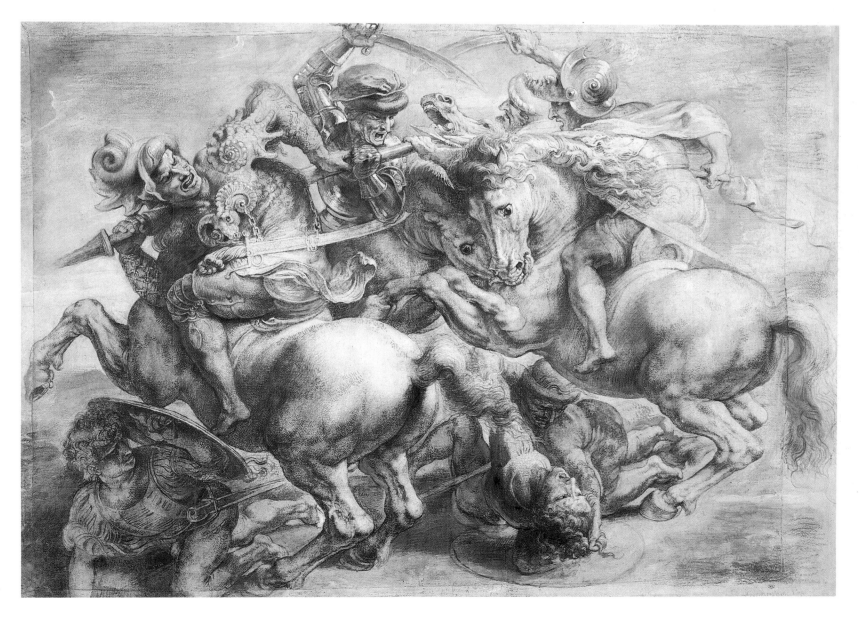

self. On some occasions he maintained a scrupulous regard for the detail and character of the original, while on others he remained as close as Beethoven did to Diabelli.

Following on his precise copies of Holbein and Stimmer (Plate 5), he made a number in the same spirit after the figures and compositions on the Sistine ceiling. (Dating of such copies remains a matter of conjecture, but it seems they were made on his first visit to Rome.) In his drawing of one of Michelangelo's *Ignudi* (Plate 27), Rubens, probably working directly from the fresco (Plate 28), produced a careful, accurate copy in red chalk, only elaborating some of the musculature. But later on he took a counterproof from this sheet (Plate 29) and freely reworked the subject with the brush and varying shades of red wash, changing such details as the drapery over the shoulder into a garland of oak leaves and covering the seat with drapery. (The paper was not large enough to accommodate the toes of the right foot, which was drawn as a separate detail below the seat.) The reworking had become stronger and more colourful, and the vigorous extrovert spirit of the young man is far removed from the dreamy introversion of Michelangelo's original. This variation on a theme was to end up thirty years later as the female figure of *Bounty* (Plate 279) on the Whitehall ceiling.

By the time Rubens was in Italy, Leonardo's famous unfinished painting of the *Battle of Anghiari*, in the Council Chamber in the Palazzo Vecchio in Florence, had long since been painted over by Vasari. Having begun by copying in black chalk some record of Leonardo's composition (Plate 30), Rubens' interest grew in size and imagination, and after adding strips to all four sides of the original sheet of paper he developed his thoughts with the brush dipped in grey ink. The final result captures the spirit rather than the letter of Leonardo's original. The pent-up fury and bloody carnage so forcefully portrayed in this elaborate study were to become the source of inspiration for a number of battle scenes (Plate 96) and hunts (Plate 136) of later years.

After Titian, Raphael was probably the artist most studied in a variety of copies and variations. Probably using reproductive engravings, Rubens made summary sketches after a number of figures from the frescoes in the *Stanze* in the Vatican, as well as from one figure in one of the Sistine tapestries (Plate 31). But there was nothing narrowly archaeological about such an exercise, and at the top of the sheet in a few barely legible pen lines he added three figures taken from Holbein's *Dance of Death*, which he had copied more precisely in earlier years. And over these summary *ricordi* he wrote out three passages in Latin from the history of Alexander the Great by Quintus Curtius Rufus. This compendium of interests, which may well have formed part of a sketchbook to be discussed later, recalls the circumstantial account given by De Piles, when speaking of the artist's particular interest in Raphael and the antique: 'What was agreeable to his taste he made his own, either by copying, or making reflections upon it, which he presently wrote down; and he generally accompanied those reflections with designs, drawn with a light stroke of his pen, carrying always about him two or three sheets of blank paper for that purpose.'[10]

Although a large proportion of his copies were devoted to the great masters of the High Renaissance, including such figures as Tintoretto, Correggio, Parmigianino and Primaticcio, his drawings also reveal an interest in later sixteenth-century as well as contemporary artists. His early drawing of the *Descent from the Cross* (Plate 110) is an amalgam of ideas of Lodovico Cigoli and Rubens himself, to which he has added written notes to remind himself to refer also to the solutions used by Daniele da Volterra in his famous painting in SS. Trinità dei Monti. A painting of *St Christopher* (Plate 112) by his friend Adam Elsheimer was the source for two close variations on the theme of the Christ-Child perched on the saint's shoulders (Plate 111). Other contemporaries or near contemporaries who served as models include Barocci, Salviati and the two Zuccaro brothers.

His painted copies after other masters, ranging in time from Mantegna, the sole

31. Rubens after Raphael and Hans Holbein the Younger, *Various Figure Compositions*, c.1602–3. Pen and brown ink, 20.2 × 15.9 cm. Kupferstichkabinett, Berlin-Dahlem.

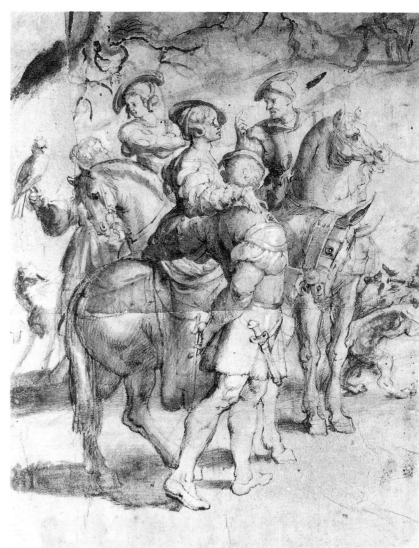

representative of the Italian Quattrocento, to Caravaggio, show a similar variety in approach. Sometimes he followed the original to the letter, while in other cases, such as Raphael's *Baldassare Castiglione* (Courtauld Galleries, London) and Titian's mythologies or *poesie* (Plate 244), he made minor alterations to match his interpretation of the original or to suit his own artistic purpose. In his painting of a *Roman Triumph* (Plate 238) he started on the right of his canvas by making an accurate copy of one of the canvasses of the *Triumph of Caesar* (Plate 239) by Mantegna, but then developed an entirely personal interpretation on the left, possibly, as will be seen, with the *Henry IV* series in mind.

Another practice which Rubens appears to have adopted already while in Italy, and continued throughout his life, was the retouching of drawings by others. In many cases these were only copies by minor artists after other works of art, such as those commissioned from young Italian artists. These would often be reworked so vigorously that the final result is more redolent of Rubens than the original artist. Recent examination of many copies previously accepted as executed entirely in Rubens' own hand has revealed that a good proportion are copies by others skilfully reworked by the master. In this activity his technique follows a general pattern, which makes it very difficult to date such exercises. Sometimes, if the drawing was reasonably good, it was only a question of strengthening the outlines, but more often he would apply bodycolour to the areas to be reworked and then draw in brush or pen, using a colour that matched that of the original copy. In the example of his reworking of a copy after one section of Annibale Carracci's ceiling in the Farnese Gallery (Plate 32), Rubens first had to repair the sheet by inserting a wedge-shaped piece of paper in the lower left, which now covers most of the painted medallion. The original copyist worked in black chalk, which is still partly visible beneath Rubens' rework in brush and brown and yellow washes, with bodycolour and touches of oil paint. Although traces of the original figures of *Apollo and Marsyas* can still be seen at the top of the medallion, Rubens chose to

32. Copy after Annibale Carracci reworked by Rubens, *Ignudo with Leda and the Swan*, c.1630(?). Brush with brown and yellow wash over black chalk, heightened with white, and reworked in grey and brown oil on yellow paper, 55.3 × 40.7 cm. Victoria and Albert Museum, London.

33. (above) Bernaert van Orley completed by Rubens, *A hawking Party*. Pen and ink with brown wash with touches of oil, 40.4 × 30.8 cm. British Museum, London.

34. Bernaert van Orley, detail from *September* for the tapestry series, *Les Belles Chasses de Maximilien*. Pen and ink with blue wash, 39.9 × 56.8 cm. Musée du Louvre, Paris.

21

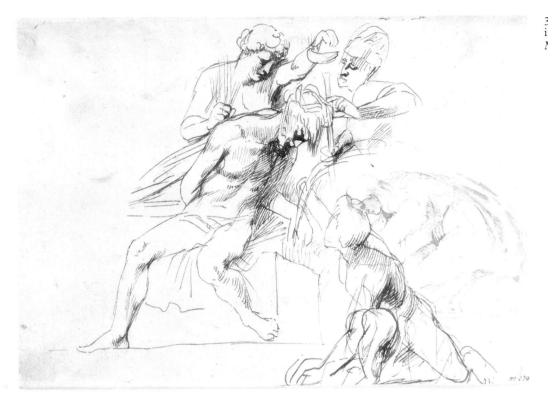

36. *The Mocking of Christ*, c.1601. Pen and brown ink, 20.8 × 28.9 cm. Herzog Anton-Ulrich Museum, Brunswick.

change the scene to *Leda and the Swan*. His reworking of this dry copy succeeds in conveying the play of light over the simulated stucco figures which provide a framework to the *quadri*.

A more unusual and extreme case of repair and retouching occurs in a drawing of a *Hawking Party* by Bernaert van Orley (Plate 33). The original sheet, which was only a fragment when it came into Rubens' hands, confined to the upper half of the figures and horses, was extended by him with strips of paper at the left and the bottom. Using his imagination, he completed the legs of the standing man and the two horses. Unknown to Rubens, Van Orley's drawing was preparatory to a tapestry (see Plate 34), which, in reverse, shows the legs placed together rather than apart in the more natural stance that Rubens introduced in his 'reworking'. And at the same time he worked over Van Orley's original drawing most dexterously to bring it into harmony with the style of his addition.

Besides studying in Rome, Rubens was given the chance of more creative work. The Archduke Albert, who before his marriage had been cardinal-archbishop of Toledo, wished to present an altarpiece to the famous pilgrimage church of S. Croce in Gerusalemme, from which he had taken his cardinal's hat. The gift may have been prompted by the recovery of the relic of the True Cross presented by Albert to the church and subsequently stolen. He wrote to his ambassador in Rome, Jean Richardot, asking him to find a suitable artist who would produce a worthy tribute. Richardot was apparently given a free hand in the choice but a limited budget. By one of those master strokes of knowing the right person at the right time, which were to play such an important part in Rubens' life, his name was soon under consideration. Writing to the Duke of Mantua to ask permission for Rubens' return to Rome, the ambassador said that he had 'lost no time in turning to a young Flemish painter called Peter Paul, who had the reputation of being a man of merit in his art'.[11] On this occasion the connecting link was Rubens' brother Philip, who had acted as secretary to the ambassador's father and was now accompanying the ambassador's brother on a visit to Italy. As a result of this contact Rubens was commissioned to paint an altarpiece of *St Helena discovering the True Cross* (Plate 35) to hang over the altar in the semi-subterranean chapel dedicated to the saint, and, to be placed over the side altars in the chapel, two smaller panels of the *Mocking of Christ* (see Plate 36) and the *Elevation of the Cross* (destroyed).

35. (facing page) *St Helena discovering the True Cross*, 1602. Panel, 252 × 189 cm. Chapel of the Municipal Hospital, Grasse.

Conforming to current Italian practice which had abandoned the traditional arrangement of separate panels joined together in one altarpiece, the three paintings were presented as a kind of triptych which brought the whole area of the chapel into play. St Helena in the centre looks up to the vision of the True Cross depicted in mosaic on the ceiling. Behind her the spectator would have been very aware of the receding distance in the picture which would have greatly enhanced his sense of space as he entered the chapel. The two pictures on the side altars with their crowded scenes within a shallow depth were conceived so as to allow for the necessary close viewing in the confined space available.

For his first Roman commission Rubens deliberately played safe and modelled himself on a mixture of High Renaissance, antique and modern sources. For the figure of St Helena he grafted Raphael's *St Cecilia* (Bologna) on to the antique marble figure of a Roman matron. The vast Salomonic columns, with bands of vine relief, recall those in Raphael's tapestry of the *Healing of the Paralytic* for the Sistine Chapel, which in turn were probably inspired by the columns of old St Peter's, brought, according to tradition, from the Temple in Jerusalem. The composition of the *Mocking of Christ* is no less obviously derived from Titian's painting of the same subject (Plate 37), at that time in Milan, a relationship even clearer in the preparatory drawing (Plate 36). The figure of Christ himself was inspired by the antique; the torso is based on the *Belvedere Torso* and the arrangement of the legs, also seen in Titian's picture, is taken from the *Laocoon* group, both of which sculptures he had copied (Plates 23–6). And other individual ingredients in these three pictures can be credited to other sources. At the same time Rubens was no less aware of contemporary painting in Rome, and the nocturnal lighting in the *Mocking of Christ*, dramatically revealing the violent action taking place, was surely a direct reflection of Caravaggio's early Roman paintings. The connection is underlined by Rubens' inclusion of a typically Caravaggesque young man with a feather in his hat in the background.

The general influence of Van Veen still lingers in such details as the putti who

37. Titian, *The Mocking of Christ*. Panel, 304.5 × 180.3 cm. Musée du Louvre, Paris.

38. *Aeneas preparing to lead the Trojans into Exile*, c.1602. Canvas, 146 × 227 cm. Musée National de Fontainebleau.

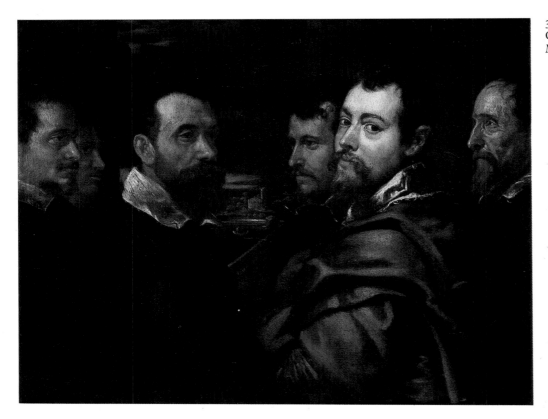

39. *The Artist with his Friends*, c.1602 or later. Canvas, 77.5 × 101 cm. Wallraf-Richartz Museum, Cologne.

attend on St Helena. But, for all the eclecticism in these three pictures, Rubens succeeds in introducing a personal note, even if such characteristics as the sharp colouring and dry rendering of the materials are common to the period. The large central figures in the three works who dwarf their surroundings may seem a little clumsy and contrived but as an ensemble in the small dark chapel they would have been powerfully impressive. And they clearly did impress at the time, since a guidebook published in 1610 has no hesitation in calling them '*Bellissimi*'.[12]

To enable him to finish this work Vincenzo Gonzaga had granted his artist several extra months in Rome, so that Rubens did not finally return to Mantua until April 1602. It may well have been at this time that in tribute to Mantua's most famous poet, Virgil, who was born nearby, he painted *Aeneas preparing to lead the Trojans into Exile* (Plate 38), which, it has been surmised, was intended with other Virgilian subjects as part of an unrecorded decorative scheme for the duke. Still harking back to the figure types of Van Veen, blended with a new interest in Giulio Romano and the Northern landscape tradition of Paul Brill, the picture has a glow and warmth of colour which already catches the spirit of Titian and Venetian art, which were to be such dominant sources of inspiration. The subject allows for a range of natural phenomena: on the left Troy still burns by night, while dawn is breaking over Mount Ida and the rocky coast on the right, revealing the huddled refugees about to sail towards a new future chosen for them by Aeneas. On the left, accompanied by Ascanius, Aeneas carries Anchises, who clutches the images of the Penates. The artist's detailed knowledge of the written source informs the entire presentation of the subject which is recreated with moving visual poetry.

Apart from a happy reunion with his elder brother Philip, we do not know much about his movements. Deep affection existed between the two brothers, and Philip had written on his arrival in Italy that 'my first desire was to see Italy, my second to meet you there again: the first is fulfilled and the second will, I hope, soon be fulfilled'.[13] And in June 1602 the two brothers and a mutual friend, Jan Woverius, finally met in Verona. As equally gifted as his younger brother, Philip was the favourite pupil of Justus Lipsius, the most distinguished humanist of the epoch. He had come to Italy to act as tutor to the ambassador's brother, Guillaume Richardot, and at the same time was engaged in reading for his degree of Doctor of

Law at the university of Rome. The brothers must have shared their joy at discovering new and different facets of the country which was to be their spiritual home, and they must have stimulated each other with their different interests and standpoints.

Possibly during this period of brotherly reunion Rubens painted the enigmatic work of the *Artist with his Friends* (Plate 39), which depicts six men half-length before a distant view of the Mantuan lake. The latter, probably taken from a window in the ducal palace, had been used by Mantegna as his background to the *Death of the Virgin* (Prado, Madrid), at that time probably in the Gonzaga collection. The painter himself is clearly recognisable in what is his first known self-portrait. Seen holding his palette, he represents himself, only on this occasion, with the tools of his profession. The head of Philip is on the left, with the venerable profile of Justus Lipsius, who could only have been present in spirit, on the other side. The other men on the left are not easily identified, and both Jean Richardot and Frans Pourbus the Younger, Peter Paul's compatriot at the ducal court, have been proposed for the central figure facing the artist. Without more certain identification the various interpretations of the picture must remain speculative. What is curious about the presentation is the manner in which the heads are placed together without any suggestion of mutual contact. The artist does not attempt to persuade us that the sitters even in his imagination ever came together in Mantua. The most fully realised portrait is that of Rubens himself, seen in a vivid and self-confident pose looking back over his shoulder at the spectator. The other men, with their detached gaze, have the appearance of isolated images assembled by the artist.

Rubens was not allowed to remain inactive for long in Mantua. He must have impressed himself on the duke as a reliable person, suitable to send on a delicate diplomatic mission, and already the pattern of his life was taking shape. For a small state to remain free and intact, while surrounded by larger powers only too ready to annex it, required considerable diplomacy as well as cunning and skill. Gonzaga showed himself ever ready to assuage the greed of the bigger powers by putting them in his debt. He was, for example, always prepared to march to war to support the emperor, or to lead his whole court to another city to do homage to the pope. On this occasion it was the turn of Spain to receive the ducal favour. Apart from promises of general protection, Vincenzo particularly coveted the post of admiral of the Spanish fleet, which owing to the disgrace of its former holder, Giovanni Andrea Doria of Genoa, was now vacant. Gifts had already been sent to Philip III and his first minister, the Duke of Lerma. Now further gifts were prepared to press home the advantage, and Rubens was chosen to accompany them to Spain and witness the presentation. As far as the pictures he was to take were concerned, Rubens remained acutely aware that he was the 'guardian and bearer of the works of others, without including a brushstroke of my own'.[14] But this situation was to be dramatically remedied by the effects of Spanish rain.

Rubens set off from Mantua in the early spring of 1603 with six chargers loaded on wagons – the presents included such bulky objects as a small coach with six bay horses – and in a series of letters addressed to the duke's secretary of state, Annibale Chieppio, who became a good friend at court, he gave a vivid account of the hazards of travel in those days, besides allowing us some insight into the artist's character and personality. For some unexplained political reason, instead of embarking at Genoa, he followed a most circuitous route. After numerous delays and changes of plan he finally reached Pisa, where he was entertained by the Grand Duke Ferdinand of Tuscany. Innocent of Italian intrigue, he was surprised that his host should be fully acquainted with his identity and the purpose of his supposedly secret mission. 'Perhaps it is my simplicity', he wrote back to Mantua, 'which causes me such astonishment at things that are ordinary at court. Pardon me, and read, as a pastime, the report of a novice without experience.'[15] Rubens had expected to go to Madrid, but on arriving in Spain he discovered that the court had moved to Valladolid, which he finally reached 'after twenty days of tiresome

travel, through daily rains and violent winds',[16] only to find that by then the court had moved on to Burgos. So in Valladolid he remained, penniless. He was not expected by the duke's treacherous agent, Annibale Iberti, 'to whom', Rubens wrote to the Duke of Mantua, 'I have unburdened . . . my charge of men, horses, and vases; the vases are intact, the horses sleek and handsome, just as I took them from the stables of Your Most Serene Highness, the men in good health, with the exception of one groom'.[17] But a week later with the arrival of the pictures, 'which were packed with all possible care by my own hand',[18] disaster struck. 'Apart from a portrait of the duke by Pourbus and a *St Jerome* by Quentin Massys, they

> were discovered today . . . to be so damaged and spoiled that I almost despair of being able to restore them. For the injury is not an accidental surface mould or stain, which can be removed; but the canvas itself is entirely rotted and destroyed (even though it was protected by a tin casing and a double oil-cloth and packed in a wooden chest). The deterioration is probably due to the continuous rains which lasted for twenty-five days – an incredible thing in Spain. The colours have faded and, through long exposure to extreme dampness, have swollen and flaked off, so that in many places the only remedy is to scrape them off with a knife and lay them on anew.[19]

This is exactly what Rubens proceeded to do, with, as will be seen, great success, replacing two pictures beyond repair with a *Democritus and Heraclitus* (private collection, Wales) of his own.

Iberti, who was at first all smiles and full of protestations of help, very soon showed his fangs, and at the presentation of Gonzaga's gifts shortly after the court's return to Valladolid, Rubens was to be given a sharp taste of the spite and petty jealousy of diplomatic behaviour, which in later years he was to know so well. The duke had commanded Iberti: 'These presents will be presented by you personally, but in the presence of and with the assistance of Peter Paul, who according to our wish will be introduced at the same time as the envoy expressly sent from here with these objects'.[20] Yet when the presentation of the coach actually took place, Iberti without a word changed the arrangements, leaving Rubens a mere spectator in the crowd. This petty injustice piqued Rubens, and he could not refrain from complaining to Mantua, following it up with another letter which was intended as an answer to the calumnies Iberti was no doubt sending back: 'I do not fear the slightest suspicion of carelessness or fraud; I can meet the first accusation with a certain experience of my services, and the second with pure innocence.'[21] He was aware of his worth and the correctness of his behaviour, and within the prescribed rules he was ready to fight for himself. He never stooped to use the weapons of the other side but had sincere belief in the triumph of justice. It took him thirty years to become disillusioned in this belief where political matters were concerned, by which time he had experienced the whole gamut of fickleness and viciousness of human behaviour. To Annibale Iberti he was indebted for his first lesson.

In Spain he received another more profound lesson – that the divine right of kings does not automatically confer absolute power. Weak, pleasure-loving Philip III was ruler in name only; the real power lay in the hands of his first minister, the Duke of Lerma. As Rubens was to recall much later on, 'The King in granting audience to an Italian gentleman, referred him to the Duke of Lerma (with whom an audience was extremely difficult). "But if I had been able to have an audience with the Duke," replied the gentleman, "I should not have come to your Majesty." All this confirms my belief that it is difficult to conduct affairs in a country where a single man has the power and where the King is only a figure-head.'[22]

His journey to Spain also gave Rubens his first opportunity to study the artistic situation there. He reported that he saw 'so many splendid works of Titian, of Raphael and others, which astonished me, both by their quality and quantity, in the king's palace, in the Escorial and elsewhere. But as for the moderns, there is

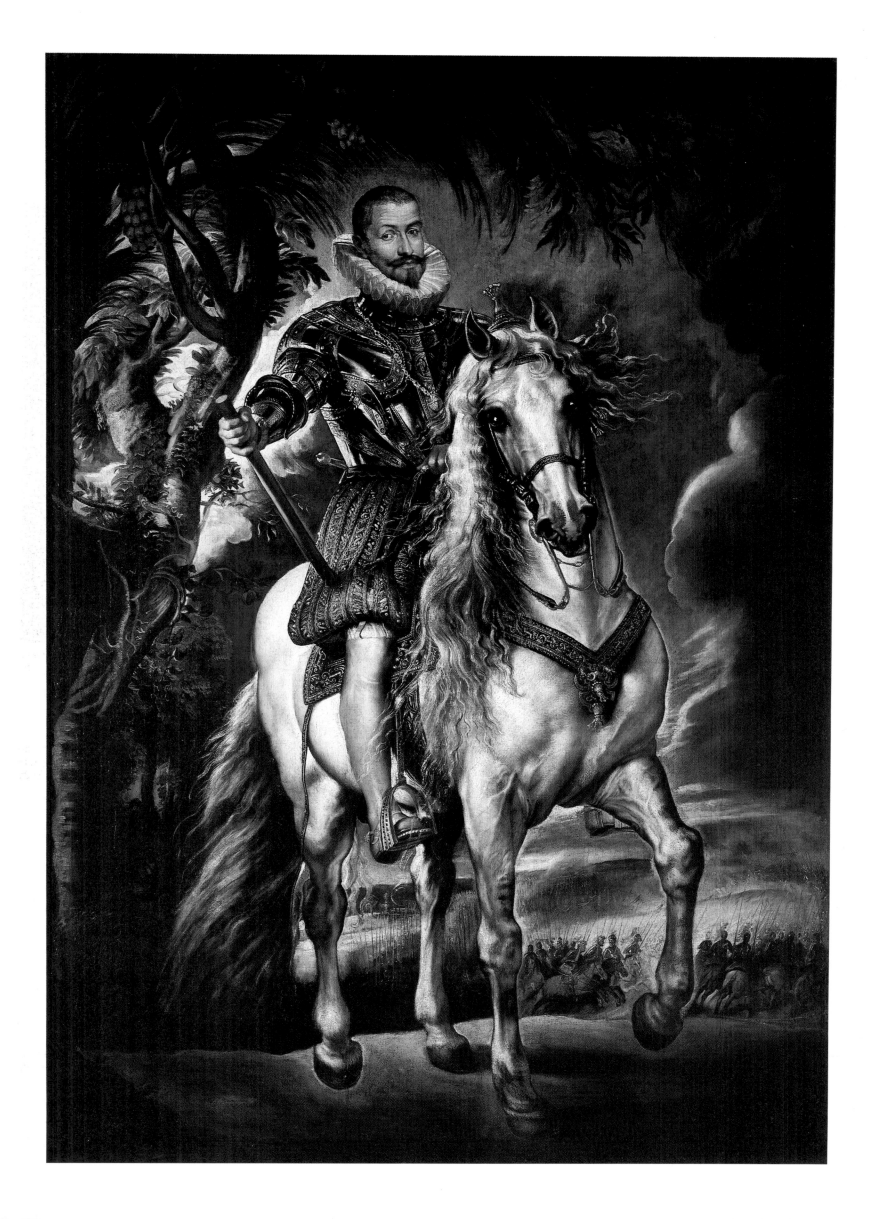

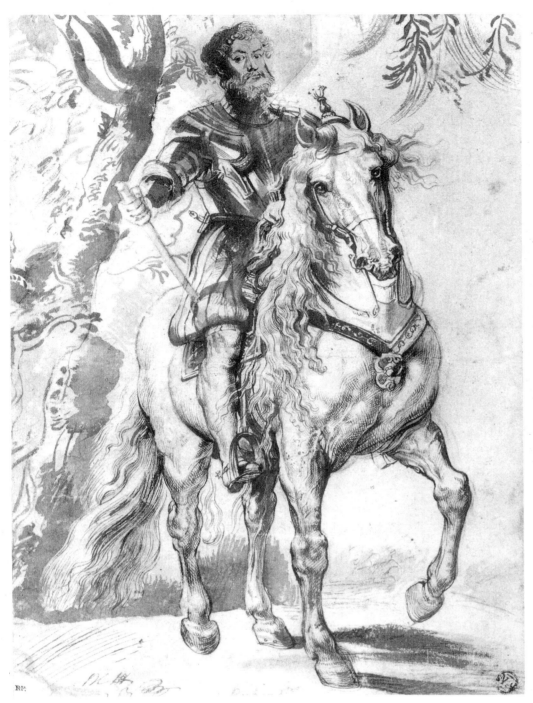

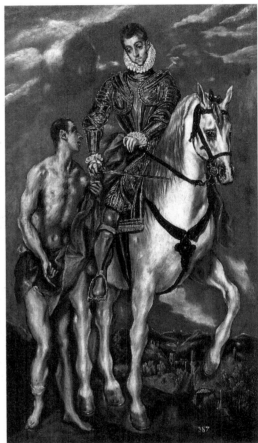

42. El Greco, *St Martin and the Beggar*. Canvas, 191.1 × 98.1 cm. National Gallery of Art, Washington.

41. (left) *A Rider on Horseback*, c.1603. Pen and ink with brown wash over black chalk (head pasted on separate sheet), 30 × 21 cm. Musée du Louvre, Paris.

nothing of any worth', he continued, with the contempt and impatience of a young man who knew his own mind. He did not mince his words when he castigated 'the incredible incompetence and carelessness of the painters here . . . God keep me from resembling them in any way.'[23] And, if not a diplomatic expression of politeness, it is an indication of the lack of knowledge about painting at the Spanish court, as well as a tribute to Rubens' skill, that Gonzaga's gifts of copies after Raphael and other artists '(thanks to good retouching) had acquired a certain authority and appearance of antiquity' and 'were for the most part, accepted as originals with no suspicion to the contrary, or effort on our part to have them taken as such'.[24]

For his master in Mantua, who, in his only assessment of the artist, allowed that he had succeeded 'well enough in painting portraits',[25] Rubens was commanded to execute a series of court beauties to take back with him. But of far greater significance for the history of art was the exercises in *Realpolitik* through which he was called upon to paint an equestrian portrait of Lerma (Plate 40), 'with the hope of proving to Spain . . . that the Duke is not less well served than His Majesty'.[26]

40. (facing page) *The Duke of Lerma on Horseback*, 1603. Canvas, 289 × 205 cm. Museo del Prado, Madrid.

Hanging in the royal collection at Madrid was that great equestrian portrait of the previous century, Titian's *Charles V on Horseback* (Prado, Madrid), which sufficiently impressed Rubens at the time for him to make a head and shoulders copy (Courtauld Galleries, London). But when he came to execute a similar work, he showed himself, unlike at S. Croce in Gerusalemme in Rome, to be remarkably independent, and by means of a new portrait type created a superb image of power. He may have recalled the description given by Pliny of Apelles' portrait of Antigonus, dressed in armour, advancing on his horse. Adapting a pattern he could have seen in sixteenth-century religious paintings, such as the representations of *St Martin* by El Greco (Plate 42) and Pordenone (S. Rocco, Venice), Rubens painted the duke frontally from below, with the horse greatly foreshortened. Engravings of triumphant rulers and Caesars, which were not without relevance to the sitter's estimate of himself, may also have played a part in creating a pattern, which other artists, most notably Van Dyck, as well as Rubens were to repeat.

Two drawings were made in preparation. In the first (Plate 41), possibly made for the duke's approval, the artist worked in pen and ink over an initial sketch in black chalk, varying in degree of finish from the carefully hatched modelling of the horse to the brilliantly free drawing of the tree. The head, for which at this stage Rubens appears to have used a stand-in, was drawn on a separate piece of paper pasted over what was probably another arrangement. All the essentials of the painting are here, except that in the latter he added an additional strip of canvas to create more space at the top and allow the branches of palm and olive, symbolic of victory and peace, to form an arch over the sitter's head, which is continued in the clouds on the right.

The canvas is painted with bravura which brings much sharply defined detail into general focus. As captain general of the cavalry, whose squadrons can be seen charging in the distance, the duke is shown bareheaded riding towards the spectator. His melancholy expression, set off by the fashionable millstone ruff of the time, befits the fact that he was in official mourning for the death of his wife, although Iberti reported that 'it is generally rumoured that the grief is more simulated than genuine'.[27] On his bay horse, the sitter in black armour chased with gold and picking up reflections of red from his sumptuously embroidered breeches stands out against the blue sky. For all the scale and grandeur of the portrait, the duke is presented as a very real person. Even the detested Iberti could not conceal that the work was arousing great interest and admiration, and he admitted to Vincenzo that the portrait 'in the general opinion has succeeded beautifully'.[28] Lerma himself was 'pleased in the extreme',[29] and asked Gonzaga whether Rubens could not remain in the king's service, doubtless with his own interests in mind.

Rubens reached Mantua at the beginning of 1604 a wiser and better-travelled man. More than that, he seems to have realised his own stature; he had a healthy opinion of his capabilities. From the young painter always at his master's command he had matured into a man who knew what he was best fitted for. A subtle change in the tone of his letters to Mantua indicates that leading a mission, albeit a small one, gave Rubens that confident feeling that the world was at his command, and not the reverse. He was no less loyal and ready to serve, but he did not wish his services to be wasted on menial tasks and did not hesitate to say so clearly, if politely. A firmness of intent and a conviction in the correctness of his own opinion underlie every letter. He was successfully following his brother's advice proferred before he went to Spain: 'Remain firm, and keep your complete liberty in a court from which it is almost banished.'[30] In addition, he had the gift not only of knowing his own mind, but of being able to make others agree with him. To a suggestion that from Spain he should go to France to paint a series of court beauties – an idea which a few months before he had positively favoured – he now pleaded that local painters should do it: 'Then I should not have to waste more time, travel, expenses, salaries (even the munificence of His Highness will

43. *The Baptism of Christ*, c.1604. Black chalk, 47.7 × 76.7 cm. Musée du Louvre, Paris.

not repay all this) upon works unworthy of me, and which anyone can do to the Duke's taste . . . I beg him earnestly to employ me, at home or abroad, in works more appropriate to my talent.'[31]

The duke took him at his word and, since he clearly regarded Frans Pourbus as the family portrait painter, it caused him no problem to give Rubens a major commission of a different kind. But before settling to this work he went, according to De Piles, to Venice 'to examine at leisure the beautiful things he had only seen in passing' on his first visit. 'He extracted from the works of Titian, Paolo Veronese and Tintoretto as much profit as he could to improve his manner.'[32] This visit would prove a good investment when he returned to Mantua to undertake, at the duke's command, a painted frieze consisting of three large canvases to decorate the main chapel in the Jesuit church, which was dedicated to the Holy Trinity. (There is some evidence to suggest that the genesis of this commission goes back several years). The *Trinity adored by the Duke of Mantua and his Family* (Plate 45) was placed over the altar, with the scenes of the Trinity's earthly appearances, the *Baptism* (Plate 47) and the *Transfiguration* (Nancy), on the side walls. (The same subjects had already been used in the Gesù in Rome.) Rubens was at last carrying out 'works more appropriate to my talent'; by June he had probably submitted the final sketches for approval, and eleven months later had completed the three canvases. Unfortunately the decoration of the chapel was removed and the central canvas cut up by Napoleonic troops.

44. Aristotile da San Gallo after Michelangelo, *The Battle of Cascina*. Grisaille on panel, 76.4 × 130.2 cm. Holkham Hall, Norfolk.

Although the arrangement has been much disputed, enough remains of the central canvas to determine its general appearance. Recalling the bronze kneeling figures of the Hapsburgs by Pompeo Leoni in the Escorial (Plate 46), members of the Gonzaga family kneel in adoration, Dukes Guglielmo and Vincenzo on the gospel or more important side, and their respective wives, Eleonora of Austria and Eleonora de' Medici, on the epistle side. Other existing fragments determine that they were accompanied by the children, also divided by sex, and attended by halberdiers, one of whom, significantly placed on the 'female' side, was apparently a self-portrait. The terrace, which is seen by the spectator from below, is flanked by a giant colonnade with the twisted Salomonic columns with vine relief already used by Rubens on his first Roman altarpiece. All eyes are directed upwards to a vision of the Trinity presented on a tapestry supported by angels. This combination of sacred and secular directly follows the Venetian tradition, seen in the Palazzo Ducale, of representing the doges with the deity and saints. Moreover, the magnificent architectural perspective open in the middle with a balustrade, as

45. *The Trinity adored by the Duke of Mantua and his Family*, c.1604–6. Canvas, 190 × 250 cm. Accademia, Mantua.

well as the use of halberdiers, were undoubtedly done in emulation of Veronese. The strong local colours – gold, silver and red – also reflect what he had just seen in Venice, while the vigorous execution is similar in spirit to Tintoretto. The vast canvas was an expression of the earthly power and spiritual privilege of the Gonzaga family.

Apart from portrait drawings of two of the Gonzaga sons (Nationalmuseum, Stockholm), no preparatory work drawn or painted for the central scene has survived. For the *Baptism* on the left there is a large squared cartoon (Plate 43) in black chalk, of the kind commonly employed by Italian artists, but which it seems was not used by Rubens again. Rubens' subsequent preference for the painted *modello* allowed him apart from indicating colour, to accommodate second thoughts without the patchwork of paper needed to correct the foliage above and two of the figures below in the cartoon. The drawing is a remarkable example of Rubens' virtuosity in the precise handling of chalk, and the combination of finely chiselled modelling of the figures with more open drawing in parallel lines in the background is reminiscent of Michelangelo's 'presentation drawings'. Despite the squaring, Rubens made changes on the canvas, which were presumably established in another cartoon. Apart from two additional angels above Christ and the more frontal pose of St John, the principal alteration was the omission of the seated young man leaning on the tree in the centre. (Like a thrifty cook, Rubens transposed this figure, probably taken from the antique, to another composition.) As a result the foreground figures are more spread out and have gained in scale. Conscious that the picture would be viewed obliquely from the left, Rubens

placed the main scene nearest to the spectator on that side. Although there was an overall pattern to the 'triptych', the grouping within each composition was arranged around the miraculous source of light from above, with each work retaining its own world of shadows and colours. The effect of flesh painted against a dark landscape in the *Baptism* is more sombre than the colourful central scene.

As in other works of the period, the *Baptism* is a masterly amalgam of Florentine and Roman form and Venetian light and colour, recalling the programme which, according to Ridolfi, was written on the walls of Tintoretto's studio. To Michelangelo's *Battle of Cascina* (Plate 44), Rubens was generally if not specifically indebted for such details as the seated man undressing on the right, while the group of Christ and the Baptist were probably suggested to him by the Raphaelesque fresco in the *Loggie* in the Vatican. Other sources can be identified, but what unifies the individual influences is the powerful pattern of light and shadow. With the greater predominance of the latter, the principal figures become a patchwork of small highlights of the kind Rubens could have studied in the work of Tintoretto.

With this major commission completed, Rubens was able to escape from Mantua by the end of 1605 and return to Rome for what was the most interesting and rewarding part of his Italian journey. His brother Philip (Plate 48), who had by this time received his degree of Doctor of Law at Rome, was already installed there as librarian to Cardinal Ascanio Colonna, so that the two brothers were able to live together in a house, waited upon by two servants, in the Strada della Croce, just near the Piazza di Spagna. The visit started off badly when Rubens was laid low with pleurisy. He was cured by a German doctor, Jan Faber, a man of wide achievements whose house provided a meeting place for Northern artists. In gratitude Rubens presented Faber with a painting of a cock, inscribed to 'my Aesculapius', which, as the doctor wrote, 'though jesting displays his erudition'.[33] Recovered, Rubens 'devoted all the summer to the study of art'.[34] He lived and breathed the atmosphere of the classical age and the Renaissance. With Philip, whose renown as a scholar led to the offer of a chair at the university of Pisa, he

46. Pompeo Leoni, *The Hapsburgs kneeling in Devotion.* Bronze, parcel-gilt. Capilla Mayor, S. Lorenzo in Escorial.

47. *The Baptism of Christ.* c.1604–6. Canvas, 482 × 605 cm. Koninklijk Museum voor Schone Kunsten, Antwerp.

undertook an intensive survey of Roman antiquity, which bore fruit in a book on the customs of ancient Rome, entitled *Electorum Libri II*, which was published by the Plantin Press in Antwerp in 1608. Written by Philip, it was illustrated with five engravings after drawings by Peter Paul of various studies of Roman sculpture, chosen not for artistic reasons but to illustrate various points made in the text, such as the correct method for an orator to fold his toga, shown in three different views of a statue of a supposed senator (Plate 49). Together they made a perfect combination, with Philip providing the scholarship and Peter Paul the artistic input. In his introduction Philip acknowledges not only the 'skilled hand' of his brother but also his 'keen and certain judgement', suggesting that his role was more than simply that of an illustrator.

In addition to what Roger de Piles wrote (see p. 20), there is evidence of Rubens' seriousness as a student of antiquity from the strictly archaeological notes he made of the various works he saw. A manuscript written by his later friend Peiresc reproduces a list of these under the title of 'Extract from the itinerary followed by M. Rubens in Rome'.[35] This programme of study led to an unpublished treatise 'concerning the Imitation of Antique Statues', now known only from the transcription given by De Piles, who at that time owned the manuscript. As one would expect, it contains much of Rubens' own practice as an artist and underlines the great importance he attached to the subject. As he said, 'to some painters the imitation of the antique statues has been extremely useful, and to others pernicious, even to the ruin of their art. I conclude, however, that in order to attain the highest perfection in painting, it is necessary to understand the antique, nay, to be so thoroughly possessed of this knowledge, that it may diffuse itself everywhere. Yet it must be judiciously applied, and so that it may not in the least smell of the stone.' He continues with practical advice about copying and selecting models as well as celebrating the excellencies of antique sculpture: 'we of this erroneous age are so degenerate that we can produce nothing like them'.[36]

The passages transcribed by De Piles were the publishable part of a much more extensive series of theoretical notes in which he undertook a much wider enquiry. Unfortunately destroyed by fire in 1720, the notebook's contents were described by De Piles as a mixture of text and illustrations, containing 'observations on optics, light and shade, proportion, anatomy and architecture, with a very unusual enquiry into the principal passions of the soul, and actions based on descriptions taken from the poets, with illustrations in pen after the best masters, particularly Raphael . . . There are battles, storms, games, scenes of love, torture, various deaths and other similar passions emotions and events, a good number of which are based on the Antique.'[37]

Apart from reflections in the work of his protégé Van Dyck, and some copies by pupils or assistants, the little existing visual evidence about the contents is confined to a few surviving sheets, such as the copies after Raphael and Holbein (Plate 31), two studies of a silver spoon (Plate 202) and studies of the *Farnese Hercules* (Plate 51). This last sheet illustrates the Pythagorean theory, written out by the artist on the verso, about the basic geometric form of the human body. While the male figure, such as that of Hercules, should be based on cubes and squares, the female should derive from circles and spheres. That Rubens never succeeded in finishing the manuscript can easily be explained by the increasing demands on his time as a creative artist, though his interest in the theory of art may also have diminished with the years. Apart from the book on the palaces of Genoa (1622), in which his contribution was minimal, none of the projects in which he became involved was ever brought to a state ready for publication.

For the artist these were important months in Rome which gave him a deep understanding of classical art and literature so that in later years he was able to penetrate to the very heart and form of the classical subjects, as his transformations so eloquently reveal. Apart from at least three finished copies, the *Farnese Hercules* (Plate 52) was, for example, studied in a quick sketch in black chalk (Plate 53), reduced to a series of cubes and squares in a sheet from his 'Pocket

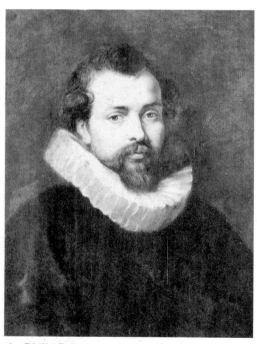

48. *Philip Rubens*, c.1610–11. Panel, 68.5 × 53.5 cm. Detroit Institute of Arts.

49. Cornelis Galle after Rubens, *Iconismus statuae Togatae* from *Electorum Libri II* (Antwerp, 1608). Engraving, 19.9 × 27.3 cm. British Museum, London.

Book' (Plate 51), and recreated into an entirely personal form in the superb chalk drawing of *Hercules Victorious over Discord, crowned by Two Genii* (Plate 54). Moreover, as the perfect embodiment of the 'strong man' his figure was transposed into that of St Christopher (Plate 109). The drawing of *Silenus surprised by the Water Nymph Aegle* (Plate 55), in which the latter with blood-red mulberries rubs the brow of the god, bound hand and foot, to persuade him to redeem his promise to sing a song, perfectly captures the spirit of Virgil's *Bucolics*.

Adopting a classical group of *Menelaus and Patroclus* (Plate 56), Rubens produced a searing illustration of the 'lament for Adonis', the best-known poem of the late Greek pastoral poet Bion (Plate 57). In the drawing, whose wonderful fluidity and freedom of penwork convey the maximum emotional intensity, Venus gazes into the eyes of the dying Adonis, whose body is supported on the lap of a woman, while a putto tends his wounds. To reinforce the psychological relationship between the two protagonists, Rubens has drawn a more schematic variation of the two heads placed closer together, underlining in the words of his Latin inscription what is most vividly shown: 'She draws out the soul of the dying man with her mouth.'

It must have been an immensely pleasurable time, surrounded by kindred spirits all absorbed in a study of the *caput mundi*, with few of the nagging irritations of court life, apart from the constant non-payment of his salary. To his activities as scholar and artist he now added that of collector, and, according to Balthasar Moretus, when he returned home to Antwerp he had already acquired at least two sculptures. He was also able to renew acquaintance with living artists and eagerly absorbed their latest preoccupations. Caravaggio was about to flee from Rome under a cloud, but Rubens had lost none of his admiration for him, and when Caravaggio's *Death of the Virgin* (Plate 50), painted for the church of S. Maria della Scala, was rejected as unfit for an altarpiece, he stepped in and recommended that Gonzaga purchase it. The duke agreed, but not for the only time was Rubens engaged in complicated negotiations over the purchase. The picture, which few had seen, became something of a *cause célèbre*, and to satisfy the curiosity of the artistic community in Rome the duke's agent had to put it on public display for a week. After his intervention Rubens was no doubt gratified that the picture was 'praised for its exceptional merit'.[38]

But the pleasant summer turned to what at first was a joyless winter. Philip

50. Caravaggio, *The Death of the Virgin*. Canvas, 369 × 245 cm. Musée du Louvre, Paris.

35

51. Rubens after the Antique, *Two Copies of the Farnese Hercules*, c.1600–8. Courtauld Institute Galleries, London.

52. *The Farnese Hercules*. Marble, ht. 317 cm. Museo Nazionale, Naples.

53. (right) Rubens after the Antique, *The Farnese Hercules*, c.1600–8. Black chalk, 22.2 × 26.8 cm. British Museum, London.

54. (facing page) *Hercules Victorious over Discord, crowned by Two Genii*, c.1615–22. Red chalk with touches of black chalk, 47.5 × 32 cm. British Museum, London.

55. *Silenus surprised by the Water Nymph Aegle and other studies*, c.1611–13. Pen and brown ink with brown wash, 28 × 50.7 cm. Royal Library, Windsor.

Rubens returned to Antwerp, as their mother's health was already beginning to cause concern. Gonzaga's funds were further strained by the marriage of one of his sons, and Rubens' salary was more tardily paid than ever. However, recognition of his talents came with an offer of an important commission, as he recounted in a letter, actually written by his brother, to the duke's agent in Mantua; 'when the finest and most splendid opportunity in all Rome presented itself, my ambition urged me to avail myself of the chance. It is the high altar of the New Church of the Priests of the Oratory [a lay order founded by St Philip Neri in 1564], called S. Maria in Vallicella – without doubt the most celebrated and frequented church in Rome today, situated in the centre of the city, and to be adorned by the combined efforts of all the most able painters in Italy.'[39] Rubens had quickly found influential patrons in Rome, such as Cardinal Scipione Borghese, nephew of Sixtus V, among whose titles was that of 'Protector of Germany and the Low Countries', and the Genoese Monsignor (later Cardinal) Giacomo Serra, who was a highly influential figure at the papal court. In this instance it was Serra who offered a substantial contribution towards the cost of an altarpiece (Plate 58) on the condition that the commission was given to his young Flemish protégé. Although the remuneration was less than Rubens might have expected for such a work, he clearly saw the political advantages in accepting. And on this occasion Rubens was not disposed to play down his triumph, 'obtained so gloriously, against the pretensions of all the leading painters of Rome',[40] when he asked Mantua for additional leave. How Guido Reni and other artists reacted to the success of a young foreigner is unfortunately left to the imagination.

If the Oratorians accepted the Monsignor's proposal, they imposed strict conditions of their own. The artist was to show them a specimen of his work and then submit a final *disegno*. Even after approval of the latter, they retained the right to reject the painting until it had been publicly exhibited on the altar. The subject was two martyrs and four saints including St Gregory who with the Virgin was patron of the church. What made the commission highly unusual was the stipulation that the small fresco of the miraculous image of the Virgin, taken from the old church of S. Maria in Vallicella, was in an unexplained way to be incorporated into the altarpiece. On these terms the artist agreed to finish in eight months (i.e. by the end of May 1607).

Rubens' only previous public commission in Rome was already four years old, and since his art had developed he probably considered that it was desirable to submit something more up to date as a specimen of his work. A large oil-sketch (Plate 59), which contains the basic ingredients of the Oratorians' commission, may well have been executed with this purpose in mind. Before a monumental arch revealing ruins on a hillside probably intended to be the Palatine, St Gregory stands with Sts Maurus, Papianus and Domitilla grouped around him. In recognition of the miraculous image to be included above, St Gregory looks up with an expression of intense devotion. In preparing this work Rubens followed a pattern that was to become his normal system of working. A rapid schematic pen-

56. Gaetano Vascellini, *Menelaus and Patroclus*, 1789. Engraving.

57. *Venus lamenting Adonis*, c.1608–12. Pen and brown ink, 30.5 × 19.8 cm. National Gallery of Art, Washington.

59. *St Gregory with Sts Domitilla, Maurus and Papianus*, c.1606. Canvas, 146 × 119 cm. Gemäldegalerie, Berlin-Dahlem.

58. (facing page) *St Gregory the Great surrounded by other Saints*, 1607–8. Canvas, 477 × 288 cm. Musée des Beaux-Arts, Grenoble.

60. *Sts Gregory and Domitilla*, c.1607. Pen and brown ink, 21 × 37 cm. Private collection, England.

61. *St Catherine, formerly St Domitilla*, c.1606–7. Brush and brown ink over black chalk, reinforced with pen and ink, 47 × 31.5 cm. Metropolitan Museum of Art, New York.

62. Titian, *The Virgin in Glory with Six Saints*. Panel, 381 × 271.8 cm. Musei Vaticani, Rome.

sketch (Plate 60) adumbrates the general arrangement of the saints. The figure of St Domitilla was then developed in a more finished drawing (Plate 61), whose combined execution in brush and chalk with some penwork beautifully portrays the play of light over the folds of her voluminous dress. Technically the predominant use of the brush demonstrates his increasing mastery of a fluid manner of painting. In the final work the saint was depicted more in profile, and perhaps not to waste such a fine study Rubens changed, possibly with another work in mind, the figure into St Catherine by adding a sword to her right hand.

Rubens' increasingly sophisticated use of the works of art which he had studied in Italy can be detected in this oil-sketch, which shows a traditional High Renaissance *Sacra conversazione*. The general arrangement of the saints shows the influence of Titian's *Virgin in Glory with Six Saints* (Plate 62), which Rubens would have known both from the original, then in the Frari, Venice, and from Boldrini's woodcut. The figure of St Gregory with one hand outstretched and the other supporting a book on his thigh can be seen as a Baroque interpretation of Raphael's figure of Aristotle in the *School of Athens* (Plate 63), a derivation even more unmistakable in the pen-sketch. In the case of St Maurus, Rubens seems to have remembered the figure of St George in Correggio's *Madonna with St George* which he himself had copied (Albertina, Vienna). And the introduction of a vista of landscape framed by architecture can be paralleled in Agostino Carracci's *Last Communion of St Jerome*, (Pinacoteca, Bologna). As the father superior of the Roman Congregation was with more understanding than accuracy to write a few years later, when recommending Rubens' services to the Oratorians in Fermo, 'He is Flemish but was raised as a boy in Rome'.[41]

This highly Roman solution, whose figures in basic colours were painted in a lighter key than he had used previously, met with approval, and the artist was able to move on to the next stage by submitting a *disegno o sbozzo*. This is probably to be identified with a finished drawing in pen and wash (Plate 64) which reflects the narrow space at the artist's disposal in the upright shape and elongated proportions of the figures. In the final work (Plate 58) Rubens made only a few alterations, but compared with the oil-sketch the colour has become richer and more sonorous especially in the painting of St Domitilla's dress. Exactly how the miraculous image of the Virgin, which Rubens said was 'to be placed at the top of my picture',[42] was to be incorporated in the finished picture is not clear.

The following year, although he had an ulterior motive, Rubens extolled to Gonzaga 'the beauty of colouring and the delicacy of the heads and draperies, which I executed with great care from nature'. (And one might instance his drawing of St Domitilla; Plate 61.) 'The composition is very beautiful because of the number, size and variety of the figures of old men, young men and ladies richly

dressed.' The artist was in no doubt that it 'is by far the best and most successful work I have ever done'.[43]

He appears to have finished the painting in the prescribed time. Nevertheless, the miraculous image could not be moved for several months; 'the two go together, and one cannot be unveiled without the other. Besides it will be necessary for me to retouch my picture in its place before the unveiling.'[44] For his work on the altarpiece Rubens had been granted six months' extension to his stay in Rome, but in the summer he was summoned back to Mantua. He was preceded by a letter to

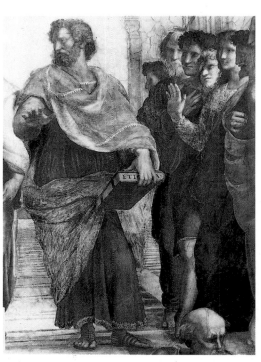

63. Detail from Raphael, *The School of Athens*. Fresco. Stanza della Segnatura, Vatican, Rome.

64. *Sts Gregory, Domtilla, Maurus and Papianus*, c.1606. Pen and ink with brown wash over black chalk, 73.5 × 43.5 cm. Musée Fabre, Montpellier.

43

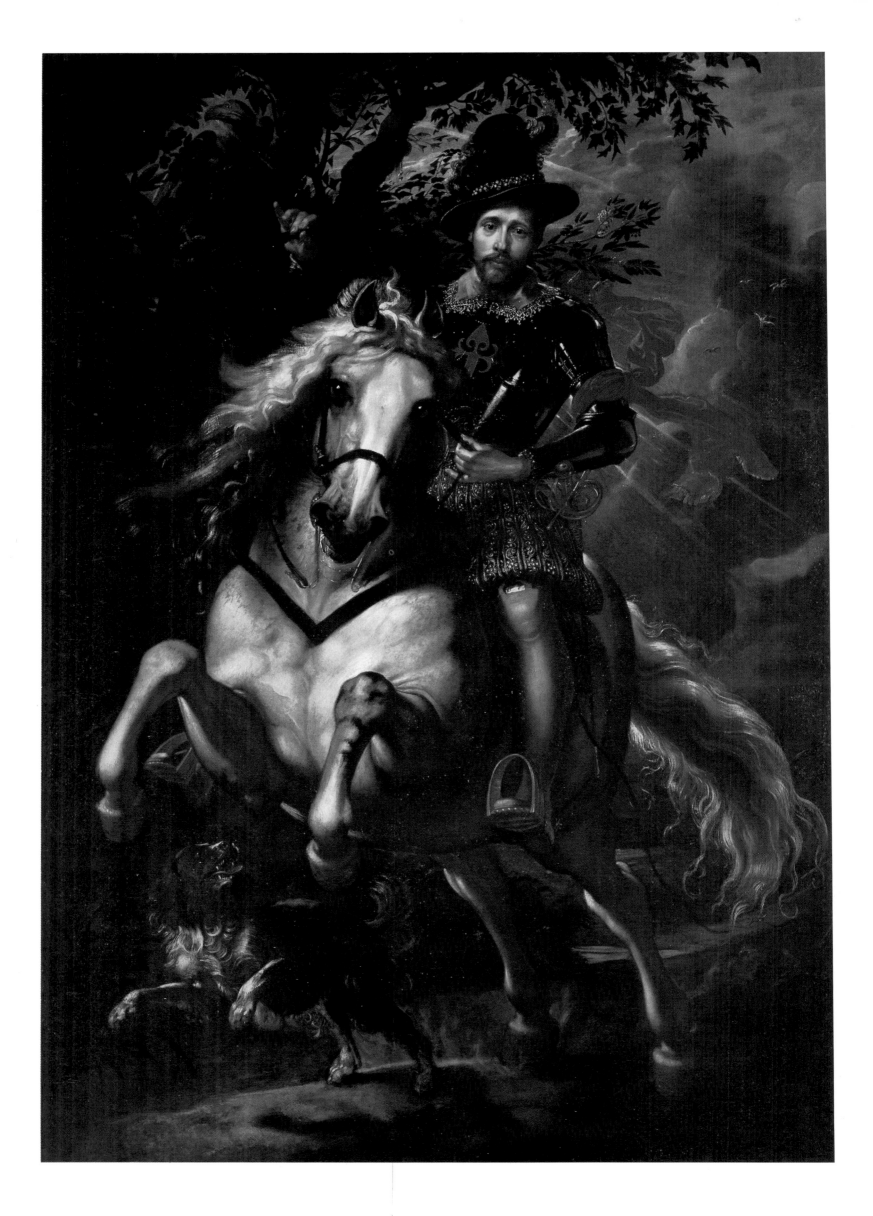

65. (previous pages left) *Giovanni Carlo Doria(?)
on Horseback*, c.1606–7. Canvas, 265 × 188 cm.
Palazzo Vecchio, Florence.

66. (previous pages right) *Veronica Spinola
Doria*, c.1606–7. Canvas, 225 × 138 cm.
Staatliche Kunsthalle, Karlsruhe.

67. '*Facciata del Palazzo F*' from *Palazzi di
Genova* (Antwerp, 1622).

the duke pleading for his speedy return so that he could complete the final work on
the altarpiece.

Rubens was probably required by the duke to accompany him on a visit to
Genoa, where we know they spent the summer months. 'The magnificent city of
Genoa', as the artist referred to it with 'singular affection',[45] was handsome and
individual in both setting and architecture. 'Built in the hollow or bosom of a
mountain . . . it represents the shape of a theatre; the streets and buildings so
ranged one above the other, as our seats are in playhouses; but by reason of their
incomparable materials, beauty and structure: never was any artificial scene more
beautiful to the eye of the beholder.'[46] Its architecture created for a prosperous
upper middle class was distinguished by the number of fine houses built by
Galeazzo Alessi in the third quarter of the sixteenth century, establishing a style of
domestic architecture of massive austere exteriors contrasting with the richly
decorated interior courtyards and delightful gardens with exotic trees inhabited
by numerous birds. Outside the city were 'pleasant Villas and fragrant Orchards
which are situated on this Coast, full of Princely retirements for the
Sumptuousness of their buildings and nobleness of the plantations; especially
those at St Pietro d'Arena, from whence . . . might perfectly be smelt . . . the
natural perfumes of Orange, Citron and Jasmine flowers'.[47]

Rubens' experience of the city seems to have crystallised his thoughts about
architecture, which he eventually expressed in the foreword to the book of
engravings after plans and elevations of Genoese palaces (Plate 67), which 'I have
collected on my journey through Italy'.[48] Since his arrival in Italy his eyes had
been opened to a very different style of building from which he was accustomed at
home. In Rome above all he would have been aware of the continuity of the
classical tradition so unlike the lingering medievalism in Flanders. Where Genoa
offered an attractive and practical example, worthy of imitation, was in its
domestic architecture, which was more appropriate for the wealthier bourgeoisie
of Antwerp than the princely palaces he had seen in other Italian cities. Catering
for a society composed of nobles rather than a single prince, the Genoese house
was 'very beautiful and comfortable'. 'However, rich or grand it might be', the
design was basically 'a solid cube with a salone in the centre'. It was presumably
the applicability of what he had seen to his own domestic building programme in
Antwerp that spurred Rubens to make his knowledge more widely available to his
fellow countrymen.

Genoa was a republic and carefully maintained its independence, although its
political affiliations were, for sound financial reasons, primarily with Spain. As a
result it became extremely prosperous, with its bankers acting as financial agents
to a hard-up Spain and its merchants growing richer from their ships protected by
the Spanish fleet. Rubens was later to recall that 'I have been several times in
Genoa and remain on very intimate terms with several eminent personages in that
republic'.[49] De Piles says that the artist particularly liked the city for its mild
climate and the warm reception he received from its inhabitants, who not only
gave him commissions but appreciated the results more keenly than elsewhere.
Although he had not passed through the city on his way to Spain in 1603, he may
well have paid his first visit on his way back to Mantua. He was certainly there in
1606 working on portrait commissions before his return in 1607. On his arrival a
major altarpiece of the *Circumcision* (S. Ambrogio), painted in Rome and shipped
to the Jesuit church in Genoa, was awaiting his attention so that it could be cut
down to fit the available space. Bellori says that he painted several mythologies for
Giovanni Vincenzo Imperiali, but his main artistic occupation there was painting
portraits, which, unlike the lukewarm praise such work evinced from Duke
Vincenzo, were undoubtedly highly valued. Moreover, it is the only society in
Italy of which Rubens left behind a body of portraits which not only record
individuals but create an image of its corporate character.

Baglione particularly mentions that Rubens 'depicted a number of Genoese
gentlemen from life on horseback, lifesize, executed with love and very similar;

and in this genre he had few equals'.[50] But only one exists today, the portrait of a member of the Doria family (Plate 65), probably to be identified as Giovanni Carlo, who was an exact contemporary of the artist. He is dressed in black armour, decorated with the red cross of the Spanish Order of Santiago de Compostela with the flowing scarlet scarf of a commanding officer attached to his arm, which provides the one brilliant note of colour in the picture. (Giovanni Carlo served as a naval commander under the Spanish.) Wearing a high-crowned hat, he nonchalantly holds up the reins in his right hand as, mounted on a bay, he leaps towards the spectator, accompanied by a spaniel, which recalls a similar companion to Dürer's 'Christian knight' in the engraving of *Knight, Death and the Devil*. Plane, ivy and olive growing in the background may symbolise good works, fame and peace respectively, while the eagle perched on the tree is a reference to the Doria arms.

More Baroque than the portrait of Lerma, the pose here may have been suggested by Antonio Tempesta's engraving of Henry IV of France (Plate 68), which in reverse uses the same diagonal leap of horse and rider towards the spectator, and includes such enlivening touches as the windswept mane and tail of the horse, and the rider's scarf. But Rubens is able to invest his picture with a superbly romantic aura as horse and rider are silhouetted against dark masses of cloud pierced by the sun's rays, suggestive of the stormy mood of nature much favoured by the artist in his landscape backgrounds. As an image realised in a pattern of strong chiaroscuro, it has an overpowering presence and scale, which continues the revolutionary innovations of Caravaggio's early pictures. The portrait of Lerma was a stately portrayal of a melancholy ruler, whereas Doria has the fiery dash of a young commander, whose intent gaze is not diminished within the panoply of extrovert movement.

In the same way that Van Dyck was to do later in Genoa, Rubens may have planned this picture as a pendant to a full-length standing female portrait. Although no such work is recorded of Doria's wife, Veronica Spinola Doria, she is known from a seated portrait (Plate 66), presumably painted in 1606 or 1607. In Genoa Rubens established a type of full-length female portrait in an interior or exterior setting. Here the sitter, placed against a background composed of split order and recessed panels, is projected before the clean rectangular pattern of the architecture. Other portraits are posed outside on a terrace loggia. The sharply cut fluted pilasters or columns with fat precise detailing in the capitals are softened by arcadian hints of trees or plants in an urn or a tall growth of jasmine.

Much of the distinction of the Genoese portraits is due to the fact, noticed by Evelyn, that the inhabitants 'are much affected to the Spanish mode and stately garb'.[51] Despite the formality of the millstone ruffs and lavishly decorated dresses of rich material, the sitters themselves, overcoming the inhibitions of being dressed-up for the occasion, communicate with Italian directness. In a picture of brilliant contrasts of tone and colour, Veronica Spinola Doria, dressed in black velvet with gold clasps and gold embroidered sleeves, is partly silhouetted against the scarlet-backed chair. The accents of gold, silver and red in the drapery echo those in the Spinola arms above. The small face with the cool perfect features of a twenty-year-old of noble birth is set off by the silver-grey ruff; a red carnation and a carnation of pearls in the hair offer a telling contrast of nature versus art. The multi-coloured parrot perched on the back of the chair helps to soften the transition from the figure to the background. In a pose deriving from Titian or Tintoretto, the sitter is seated in a high-backed chair, her hands, one of which holds a fan, resting on the arms. Her aristocratic mien conveyed by her rigid posture and fashionably narrow waist lacks the affectation and *hauteur* seen in her Spanish counterparts, at the same time as it differs from the earthy humanism of the Venetian High Renaissance.

Although Rubens never returned to Genoa he established good contacts for the future, which led to such commissions as another altarpiece, of the *Miracles of St Ignatius* (S. Ambrogio, Genoa) for the Jesuit church, and his first tapestry designs.

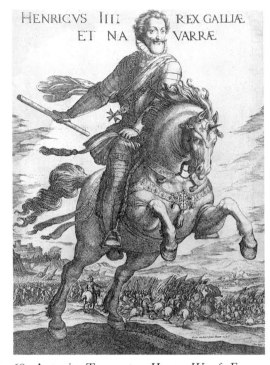

68. Antonio Tempesta, *Henry IV of France*. Engraving, 53.6 × 35.8 cm. British Museum, London.

70. *Sts Gregory, Maurus and Papianus*, 1608. Slate, 425 × 250 cm. S. Maria in Vallicella, Rome.

71. *Sts Nereus, Domitilla and Achilleus*, 1608. Slate, 425 × 250 cm. S. Maria in Vallicella, Rome.

59. (facing page) *Virgin and Child adored by Angels*, 1608. Slate, 425 × 250 cm. S. Maria in Vallicella, Rome.

He left the city at the end of August and was permitted by the duke to return to Rome. His last stay there lacked the serenity of the previous summer and he was beset by numerous worries and anxieties. News of his mother's health was not encouraging and Archduke Albert unsuccessfully interceded with Gonzaga for his return. Constant irritants were Gonzaga's demands for him to return to Mantua and his failure to pay his salary. The great altarpiece in the Chiesa Nuova (Plate 58), apart from retouching, finished before he left Rome for Genoa, was at last ready for installation and according to the Gonzaga agent in Rome, Giovanni Magno, 'the Fathers of the Oratory were extremely satisfied'.[52] But the final act of putting the altarpiece in place turned success into a tragedy vividly described by the painter himself:

> You must know, then, that my painting for the high altar of the Chiesa Nuova turned out very well, to the extreme satisfaction of the Fathers and also (which rarely happens) of all the others who first saw it. But the light falls so unfavourably on this altar that one can hardly discern the figures, or enjoy the beauty of colouring, and the delicacy of the heads and draperies, which I executed with great care, from nature, and completely successfully, according to the judgement of all. Therefore, seeing that all the merit in the work is thrown away, and since I cannot obtain the honour due to my efforts unless the results can be seen, I do not think I will unveil it. Instead I will take it down and seek some better place for it . . . But the Fathers do not wish the picture to be removed unless I agree to make a copy of it by my own hand, for the same altar, to be painted on stone or some material which will absorb the colours so that they will not be reflected by this unfavourable light. I do not, however, consider it fitting to my reputation that there should be in Rome two identical pictures by my hand.[53]

Rubens consoled himself with the thought that another purchaser might be found for the first version and not without justification was turning to Gonzaga who, as he was only too keenly aware, after seven years possessed no major work by him, although pious wishes were not lacking. Having, as we have seen, extolled the beauty of the picture to the duke, he was quick to discount any possible objections on the score of it having been a specific commission: 'Although all these figures are saints, they have no special attributes or insignia which could not be applied to any other saints of similar rank. And finally, the size of the picture is not so excessive that it would require much space; it is narrow and tall. All in all, I am certain that Their Highnesses, when they see it, will be completely satisfied, like the crowds who have seen it in Rome.'[54] He was in no doubt that 'the picture would surely hold its place in that gallery which is filled by the competition and rivalry of so many reputable men'.[55] But discouraging news came from the duke's secretary of state, Annibale Chieppio: 'I do not find His Highness disposed to acquire the painting of Sig. Peter Paul. We are now proceeding with great reserve in the matter of expenses.'[56] Although the excuse contained more than a grain of truth, it was a decision which must have confirmed Rubens' presentiment that as far as he was concerned the duke preferred painters to painting. And at the same time he was engaged in the tiresome and humiliating matter of trying to extract payment from the duchess for the purchase of an altarpiece by the fashionable Pomerancio, which she had 'through countless letters and numerous solicitations'[57] imposed on him to negotiate. At least Rubens could take some consolation that his own 'picture has been publicly exhibited in a better location in the same church, and for several days has been viewed with great approval by all Rome'.[58]

Whereas a weaker man might have despaired over the situation Rubens found himself in, he put a brave face on it, and his last months in Rome were occupied with the task of producing a second altarpiece for the Oratorians. He did not rest content with making a faithful copy on non-reflecting material as had first been suggested, but at his own request produced an entirely new composition divided into three different sections. The miraculous image adored by angels and saints

was planned to be placed over the altar in the centre (Plate 69) and two groups of three saints each (Plates 70–1) on the walls of the apse. To solve the problem of reflection, these were to be painted on slabs of slate. But before the support could be ordered the artist had to submit new *modelli* for his patron's approval.

Although the iconographical ingredients were different, the new arrangement was in essence a return to what Rubens had done for the Jesuit church in Mantua. The centre was reserved for the heavenly presence adored by a heavenly throng. The sacred image itself, an indifferent fourteenth-century fresco, received as a result greater prominence than in the first version, which may well have pleased the Oratorians for whom it was an object of such veneration. (The fresco was placed inside a frame inserted in Rubens' picture; only displayed on special occasions, it was otherwise covered by a piece of copper on which Rubens had painted a free copy of the image.)

The two pictures containing St Gregory and the five early martyrs whose relics had been deposited in the new church were hung on a lower level so that not only was there a separation between the divine image and the saints but the relative height of the latter emphasised their act of worship. In a characteristically Baroque manner the action is spread across the area of the apse, involving the spectator more directly in the event represented.

In painting the right-hand section Rubens must have been aware of Pomerancio's picture of the same three saints, Domitilla, Nereus and Achilleus, in another Roman church (Plate 72) in which the figures are similarly placed side by side, with angels above. But Rubens succeeds in imparting greater psychological unity, as the two male saints glance at St Domitilla whose eyes are raised in adoration towards the central panel. The diagonal placing of the figures acknowledges that this was to be one wing of a triptych rather than a work on its own. The sense of limited but well-defined space behind the saints, absent from Pomerancio's version, is accentuated by the large and luxuriant palm tree, the fronds of which are held by the saints. Memories of his recent study of antiquity with Philip Rubens occur in the depiction of St Achilleus depicted in the same pose as the right-hand figure in one of the illustrations to *Electorum Libri II* (Plate 49) after Rubens' drawing. Moreover, the heads of both male saints have the same finely chiselled features of the Roman sculpture, and St Domitilla is placed in a similar stance, in reverse, to that of the central figure in the engraving. Following what the artist had written in his treatise about the necessity of understanding the antique, theory was clearly put into practice and made the more meaningful by the fact that these were Roman martyrs.

Departing from Rome at the end of October 1608, Rubens wrote, 'My work . . . on three great pictures for the Chiesa Nuova is finished, and if I am not mistaken, is the least unsuccessful work by my hand. However, I am leaving without unveiling it (the marble ornaments for it are not yet finished), for haste spurs me on. But this does not affect the essence of the picture, for it was painted in public, in its proper place, and on stone.'[59] Although he was not aware of it at the time, the completion of this major work was to be his last act on Italian soil.

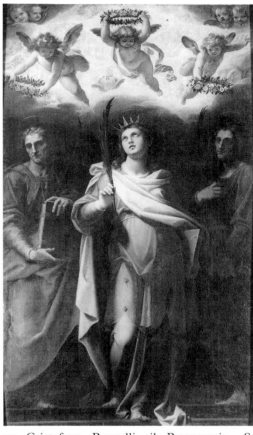

72. Cristofano Roncalli, il Pomerancio, *Sts Domitilla, Nereus and Achilleus*. Canvas, 275 × 170 cm. Chiesa dei Santi Nereo e Achilleo, Rome.

III

'Bound with fetters of gold'

WHEN an urgent call came in the autumn for Rubens to return home as quickly as possible because his mother was dying, he cannot have felt any deep regret in leaving the service of the House of Gonzaga. At least he left of his own accord and was not ignominiously dismissed like Monteverdi after twenty years' devoted service. 'Leaping into the saddle',[1] Rubens wrote in haste to ask permission for leave of absence, though in fact he was taking it. The relationship had served its purpose for both parties, and, apart from Rubens' good manners, there were no expressions of regret on either side. He had probably been contemplating a visit home for the whole summer and was held up only by the necessity of finishing the second version of the Chiesa Nuova altarpiece. Quite apart from his anxiety about his mother's health, he was now a mature man of thirty-one and most likely felt that it was time to settle. Though he did not lack patrons or commissions in Rome, he must have sensed that as the servant of Gonzaga he was only a visitor on a prolonged stay. Any uncertainty about his future plans was cut short by the summons home. Fate was making up his mind for him.

His haste was in vain. His mother had died nine days before he left Rome, and he arrived home to find her buried in the Abbey of St Michael, not far from the house in the Kloosterstraat where she had moved from the Meir in 1601. To make amends for his absence from her deathbed, he had an altar constructed in the chapel where she was buried, and above it placed the first version of the altarpiece he had painted for the Chiesa Nuova (Plate 59). The painter himself had described it as 'the best and most successful work I have ever done', an opinion in which his mother, who thought his earlier works 'beautiful', would have wholeheartedly concurred, and it was fitting that her memory should have been honoured with the fruit of the time spent in Italy. Rubens must have spent many enjoyable hours with his brother, besides renewing acquaintance with his old friends in Antwerp. To compensate for the family grief at the death of Maria Pypelinx, a happier event in the shape of Philip's marriage took place in the following year, in the spring of 1609. In an effusive moment Rubens wrote to a friend in Rome that 'In short my brother has been favoured by Venus, the Cupids, Juno and all the gods; there has fallen to his lot a mistress who is beautiful, learned, gracious, wealthy and well-born, and alone able to refute the entire Sixth Satire of Juvenal'. More to the point were his own plans. He found himself at the crossroads:

> I have not yet made up my mind whether to remain in my own country or to return forever to Rome, where I am invited on the most favourable terms. Here also they do not fail to make every effort to keep me, by every sort of compliment. The Archduke and the Most Serene Infanta have had letters written urging me to remain in their service. Their offers are very generous, but I have little desire to become a courtier again. Antwerp and its citizens would satisfy me, if I could say farewell to Rome.[3]

The rub lay in the last phrase; Rome provided all that was congenial in artistic

73. Detail of Plate 83.

53

interest and companionship with none of the stranglehold of court life. He could not refrain from sending warm greetings to 'my friends whose good conversation makes me often long for Rome'.[4] Rubens was paying the price for the fame and popularity which had preceded him back to his home country. Once again he was overtaken by events, and he rapidly found himself established in Antwerp by his indispensability to the city and to the court. As he mounted his horse in Rome he may, although ostensibly intending to return, have had a presentiment that he was saying a double farewell – to carefree days and to Italy. The latter was never far from his thoughts or his painting, and throughout his life it remained the Mecca of his dreams. Twenty years later in London he could write from the bottom of his heart: 'I have not given up hope of fulfilling my wish to go to Italy. In fact this desire grows from day to day, and I declare that if Fortune does not grant it, I shall neither live nor die content.'[5] Even if Fortune did not grant it, she made generous amends.

So much was Rubens the painter of Antwerp, giving glory to its name, that it is an automatic reaction to suppose that the fecundity and well-being of the man reflect similar qualities in the city. It comes as a shock to learn that while Rubens was climbing to the very height of success the city of Antwerp, which had been the greatest port and richest city in Northern Europe in the sixteenth century, was embarked on its decline and fall. What Antwerp had been in the sixteenth century, Amsterdam became in the seventeenth. Antwerp had suffered heavily both psychologically and physically in the war between Spain and the northern Netherlands. Whereas the latter expressed all the youthful energy of a new nation, Flanders was weakened by the division of the country and unlike the north was still bowed under the Spanish yoke. It became the real victim of the war, and the deepest wound was the blocking of the Scheldt by the Dutch, which totally closed the port of Antwerp. Rubens' return almost coincided with the signing of the Twelve Years' Truce with the United Provinces in 1609. This, accompanied by the opening of the Scheldt on the payment of dues, must have seemed like the end of the city's miseries, and at the time Rubens wrote to Jan Faber in Rome that 'it is believed that our country will flourish again'.[6] But, although finance and commerce revived moderately, the city never regained its former prosperity.

When Sir Dudley Carleton, the English ambassador in The Hague, with whom Rubens was to have close relations, visited Antwerp in 1616, he wrote,

> it exceeds any I ever saw anywhere else for the beauty and uniformity of its buildings, the height and width of its streets, the strength and fairness of its ramparts', but 'the whole time we spent there I could never set my eyes in the whole length of a street upon forty persons at once: I never met coach nor saw man on horseback, none of our company saw one penny worth of ware either in the shops or in the streets bought or sold . . . in many places grass grows in the streets, yet (that which is rare in such solitariness) the buildings are kept in perfect repair.[7]

Carleton rightly concluded that Antwerp's 'condition is much worse since the truce than before it'. And the situation got no better; years later Rubens himself wrote that 'this city, at least, languishes like a consumptive body, declining little by little. Every day sees a decrease in the number of inhabitants, for these unhappy people have no means of supporting themselves either by industrial skill or by trade.'[8]

But to the artist debating his decision whether to return to Italy, there must have seemed hope. Besides repairing damage inflicted during the Protestant revolt, the Counter Reformation movement led by the Jesuits and encouraged by the government was continuing to promote extensive building and decoration of churches, promising a substantial number of rewarding commissions for the painter. Rubens was hardly back in Antwerp before he was being approached with offers from city officials and wealthy art-loving merchants. Such opportunities must have played a decisive role in keeping him at home.

One of the most attractive features of Rubens, and indeed one which contributed so enormously to his general happiness of life, was his self-knowledge. He knew his worth and was prepared to argue on that basis. He was ambitious, but he was not prepared to sell his soul to achieve his aspirations. If he stayed in Antwerp, one of the decisions he had to face was whether to accept Albert and Isabella's offer to become court painter. He had already tasted court life in Audenarde, Mantua and Spain, and he knew well how much he disliked the stultifying, petty atmosphere that almost invariably surrounds a close circle centred on an autocrat. As he himself said, 'I have little desire to become a courtier again'.[9] He wished for freedom of thought and action. Something of this was realised by Albert and Isabella. Although 'they made him a member of their court and bound him with golden fetters',[10] Rubens was in fact obliged to accept nothing more constraining than an annual pension of five hundred florins, and 'the rights, honours, liberties, exemptions and franchises' enjoyed by a member of the archducal household. Moreover, he was absolved from the necessity of living at the court in Brussels and could pursue his life as a free man in Antwerp, where he was permitted 'to teach his art to whomever he wished, without being subject to the regulations of the guild'.[11] Apart from the social distinction of not being answerable to a guild with its connotations of manual labour, this freedom had immense advantages; he could employ as many assistants as he wanted, his pupils need pay no entrance fees, his widow no death duties to the guild, and he need never again hold the office of dean. His post at Brussels entailed no duties, and any works executed for the archducal pair were to be paid for separately. All in all he was gaining honour and advantage without loss of freedom. It was an auspicious beginning in the artist's very special relationship with the archduke and above all with his wife, which deepened through the years. To seal the agreement a gold chain and medal bearing portraits of Albert and Isabella were sent to the artist.

Ruben's new patrons were no upstarts in European aristocracy. Albert, who had been brought up at the Spanish court, was the third son of the Emperor Maximilian, while his wife, the Infanta Isabella, who was his first cousin, was the favourite daughter of Philip II of Spain. With Isabella's hand had gone the sovereignty of the Netherlands, but the gift was hedged with conditions that made its return to Spain only too probable. Moreover, though entitled to rule as sovereigns, Albert and Isabella had to suffer considerable interference and pressure from the Spaniards. Albert was a dutiful husband and a worthy and upright man. In common with other rulers of seventeenth-century Europe, he was a great admirer of the fine arts and owned a large collection of pictures. He was ready to honour artists, and apart from Rubens, Jan Brueghel and Otto van Veen were also granted the title of court painter. A biography of the archduke published the year after his death reports that after dinner he took particular pleasure in conversing with these three artists and the court architect Wenzel Cobergher. Philip Rubens informs us that 'Albert had a particular fondness for Rubens. In fact Peter Paul named his first-born son Albert, after the archduke.'[12] Isabella, was also a person of calibre, but her true personality came to light only in later years after her husband's death, when Rubens was there to see and admire it – and to serve her.

'The rulers Albert and Isabella wished him to paint their portraits',[13] and this no doubt was the first official duty he had to undertake. Whether the pair we know today (Plates 74–5) represent Rubens' first state portraits or, as style suggests, slightly later revisions, they provide powerful images of rulers made the more striking by their brilliant scarlet backgrounds evoking a fiery sunset. In knee-length poses, probably suggested by Titian's imperial portraits, Albert is seen standing, one hand on his sword-hilt, while Isabella is seated holding a fan. Despite the formality of the portraits, increased by the strong silhouette and the richly embroidered and decorated clothes, Rubens is successful in conveying through their very direct gazes something of the humanity of the sitters, more so in the case of Albert, whose greying temples and sensitive expression are suggested

74. (following pages left) *The Archduke Albert*, 1609. Panel, 105 × 74 cm. Kunsthistorisches Museum, Vienna.

75. (following pages right) *The Archduchess Isabella*, 1609. Panel, 105 × 74 cm. Kunsthistorisches Museum, Vienna.

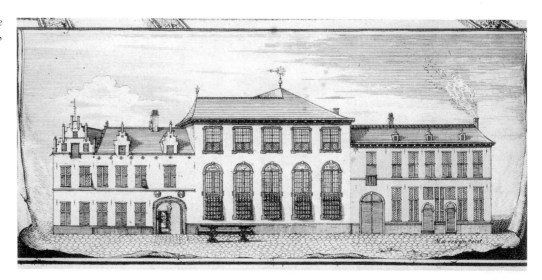

76. Jacques Harrewijn after J. van Croes, *The Facade of Rubens' House*, detail from engraving, 33 × 43.5 cm. Private collection, Oxford.

by the masterly painting of the surface of the head. Throughout the two panels Rubens has painted the rich detail and simple contrasting colours with superb control and assurance, permitting himself flourishes such as the bravura execution of Albert's high-crowned hat adorned with feathers. The unfinished parts, notably his right hand and his wife's fan, may indicate that they were *ad vivum* studies retained in the master's studio as models for the inevitable repetition required of an official state portrait.

In Antwerp Rubens at first lived with his brother Philip, who in 1609 became secretary of the city, in their mother's house in the Kloosterstraat, near the Steen and the harbour. Philip was the first to leave, when he married, and in spite of Peter Paul's firm declaration that 'I will not dare to follow him, for he has made such a good choice that it seems inimitable',[14] his brother's example, as so often happens with close friends and relations, was followed only a few months later when the younger brother fell in love with the niece of his sister-in-law. He had already set the pattern of his courtship when he said in the letter just quoted above that 'I find by experience that such affairs should not be carried on coolly, but with great fervour'. The wedding was celebrated in October 1609 in the Abbey of St

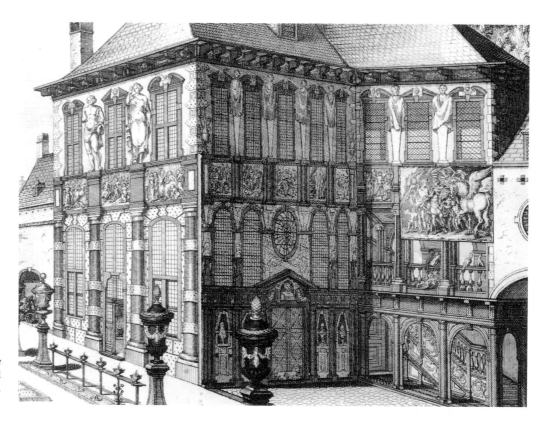

77. Jacques Harrewijn after J. van Croes, *The Courtyard of Rubens's House with his Studio*, detail from engraving, 29.5 × 36 cm. Private collection, Oxford.

Michael, where his mother was buried. Since this was not a parish church and the marriage was registered elsewhere, it is clear that filial piety prompted this special arrangement. His bride, Isabella Brant, born in 1591, was the eldest daughter of Jan Brant, who, in company with Philip Rubens, was one of the four secretaries of Antwerp, and whose wife's sister Philip married. Jan Brant was well-educated and, like many public servants of those days, pursued academic learning as a pastime. His chosen field of Sunday study was classical literature, and he published, among other works, notes on Julius Caesar. Although not shown as the conventional scholar at his desk, his bookish interests are referred to in the portrait (Plate 79) Rubens painted many years later, when the sitter was seventy-five. (This with other of his effects was bequeathed by Brant to his elder grandson, Albert Rubens.) Apart from the books Brant holds, a shelf above contains several volumes including the works of Cicero and naturally Julius Caesar. There is something appealing in his vigorous high-coloured face, which gives an impression of bluffness, though not lacking in sensitivity. His relationship with Rubens was not confined to that of father and son-in-law, and a true friendship existed between them, so that contact, as the portrait shows, was maintained long after Isabella's death. His daughter, like so many women of the time, remains a far more shadowy figure. The only description of her is Rubens' own tribute on her death, when he wrote of her as 'an excellent companion, whom one could love – indeed had to love with good reason – as having none of the faults of her sex. She had no capricious moods, and no feminine weaknesses, but was all goodness and honesty. And because of her virtues she was loved during her lifetime, and mourned by all at her death.'[15]

The double portrait (Plate 83), probably painted in the year of their marriage to record the event, sets the tone of their partnership. In a bower of honeysuckle Isabella, wearing an embroidered stomacher, sits at Rubens' feet, her hand resting affectionately on her husband's; she looks out a little shyly, with her head set off by an elaborate lace ruff and high-crowned straw hat worn over a lace cap. As a good wife she was clearly ready to serve her husband, but there was nothing hesitant or formal about their relationship. The perfect harmony between them is expressed by the interlocking flow of movement from one figure to the other. He portrays himself not as an artist but as elegantly dressed as his wife, leaning nonchalantly on

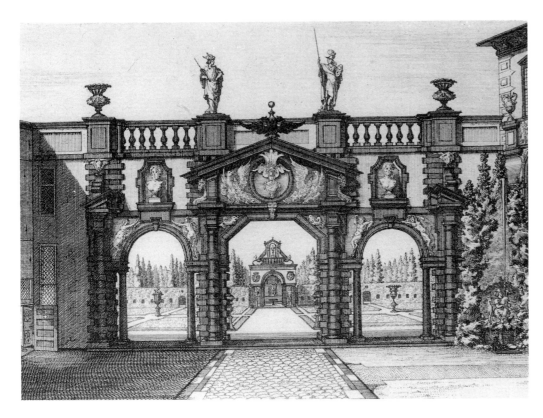

78. Jacques Harrewijn after J. van Croes, *The Arch in Rubens' House*, detail from engraving, 29.5 × 36 cm. Private collection, Oxford.

59

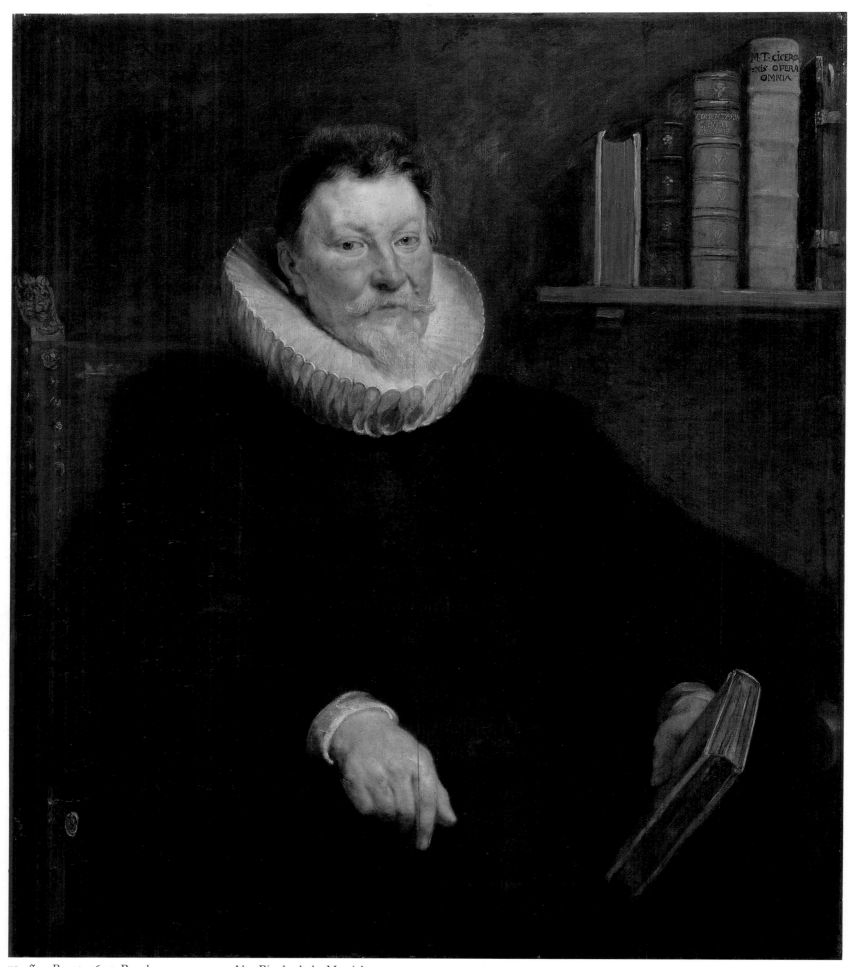

79. *Jan Brant*, 1635. Panel, 109 × 94 cm. Alte Pinakothek, Munich.

a jewelled sword-hilt, his yellow stockings creating a colourful accent in an otherwise dark-keyed painting. The painting is an unmistakable statement about social position, redolent of middle-class directness rather than aristocratic pretensions.

So natural is this expression of marital love that we are beguiled into accepting it as a 'snap-shot' image. But the large size of the canvas, highly unusual for an artist's family portrait, prompts the question in which house and where the picture was to hang. Although not individually listed it was probably among family portraits recorded in the artist's estate at his death. The relatively low viewpoint, which despite the informality of the sitters imbues them with an unusual degree of authority, suggests that the picture hung in a raised position probably over a fireplace. Whereas the honeysuckle, which provides such natural cover, can be read as a symbol of fruitful love, the motif of clasped hands follows fifteenth-century Northern pictorial tradition and was later, with a couple represented seated, chosen by Alciati as an appropriate emblem of marital fidelity.

The happiness of a successful marriage promised here was confirmed in an intimate drawing (Plate 84) made shortly before Isabella's death. Executed *à trois crayons*, the beautifully finished head is contrasted with the freely sketched bust, and the sheet offers a perfect example of Rubens' technical range from polished modelling to suggestive outline. The girlish charm of the double portrait has been exchanged for a fuller, maturer face with plump cheeks. She is now attractive by virtue of her personality rather than her actual looks. Her eyes sparkle with vitality, and she cannot resist breaking into a gay smile, giving her large dimples, as she lovingly looks directly at her husband drawing her. Such an intimate and vivacious portrait speaks for perfect happiness after many years of marriage. For a serious young man, already with a great reputation, she must have provided the ideal, steadfast companion as they marched ahead, like Tamino and Pamina, *Mann und Weib und Weib und Mann*.

After their marriage they went to live with her father who, in the street where Rubens' mother had lived, owned a much grander house which could provide a studio with sufficient room for the artist to paint, *inter alia*, the *Descent from the Cross* (Plate 108). But this was intended only as a temporary arrangement while they looked around for a home suitable both in size and in status. By the end of 1610 Rubens had found what he wanted. He bought a large house with an extensive garden on the Wapper, a canal formerly part of the moat of the old fortifications of the city, near the fashionable thoroughfare of the Meir. Even if very expensive, it was an admirable purchase because it gave the Rubens household extensive accommodation with sufficient space for further building. Though he specifically disclaimed any intention of living like a prince, the scale and style of his house and possessions were nevertheless in many ways a smaller version of some of the Italian courts he had seen and lived in. The existing building, a typical sixteenth-century Flemish house, consisted of a wide front facing the street (Plate 76), with an additional wing at the back of the building, bordering the courtyard, which had been used as a laundry. At the back the large garden adjoined the premises of the Guild of Arquebusiers or Musketeers. As it stood, the property was not sufficient for the artist, and on the other side of the courtyard over the course of the next decade 'he built a large summer house in Roman style adapted for use as a studio'[16] (Plate 77). Situated on the ground floor with north and east lighting, it provided him with sufficient room to work on several sizeable pictures at the same time, which could be removed through a tall narrow door on the outside wall. On the floor above he built a studio for his pupils, 'a vast room without windows, but lit by a large opening in the middle of the ceiling',[17] as well as a small private one, where he could work from the model, paint oil-sketches and portraits, and also use as an office. Closing the courtyard on the garden side, Rubens erected a triumphal arch. Although the contract was signed in January 1611, much renovation was clearly required, since he is not recorded as living there before the beginning of 1616. In that year he built the

main staircase in the Genoese style, adorned with statues carved by Hans van Mildert. (Much of the existing building is a modern reconstruction.)

The new building containing the studio and the garden arch allowed him to demonstrate his taste for architecture. Although too late in the day to help with his new house, his interest in architecture is confirmed by his purchase from Balthasar Moretus in 1615 and 1617 of several architectural books including two editions of Vitruvius and Scamozzi's *Architettura*, as well as his having a copy of Serlio bound. To assist him in his design he already owned the drawings of elevations and plans of Genoese palaces, which he published in 1622. Following the example of Italian palaces, notably those in Genoa, the street façade was austere and unadorned, and only after passing through the entrance did the visitor become aware of the wealth of painted and sculpted decoration that faced him in the courtyard.

With its massive deeply cut broken pediment carried on banded columns, the arch (a modern copy today) dividing courtyard and garden (Plate 78) contained eagles supporting swags in the centre and male and female satyrs supporting tablets at the sides. Statues of Mercury and Minerva crowned the balustrade. Although reminiscent of Giulio Romano's Palazzo del Tè and Michelangelo's Porta Pia, the eventual style is a personal invention probably of Rubens himself. With its very deep eaves and windows with broken pediments on the top floor and niches on the ground floor, the studio building is also Italian in derivation. What gives the courtyard its special character, however, is both the type and the iconography of the decoration. Statues of Minerva, goddess of wisdom and learning, and of Mercury, god of painters, were eminently suitable as the presiding deities, and Rubens is unlikely to have forgotten that a statue of the god was placed above Giulio Romano's house in Mantua. Moreover, the theme of the union of the two gods, Hermathena, also present in the decoration of Giulio's house, can be traced back to Cicero.

Rubens' humanist interests and Stoic beliefs are illustrated by the two passages selected from Juvenal's *Satires*, which were inscribed in tablets above the flanking arches: on the left is written, 'Leave it to the gods to give what is fit and useful for us; man is dearer to them, than to himself'; and on the right, 'One must pray for a sane spirit in a healthy body, for a courageous soul, which is not afraid of death, which is free of wrath and desires nothing'.

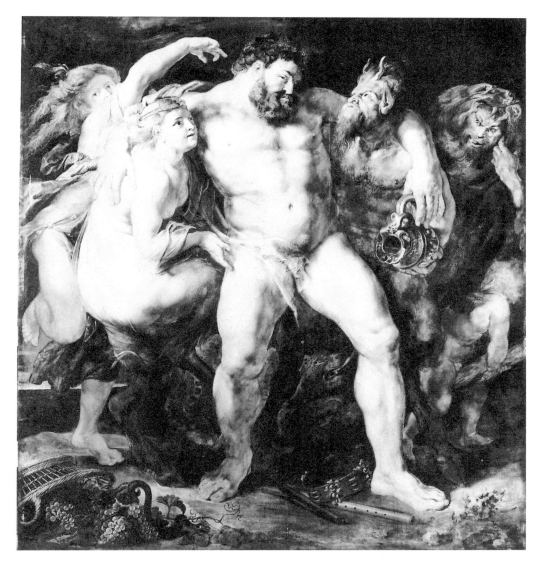

81. *The Drunkenness of Hercules*, c.1612–14. Panel, 220 × 200 cm. Gemäldegalerie, Dresden.

82. Engraving after a Roman relief, *The Drunkenness of Hercules*, 1779.

The façade of the studio was extensively decorated in a combination of sculpture and painting. Busts on pedestals in relief and busts in the round set in niches, the subjects of which are now unidentifiable, decorated the top and ground floors respectively. Above the first-floor windows a series of panels painted in grisaille and simulating sculpted reliefs were devoted to subjects illustrating either incidents from the lives of the ancient Greek artists or re-creations of works by them. In certain cases, such as the *Drunkenness of Hercules* (Plate 80), it can be established that the representation was based on a painting by Rubens (Plate 81) which was appropriately derived from an ancient Roman relief in the Mattei collection in Rome (Plate 82). In decorating his house with painting Rubens was following a tradition established by such artists as Mantegna and Giulio in Mantua and Federico Zuccaro in Rome. He would also have been aware of the local example of Frans Floris's house in Antwerp.

The decorative scheme was continued on the reverse wall of the new building, i.e. the three bays facing the garden arch. It contained one significantly unusual feature, which can be seen in the seventeenth-century engraving of the house (Plate 85). An account, probably provided by Justus Sustermans, who knew Rubens well, was given by Baldinucci: 'he painted with his hand a loggia with perspectives, architecture and bas reliefs of rich invention, and among other things feigned that a picture had been attached to that architecture to dry in the sun, so well detached from the ground that, it is said, seen one day by the most serene Clara Eugenia Infanta of Spain . . . she ordered that the canvas should be taken down, because she believed it real and not painted'.[18] The idea of the deceptive picture can be traced back to Pliny's description of the grapes painted by

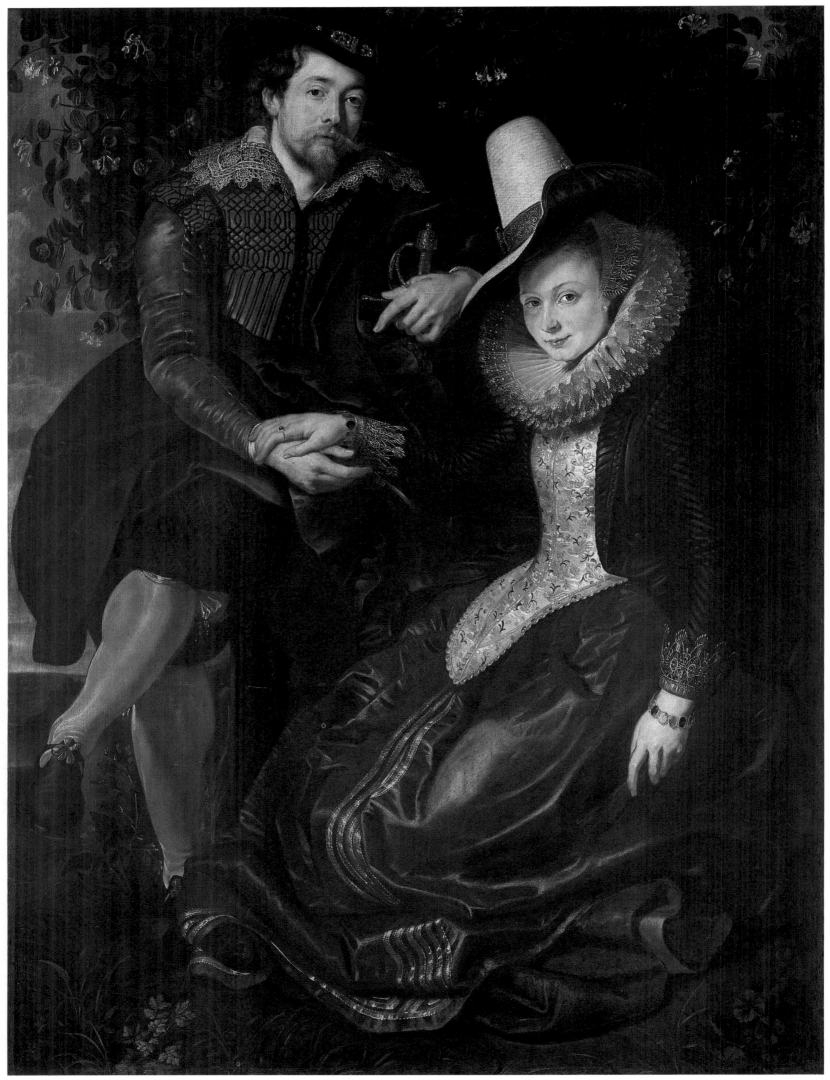

83. *Self-portrait with Isabella Brant*, c.1609–10. Canvas, 174 × 132 cm. Alte Pinakothek, Munich.

84. *Isabella Brant*, c.1622. Black and red chalk, heightened with white with some pen and wash, 38.1 × 29.2 cm. British Museum, London.

Zeuxis which appeared so real that the birds tried to eat them. This classical topos was nicely combined here with a preoccupation of Rubens' own, the drying of pictures in the sun, to which he frequently refers in his letters. (To the agent of one patron, he explained that 'paintings need to dry two or three times before they can be brought to completion'.)[19] The painting represented here was based on his recently completed *Perseus and Andromeda* (Leningrad). The illusionism was continued below and to the left of the picture by painting an open arcade with figures and birds on what was in fact a blank wall. In Italy Rubens would have seen such famous Italian examples of illusionist painting as Mantegna's Camera degli Sposi in the Palazzo Ducale in Mantua and Peruzzi's Sala delle Prospettive in the Farnesina in Rome, but once again he freely invented his own arrangement. The whole ensemble of architecture, for the most part constructed in stone, adorned with painting and sculpture inspired by the classical tradition and Italian Renaissance practice, offered a telling contrast with the traditional Flemish building in brick across the courtyard. Not surprisingly, its novelty evoked much admiration from the artist's contemporaries.

Although in a suitably different vein, the classical character of the house

65

continued in the garden, at the end of which Rubens built a pavilion in the form of a small rustic temple (Plate 86). In a niche crowning the building, the figure of Abundance presided over the fruits of the garden below. A full-length statue of Hercules may have been placed against the back wall of the loggia, with two further statues sited between the columns on either side of the central arch. One of these, that on the left, can be identified from the engraving as Venus and Cupid. The notion of a garden as the appropriate setting for love was echoed by Rubens in the painted celebrations of both his marriages; with Isabella Brant in a bower of honeysuckle (Plate 83) and with Helena Fourment, his second wife (Plate 258), in this very garden. The horticultural iconography was continued on the upper floor of the façade of the studio facing the garden, where relief sculptures of Bacchus, the god of the vine, and Flora, holding a bunch of flowers, popular in the seventeenth century as the patroness of architecture, were placed.

The contents of the garden received no less thought and invention. His nephew records that Rubens 'planted a very extensive garden with all sorts of trees'.[20] What these were is partly documented by the master's instructions given near the end of his life to his pupil Lucas Fayd'herbe when the latter was asked to 'remind William the gardener that he is to send us some Rosile pears as soon as they are ripe, and figs when there are some'.[21] In addition there were orange trees in tubs, visible in the painting of Rubens with Helena Fourment and his son Nicolaas (Plate 87). This picture, although of questionable horticultural accuracy, portrays an inner garden with flowers (tulips?) growing in long grass surrounded by a low (box?) hedge. In the left background a formal garden can be made out divided by paths surrounding a fountain, the basin of which holds a putto playing with a dolphin. Both the landscaping and type of tree were predominantly Italian, and for an unwilling exile from the south, Rubens' house and garden provided him with as much consolation as can be obtained in a northern climate. He never hesitated to include various details of this local paradise in the backgrounds of his pictures.

85. Jacques Harrewijn after J. van Croes, *The Courtyard of Rubens' House with Perseus and Andromeda*, detail from engraving, 33 × 43.5 cm. Private collection, Oxford.

86. Jacques Harrewijn after J. van Croes, *The Garden Pavilion in Rubens' House*, detail from engraving, 33 × 43.5 cm. Private collection, Oxford.

The major addition made by Rubens to the old house was the construction at the back of the building overlooking the garden of a room which was to house his collection of sculpture. This became famous at the time and was described in some detail by Sandrart, De Piles and Bellori. The last stated that: 'He had a circular room built in his house in Antwerp with only a round skylight in the ceiling, similar to the Pantheon in Rome, so as to achieve the same perfectly even light. There he installed his valuable museum.'[22] By taking the Pantheon as his model, Rubens was not only choosing one of the most famous classical buildings, whose original function was intended as a place for the display of sculpture, but one which was specifically praised by such writers as Scamozzi and Serlio for its diffused light falling from the circular aperture above. This arrangement, they claimed, provided the ideal lighting for the display of sculpture and paintings. Rubens' 'Pantheon' was in fact only a hemisphere but, following the general design of its classical model, was divided into eight bays containing niches to house busts, separated by pilasters, against which full-length statues could be placed. To complete his museum, Rubens built a rectangular room adjoining the 'Pantheon' in which to hang his collection of pictures, which following the advice of Vitruvius and later Italian writers was primarily lit from the north.

From his earliest days Rubens was an avid collector. He wrote in 1634 that 'I have never failed, in my travels, to observe and study antiquities, both in public and private collections, or missed a chance to acquire certain objects of curiosity by purchase'.[23] Rubens' nephew says that 'From Italy he caused to be gathered for him a great number of ancient statues and gems and a large quantity of old coins with which he adorned his home'.[24] Apart from his extensive collection of pictures, about which more will be said, he built up, as we learn from the sales records of the Plantin Press, a substantial library, whose size can be gauged by the large fee payable for drawing up an inventory after his death. Apart from books on art and architecture, it ranged from the Latin classics and Latin translations of Greek authors to writings on zoology and botany. It also included books and pamphlets on contemporary politics. But, as any collector with limited space at his disposal learns, there comes a time when, if the impetus to acquire does not diminish, the housing of objects becomes a serious problem. To ease the situation, his library which had become so large was moved to a separate building the year before the artist's death. But books were only one part of the problem and De Piles records that the space in the two rooms in the museum set aside for the sculpture and painting, arranged 'by order and symmetrically', eventually proved insufficient, and works of lesser quality 'served to decorate other rooms in the apartments of the house'.[25]

One can surmise that this large assembly of works of art, books and curiosities, which included such things as two globes, an Egyptian mummy and a number of shells, was partly collected for the artist's own pleasure and instruction, as well as for professional use. It is, however, remarkable that there are relatively few examples of his own work which contain motifs derived from objects in his collection. Far more often Rubens turned to the great works of art which, although he may have copied, he did not own. His purpose in collecting was almost certainly more diverse and complicated, and was stimulated by such motives as acquiring social status; in later years he was influenced by diplomatic considerations. Rubens was imitating, albeit in a humbler way, the great princely collections he had studied and admired in Italy. Moreover, financial gain or at least security against the future also played a significant part. As Rubens surely intended, his house and collections acquired a fame that spread far and wide. Bellori says that the collection 'was visited by men of letters and learning and by lovers of painting; no foreigner would pass through Antwerp without seeing his cabinet, and even more the man who created it, the summit of *virtu* and fame'.[26] He lists such distinguished visitors as Sigismund, Prince of Poland, the Infanta Isabella and the Marquis Spinola, to whose names can be added that of Maria de' Medici, who expressed 'the curiosity to see all the beautiful and rare pictures which are in the

87. (following pages) Detail from the *Self-portrait with Helena Fourment and Nicolaas Rubens*, plate 258, c.1631. Panel, 97 × 131 cm. Alte Pinakothek, Munich.

house of Monsieur Rubens'.[27] Golnitzius, the secretary to the King of Denmark, who visited the house around 1625, declared that it was impossible to describe the riches of the collection. Its fame was also a matter for local pride, and in a letter from Jan Woverius, the town clerk, to Balthasar Moretus praising 'the magnificence of your abode', the writer goes on to say that 'Happy is our Antwerp to have two citizens like Rubens and Moretus! The houses of both will be admired by strangers and visited by travellers. We shall rejoice for all time in the favour and the friendship of two such friends.'[28]

Already while he was in Italy Rubens had started to collect antique sculpture; his close friend Balthasar Moretus reported that among the antique treasures he brought back was a supposed likeness of Seneca (see Plate 88), which was soon to serve his own artistic purpose. A sarcophagus, which included the figure of an infant wrapped in swaddling clothes, was also acquired in Rome at this time. But his major acquisitions in this field came through an exchange effected with Sir Dudley Carleton. Fortunately, most of his correspondence relating to this deal exists and allows us to watch Rubens as an honest, straightforward, but hard bargainer. As he said on another occasion, 'I like to be correct in my affairs, and to give full satisfaction to everyone'.[29] The affair opened almost casually with Carleton's agent, Toby Mathew, being sent to Antwerp to try to exchange a diamond necklace for a hunting piece by Rubens, but the artist valued his picture more highly than the necklace and was not prepared to reduce the price on his work. As the same agent, speaking of the 'cruel courteous painter', put it on a later occasion, 'I did with all the discretion I had, deal with him about the price, but his demands are like the laws of the Medes and Persians which may not be altered'.[30] Such behaviour represents a significant reversal of the normal procedure whereby the patron rather than the painter fixes the price, and proves Rubens' increasing stature in the international scene by 1620.

This was only the first salvo in their relationship, and in 1618 Rubens wrote to Carleton about the latter's 'rare collection of antiquities',[31] which he had heard Carleton was prepared to exchange for pictures by his hand. Several years earlier, Carleton, acting as agent for the Earl of Somerset when he was ambassador in Venice, had acquired on the earl's behalf 'twenty nine cases with antique figures and heads, of marble',[32] but to his chagrin was left with them when Somerset was arrested for murder. 'By mischance made a master of such curiosities',[33] he shipped them to his new residence in The Hague where he clearly hoped to dispose of them. It was a curious deal between the Flemish painter and English diplomat, since neither actually saw what the other was offering, even though at one point Carleton suggested that Rubens should visit him 'before proceeding any further in the transaction, not to buy, as one is wont to say, the cat in the bag'.[34] For his part Rubens drew up a list of pictures he had in stock, stating whether they were entirely by his hand or done with the assistance of pupils. Among the works were 'A Prometheus bound on Mount Caucasus, with an eagle which pecks his liver. Original by my hand, and eagle done by Snyders' (Plate 148), and a picture of 'Leopards, taken from life, with Satyrs and Nymphs. Original, by my hand, except a most beautiful landscape done by the hand of a master skilful in that department' (Montreal).[35]

Although describing the goods honestly and accurately, Rubens was not averse to a little sales talk to encourage; 'I find that at present I have in the house the flower of my stock, particularly some pictures which I have kept for my own enjoyment.'[36] For his part, Carleton was to say what his collection had cost him; 'In regard to this I wish to place complete trust in your knightly word. I am also to believe that you made such purchases with all judgement and prudence, although', Rubens added shrewdly, 'high personages, in buying or selling, are sometimes likely to have a certain disadvantage, because many people are willing to compute the price of goods by the rank of the purchaser – a practice to which I am very averse.'[37] After some gentlemanly but hard bargaining, the deal was concluded, and, as Rubens somewhat one-sidedly put it to Carleton, 'in exchange

88. *The Bust of 'Seneca'*. Marble, ht. 41 cm. Ashmolean Museum, Oxford.

for marbles to furnish one room' (namely twenty-one large statues, eight statues of children, four torsos, fifty-seven heads of various sizes, seventeen pedestals, five urns, four bas-reliefs and eighteen busts of Roman emperors!) 'Your Excellency receives pictures to adorn an entire palace'.[38] Carleton in fact got six pictures, albeit large ones, including the two listed above; nevertheless he saw it 'as a good bargain for us both, only I am blamed by the painters of this country who made idols of these heads and statues'.[39] Within a few months Carleton's ultimate purpose became clear, and in the belief that paintings by Rubens were more readily negotiable than antique sculpture he was attempting to sell his new acquisitions to the King of Denmark.

With the addition of Carleton's marbles, Rubens could claim to have assembled the most distinguished collection of antique sculpture in Northern Europe. But he kept it for less than a decade and, for reasons to be discussed, sold most of the antique sculpture to the Duke of Buckingham the year after Isabella Brant's death. Within a few months the artist, according to Philippe Chifflet, intended to set off for Rome. 'He will take with him ten or twelve thousand guilders to buy antique statues. The people of Rome are not at all pleased that the finest ornaments of their city should be dispersed in this way.' Whether Chifflet was correct in saying that 'Rubens only wishes to buy them in order to sell them at a profit'[40] remains academic since the visit never materialised. For the remainder of his life Rubens had to be satisfied with the 'certain rare and well made antique faces of marble'[41] recorded in the inventory drawn up after his death, as well as plaster casts, in order to decorate his Pantheon.

In 1634 Rubens wrote to his friend Peiresc that 'I have kept for myself some of the rarest gems and most exquisite medals from the sale which I made to the Duke of Buckingham. Thus I still have a collection of beautiful and curious things in my possession.'[42] This side of his collecting activities which also goes back to his days in Italy can be more meaningfully studied in the context of his relationship with the French scholar.

Although some of the pictures in Rubens' collection were included in the sale to Buckingham in 1627, the larger part of his extensive holdings of works by other artists remained with him. Apart from works by Rubens himself or copies by him after other artists, which have already been mentioned, the inventory drawn up after his death lists a substantial number of pictures by a very varied group of artists which testify to the owner's catholic taste. Pride of possession goes, as one might expect, to the Venetian school, above all to Titian by whom he owned nine pictures, including a self-portrait (Madrid); Tintoretto and Veronese were also represented by five pictures and four pictures and two drawings respectively. But, apart from Rubens' own personal preferences, it should also be remembered that, given princely tastes, pictures of the Venetian school were a very saleable commodity, especially in England. Rubens owned a portrait by Raphael and a mythology by Perugino, who was the only fifteenth-century Italian artist to be represented. He revealed a much greater interest in Flemish paintings of the same period, possessing examples by Jan van Eyck, Hugo van der Goes and Quentin Massys, traditional founder of the Antwerp school. Continuing his early interest in the German school, he owned works by Holbein and Dürer. There were numerous examples from the sixteenth-century Netherlandish school and the inventory lists the names of Lucas and Aertgen van Leyden, Jan van Scorel and Frans Floris. But clearly his favourite artist of this period was Pieter Bruegel the Elder, by whom he owned twelve pictures, including the *Death of the Virgin* (Plate 89), probably painted for Bruegel's friend the cartographer Abraham Ortelius.

He was also a keen collector of pictures by his contemporaries. Apart from works by collaborators such as ten examples by Van Dyck, five by Snyders and eight by the Dutch artist Cornelis Saftleven, he possessed eight pictures by Elsheimer, including *Judith and Holofernes* (Plate 90), and no fewer than seventeen by Adriaen Brouwer, both artists for whom Rubens' own work expresses no less clearly his admiration.

89. Pieter Bruegel the Elder, *The Death of the Virgin*. Panel, 36 × 55 cm. Upton House (National Trust), Banbury.

90. Adam Elsheimer, *Judith and Holofernes*. Silvered-copper, 24.2 × 18.7 cm. Wellington Museum, Apsley House, London.

71

When his collection is seen as a whole, and especially at a time before the sale to Buckingham, it is hardly surprising that it made such an impact on his contemporaries. Not only was it the creation of a man who was not a prince and who earned his livelihood by the products of his brush, but it represented the first significant collection of Italian painting and antique sculpture in Antwerp (and Flanders). A man's home and possessions provide a natural indication of his interests and tastes, but in Rubens' case they became in addition a very conscious expression of social and professional status, learning and philosophy. They offer a carefully constructed key to his personality.

Roger de Piles describes Rubens as having 'a tall stature, a stately bearing, with a regularly shaped face, rosy cheeks, chestnut brown hair, sparkling eyes but with passion restrained, a laughing air, gentle and courteous'.[43] Apart from tactfully ignoring his premature baldness, already clearly visible in the Mantua 'friendship portrait' (Plate 39), De Piles' description accords with the image presented in the self-portraits, although his tall stature, which was also mentioned by Bellori, can only be measured in relation to that of Helena Fourment in their double portraits (see Plate 87). His general manner was vividly evoked by Sandrart, who got to know him well on his visit to Holland in 1627; 'he was generally highly esteemed because of his agreeable conversation, his knowledge of languages, and his polite manners. Quick and industrious in his work, he was courteous and kind to everybody and since all found him pleasant he was very popular.'[44] The geniality of his character was already apparent during his school-days, when his friend and contemporary Balthasar Moretus recalls him as 'very good natured and most likeable'.[45]

The most circumstantial account of his 'life-style' is provided by De Piles on the basis of what the artist's nephew told him.

He rose daily at 4 in the morning, and unless prevented by gout from which he suffered greatly made it a rule to hear mass; thereafter he set to work, invariably with a hired reader who read a chosen book aloud, usually Plutarch, Livy or Seneca. As he was much devoted to his work, he lived in a manner which facilitated this and without injuring his health; for this reason he ate little at dinner for fear that the vapour of meat should hinder his application, and having set to work, that he would fail to digest the meat. He worked until five in the afternoon when he mounted a horse to take the air outside the city or on the ramparts, or undertook something else to relax his mind. On his return from his ride, he usually found some friends who dined with him and who contributed to the pleasures of the table. He maintained a great aversion against too much wine and good living, as well as gambling. His greatest pleasure was to ride a fine Spanish horse, to read a book, to look at and contemplate his medals, agates, cornelians and other engraved stones, of which he had a very fine collection.'[46]

Bellori, who speaks of his penchant for 'riding through the city, like other *cavalieri* and persons of title',[47] attributes to him a social distinction which set him apart from fellow artists. This description was confirmed by a contemporary of the artist, the diplomat Sir Thomas Roe, who had known Rubens in Antwerp, 'where he had grown so rich by his profession that he appeared everywhere, not like a painter but a great cavalier with a very stately train of servants, horses, coaches, liveries and so forth'.[48]

A fundamentally unromantic attitude seems to have underlain Rubens the man. It is hard to know whether he was ever faced with soul-searching moments in his life, since his response to every problem or event appears to have been one of action, and not of reflection inspired by doubt. His life is a shining example of the *vita activa*. Above the archway leading into his garden were inscribed the words *mens sana in corpore sano*, and their message was taken as a guiding principle by the artist. But one is led to wonder whether his belief in himself, in his art and in his religion could have been as uncomplicated as it appears. Was such an exemplary life achieved with so little real struggle? As we know him today, he stands apart

91. Detail of Plate 83.

from the rest of humanity as a very great man almost without any dark corners in his make-up. Anyone with a healthy cynicism towards perfection in human nature must come to this conclusion reluctantly, but before accusing Rubens of lacking finer feelings one should remember that his activities in other spheres made him a highly sophisticated man, with a protective public image, behind which it is difficult to penetrate. With a few exceptions, letters of a more personal nature no longer survive, and we have to accept the fact that we cannot know the private man. Behind the cool judgements and reactions, a man of deep emotions and contradictions, frequently gnawed by human doubt, may have existed. Yet it is no less conceivable that, had one had the opportunity to know him intimately, one would have discovered that the deeds of his life were the whole person, and that our understanding of the man is not impaired by the lack of personal records.

Ambition was undoubtedly a driving force in Rubens' career, but if it was initially inspired by self-advancement it was very soon directed towards entirely worthy causes. Already from his days in Italy he had a very healthy opinion of himself and his works, but he never succumbed to conceit and self-satisfaction. He maintained a strong professional pride, which led him, for example, to expressions of controlled indignation when the new bishop rejected his proposed altarpiece for the church of St Bavo in Ghent (see p. 111). On another occasion, in 1630, he resolutely refused to improve the work of a lesser artist. 'He would rather make a new design than rework this drawing.'[49] Where patrons were concerned, Moretus reported that he 'sends less competent judges to a less capable and expensive painter; he himself is in no want of buyers for his excellent but costly pictures'.[50]

In financial matters he was hard headed and calculating, charging according to the day's work. He seemed to approach each project as a job to be executed with the maximum efficiency. This was the outcome of a careful and orderly mind, reflected, for example, in his will, and he was an excellent administrator, as his supremely well run workshop testifies. Like a craftsman he never appears to have been becalmed for want of inspiration. Although Sandrart mentioned that he had a reputation for being careful about money, he was not in the final resort grasping. His lament about Elsheimer, who 'could have built up a great fortune and made himself respected by all the world',[51] reflected his own view. Money legitimately earned not only had its own material rewards but led to an enhanced social status. In his business transactions he was commendably clear cut and honest. To Sir Dudley Carleton he said, 'I like brief negotiations where each party gives and receives his share at once'.[52] He was not prepared to waste time, and he quoted with approval 'the familiar proverb, "He who wants something, goes himself; he who does not, sends another"'.[53] When under pressure he displayed a natural impatience, and he did not suffer fools gladly. But these are peccadilloes to be set against the positive good in his character, and we are filled with admiration for his noble sentiments and actions, his extensive and deep knowledge, his generosity, his shrewdness about human nature. He was, for example, unwilling to believe ill of someone without making his own investigation: 'I do not want to rely upon public gossip, to the detriment of so illustrious a man. I shall visit him at home, and talk with him intimately, if possible.'[54] In smaller, more everyday matters, he showed himself keenly aware of human behaviour: 'this book which I brought recently from Paris, upon your suggestion, pleased me so much that I did not want to enjoy alone the satisfaction it gave me, and so I lent it to an intimate friend. I have never been able to get it back, which will make me more careful about lending books in the future.'[55]

Rubens put his finger firmly on the nature of his character when he declared: 'As for me, I assure you that in public affairs I am the most dispassionate man in the world, except where my property and person are concerned.'[56] Detachment allowed him a very objective view of the world at large. He was doubtless right when he claimed that he 'could provide an historian with much material, and the pure truth of the case, very different from that which is generally believed'.[57] Unfettered by self-interest and *parti-pris*, he could see the world in a colder more

accurate light. The eighteenth-century Swiss artist Henry Fuseli rightly paid tribute to Rubens' 'full comprehension of his own character'.[58] Moreover, his aloof position was protected by his continuing reluctance to get involved in the in-fighting of everyday political life. He formulated his creed and he kept to it: 'I am a peace-loving man, and I abhor chicanery like the plague, as well as every sort of dissension. I believe that it ought to be the wish of every honest man to live in tranquillity of mind, publicly and in private, rendering service to many and injuring no one.'[59] For a man of his century, peace was an obsession, in whose cause he never ceased to fight. All his diplomatic activities were directed towards the cessation of hostilities and an honourable truce. That represented the ideal for which he fought, and never for personal aggrandisement or national glory.

One major influence on Rubens' character and comportment stems from his contacts with neo-Stoic thought so popular at the time as a spiritual weapon against the current political troubles. The leading exponent was the distinguished and, in his day, very famous Latinist Justus Lipsius, an authority on Seneca, an edition of whose writings he published in 1605. In his own writings Lipsius had blended Stoic thought with Christian belief, thereby making his philosophy relevant to the requirements of the day. He was a friend of Jan Brant and counted among his brightest pupils, Philip Rubens, who was offered the succession to his chair at Louvain. Even if Rubens never met him, both Lipsius's personality and his beliefs would have been well known to the artist.

Constancy and equanimity are the most obvious qualities praised by the Stoic philosophy to which Rubens aspired. He remained a firm believer in the necessity of mastering the emotions and submitting to divine fate. On the portico dividing his house and garden he had inscribed two quotations from Juvenal which can be seen as paradigms for the conduct of his life (see p. 62). These were no pious thoughts unrelated to his beliefs.

When faced with the death of Isabella, Rubens expressed himself unable to live up to the precepts by which he sought to conduct his life:

> You do well to remind me of the necessity of Fate, which does not comply with our passions, and which, as an expression of the Supreme Power, is not obliged to render us an account of its actions. It has absolute dominion over all things, and we have only to serve and obey. There is nothing to do, in my opinion, but to make this servitude more honourable and less painful by submitting willingly; but at present such a duty seems neither easy, nor even possible. You are very prudent in commending me to Time, and I hope this will do for me what Reason ought to do. For I have no pretensions about ever attaining a stoic equanimity; I do not believe that human feelings so closely in accord with their object are unbecoming to man's nature, or that one can be equally indifferent to all things in this world.[60]

To his friend Jan Caspar Gevaerts, another pupil of Lipsius, in a similar situation he counselled: 'If any consolation is to be hoped for from philosophy, then you will find an abundant source within yourself. I commend you to your *Antoninus* [Marcus Aurelius] whose divine nourishment you still distribute liberally to your friends. I shall add only this, as a poor kind of comfort: that we are living in a time when life itself is possible only if one frees oneself of every burden, like a swimmer in a stormy sea.'[61]

In a more general context, when faced by the war-like behaviour of Europe's rulers, he wrote that 'one must believe that this is heaven's decree, and must accept the divine will'.[62] Throughout his life Rubens did, despite his moments of doubt, accept his fate, both good and bad, and it may be that this inner strength which controlled his emotions accounts for our difficulty today in getting beneath the carapace protecting the inner man.

Rubens' art no less than his life was in tune with Stoic philosophy. Shortly after his return from Italy he painted a *Death of Seneca* (Plate 92), a subject which would have appealed to a number of people in Antwerp. The artist followed the

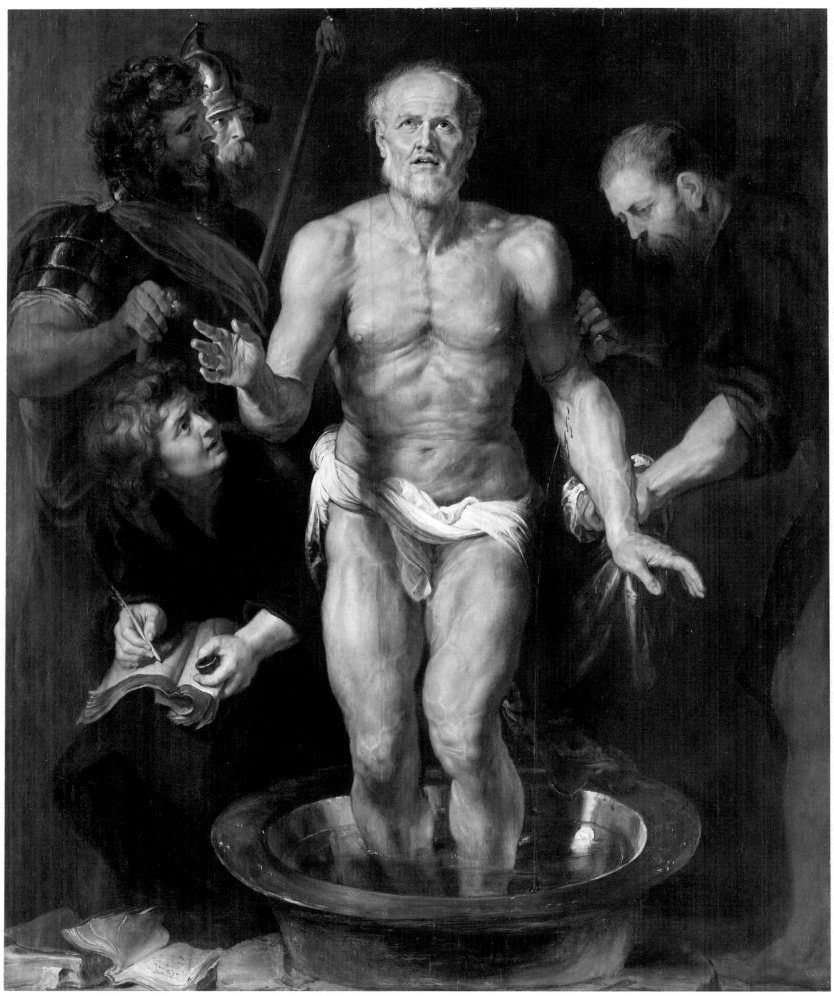

92. *The Death of Seneca*, c.1608–9. Panel, 181 × 152 cm. Alte Pinakothek, Munich.

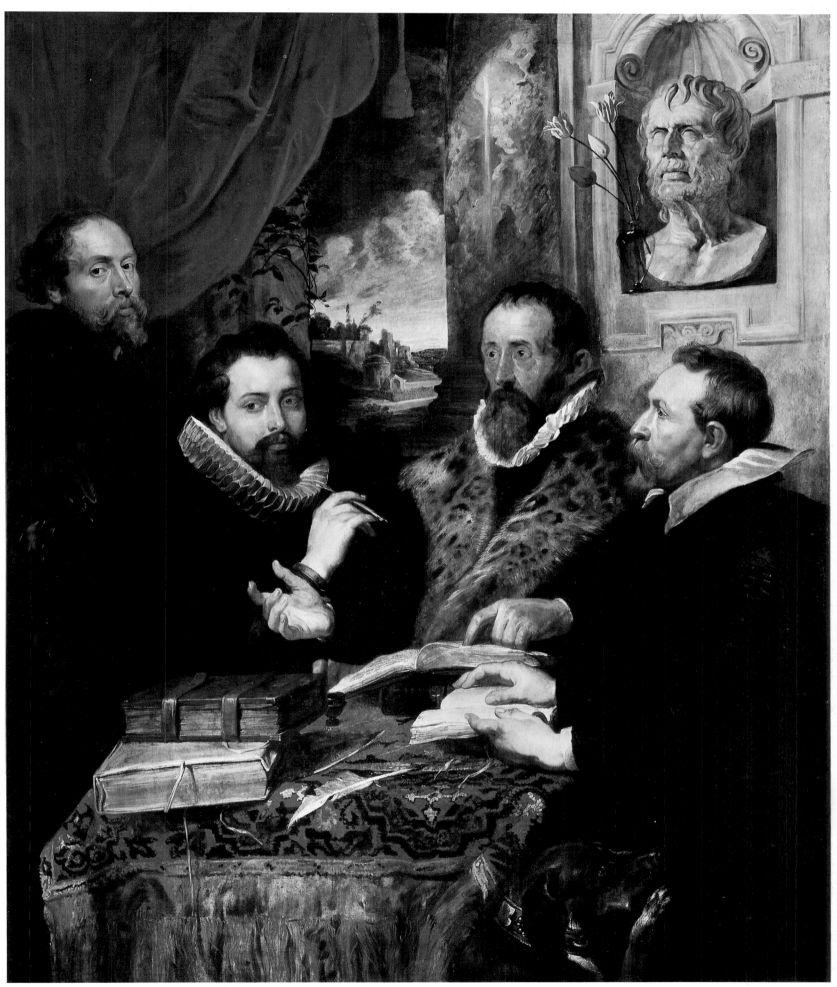

93. *Justus Lipsius and his Pupils*, c.1615. Panel, 167 × 143 cm. Galleria Pitti, Florence.

account by Tacitus, in which the philosopher, anticipating his death at the hands of his former pupil Nero, took his own life by cutting his veins, speeding the process by standing in hot water. He is accompanied by a doctor whom the philosopher had befriended and a disciple who eagerly takes down his last words, while Nero's soldiers watch in the background. Moretus, in his foreword to the Lipsius edition of Seneca's writings, makes much of the artist's use of authentic images of the Roman philosopher, although ironically both sources were wrongly identified at the time as portraits of Seneca. For the head Rubens used the bust in his own collection (see Plate 88), while the body is based on the sculpture, now known as the *African Fisherman*, which Rubens had copied several times (Plate 21) when he saw it in the Borghese collection in Rome. (At the time the sculpture was identified as the dying Seneca and was placed in a marble bowl.) In this very deliberate adaptation of antique sculpture the artist demonstrates his belief that 'the imitation . . . must be judiciously applied, so that it may not in the least smell of the stone'.[63] Especially admirable in this large panel is the transformation of the realistically gruesome representation of the philosopher's suicide into an image of nobility and strength, made the more imposing by the low viewpoint. The grouping of the figures, closely knit both formally and psychologically in a shallow depth, offers further evidence of the picture's classical source by imitating the qualities of the sculpted bas-relief, one of the major forms of antique sculpture.

More personal to the practice of neo-Stoicism in Antwerp is the painting of the imaginary gathering of *Justus Lipsius and his Pupils* (Plate 93). The seated philosopher is flanked on his right by Philip Rubens and on his left by another pupil, Jan Woverius, later town clerk of Antwerp, jumping up at whose side is Mopsus, one of Lipsius's three much-beloved dogs. The painter himself stands on the left-hand side. The supposed bust of Seneca is placed in a niche behind, while on the left the curtain is drawn to reveal an idealised view of the Palatine, where symbolically all their thoughts are directed. The painting was probably done either to commemorate Philip Rubens' death in 1611 or, more probably in view of the maturer style, to celebrate the second edition of Lipsius's writings of Seneca and an edition of Philip Rubens' own writings, both of which were published by the Plantin Press in 1615. The books on the table may be intended as a general reference to these publications. The commemorative nature of the painting is further underlined by the tulips in the glass, which act as symbols of mortality; two in bloom for the living and two closed for the deceased. The ivy entwined around the column offers another emblem with a similar meaning, which Rubens used later in his last portrait of *Isabella Brant* (Plate 217). Whereas the two living sitters placed on the outside could be studied from the life, Rubens had in the case of the other two to rely on his own earlier portrait of his brother (Plate 48), and a portrait of Lipsius by Abraham Janssens, now known only from an engraving. And both the latters' by now old-fashioned millstone ruffs make a further distinction between dead and living.

As he had done in the *Artist with his Friends* (Plate 39), painted in Mantua, Rubens makes no attempt to create any sense of psychological unity between the sitters. Whereas the two Rubens brothers look out at the spectator, the other two men stare straight ahead, absorbed in their own thoughts. The sense of separation between sitters is increased by the placing of the figures – although contiguous each appears individually composed. Only the motif of the three pairs of interlocking hands seems to provide some meaningful link between the master and his two pupils. The appropriate sobriety of dress, with the exception of the ermine fur around Lipsius's shoulders, is in marked contrast to the rich colour of the accessories, such as the oriental carpet on the table and the crimson curtain and the column of rich *breccia* marble perhaps intended for jasper or onyx in the background.

Although with the benefit of historical hindsight we tend to regard Rubens as a slowly developing artist who only reached a mature personal style in the middle of the second decade, it is remarkable how at the time his reputation can be said to

have preceded his achievements. Already in 1607 when he was still working on the Chiesa Nuova altarpiece, Caspar Scioppius was praising him in extravagant terms, speaking of 'his mastery in painting, an art, in which, according to the connoisseurs, he has reached perfection, as far as anyone has managed that in our age'.[64] From then on it became customary to praise Rubens for a variety of achievements, sometimes expressed in suspiciously similar terms which suggest that the writer was repeating received opinion rather than making a personal observation.

His art was naturally the primary source of admiration, and by 1611 he was being referred to as the 'Apelles of our age', hyperbole much to the taste of the century, which was repeated with monotonous regularity throughout his life. And the writer, Dominicus Baudius, a professor at Leiden university, goes on to say, 'may your talents and your merits be recompensed by a new Alexander'.[65] More sober recognition came in 1616 from Frans Sweertius, the eminent Flemish antiquarian, who in writing to his counterpart in England, William Camden, reports that 'we have here a painter of great renown, named Rubens, who is known all the world over'.[66] In reply to Rubens' protestations that 'I am not a prince, "but [quoting the Psalms in Latin] one who lives by the work of his hands"',[67] Sir Dudley Carleton wrote, 'I esteem you the Prince of Painters and of Gentlemen'.[68] Three years later, in 1621, the young Danish doctor Otto Sperling speaks of his visit to 'the very famous and gifted artist',[69] while Peiresc writes to the latter that 'you have reached the highest point of perfection in the noble art which you profess that you surpass all others of this century. I do not say of past centuries in order not to offend your modesty, but I am certain you are the equal of the most excellent masters.'[70] His assured position as a famous man is perhaps best summed up by his friend and fellow-artist Jan Brueghel when he wrote in 1623 (that is, about half-way through Rubens' professional life) that, 'In whatever concerns art, Rubens is continually achieving increased perfection; he is the favourite of fortune to the point that he surpasses all the artists of our age in honour and riches'. He was fortunate that his reputation never waned, and he met with critical adulation for the remainder of his life.

His agreeable personality met with hardly less praise. Such very different people as Scioppius and Sandrart have already been quoted. Peiresc succinctly states the contemporary view: 'He was born to please and delight in all that he does or says.'[71] And, uniquely for an artist, both Philip IV and Charles I took particular pleasure in his conversation. Allied to the general recognition of his attractive character was an appreciation of his learning. The most knowledgeable testimonials came, as we shall see, from Peiresc, but he was not alone in his estimate. On the artist's death, Philippe Chifflet, chaplain formerly to the Archduchess Isabella and now to the cardinal-infante, could write without exaggeration that 'he was the most learned painter in the world'.[72]

Wide recognition of his role as political adviser and diplomat grew with the years, and, given the initial hostility he was to meet in this area, such praise would undoubtedly have given the artist particular pleasure. Rulers in several countries as well as members of their political entourage were to pay warm tribute to the soundness of his judgement as well as to his loyalty and devotion. In 1632 Jean Puget de la Serre, the historian of Maria de' Medici, while paying lip-service to his art, continued that this 'is the least of his qualities; his political judgement, his spirit and sense of direction lifted him so high above his profession, that the works of his wisdom are as admirable as those from his brush'.[73] And a year after his death his old friend Jan Caspar Gevaerts was doing no more than echoing the general sentiment when he spoke of 'the outstanding and singular virtues of Rubens' who 'had perfect knowledge of literature, and all the sciences, and was everywhere respected for his expert knowledge of public affairs'.[74]

Rubens' most important and immediate achievement during the first decade after his return from Italy was the part he played in the decoration of a number of Antwerp churches. These large altarpieces served to establish Counter

94. (following pages) Details of Plate 92.

79

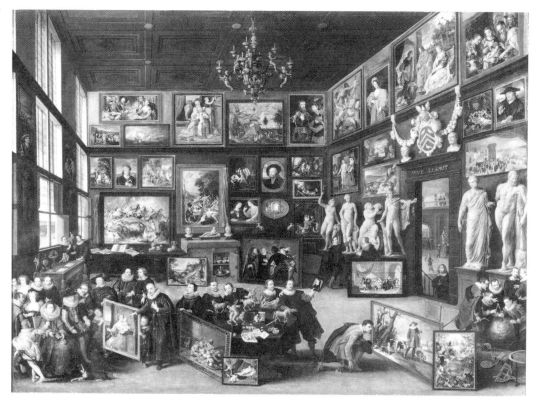

Reformation iconography in the southern Netherlands and at the same time provided him with the opportunity to achieve full maturity as an artist. The city's churches had suffered extensively in 1566 and 1567 when in their attempt to remove all idolatrous images the Protestant iconoclasts had destroyed many pictures and works of art. This had been followed by a second more orderly purge undertaken by the Calvinist city council in 1581. The re-establishment of the Catholic church began after the capture of the city by Alessandro Farnese in 1585 but only fully materialised with the arrival of Albert and Isabella in 1599. Although far less oppressive than their Spanish counterparts, they strongly promoted the Counter Reformation movement and were themselves responsbile for providing money for churches and altarpieces. This new spirit of Catholicism had not been long under way before Rubens' return from Italy and, as has been said, the opportunities it promised the artist were probably decisive in persuading him to remain at home. He must have realised that if many commissions were in the offing there were also no obvious major artists of sufficient stature to execute them in the appropriate style. In his clear-headed way he saw what could be done and, assured by his Italian experience, realised his own ability to fulfil the task. That he was the right man was almost immediately recognised, and in 1611, two years after his return, an Antwerp merchant, when asked for the 'best master' to paint an altarpiece for a Benedictine abbey, replied: 'We have here a good master who is called the god of painters, Peter Rubens', and he goes on to list the 'various pictures which are held in high esteem . . . they are beautiful'.[75]

The embellishment of new or restored churches with movable altarpieces was not solely a question of painting the traditional subjects in an up-to-date style. The artist had to devise a different iconography to take account of the new interpretations of Christian dogma promulgated by the Council of Trent. As a result of the establishment of the Society of Jesus and the strengthening of other religious orders, Antwerp soon developed into an important centre of religious literature, with church leaders and critics ever ready to give directions and advice. Responding to Protestant objections, there was now much greater concern for truth and accuracy than there had been before the Reformation, so that representations of the saints were for the most part purged of the charming and fanciful legends that had been so widely spread through such works as the *Legenda*

Aurea. Other religious themes received new modified emphasis. As a counter to Protestant attacks on the cult of the Virgin, her role as the intermediary between God and man was actively promoted and strengthened. Following the rules laid down by the Council of Trent, all new religious paintings had to be submitted for ecclesiastical approval, and Rubens was more often than not required to produce some form of *modello* for scrutiny before the final work was sanctioned. And we can be sure that accuracy and propriety in the presentation of the subject were as important as, if not more so than, awareness of pictorial qualities.

In creating a new iconography which would instruct and move the faithful, Rubens was no cipher subserviently following ecclesiastical directions. The subjects he chose and the manner in which he painted them were the result of careful thought and scholarship on his own part. His attitude to the subject was considerably more complex and variable than the guidelines formulated by religious authorities might lead one to expect. Although constantly taking note of the new iconography, he was not, when it suited him, averse to falling back on tradition. Moreover, he was perfectly capable of introducing innovations and refinements of his own. Steeped in religious learning, he was not minded to accept criticism without protest when he believed himself to be in the right. To no less an authority than a Benedictine abbot who thought he had discovered an error in the image reproduced on a frontispiece (Plate 167), Moretus was forced to reply that Rubens 'will not admit that it is a mistake, but insists that he has painted his with good reason and judgement: Jesus Christ appears above, and the Mother of God at His right side, according to the text of the Holy Scripture: the Queen stood at His right side'.[76]

When out of filial piety Rubens installed the rejected altarpiece for the Chiesa Nova (Plate 58) over his mother's tomb, he may also have had an ulterior motive of demonstrating to his fellow citizens what he was capable of. Whatever his intentions, this richly glowing work became the first of his altarpieces to hang in his native city and was one of the works described by the Antwerp merchant as 'beautiful'. From the time this picture was unveiled until the end of the decade Rubens' major artistic activity was devoted to painting altarpieces, which through their accessibility to both the native public and foreign visitors led directly to the establishment of his reputation. The spreading of the name of Rubens was further

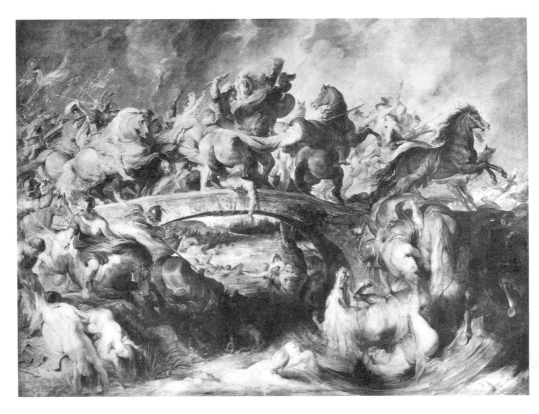

96. *The Battle of the Amazons*, c.1618–20. Panel, 121 × 165 cm. Alte Pinakothek, Munich.

98. Detail from Anthoon Gheringh, *The Interior of St Walburga with the Raising of the Cross.* St Paul, Antwerp.

97. *Sketch for the Raising of the Cross*, c.1610. Three panels, 67 × 25 cm, 68 × 51 cm and 67 × 25 cm. Musée du Louvre, Paris.

assisted in the following decade by the wide dissemination throughout Europe of reproductive engravings after these works. During this period he and his studio produced over sixty altarpieces, about one-third of which were executed for his native city and the remainder for other destinations in Flanders. In addition a certain number were carried out for foreign patrons. As leading promoters of the new building and decorating programme in Antwerp, the city councillors not only gave money to such projects but in 1611 decreed 'that alms shall be collected during high masses and sermons for the purpose of restoring or repairing the churches'.[77] And when the various religious authorities took action, Rubens, by a combination of having established his artistic pre-eminence and knowing the right people, succeeded in attracting the majority of commissions. Two of his masters, Van Noort and Van Veen, were still alive and a number of younger established artists such as Abraham Janssens and Hendrick van Balen, all of whom in terms of what they had actually carried out locally, could claim priority. But there was already an aura about Rubens so that his nephew with only some exaggeration could say that 'When he returned to Flanders in 1609, his fame had already spread far and wide'.[78]

The city itself quickly recognised Rubens' presence, and when it required decoration for the room set aside for the negotiations for the Twelve Years' Truce commissioned or purchased a number of pictures by various artists, including the *Adoration of the Magi* (Madrid) by Rubens, for which he was paid in 1610. (Two years later the picture was given away by the magistrates and was later bought by Philip IV, in whose collection Rubens enlarged and repainted it when he was in Spain in 1628.) Other early commissions and purchases were received from the Dominican church of St Paul, which still owns the *Nativity* and the *Glorification of the Holy Eucharist*, both early works still typical of his Italian style. The latter belonged to, and was probably commissioned by, the Brotherhood of the Holy Sacrament, one of whose members was the wealthy merchant, art collector and philanthropist Cornelis van der Geest, who judging by his later deeds may well

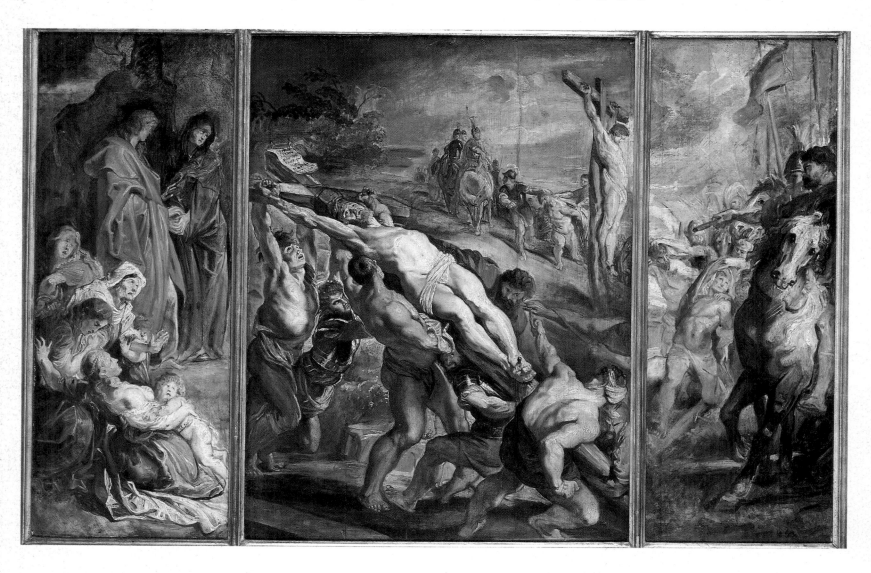

have played an important role in commissioning and paying for the altarpiece.

Although subsequently renowned for his princely patrons, Rubens was at least at this stage of his career largely indebted to middle-class figures for either direct or indirect patronage. The need for new painting and sculpture in the churches immediately posed the question of funding and in many cases the costs were assumed by wealthy burghers or members of confraternities and guilds. Many of these people became friends of the artist and were ultimately responsible in the early years for providing Rubens with so much work in the local churches. As will be seen, their involvement in such commissions led to more personal orders for paintings from the artist. Very quickly Rubens became a central figure in the general life of the ecclesiastical and city establishment.

Shortly after Rubens' return to Antwerp, the authorities of the church of St Walburga (now destroyed) decided to commission a new altarpiece for the high altar. In June 1610, a month after 'a tour of the parish by the priest and church-wardens with the collection plate, for the making and painting of the high altar',[79] agreement was reached with Rubens at a banquet given at a local inn for the purpose. Van der Geest, who lived nearby and had just become dean of the prestigious Guild of Haberdashers, is specifically mentioned among those present and it appears that not only was he responsible for obtaining the commission for Rubens but he also made a sizeable contribution towards the cost. (Three years later in a spirit of romantic antiquarianism he paid for the restoration of the crypt, where according to local legend the titular saint, St Walburga, had retired to pray.) His vital role in commissioning the altarpiece was not forgotten by Rubens thirty years later, when on the reproductive engraving after the picture (see Plate 157) he referred to Van der Geest as 'praecipuus [principal] Author et promotor'.

But the relationship between artist and patron went much further, and in the dedication on the print, which became the artist's obituary tribute, Rubens spoke of Van der Geest as 'the best of men and oldest of friends, in whom ever since youth he found a steadfast patron'. A similar sentiment had been expressed some years earlier in a legal document signed by both men, in which Van der Geest referred to 'the friendly relationship which he has had and still maintains'[80] with the artist. The intimacy between the two men is recorded in a painting dated 1628 (Plate 95) by Willem van Haecht, the son of Rubens' first master, commemorating in an imaginary form Van der Geest's famous collection of works of art and the distinguished visitors of high rank who came to see them. This picture includes at least two pictures by Rubens, one of which, the *Battle of the Amazons* (Plate 96), is placed prominently on the table by the window. (If Van der Geest owned Rubens' copy (Louvre) rather than Quentin Massys' original of the portrait of *Paracelsus*, seen immediately above, the number by the former is increased to three.) In the foreground, the collector shows a *Virgin and Child* by Massys to the seated Albert and Isabella, surrounded by various identifiable people of status. Van Dyck, appointed court painter in this year, is included among the select behind Van der Geest. Rubens, in a place of honour beside the archduke, seemingly leans forward to tell him something about the picture. In view of the dramatic emphasis on Massys' work and Rubens the man and artist, the painting may be regarded as a celebration of the accredited founder of the School of Antwerp and then the subject of veneration, and its most famous living member, both dear to the heart of the collector.

Having submitted his sketches (Plate 97) for approval by the church authorities, Rubens signed a contract to paint the high altar of St Walburga in June 1610. The painting itself was finished by the following year, when the artist received a second payment. In view of its size, Rubens had to paint the panel on the site, but in order to provide him with some privacy a payment was authorised in 1610 as a 'gratuity to the Admiral's workmen for the sail kindly lent by the captain to be hung while the painter Rubens painted the high altar'.[81] The position of the high altar was very unusual; owing to the crowded district in which the church was built, the choir had to be raised above the street running at the back of the church. The altar

was approached from the nave by a flight of nineteen steps which automatically gave Rubens' picture a very dominant position (see Plate 98). The main part of the altarpiece consisted of a triptych (Plate 100), the wings of which, when closed, showed four saints, Amandus, Walburga, Eligius and Catherine (Plate 101), all of whom were venerated in Flanders. In accordance with the old-fashioned format of the altarpiece, three predella panels, the *Crucified Christ* (lost) between the *Miracle of St Walburga* (Plate 99) and the *Burial of St Catherine* (lost), were originally placed below the triptych; above, the figure of God the Father was flanked by angels painted on board cut around their contours (Plate 102); a gilt wood pelican, the emblem of Christ's sacrifice, surmounted the whole ensemble. For Rubens after his experience in Italy this marked a return to the traditional form of medieval polyptych which had never gone out of fashion in Flanders. At this stage of his career Rubens was in no position to change taste, and with that conservative streak in his nature he would not have found the task uncongenial. But he was able to introduce one major innovation.

As his sketch already shows, Rubens conceived the principal scene as spreading across the entire surface of the triptych, for all intents ignoring the divisions made by the frame between the central panel and the wings. The unification of the different parts of the altarpiece was further established by the motif of Christ's upward gaze to the figure of God the Father at the very top of the ensemble; the crowning pelican offered a meaningful symbol of the event taking place below. This predilection for expanding the dramatic range of the central scene beyond the confines of the frame was to become a feature of Rubens' altarpieces and was to find general favour during the century. And in this instance the unity is extended to the architectural setting, and the fall of light throughout the altarpiece conforms to the natural source of light coming from the tall windows on the south side of the choir.

With the general composition established in the oil-sketch, Rubens was now able to turn his attention to realising the individual figures, which he proceeded to do, following the example of such Italian artists as Annibale Carracci, by making large-scale chalk drawings. These were of use both to the master and to any assistant involved in the execution of the picture. In this work, which required vivid expressions of both physical and emotional struggle, the display of strength

100. (following pages left) *The Raising of the Cross*, 1610–11. Panel, centre 462 × 341 cm, whole 462 × 641 cm. Cathedral, Antwerp.

101. (following pages right) *Sts Amandus, Walburga, Eligius and Catherine*, 1610–11. Panel, 462 × 300 cm. Cathedral, Antwerp.

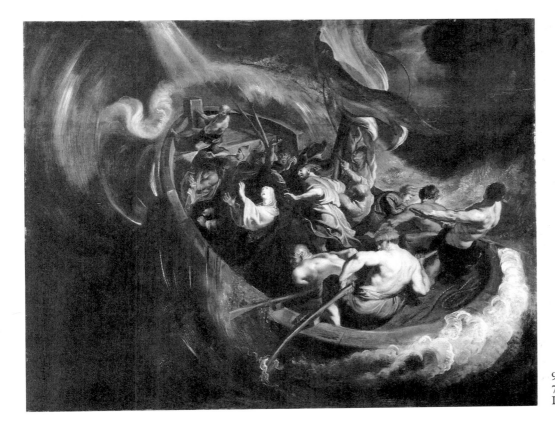

99. *The Miracle of St Walburga*, 1610–11. Panel, 75.5 × 98.5 cm. Museum der Bildenden Künste, Leipzig.

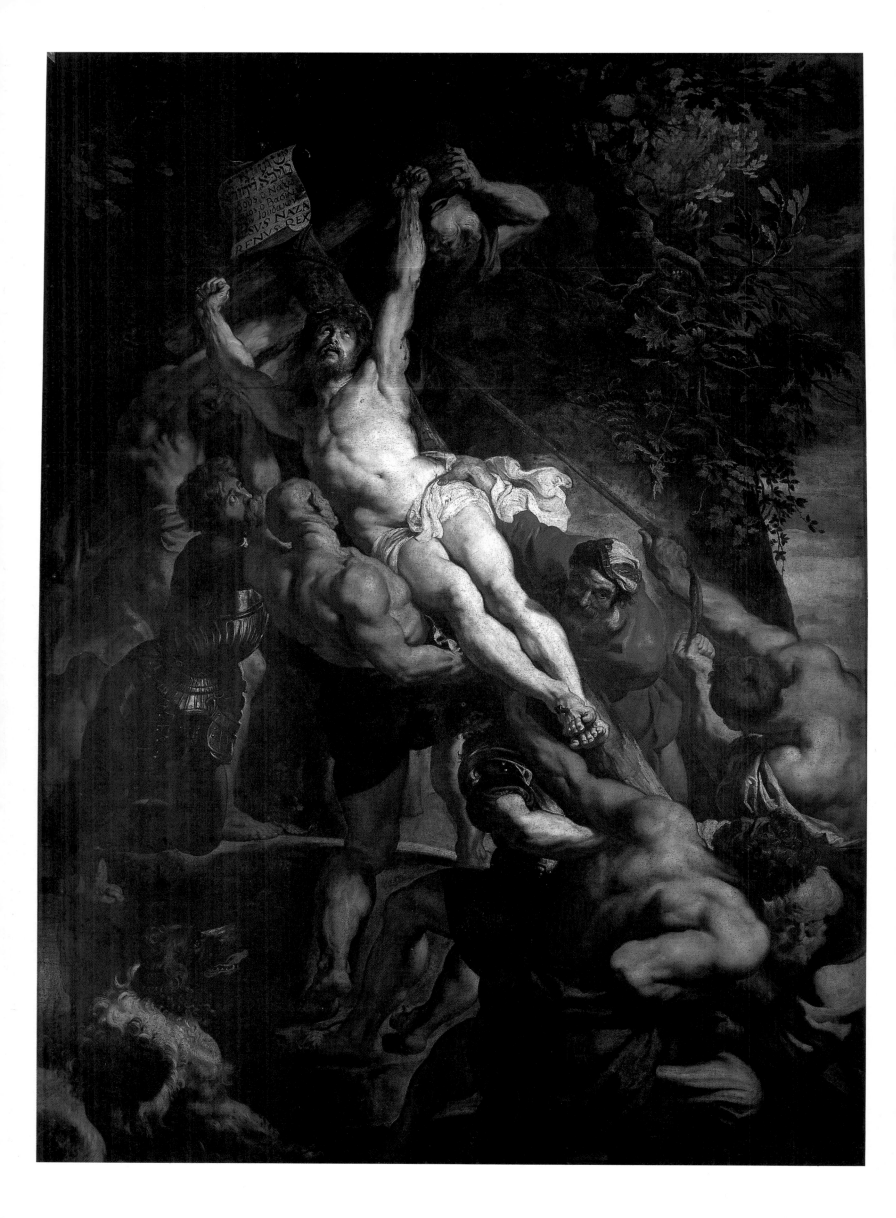

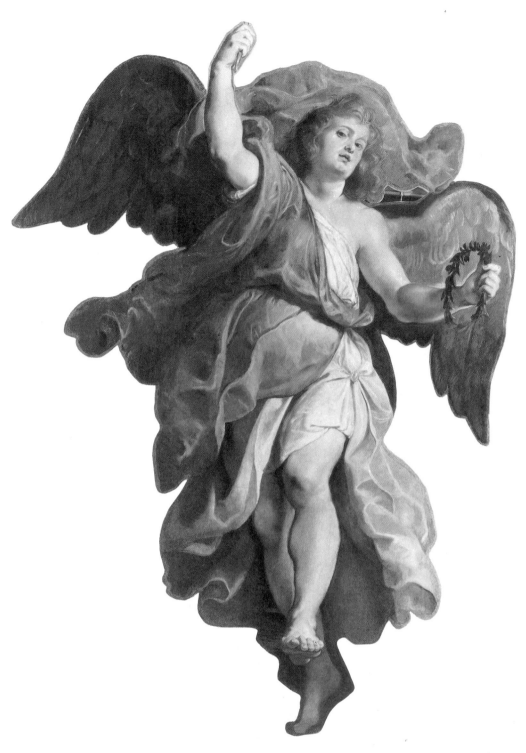

102. *An Angel*, 1610–11. Panel, 205.7 × 150 cm (max). Flint Institute of Arts, Michigan.

required in the act of lifting is magnificently realised in the study of the upper torso of a man seen partly from behind (Plate 105). His broad shoulders and flexed muscles vividly depict his action, and both form and outline are established by bold drawing with black chalk, heightened with white bodycolour. (In the final work the young model was transformed into a bald elderly man, the incarnation of evil.) A similarly executed drawing (Plate 103) is devoted to the man in profile beside him, although in this instance the artist's uncertainty about the position of the left leg may indicate that it preceded the oil-sketch. In the final work his head is turned slightly to the front, and he is shown clothed and wearing a metal cuirass. This drawing demonstrates Rubens' ability to study nature through the example of antiquity, since the pose probably derives from a figure raising a Dionysos Herm on a late classical sarcophagus (Plate 104). (In the relief the left leg, which caused Rubens some uncertainty, is hidden by drapery.) This connection with antique art highlights Rubens' concern for the proportions of the body. In his unpublished treatise recorded by De Piles, he laments that today 'we see so many paunch-bellies, weak and pitiful legs and arms, that seem to reproach themselves with their idleness'. By contrast he praises the kind of classical body perfected by strenuous training: 'For the arms, legs, neck, shoulders, and whatever works in the

90

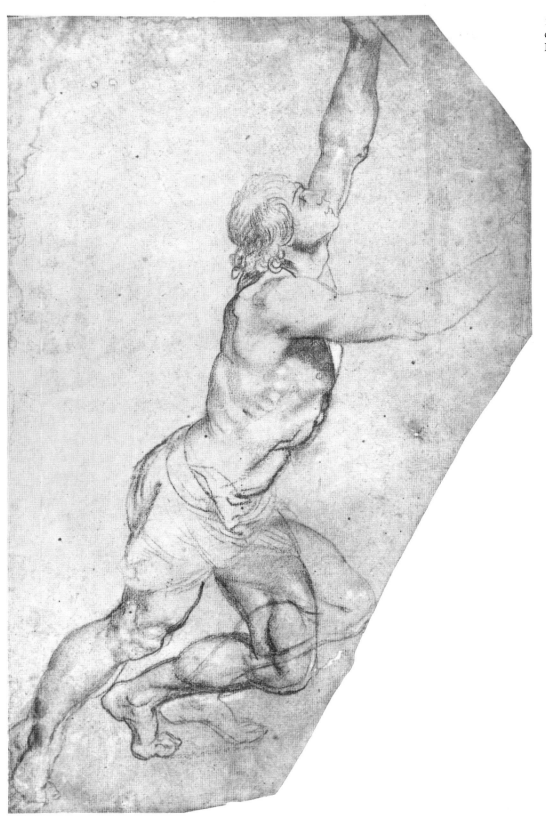

103. *Nude Man with Arms raised*, c.1610. Black chalk, heightened with white, 48.8 × 31.5 cm. Royal Collection, The Hague.

104. Late Roman sarcophagus, *The Raising of a Dionysos Herm*. University Art Museum, Princeton.

105. *Nude Man seen from behind*, c.1610. Black chalk, partly stumped, heightened with white, 31.5 × 36.7 cm. Ashmolean Museum, Oxford.

106. *Studies of Heads and Hands*, c.1610. Black chalk, heightened with white, 39.2 × 26.9 cm. Graphische Sammlung Albertina, Vienna.

body, are assisted by exercise, and nourished with juice, drawn into them by heat, and thus increase exceedingly both in strength and size; as appears from the backs of porters, the arms of prize fighters, the legs of dancers, and almost the whole body of watermen.'[82] And this last statement perhaps contains an indication of the models Rubens chose in his search for a well-developed body.

Another sheet connected with the painting (Plate 106), made up of two pieces of paper, shows various studies executed at different times. Two pairs of clasped hands were done in preparation for those of the Virgin. The fingers drawn in a rich black chalk with accents of light put in with touches of white bodycolour are marvellously expressive. The effect is varied by drawing the fingers open in one study and closed in the other. Above, beside a head in profile probably copied from the antique, the bearded man drawn in lighter grey chalk is possibly the portrait study of Van der Geest, who as a major donor might well have been intended to make an appearance in the same way that Nicolas Rockox did in the Arquebusiers' altarpiece (Plate 108).

For an artist of such habitual forethought and planning, the genesis of this work reveals an unusual change in the oil-sketch itself. The middle panel contains the crucifixion of one thief and the procession of the other. Since both thieves also appear in the right panel, it seems that the artist originally envisaged a different

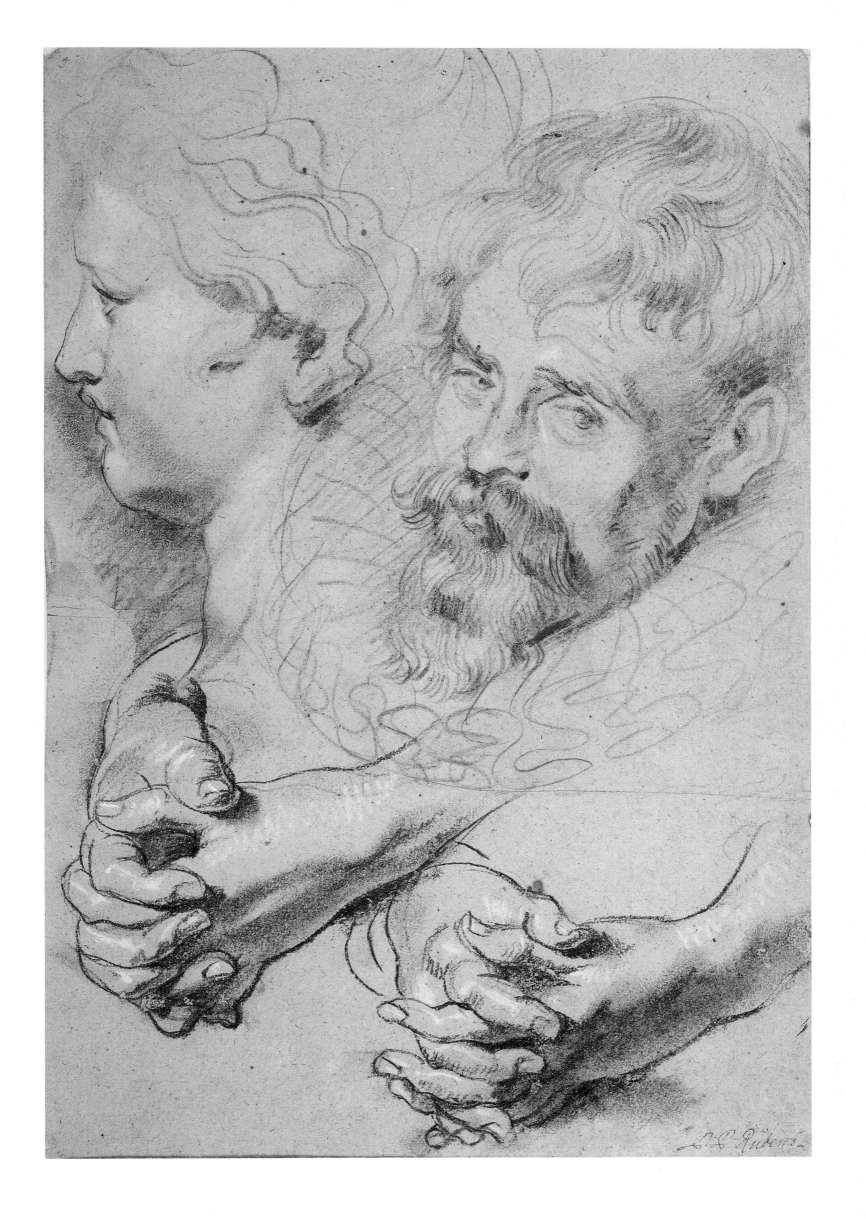

arrangement, and when presenting the oil-sketch to the authorities he must surely have offered some explanation about the duplication. Other changes were introduced in the finished work. The cross was placed in a more vertical position nearer the top of the panel avoiding the awkward more horizontal arrangement in the sketch which echoes that in the altarpiece for S. Croce in Gerusalemme. In the final work, whereas the emotional anguish of Christ, whose figure is now shown frontally, is increased as he raises his head towards God the Father, the sense of physical effort required to raise the cross is lessened by adding two further helpers to the original seven men. Initially the event was conceived as taking place on a barren stony plateau, but the artist introduced a rocky wooded escarpment, which serves to project the event taking place on the cross. As the shallow space of the central panel emphasised the upward thrust of movement to the very top of the panel, the impact on the spectator, especially when the altarpiece was seen in its original position from below, was much greater.

In reaching such a highly original solution, Rubens continued to draw heavily on his Italian experience. Tintoretto's vast canvas of the *Crucifixion* in the Scuola di San Rocco (Plate 107) was a potent prototype, the influence of which was all the more obvious in the preliminary oil-sketch. The type of massive figure with exaggerated musculature must surely derive from Rubens' study of Michelangelo. And whereas the formal link with antique sculpture seen in the figure pushing up the cross has already been remarked upon, the intensity of suffering, so movingly apparent on Christ's face, may well be a recollection of his Roman copies of the *Laocoon* (Plate 25), whose grief found such poignant expression. But in this work, unlike in earlier altarpieces, Rubens displays a maturity in the way that he blends the various foreign ingredients, which are now interpreted in a personal manner through his own characteristic line and colour and above all in this work by his rich and dramatic use of chiaroscuro.

Although the space is continuous throughout the triptych, each wing has its own formal and iconographic independence from the centre. The right panel is devoted to the soldiery and two thieves, a scene of dominant action and physical violence, whereas the other side concentrates on the emotional response of the Virgin and her female companions, arranged in a receding semicircle, whose intense realism of representation recalls the work of Caravaggio. Although Rubens had largely worked out the colour scheme in the sketch, the colour of the dress of St John, the only male figure on the left, was later changed from red to blue to match that of the Virgin, thereby identifying the two figures more closely in their combined sorrow.

The four patron saints, whose arrangement recalls the figures in the first Chiesa Nuova altarpiece (Plate 58), then hanging nearby in the Abbey of St Michael, were placed on the outer wings and were therefore visible to the congregation only when the altarpiece was closed. By devoting the central space to such a fundamental Christian scene as Christ's death and sacrifice rather than to the activities of local saints, who were sometimes of doubtful authority, Rubens was

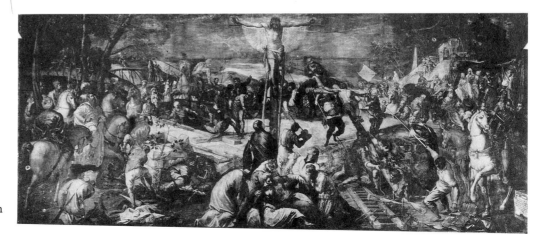

107. Tintoretto, *The Crucifixion*. Scuola di San Rocco, Venice.

following the precepts laid down by the Council of Trent for religious art. In a pervasive way Rubens has created in this altarpiece a perfect embodiment of Counter Reformation ideology which he was to repeat with variations over the course of his life. All who saw the picture should be both instructed and confirmed in their faith. The picture should not only produce a cerebral effect but should stir the emotions and induce a fervent piety in the beholder. What Rubens presents is not a detached record of a past event but one happening now with all the attendant immediacy. Undoubtedly influenced by his understanding of Caravaggio's art, Rubens achieves a very vivid realisation of the event by a clear definition of the role of each participant in the story. (The individuality of each figure is emphasised by the use of juxtaposed local colours, which was a feature of Rubens' painting at this period.) The physical struggle is expressed by the men raising the cross whereas the appropriate emotional response is conveyed by the women on the left. Apart from the Virgin, none of the women is essential from a liturgical point of view, and drawn from the ranks of the three ages of mankind they perform as a Greek chorus commenting on the event in a way which would have induced immediate empathy in the contemporary beholder.

Rubens, above all in the finished work, was intent on producing a spiritual response, and in the upper part of the triptych the varied emotions so movingly identifiable in the faces of Christ, the Virgin and St John are in marked distinction to the expanse of outward energy below. In conformity with Counter Reformation doctrine, the Virgin no longer swoons as she had in Rubens' earlier version of the subject, but stands bearing her grief with stoic calm. The contained but visible inward anguish on Christ's face is in eloquent contrast to his tortured body, blue from bruises and lack of circulation, and stained with blood running down his arms. To the priest celebrating the mass below, holding up the symbolic body of Christ at the moment of consecration, this spiritual identification would have been most fully realised. And as he raised his eyes upwards he would have recognised traditional Flemish symbols in the entwined mass of foliage behind the top of the cross; oak, from which Christ's cross was traditionally made, the Tree of the New Faith and a symbol of endurance; fern, a symbol of humility; the vine with its eucharistic connotations; and the thorny rose, the symbol of martyrdom. At the very bottom of the panel, the incongruous appearance of a large spaniel so positively involved in the proceedings may well be read as a symbol of fidelity. In this great work Rubens moves through the full range of pictorial expression, revealing his ambition to succeed in the first major altarpiece carried out for his native city.

In the same year in which Rubens probably finished the *Raising of the Cross*, the Guild of Arquebusiers approached him with a commission for an altarpiece in their chapel in the cathedral. Illustrating another event from Christ's Passion, he produced a quieter more inward reading, which represents a considerable contrast with his earlier picture, made the more apparent today when the two works hang so close to one another. The central panel devoted to the *Descent from the Cross* (Plate 108) requires intense contemplation from the spectator, who is no longer subject to an assault on his senses by the overpowering struggle taking place before him. Although the eye is led into the picture by the figures of Mary Magdalen and Mary Cleophas in the lower left, the event itself is largely contained not only within the pictorial space but within a closely organised group of interlocking figures in the centre of the panel. A strong side light increases the sculptural sense of the group represented before the largely neutral background of clouds and sunset, in accordance with the time of day recorded by the Gospels. The Virgin, usually swooning in the middle of a separate group, here participates in the central action. Once again the keenest expression of grief comes from the women, whether from the anguished face of the Virgin drained of colour or the more worldly and touching sorrow of Mary Cleophas whose intensity of feeling almost induces a smile. The men go about their task with an air of solemnity and suppressed emotion set into relief by the inert expression on the face of the dead Christ. So

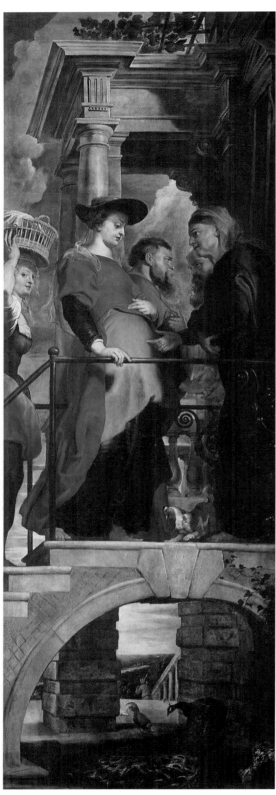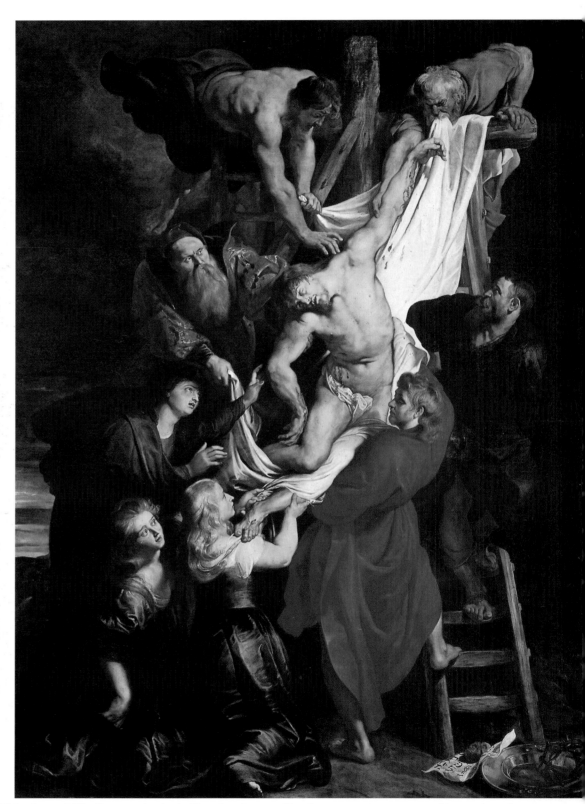

108. *The Descent from the Cross*, with side panels *The Visitation* and *The Presentation in the Temple*, 1611–14. Panel, centre 420 × 310 cm, side panels each 420 × 150 cm. Cathedral, Antwerp.

109. *St Christopher and the Hermit*, c.1612–13. Panel, 76.9 × 68 cm. Alte Pinakothek, Munich.

110. *The Descent from the Cross*, c.1601–2. Pen and ink with brown wash over black chalk, 43.7 × 38 cm. Hermitage, Leningrad.

111. *Two Studies for St Christopher*, c.1611–13. Pen and brown ink, 26.7 × 16.7 cm. British Museum, London.

harmonious is the pattern of the figures, that it requires a deliberate effort to read the picture figure by figure.

The composition was undoubtedly developed from a drawing (Plate 110), probably made during Rubens' early years in Italy, which, as has been mentioned, represented a free variation on an altarpiece by Lodovico Cigoli. The grouping of the figures of Christ carried by St John and supported by Joseph of Arimathea, as well as those of Mary Magdalen and Mary Cleophas, is common to both Rubens' drawing and his painting. In the former the Virgin, in a swoon, is placed apart in the traditional manner. Her more active role here accords with contemporary Catholic devotion to her cause, which was particularly strong in Antwerp. In the painting the additional man leaning over the bar of the cross was already adumbrated in Rubens' note on the drawing, in which he mentions Daniele da Volterra's famous picture in SS. Trinità dei Monti. Strong echoes of the *Laocoon* group (Plate 25) occur in the figures of Christ and Nicodemus, whose poses recall the father and the eldest son, but unlike the Christ of the earlier altarpiece the influence is one of form rather than expression. For Christ's face, Rubens may well have turned to the fragment of the fallen giant from the Pergamon altar which was soon to belong to the Earl of Arundel. For all the realism of the corpse, the idealised beauty of Christ's body is a perfect expression of the artist's understanding of classical form. But continuing the trend seen in the *Raising of the Cross*, the individual borrowings are digested and expressed in an entirely personal manner. And for all its Southern spiritual heritage, the iconography, apart from the role of the Virgin, follows the traditional Flemish pattern going back to the fifteenth century.

Instead of continuing the space throughout the three panels, the *Visitation* and the *Presentation in the Temple*, which occupy the wings, are set in their own circumscribed space and provide a pictorial buttress to the central scene. (The

classical architecture of columns and coffering offers a didactic contrast to the medieval structure of the cathedral). But by repeating in each of the three panels the diagonal pattern and the clear, local colours, which have become a richer and more dominant feature of Rubens' painting, the artist has taken pains to create a discernible unity. St Christopher, the patron saint of the guild, was relegated to the outside of the altarpiece where across both wings he is seen bearing the Christ-Child, lit up by the lantern held by the hermit (see Plate 109). The pose of this vast figure, whose nakedness upset the sensibilities of the cathedral authorities, is an unmistakable reflection of the *Farnese Hercules*, that essential classical prototype for an image of strength, which Rubens had studied in Rome (Plate 52). Moreover the relationship between the diminutive Child and the giant was developed from two studies on a sheet (Plate 111), which are freely based on a painting by Adam Elsheimer (Plate 112). But if the patron saint is banished to the exterior, the etymology of his name, Christ-bearer, provides the underlying theme of the three main panels, Visitation, Presentation and Deposition, thereby attaining a rare iconographical unity throughout the entire altarpiece. Once again Flemish symbolism abounds; ivy, fern and vine grow, while the salamander, which appears beside St Christopher's club, can be read as a symbol of strength against the devil over whom Christ was to triumph. The whole work is rich in incident, meaning and human emotion.

112. Detail from Adam Elsheimer, *St Christopher*. Copper, 22.5 × 17.5 cm. Hermitage, Leningrad.

This work came as a direct result of the pressure exerted by the cathedral authorities on the guild to replace their existing altarpiece with something worthier, following their movement to redecorate and adorn the building. In September 1611 the commission was given to Rubens, who shortly before had bought the property adjoining the guild's headquarters, and exactly twelve months later the central panel was moved from his studio in his father-in-law's house in the Kloosterstraat and installed in the cathedral. For some unexplained reason the wings were completed only early in 1614, but the iconography suggests that they must have been part of the original conception. In the following year Rubens' wife received the customary gift of a pair of gloves from the patrons, but the artist himself had to wait another six years before receiving full payment. This would have come as no surprise, since the guild's reluctance to act in the first place was due to lack of money.

At the original meeting with Rubens in 1611, the guild account book specifically records the presence of their president, Nicolaas Rockox, whose importance in this commission is acknowledged by the inclusion of his portrait among the faithful in the *Presentation in the Temple*. Like Van der Geest, Rockox was, as an alderman and burgomaster on several occasions, a man of influence in city life, and at the same time a good friend of Rubens, who later described him as 'an honest man and a connoisseur of antiquities . . . he is rich and without children, a good administrator, and all in all a gentleman of the most blameless reputation'.[83] As was natural, their friendship brought Rubens both public and private commissions. Apart from his role in commissioning the altarpiece for the Arquebusiers, Rockox may already as head of the city administration in 1609 have been involved in the commissioning of the *Adoration of the Magi* (Madrid) for the town hall just after Rubens' return, while at the same time ordering a *Samson and Delilah* for his own house. Several years later he commissioned an altarpiece for his tomb in the church of the Recollects, and in 1620 for the high altar of the same church he was responsible for commissioning the *Coup de Lance* (Madrid), as well as other altarpieces there.

The painting of *Samson and Delilah* (Plate 113) must, judging from its style, have been one of the first commissions carried out after Rubens' return to Antwerp. Recognising the importance of the occasion, he made a compositional drawing as well as a painted *modello*, which reveal how he introduced at each stage carefully thought out modifications of detail. As can be seen in the partly fanciful view of the great saloon of Rockox's house, filled with his collection of paintings and antique sculpture (Plate 115), Rubens' picture was intended to hang in the

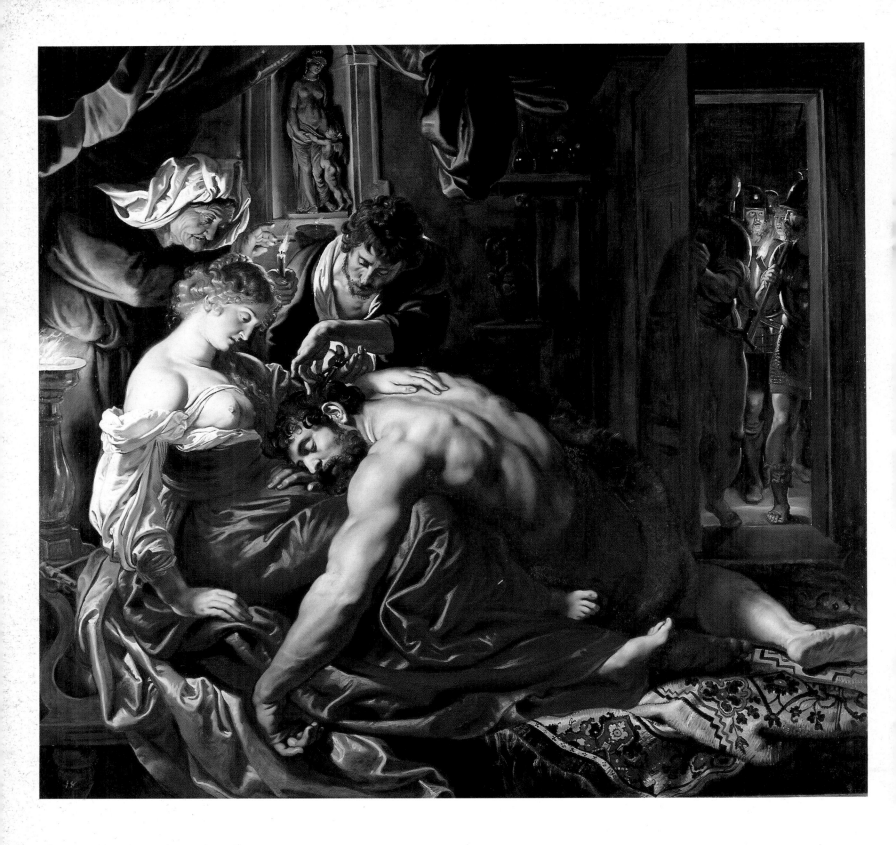

113. *Samson and Delilah*, c.1609. Panel, 185 × 205 cm. National Gallery, London.

114. (facing page) Detail of Plate 113.

place of honour over the fireplace, where it would be admired by the patron's influential friends and visitors.

The story of Samson and Delilah, with its basic ingredients of male strength pitted against the wiles of female beauty, was popular in the seventeenth century, and in this painting Rubens gloriously realised the full implications of the situation. The vast muscular figure of Samson, with echoes of both Michelangelo and the antique, is lost in post-coital slumber on the lap of the refulgent and seductive Delilah, whose luscious breasts are deliberately revealed between the opening of her chemise. Her pose is an echo of Michelanglo's figure of Leda in his lost painting of *Leda and the Swan*. As she leaves the act of cutting of Samson's hair to a barber, Delilah expresses an absorbed fascination with her victim; she is a triumphant but not unaffectionate victrix. The statue of Venus with a blindfold Cupid, placed in the niche above, underlines the moral of the story. The presence of the old woman who plays the role of procuress in a brothel indicates that Rubens

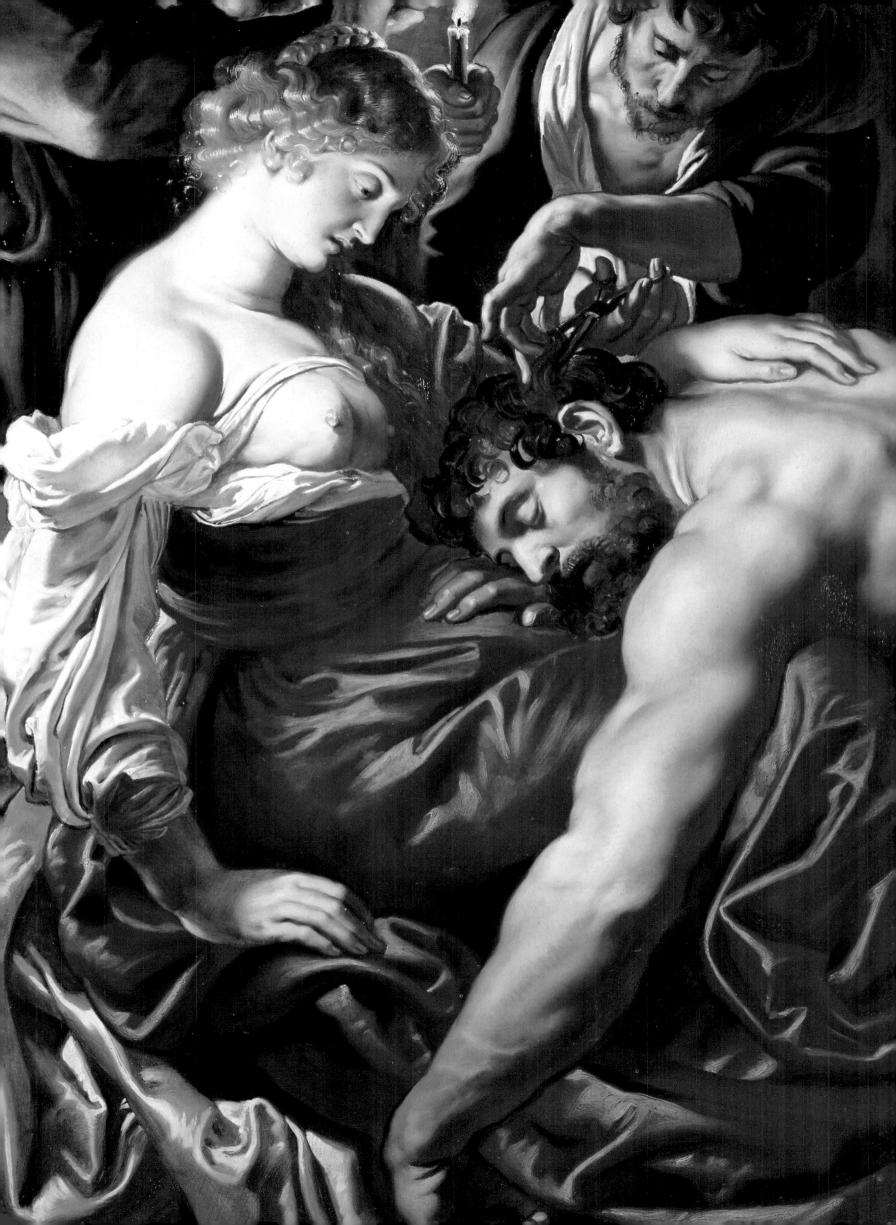

115. Frans Francken the Younger, *The Interior of Nicolaas Rockox's House*. Panel, 62.3 × 96.5 cm. Schloss Schleissheim, Munich.

followed the account given by Flavius Josephus in which Delilah is portrayed unmistakably as a whore.

Although enlarged to a much grander scale, Rubens' evocative dark interior broken by patches of strong light may well be a tribute to the art of Adam Elsheimer in a work such as the *Judith and Holofernes* (Plate 90) in Rubens' collection. The principal source of light falls on the central figures casting a pattern of light and shadow over the walls, while the candle held by the approaching Philistine soldiers in the doorway serves to increase the depth of the picture at the same time that it reveals another incident in the story. But, although a study in chiaroscuro, the picture has much richer colouring than is found in other contemporary works by Rubens. Applied with a masterly free handling of the brush, the brilliant red and gold of Delilah's garments combined with the richly patterned rug covering the bed create a glow of colour in the foreground, which is framed by the dark purple curtains suspended from above. The curtains suggest the intimacy of the boudoir and contribute to the pervading atmosphere of eroticism which provides the moral of the story.

In another commission of a very different character, Rockox ordered a devotional triptych (Plates 117–19) which was to be placed over the tomb of his wife and himself in the church of the Recollects. The date of 1613 altered to 1615 inscribed on the left-hand panel probably indicates the time spent on completing the work, which was presumably ordered after the delivery of the central panel of the Arquebusiers altarpiece. It represents a type of commemorative altarpiece, which Rubens was called upon to execute for a number of patrons during the first decade of his return from Italy. The triptych form, with donors in the wings, is probably to be seen as a deliberate revival of an earlier type, one, moreover, which would match the medieval building in which it was to hang. It represents a perfect example of his epitaph altarpiece, so much in demand from his contemporaries in Antwerp.

Although usually identified as the *Incredulity of St Thomas*, the central panel is more likely to be an illustration of the related theme of *Christum videre*, in which the appearance of the risen Christ is here witnessed by three disciples, two older, probably Peter and Paul, and one younger, probably Thomas, who wears the traditional green costume. Two of the men study the nail hole in Christ's left hand while the third looks up at his face. The theme of believing without seeing, associated with the story of St Thomas, was eminently suitable for an epitaph altarpiece, in which the donors are presented as unquestioning believers. The

main scene takes place against a plain dark grey ground. To emphasise the different realities Rockox and his wife (Plates 118–19) are projected before an archway in the real world recalling in a plainer form the architectural backgrounds of Rubens' Genoese portraits.

Although cast within a medieval form, the portraits themselves are as vividly individual as any Rubens was to paint during these years. The omission of patron saints who would normally present them to the deity not only underlines the meaning of the work but enhances their realism. In a rare unfinished but brilliant oil-sketch (Plate 116) the artist had studied Rockox, with what is probably a handkerchief in his hand, and this likeness would have served for his appearance in the *Presentation in the Temple* as well as in the triptych. Indicative of his office of burgomaster, he is portrayed sombrely dressed in black with brown fur stole and millstone ruff in the triptych. One hand reverently placed on his breast and the other holding a book, he turns towards the central event in a manner suggestive of an everyday act of spiritual contemplation rather than as a participant in the imaginary world of medieval saintly devotions. Also dressed in black with a ruff, but framed above by a crimson curtain, Adriana Perez looks out intently at the spectator as she goes through the motions of reciting her rosary. Emerging from exquisitely painted lace cuffs, her hands loosely hold the coral beads, whose colour echoes that of the binding of her husband's book, and provide a secondary centre

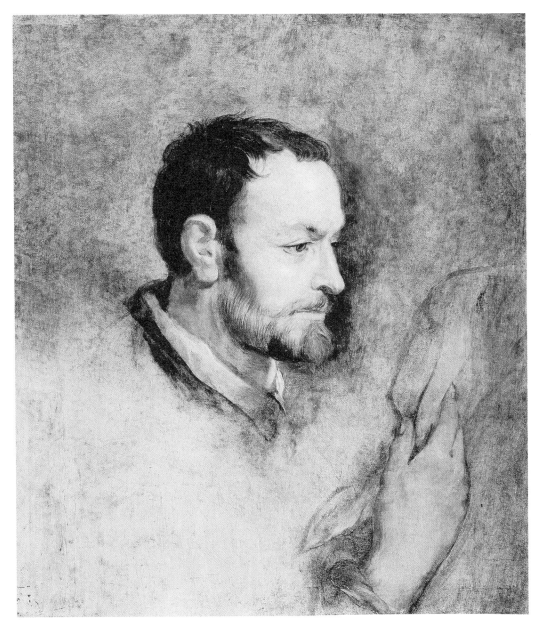

116. *Nicolaas Rockox*, c.1613. Panel, 65 × 56 cm. Private collection, England.

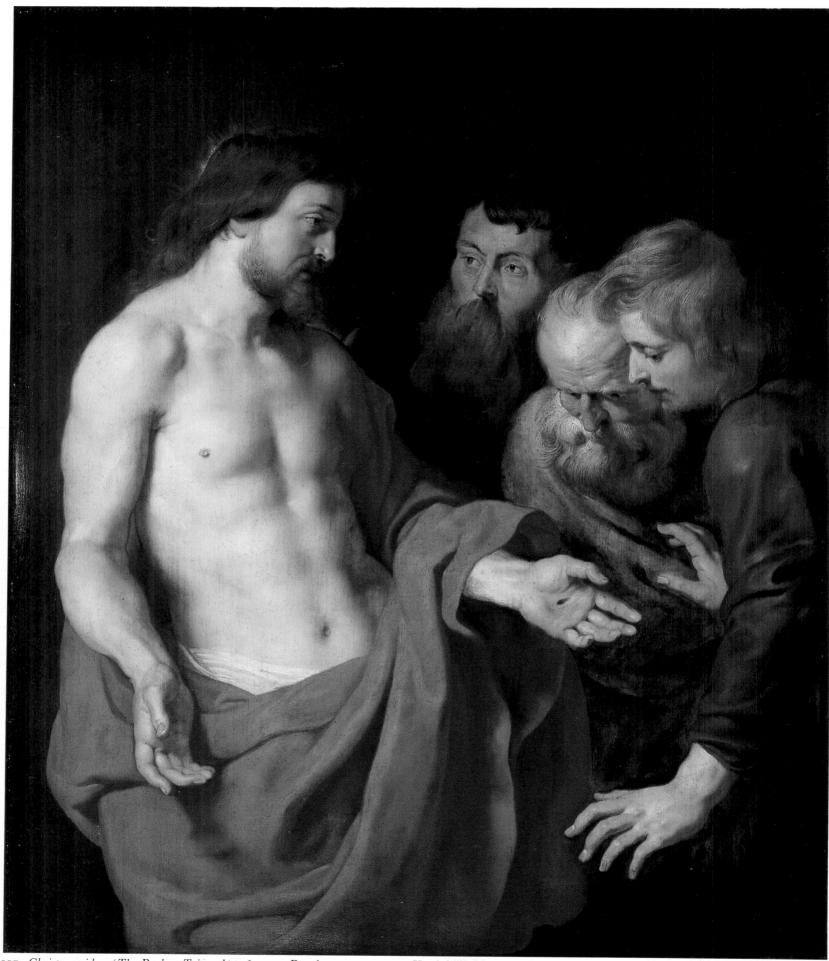

117. *Christum videre (The Rockox Triptych)*, 1613–15. Panel, 234 × 145 cm. Koninklijk Museum voor Schone Kunsten, Antwerp.

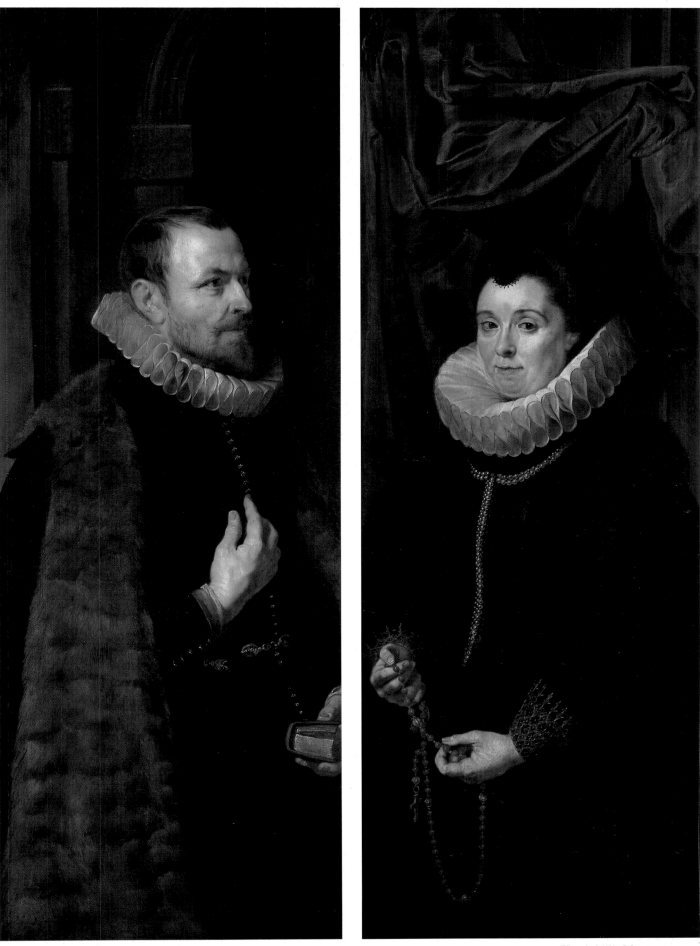

118–19. *Nicolaas Rockox* and *Adriana Perez (The Rockox Triptych)*, 1613–15. Panels, each 145 × 56 cm. Koninklijk Museum voor Schone Kunsten, Antwerp.

of interest in the lower part of the elongated wing. Throughout the two panels the brushwork has a freedom and spontaneity which greatly enlivens the presentation of the donors.

By contrast the central panel is much lighter and cooler in tone. The dominant red of Christ's cloak is juxtaposed with the green and greyish-blue of the disciples' robes. The combination of areas of unbroken colour in a limited range with full modelling within tight outlines suggestive of a deeply sculpted relief of figures in static poses partakes of the character of works of the middle of the decade.

Rubens' reputation as a painter of altarpieces was spreading rapidly outside Antwerp and he was receiving commissions from a number of institutions in the southern Netherlands as well as from further afield. Founded in 1612 with the generous support of the archduke and archduchess and various members of the nobility, the church of the Discalced Carmelites in Brussels was consecrated in the presence of the benefactors two years later. Either then or more likely shortly afterwards an *Assumption* (Plate 120) for the high altar was delivered by Rubens. With the current emphasis placed on the glorification of the Virgin, the *Assumption* was understandably a much favoured theme which Rubens was called upon to paint on a number of occasions. It was perhaps the most contentious aspect of Mariolatry and therefore acted as a potent propaganda weapon against the Protestants.

By the time Rubens painted the picture for Brussels he had already treated the subject in two oil-sketches (Leningrad and Royal Collection) intended for the cathedral in Antwerp, as well as in one of the designs for the Roman Breviary (Plate 161). Although there was no question of exact repetition in these various representations, there are few formal or iconographic differences between them. Titian's famous rendering of the theme on the high altar of the Frari in Venice provided the obvious starting point for Rubens, even if he also turned his eyes elsewhere. Rubens followed the basic arrangement of Titian's picture, in which the figure of the Virgin soars upwards in the middle of the canvas while the assembled group of apostles are represented below in dramatic silhouette. But whereas God the Father appeared at the top of Titian's canvas he is represented in the church in Brussels as a sculpted image outside the area of the picture, reflecting Rubens' taste for expanding the area of action of his works beyond the limits of the frame. In another variation from Titian, Rubens included the three holy women at the tomb, who, unlike the apostles seen from behind, face the spectator. Once again the female figures become the major vehicle for expressing the appropriate emotional response to the subject.

The relative poverty of the order may account for the fact that the picture was clearly executed with considerable participation of assistants. But if the details lack the master's fluid touch, the colour has, in common with other works of this period, become much brighter and more varied, as can be seen in the richly coloured clothes of the apostles and holy women. But the spectator is above all moved by the range of brilliant blues which, echoed in several figures below, convey the shimmering appearance of the Virgin on clouds, backed by the golden rays against the sky. Already one is aware of the artist's gradual use of a much subtler range of colour.

Probably as the result of a visit to Antwerp in 1615 by Count Wolfgang-Wilhelm, Duke of Neuberg, a Catholic convert whose fervour did much to propagate the spirit of the Counter Reformation in southern Germany, Rubens was commissioned to paint a *Last Judgement* (Plate 121) for the high altar of the Jesuit church in Neuberg on the Danube, which also served as the court chapel. It was recorded as being on show in 1617, and was followed shortly afterwards by two altarpieces for the side altars. Either the duke or the Jesuits were responsible for choosing a subject much favoured in previous centuries, but very rarely in the seventeenth century. Reflecting the new tenets of the Counter Reformation, which had taken account of Luther's abhorrence of the fear inherent in man's traditional attitude to judgement, the theme had been transformed into one of

120. *The Assumption of the Virgin*, c.1615–16. Canvas, 490 × 330 cm. Musées Royaux des Beaux-Arts, Brussels.

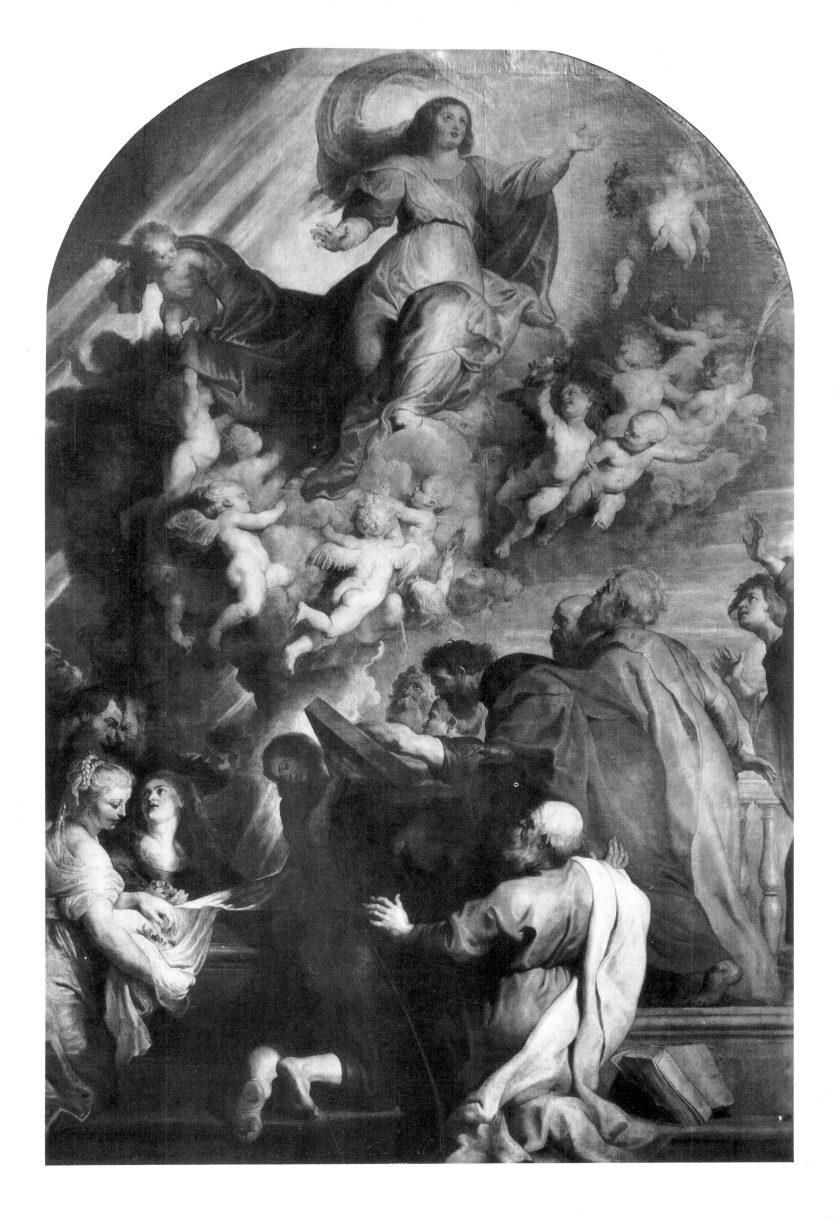

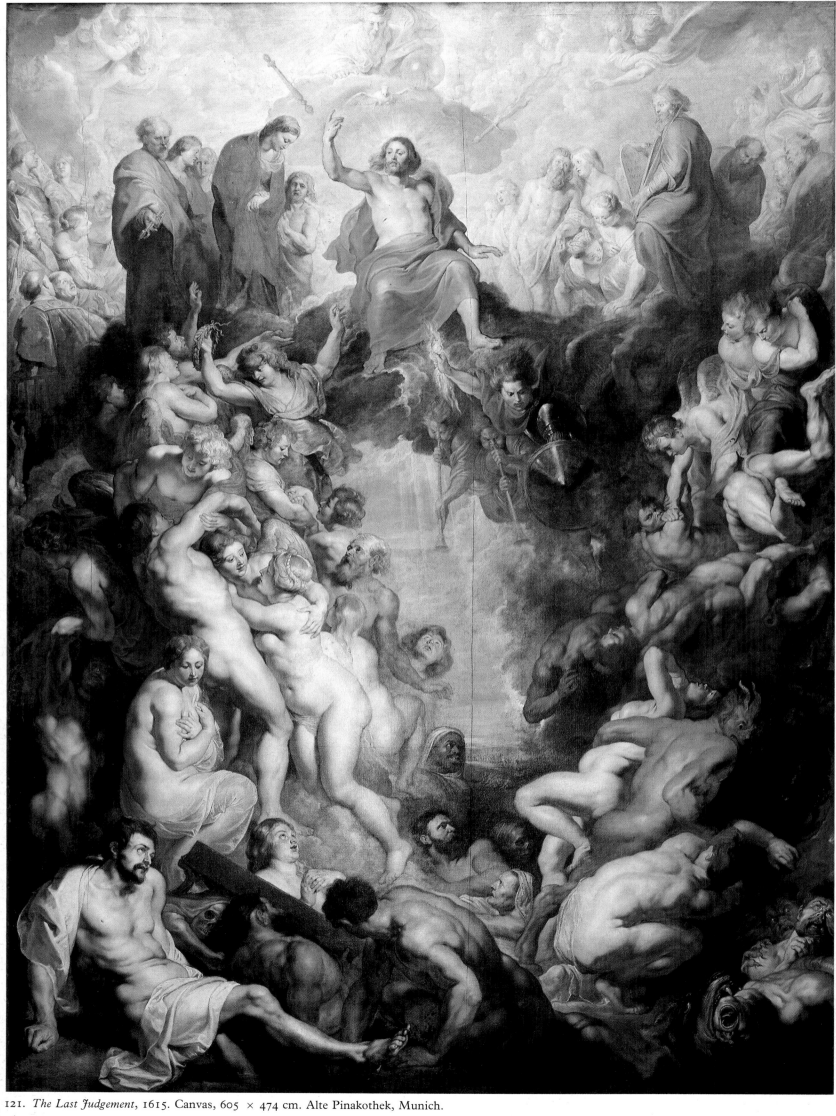

121. *The Last Judgement*, 1615. Canvas, 605 × 474 cm. Alte Pinakothek, Munich.

122. (facing page) Detail of Plate 121.

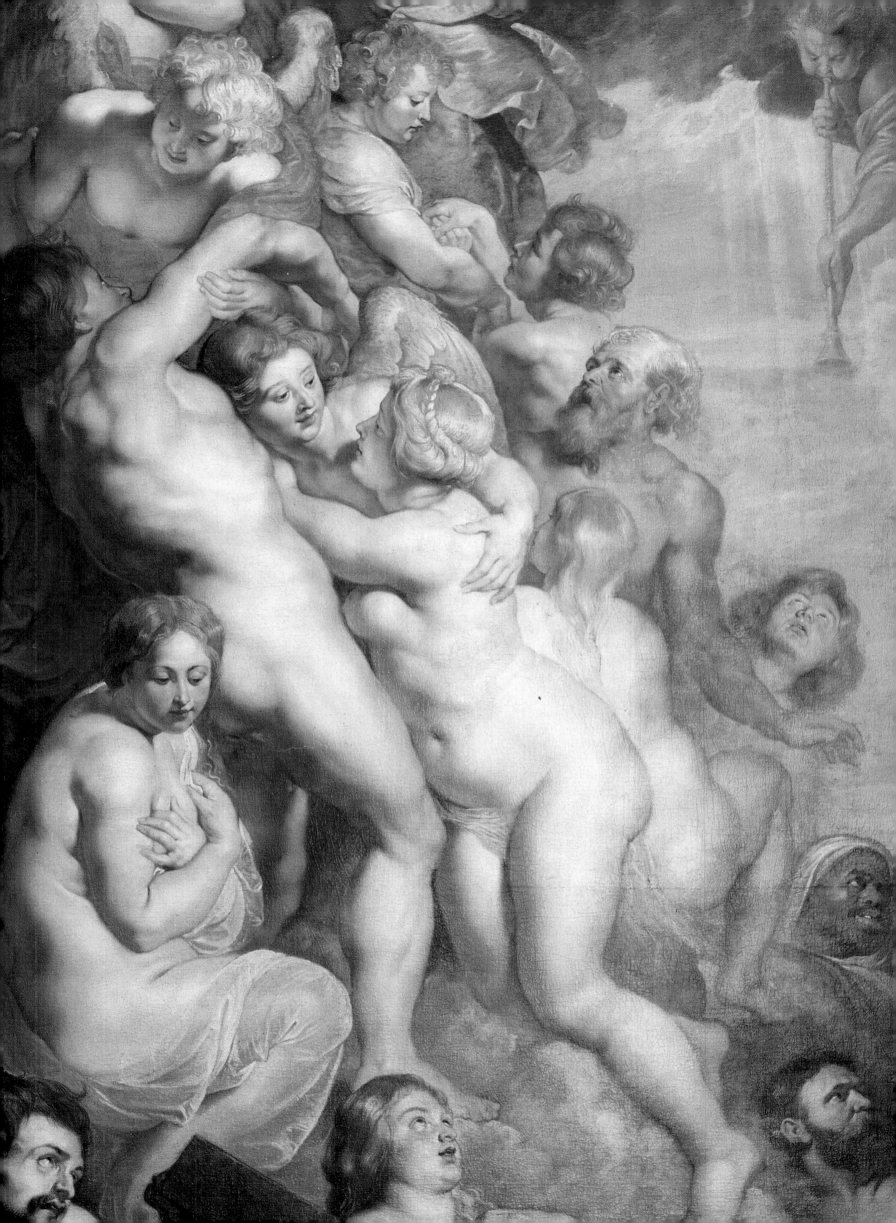

123. Detail from Michelangelo, *The Last Judgement*. Fresco. The Sistine Chapel, Rome.

humanity and optimism. Rubens' Christ partakes of none of the *terribilità* of Michelangelo's figure on the wall of the Sistine Chapel (Plate 123).

Perhaps in no other religious work since the early *Baptism* (Plate 47) does the nude, as the subject requires, play so dominant a role. Although there are strategically placed accents of strong colour, the rich variety of sculpturally conceived flesh provides the dominant effect. Each figure, imagined in the round, with expression and gesture carefully realised, is at the same time skilfully related to the whole figural group. (It would have come as no surprise to learn that Rubens had followed Tintoretto's practice of making preliminary plaster models.) Besides in such details as the two trumpeters below Christ, Rubens followed Michelangelo's arrangement in the ascent of the blessed on the left and the fall of the damned on the right. But within his much narrower format Rubens divides his figures into two great columns with the emphasis, by virtue of the lighting, placed on the blessed ascending. Overall, each participant is subsumed into the vast circle of figures, brilliantly organised over the surface of the canvas and leading inexorably to the relatively small figure of Christ, whose act of approval to the blessed is far more apparent than his gesture of rejection. The multi-figured composition may also reflect the artist's awareness of such a work as the central part of the Frankfurt altarpiece devoted to the *Exaltation of the Cross* by Elsheimer. Apart from producing a careful balance of form and colour, Rubens unites the surface with a pervading atmosphere only realisable by the master. Although he clearly employed assistants, his own contribution remains paramount, so that a division of different hands is not possible. If challenged he could justifiably have replied that the final result was essentially 'an original by my hand'.

By this time the Jesuits in Antwerp were beginning to claim more of Rubens' time in connection with their new church, in the decoration of which the artist was to play a major role. The foundation stone was laid in 1615, and shortly afterwards he must have received the commission for two very large altarpieces, of *St Ignatius* (Plate 126) and *St Francis Xavier* (Vienna), both performing various miracles credited to their names. The two pictures were designed to be displayed alternately on the high altar. By 1617 they were either finished or very nearly finished, since the artist is recorded as being in credit to the order for the entire sum agreed for payment. What is highly unusual about these two works is that the two men who are the subjects of the pictures were only canonised in 1622, a year after the consecration of the church, and at the time of the commission for the alterpieces only Ignatius had been beatified. The pictures were therefore intended as propaganda on behalf of their subjects who were portrayed as Jesuit heroes performing the miracles – Rubens himself refers to them as 'exploits' – which would serve to promote their case for canonisation. It was unprecedented to represent them on pictures destined for the high altar in anticipation of their eventual canonisation.

Whether Rubens was responsible or not for selecting the incidents shown in the pictures, he was already familiar with the life of St Ignatius, the founder of the order, from his illustrations for the *Vita Ignatii*, published in 1609. Both altarpieces combine miracles performed at different times in different places. Set in a church resembling St Peter's in Rome, where in 1538 Ignatius had sought papal permission for founding the order, he stands on the altar accompanied by nine other Jesuits, including Francis Xavier on his right. Arranged below are a number of people who were either saved or cured by Ignatius. Although their various actions clearly identify them, they are for pictorial purposes conceived as a harmonious group. (Such a representation must have met with general Jesuit approval, since in 1620 Rubens dispatched a variant to the chuch of S. Ambrogio in Genoa, for which he had already painted a *Circumcision* when he was in Italy.)

As usual Rubens prepared a *modello* (Plate 127) to submit for approval. (In this instance both *modelli* were handed over to the church where they were displayed on a pillar flanking the choir.) In establishing his composition he may well have

recalled Giovanni Balducci's fresco of the rare subject of the *Investiture of Carloman*, painted in S. Giovanni dei Fiorentini in Rome shortly before Rubens' arrival in Italy. But, indebted to no one artist, Rubens followed the usual procedure by taking various elements from other artists as well as from his own work. Whereas the strongly foreshortened man, lying flat on his back, recalls the dead slave in Tintoretto's *Miracle of St Mark* (Plate 124), the crouching man on the left beside him repeats, in reverse, a similar figure found in the bottom centre of the *Last Judgement* (Plate 121), on which Rubens was working almost contemporaneously.

Rubens introduced a few minor changes between *modello* and final canvas. Apart from modifying some of the detail of the architecture as well as the foreshortening, his alterations were directed towards simplifying the action so as to enable a clearer reading of the picture. In realising the role of each participant he may well have prepared such drawings as the study after the head of *Seneca* (Plate 128), which served for the head of the man seen above the woman possessed by a devil on the left. But where a difference occurs between the two works is in the artist's use of colour. By abandoning the more blended colour scheme of the *modello* in favour of strongly contrasting local colours, which emphasise the realism and individuality of each figure, Rubens lost some of the overall unity of his initial conception in the altarpiece. In this respect his sketch was more advanced than his final work.

On his immediate return from Italy Rubens had had little option but to comply with the local demand for the old-fashioned triptych set into a relatively simple frame, although by using sculpture in the St Walburga altarpiece, he did attempt to breathe new life into an old form. But taste was changing slowly in favour of a more monumental framework employing the forms of classical architecture, and Rubens was quick to develop his own ideas in this area. That soon after his return home his thoughts went beyond the execution of the canvas or panel is clear from his annoyance at the rejection of his *modelli* for the church of St Bavo in Ghent, on which, he later told the archduke, he had devoted 'considerable effort into drawing up the plan for the entire work, as much for the marble ornamentation as for the picture'.[84] Reflecting his concern for overall detail, he engaged in 1619 in considerable discussion with the Duke of Neuberg about the design for an altar frame and the effect which the addition of an outer half-pilaster would have on the proportions of his picture of the *Fall of the Rebel Angels* (Munich).

With his growing reputation at home Rubens was in a position to call the tune, and by the middle of the second decade he became increasingly responsible for designing his own altars, which had a noticeable effect on the altarpiece itself. From now on, except in special circumstances, he abandoned the triptych form, whose movable wings could not be satisfactorily incorporated within the portico frame he now favoured. The shape of the latter also led him to modify the proportions of his pictures, so that the height of his altarpieces increased in relation to the width, as can be seen by comparing the *Descent from the Cross* (Plate 108) with the altarpiece of *St Ignatius* (Plate 126).

Rubens' existing designs for the high altar of the Jesuit church established the type of portico altar ensemble that he was instrumental in popularising throughout the southern Netherlands. In a preliminary idea (Plate 129), the painting is framed by twisted double columns which support a broken pediment of elaborate design. The entire upper area is much enriched by sculpture; two angels reclining on the volutes hold up wreaths in the direction of the Virgin on the crescent moon at the top of the frame. The two angels were included in the executed design (Plate 130) with additional sculpted figures, such as the angel bearing a torch on the left of the pediment. The latter can be seen in Rubens' preparatory drawing for the sculptor (Plate 125), who is probably to be identified as Hans van Mildert. Pairs of columns with cabled fluting in brown marble, one set before the other, replace the twisted columns at the side, and at the same time further enrichment of the pediment and its decoration was carried out. In contrast

124. Tintoretto, *The Miracle of St Mark*. Canvas, 415.3 × 543.6 cm. Accademia, Venice.

126. (following pages left) *The Miracles of St Ignatius Loyola*, c.1617. Canvas, 535 × 395 cm. Kunsthistorisches Museum, Vienna.

127. (following pages right) *Sketch for the Miracles of St Ignatius*, c.1617. Panel, 104 × 72 cm. Kunsthistorisches Museum, Vienna.

125. *Study for a standing Angel*, c.1617. Pen and ink with grey-brown wash over black chalk, 16.2 × 7.8 cm. Kupferstichkabinett, Berlin.

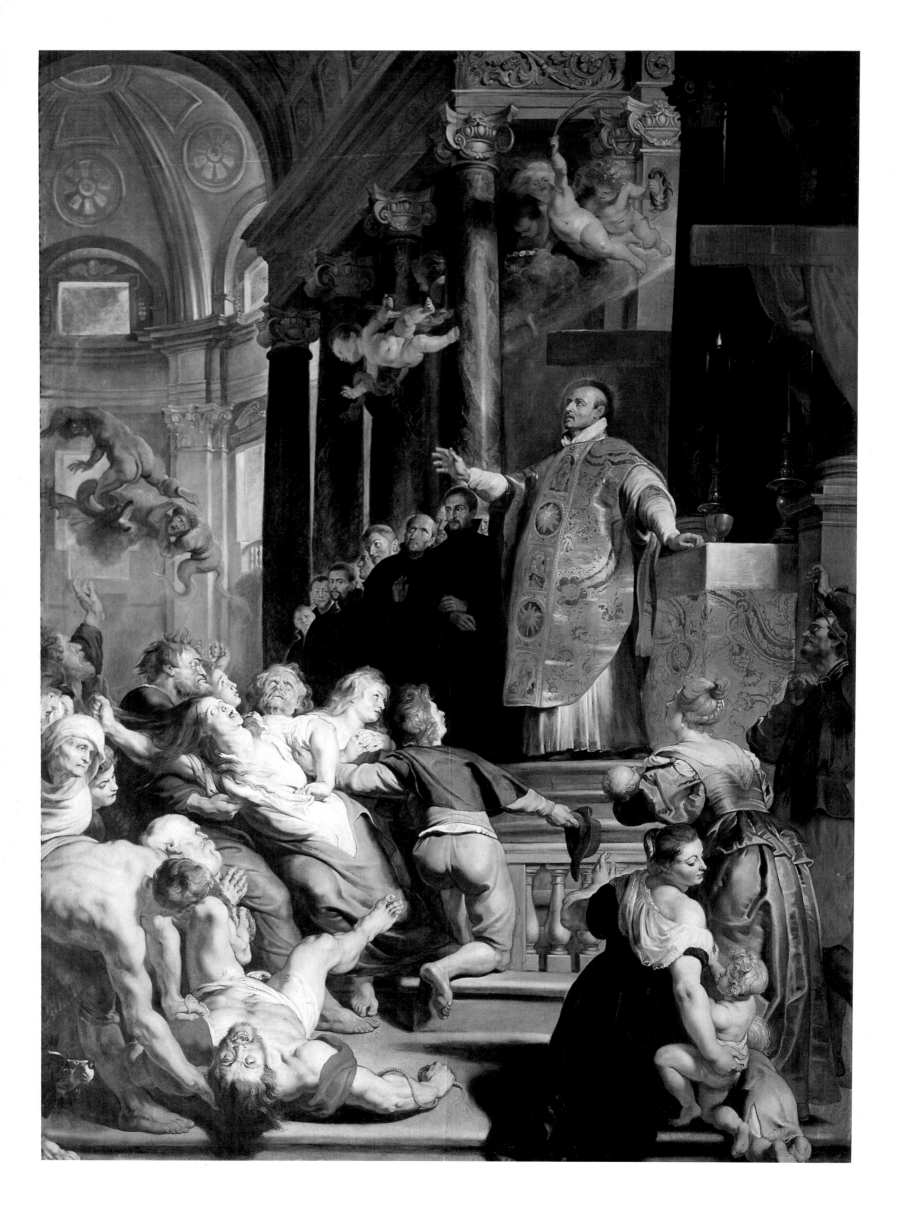

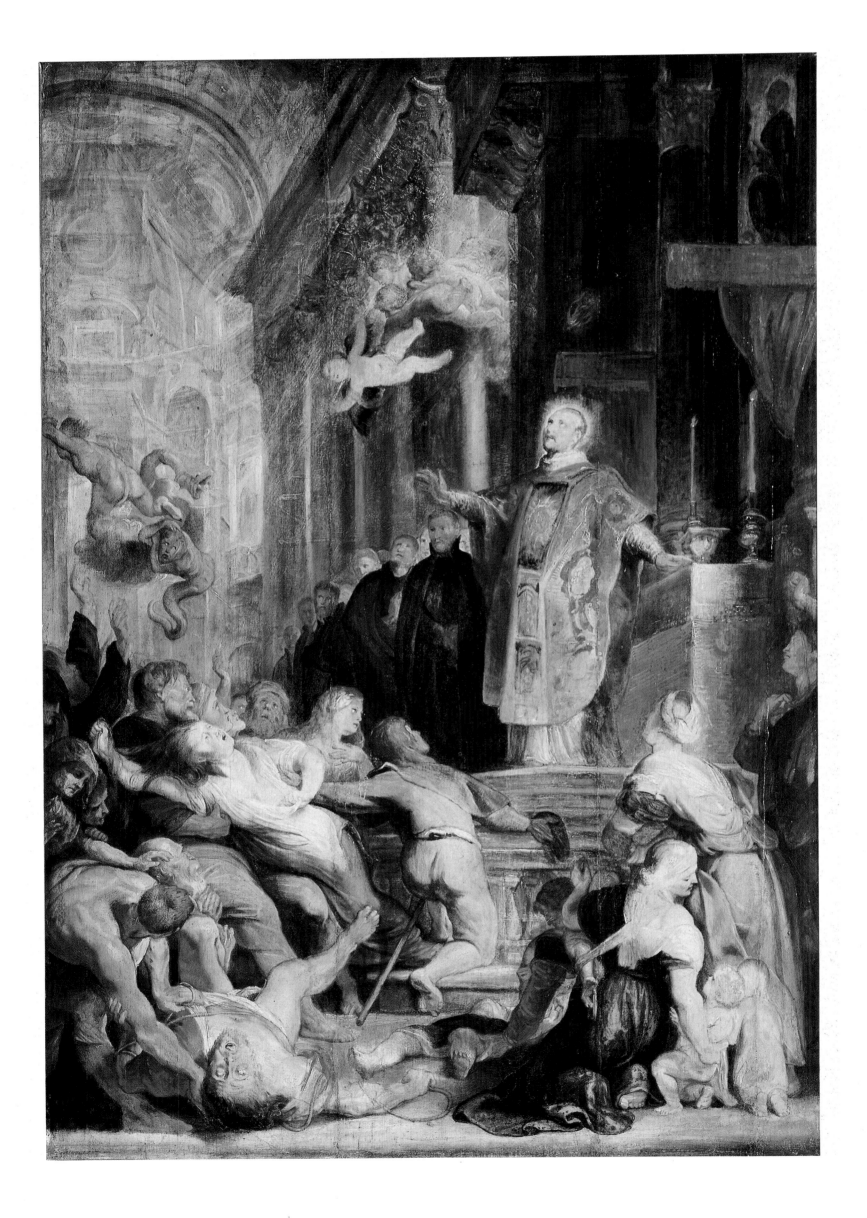

130. (facing page) The interior of the Jesuit church today.

to the medieval format of the St Walburga altarpiece (Plate 98), the framework was designed in the language of classical architecture which Rubens had studied in Italy. Following the example of his earlier work, sculpture and architecture form an integral part of the whole ensemble; he often used sculpture to enlarge the subject beyond the confines of the picture. Here the figures of the Virgin enthroned and Christ on her lap in the act of blessing connect not only the theme of the altar below but symbolically include the entire congregation within their action. Thereafter Rubens favoured a combination of black, white and coloured marble for columns and pilasters, often twisted or fluted, and for pediments, all variously composed, adorned with sculpture and architectural decoration. At this date what he was doing was in advance of what was happening in Italy.

Towards the end of the decade Rubens was increasingly occupied with commissions for large-scale altarpieces. To cope with this situation his studio learnt to become proficient in working from the master's designs in order to produce the highly professional result required by Rubens and his patrons. What these works lacked to a greater or lesser degree was the personal touch of the master himself. They were conceived as large-scale decorations for which the designation 'an original by my hand' was not a basic condition. The *Last Communion of St Francis of Assisi* (Plate 133) completed by 1619 for the Franciscan church in Antwerp might very well have been another example. It had been commissioned by the merchant Gaspar Charles for the altar dedicated to the titular saint beneath which was built his family vault. For this work Rubens was to receive only half what he was paid for each of the Jesuit altarpieces (which were somewhat larger in size). But for reasons not immediately apparent Rubens chose

128. *The Head of Seneca and other Studies*, c.1617. Black chalk, heightened with white, 32 × 22 cm. Hermitage, Leningrad.

129. *Study for the Altar Frame in the Jesuit Church*, c.1617. Pen and ink with brown wash over black chalk, 40.7 × 26 cm. Graphische Sammlung Albertina, Vienna.

133. (facing page) *The Last Communion of St Francis of Assisi*, 1619. Panel, 420 × 225 cm. Koninklijk Museum voor Schone Kunsten, Antwerp.

to paint the entire surface himself, so that in contrast to the highly polished works of these years we are presented with a panel of shimmering fluidity of execution in which the paint is so thinly applied that every brushstroke can be read. We are made to feel that sense of personal commitment with which in certain masterpieces Rubens both overwhelms and convinces the spectator that painting was not just a job of work but a personal act of faith.

In a representation in the church of S. Maria in Portiuncula near Assisi, St Francis, pointing to the wound in his side, is shown during his last hours. At his request he was stripped naked so as, in the words of St Bonaventura, to be 'in all things like unto Christ crucified'. Looking towards his companions he is reported to have said, 'I have done what was mine to do, may Christ teach you what is yours'. The brothers wept, 'stricken with keen pangs of pity'. Not recorded in the literary source but portrayed by Rubens is the administration of the *Viaticum* to the saint. The intensity of individual feeling, which this picture so movingly conveys, can be seen as an expression of the artist's own devoutness.

Rubens' preparatory drawings for this work are unusually informative about his intentions. A highly schematic study (Plate 131), done with rapid flowing open lines, establishes the central group. This was developed in an even more summary sketch (Plate 132), amplified with written notes, to encompass the entire composition, which now contains unmistakable echoes of another *Viaticum*, that of St Jerome represented in the paintings by Agostino Carracci and Domenichino. (The latter was painted after Rubens' departure from Italy, and one can only surmise that he knew such a famous picture from a copy.) At the bottom Rubens wrote, for some reason in Italian, the pictorial key to the picture: 'the whole group in shade and a strong sunlight entering through the window'. In the picture Rubens followed these instructions precisely, but added another source of light which illumines the saint's body in a golden glow against the penumbra surrounding his companions, an effect which is especially strong when the picture is viewed from a distance. The subtle play of light and shadow is greatly enhanced by the contrast between the sumptuous red curtains on the left and the low-key greys and browns on the right-hand side.

The emotion aroused by the saint's last moments on earth is eloquently portrayed in the individual expressions and poses. We sense it in the bent position of the elderly priest administering the sacrament, while the two torch-bearing acolytes unashamedly wipe tears from their cheeks. Each of the strongly characterised friars on the right of the picture reveals the strength of his feelings in his face; some in addition clench their fists or clasp their hands as if attempting to contain the pent-up emotion welling up within them. To realise these figures

131. *The Last Communion of St Francis of Assisi*, c.1619. Red chalk with some black lead, 29.3 × 23.7 cm. Private collection, England.

132. *The Last Communion of St Francis of Assisi*, c.1619. Pen and brown ink, 22.2 × 31 cm. Stedelijk Prentenkabinet, Antwerp.

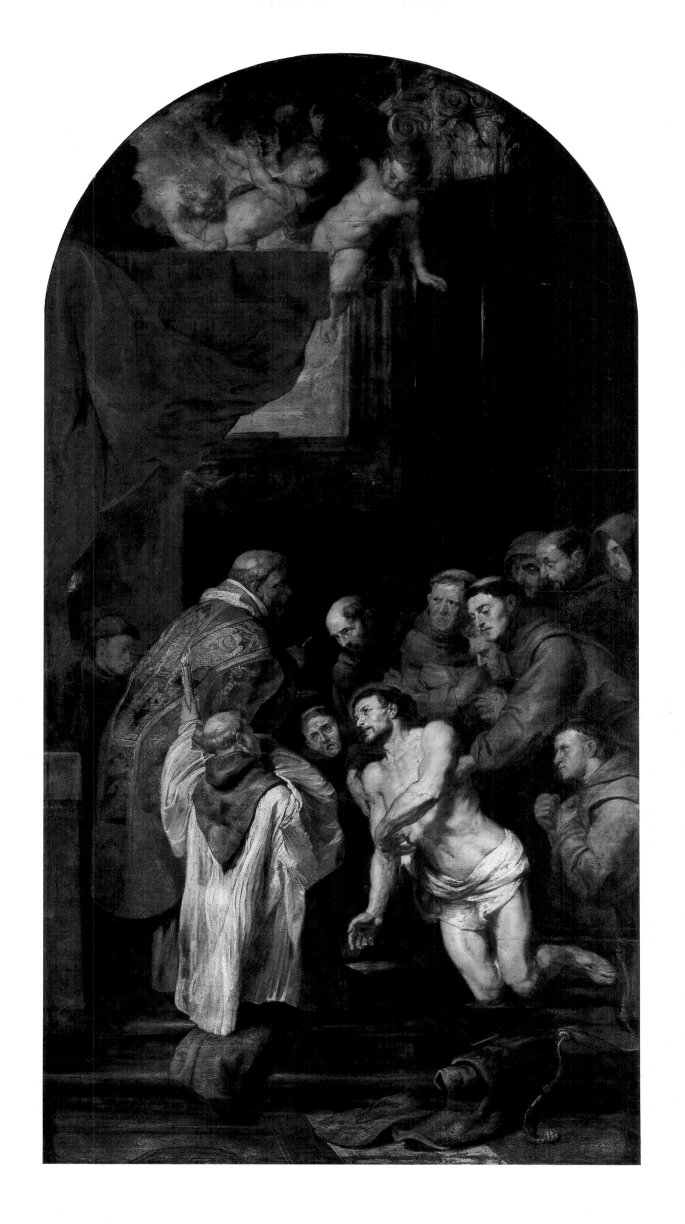

134. *Two Studies for a Franciscan Monk*, c.1619.
Black chalk with touches of red chalk, heightened
with white, 56 × 40.3 cm. The Devonshire
Collection, Chatsworth.

Rubens made at least two superb chalk drawings. On one sheet (Plate 134), using
the same model, he made two studies, for the young Franciscan who supports the
saint and for another brother seen in the top right. On another sheet (Plate 135) he
drew a kneeling male nude to establish the pose of the dying saint.

Rubens' services were also in demand from foreign patrons, and not only for
altarpieces. Hunting scenes, with lions, tigers, leopards, wolves, foxes and wild
boar, as well as one composition with a crocodile and a hippopotamus, appealed to
the taste of princely collectors who regarded them as magnificent decoration for
their palaces or houses. In the case of lion hunts, which proved to be the most
popular subject, Rubens evolved three basic compositions, which were repeated
in the studio. These met with varying degrees of success as far as English patrons
with their highly developed sense of the importance of originality were concerned.
Befitting their destination, all the hunting pictures were carried out on a grand
scale which clearly appealed to the artist's sense of his own capacity. Speaking of
the *Lion Hunt* 'with the figures life-sized' that he was painting for Lord Digby to

present to the Marquess of Hamilton, Rubens agreed with his correspondent, William Trumbull, that 'such things have more grace and vehemence in a large picture than a small one'. And in connection with the version promised for the Prince of Wales, Rubens wrote that 'I should be glad if this painting . . . were of larger proportions, because the large size of a picture gives one much more courage to express one's ideas clearly and realistically'.[85] It is the clarity and above all the realism that are the dominant characteristics of such works.

For Maximilian, Duke of Bavaria, one of his earliest patrons for this category of picture, Rubens painted a *Lion and Tiger Hunt* and a *Lion Hunt*, which were completed by 1617. Although at this stage lacking any tigers, the sketch of a *Lion Hunt* (Plate 136) is almost certainly a preliminary study for the former composition. The central incident of a lion attacking a mounted horseman (a motif, probably taken from the antique, which Rubens repeats in a summary

135. *A kneeling male Nude*, c.1619. Black chalk, 42.2 × 29 cm. Fondation Custodia, Paris.

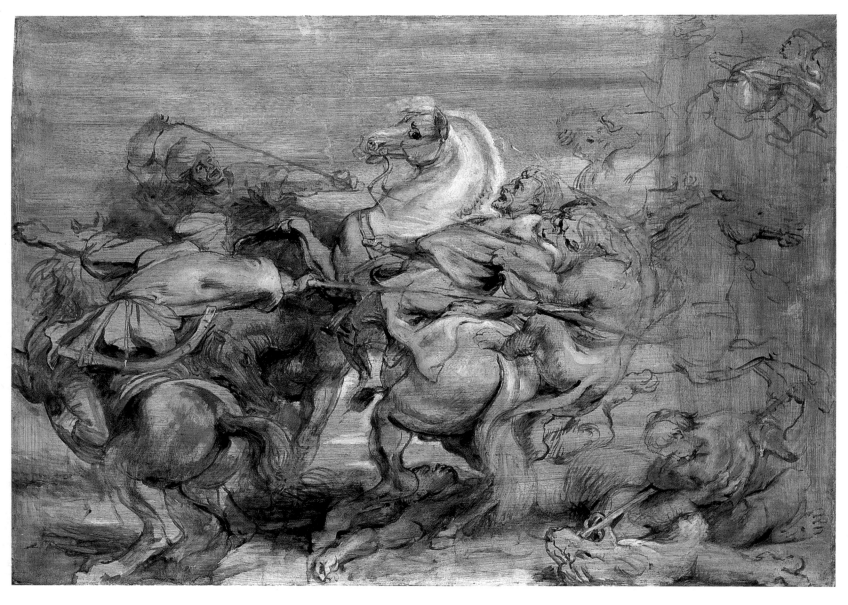

136. *Sketch for a Lion Hunt*, c.1615. Panel, 74 × 105.5 cm. National Gallery, London.

sketch at the top right of the panel) vividly conveys the elemental conflict between man and beast and the attendant dangers. While three other horsemen attempt to kill the lion, another of their number lies dead while a sixth succeeds in killing a lion lower right, to demonstrate that at this stage honours are even between man and beast. The maelstrom of men, horses and lions, whose arrangement clearly recalls Rubens' thoughts inspired by Leonardo's *Battle of Anghiari* (Plate 30), conveys the frenzy of battle in this masterly sketch drawn with the brush on panel. The artist proceeded in the final version to articulate figures and movement in order to heighten the sense of danger, which must have excited the imagination of his patrons as participants in such activities.

Commissions for decorations of a different kind were given by Genoese patrons who in 1616 ordered designs for a set of tapestries illustrating various events from the life of the Roman consul Decius Mus. In the contract only Franco Cattaneo, a businessman belonging to a leading Genoese family, is mentioned, but since two sets with slightly varying dimensions were required it is evident that a second patron was involved. The latter may be identified as Nicolo Pallavacini, a nobleman with whom Rubens stayed when he was in Genoa in 1607, and who became proxy godfather to the artist's second son, Nicolaas, in 1618.

This commission represents Rubens' first venture in making designs for tapestries, an activity which he repeated in several major commissions in future years. Although he threw himself into such work wholeheartedly, he made a fundamental distinction; as he wrote to Carleton, 'one evaluates pictures differently from tapestries. The latter are purchased by measure, while the former are valued according to their excellence, their subject and number of figures'.[86] By this time tapestry weaving, a slow and expensive process, was well established in Flanders and it is hardly surprising that Rubens should become involved, all the

more so since his maternal grandfather was a tapestry manufacturer. (His links were to become closer in 1630 when Daniel Fourment, a dealer in tapestries, became his second father-in-law.) By 1618 Rubens was already claiming, presumably on the basis of his experience with the Genoese commission, that 'I have had great experience with the tapestry-makers of Brussels, through the many commissions which come to me from Italy and elsewhere for similar works'. For the *Decius Mus* series Rubens produced eight large cartoons on canvas. (The compositions were reversed, to allow for the fact that the weavers worked from the back.) What is most unusual about these works, which distinguishes them from future tapestry commissions undertaken by Rubens, is that they are virtually paintings in their own right rather than the customary cartoons on paper prepared by assistants from the master's *modelli*. Although seventeenth-century sources invariably refer to their execution as the responsibility of Van Dyck, who was working with Rubens at this time, Rubens specifically in the same letter quoted above says that 'I myself have made some very handsome cartoons at the request of certain Genoese gentlemen'.[87] Taking this statement in conjunction with the very high quality of execution in bold, open brushstrokes, makes it seem likely that Rubens, albeit depending on some studio participation, was doing no more than telling the truth.

Although there is no evidence, it may well be that the subject, which would have appealed to Rubens on two different counts, was chosen by him. The Roman background of the hero allowed him to realise in imaginative form the studies of Roman life he had undertaken so assiduously with his brother in Rome. It was the first time that he had the opportunity to treat on a grand scale a subject taken from Roman history, and, despite a few anachronisms, it is remarkable that in this work he was archaeologically more accurate in rendering the details than in any other representation of Roman history.

But the subject would have had another attraction for Rubens. Decius Mus, who willingly submitted to the will of the gods by sacrificing his own life to obtain victory for his legions, was a perfect example of a Stoic hero, moved by religious belief and trust in the wisdom of the gods. The most moving and central event of his life occurs when the consul solemnly consecrates himself to death (Plate 137). Covering his head and standing on his sword, he makes a solemn vow before the highest priest, Marcus Valerius, whose richly embroidered gold and blue robes provide with the brilliant scarlet toga of the former the strongest colour accents in the picture. Two lictors witness the scene on the right while the consul's horse bows his head and raises a foreleg. The background is carefully designed to reflect the pattern of the figure composition and to highlight the central figure in the drama.

In popular esteem today Rembrandt probably rates higher than Rubens as an inspired interpreter of his chosen subject-matter, so it is salutary to recall that in 1634, albeit before Rembrandt was widely known outside his own country, Rubens was held up to the English gentleman as 'the best story-teller of our times'.[88] This opinion was even more emphatically expressed at the turn of this century in the memorable concluding words of Jakob Burckhardt's book on the artist, in which he linked Rubens with Homer as 'the two greatest story-tellers our earth has ever borne'.[89] The ability to reveal the essence of the story was of course essential to the history painter, which is how Rubens primarily regarded himself. And his qualities as story-teller became ever more pronounced in the works produced during this decade, whether like the *Last Communion of St Francis* (Plate 133) the painting was destined for an altarpiece, or like *Samson and Delilah* (Plate 113) carried out for the delectation of a private patron. But it is perhaps above all the very varied subjects chosen from classical literature which reveal Rubens as the supreme interpreter both in the empathy he brings to his literary source and in his vivid recreation of a past or imaginary world. This is equally evident whether he is conjuring up the noble image of Seneca dying by his own hand (Plate 92) or depicting the defeat of the Amazonian warriors by the Greeks

(Plate 96) in a bloody confrontation whose frenzy is conveyed by the sheer mass of entangled men, women and horses overfilling the bridge and surrounding landscape. In defining the varied incidents the bright colouring of reds and blues plays an essential role. It offers a comment on the realism of contemporary taste that such a violent and gory drama should have hung in the place of honour in a patron's private house, while on other occasions the artist should have deliberately chosen scenes in which heroes such as Hercules are not displayed in their great moments but are mercilessly exposed in acts of non-heroic behaviour.

In the humanist atmosphere of Antwerp Rubens' classical subjects met with immediate approval, but it seems also to have been the case that often the artist painted such scenes without a commission in mind, presumably for his own pleasure. Works such as the *Prometheus* (Plate 148) or *Cimon and Iphigenia* (Plate 150) were only sold some years after they were painted, while others such as the *Drunkenness of Hercules* (Plate 81) remained with him until his death. Despite the collaboration with other artists (see p. 134), the *Cimon and Iphigenia*, executed about a decade before it probably formed part of the sale of works of art to the Duke of Buckingham, ranks as one of the most beautiful of subjects inspired by earlier literature. In this instance the artist's source was the tale from Boccaccio's *Decameron*, illustrating the power of love over a noble-born youth who has

137. *The Consecration of Decius Mus*, c.1617. Canvas, 284 × 338 cm. Sammlungen des Fürsten von Liechtenstein, Vaduz.

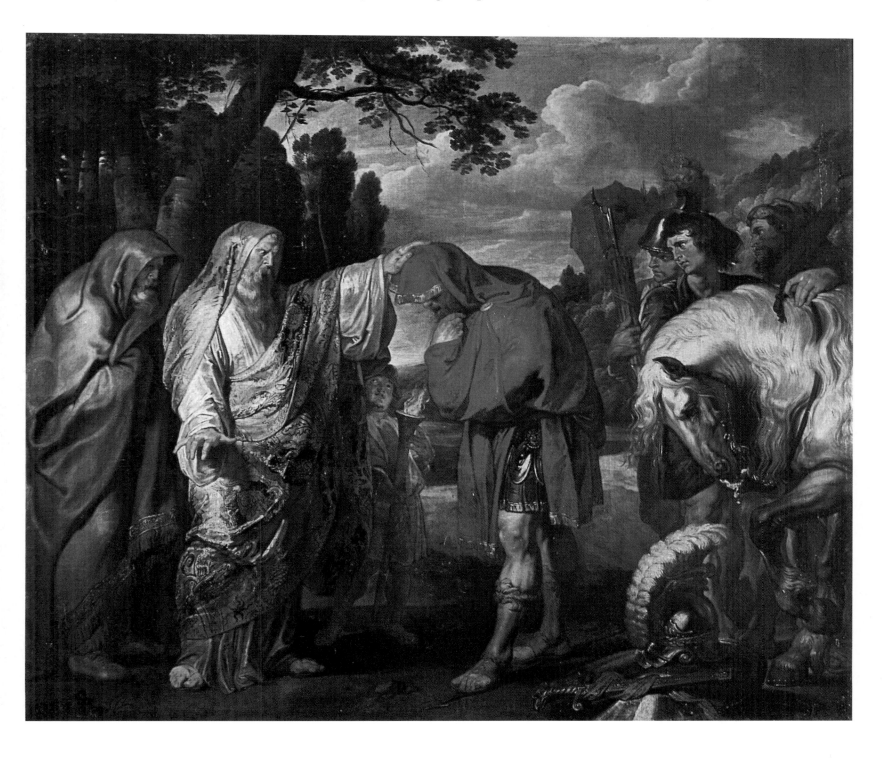

shunned education in favour of a boorish peasant-life. By chance discovering the beautiful Iphigenia seemingly asleep beside a fountain, accompanied by her two maids and a servant, the instantaneously enamoured Cimon dedicates himself to acts of prowess and chivalry to make himself worthy of her love, thereby proving his innate nobility. To enhance the love story, the girl's half-closed lids reveal that her eyes reciprocate the intense gaze of Cimon. And to add a personal touch to his representation, Rubens employed his elder son, Albert, as the model for the sleeping servant, while the fountain with a putto riding a dolphin appears to have been based on the one he had acquired for his own garden (see Plate 87).

Although more softly modelled than earlier representations of the female nude, the three women are sculptural in conception and are arranged like a bas-relief in a carefully assembled group framed by the male figures against the backdrop of landscape. That a classical sculpture housed in the Vatican of a reclining Ariadne, which in Rubens' time was identified as Cleopatra, was probably used as a partial model for two of the figures was eminently appropriate. The beauty of the nudes, the essence of the story and the centre of interest of the picture, is realised in delicate silvery tones, set off by the individual contrasting colours of blue, red and gold of the women's cloaks, further enriched by the blue clothing of the sleeping boy and Cimon's dark brown cloak. Whereas the still life with animals and birds in the foreground is painted by Snyders with the virtuosity of the specialist intent on making his mark in the master's picture, Rubens himself creates a beautiful screen of foliage and fruit behind the figures. The trunk of a large fig tree in fruit in the centre is entwined with a vine with bunches of grapes, while quinces, symbol of love and happiness to the Greeks, hang heavy on the branches on the left beside the arch enclosing the grotto. Nature is portrayed at its ripest and most idyllic in harmony with the story.

The subject of landscape painting only entered the artist's repertory during the decade after his return from Italy, and except for his last years at Steen essentially remained an occasional exercise undertaken, it would seem, largely for his own gratification. Many of the landscapes we know today still remained in his studio at his death. His first training had been in the hands of a landscape painter, Tobias Verhaecht, and from his earliest days landscape had played an important role as a background, although he was sometimes, as we have seen, to subcontract it to 'a man competent in his field'. Possibly it was the demands of such subjects as the *Adoration of the Magi* or the *Shepherds* set in stables or hunting scenes in the open landscape which encouraged a more direct interest. Just beyond the perimeter of the city Rubens would have found on his daily rides numerous farms which would have provided the raw material for stable settings and all the life and equipment of the farm. Several of his drawings show that he took advantage of such opportunities. In the *Prodigal Son* (Plate 138), although not strictly landscape but normally treated under this heading, the principal subject has been relegated to one corner of the picture, where the Prodigal Son 'would fain have filled his belly with the husks that swine did eat; and no man gave unto him'.[90] His request is received with cool detachment by the farm girl and with peasant suspicion by the bearded worker who glares from a safe position behind the support to the barn. Whereas earlier Italian artists had used this subject as a study in forgiveness and their Northern counterparts as an occasion for a representation of loose living, Rubens had followed Dürer's engraving (Plate 139) in choosing the incident in the farmyard. And one cannot help thinking that the opportunity offered by the setting was the inspiration for the picture, since the remainder of it is given up to a detailed portrayal of farm life recorded with remarkable fidelity.

The calculated play of verticals, horizontals and orthogonals naturally supplied by the structure of the barn represents a careful exercise in perspective reminiscent of Dürer's engraving of the *Holy Family* (Bartsch 2). Within its interior Rubens has skilfully incorporated all the appropriate people, animals and equipment that can be accommodated in such a confined area. The stabling of horses and cattle plus attendant activities provides a scene of leisurely animation.

123

138. *The Prodigal Son*, c.1617–19. Panel, 145 × 225 cm. Koninklijk Museum voor Schone Kunsten, Antwerp.

139. Albrecht Dürer, *The Prodigal Son*. Engraving, 24.8 × 19 cm. British Museum, London.

And through the door of the barn the farmhouse surmounted by a dovecote provides a setting for further scenes of country life, such as the man watering two horses in the pond before the sunset. Clearly the artist depended directly or indirectly on drawings made of individual detail or figures. A study of a man threshing (Plate 140) includes the farm cart shown here. Known drawings of animals, such as a horse and a bullock, provided the basic knowledge required for such pictures, although in the case of the left-hand horse in the picture recollection of Giambologna's equestrian portrait of Cosimo I may also have come to hand. And the shepherdess is similar in type to the girl with a jug on her head (Plate 141), who in other drawings is studied churning butter or milking a cow. We can guess that sketches of the various equipment, such as harnesses, baskets and tools, were made perhaps in a sketchbook reserved for such observations. In his approach to landscape Rubens would certainly have been familiar with the classical precedent for such a loving picture of farmlife which occurs in the *Georgics*. Whereas Rubens' contemporaries preferred scenes of picturesque decay, his barn is well kept and his farm prosperous.

What is unusual about Rubens' picture is that although it is a daylight scene it also combines a beautiful study of artificial light within the darkened barn. Both the candles on the wall beside the stable boy gathering hay and that held partially hidden by the old lady beside the cows create a varied pattern of shadows of infinite subtlety so that the eye moves unconsciously from daylight to darkness. Apart from the single note of bright colour on the girl's jacket, the natural browns, greens and blues of the landscape itself predominate so that, unlike other pictures of this period, the figures do not stand out. Once more one can point to the example of Elsheimer, which was to be as potent in Rubens' landscapes as it was in his figure subjects. This relationship is nowhere more apparent than in the

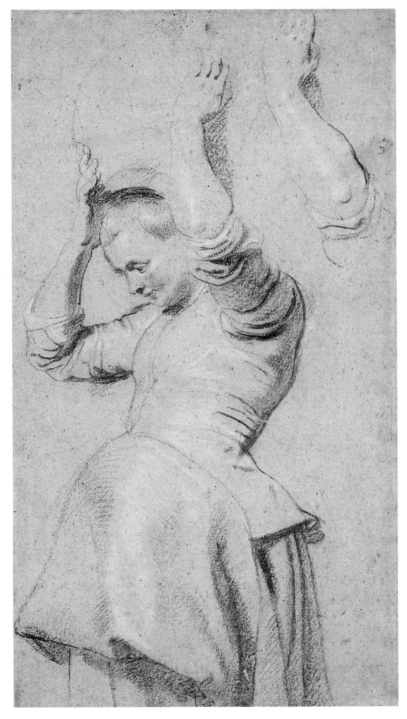

140. (above) *Farmyard with a Farmer threshing and a Haywaggon*, c.1617. Black and red chalk with touches of coloured wash, 25.5 × 41.5 cm. J. Paul Getty Museum, Malibu.

141. *Woman with a Milk Churn on her Head*, c.1617. Black chalk with some red chalk, heightened with white, 48.9 × 26.9 cm. Kupferstichkabinett, Berlin.

142. *Landscape with the Flight into Egypt*, c.1613. Canvas, 74 × 105 cm. Musée du Louvre, Paris.

143. Adam Elsheimer, *The Flight into Egypt*, 1609. Copper, 31 × 41 cm. Alte Pinakothek, Munich.

Landscape with the Flight into Egypt (Plate 142), painted in the early 1610s, which is a recognisable but personal paraphrase of the German artist's small copper of the same subject (Plate 143). The latter, completed in the year of the artist's death, is probably the picture which Rubens was so anxious for Elsheimer's widow to 'send . . . directly to Antwerp, where there are countless numbers of people interested in works of small size'. As a declaration of his support, Rubens promised that 'I shall take particular care of it and serve as curator with all my ability'.[91] But if Rubens was inspired by Elsheimer's poetry and realism, he introduced a quality of his own, the vitality which enlivens every part of his composition. The fecundity of nature is brilliantly animated by the freedom and control of the master's brush which insinuates the organic character of each growth in the landscape on his easel before him.

The principle of assembling a number of observed details, composed in much the same way as a figure composition, was followed in his few exercises in pure landscape. The raw material was contained in several studies, sometimes accompanied by nature notes, of fallen trees and brambles. In one such drawing (Plate 144) the combination of a living tree and a fallen tree trunk provides a frame to an intimate view of nature. At first drawn freely in black chalk, the sheet was subsequently worked over in pen and ink, which not only strengthens and defines detail but in the regular pattern of the shading creates a beautiful play of light and shadow which unifies these random observations. This drawing came to hand when he was painting the scene of the kill in the contemporary *Landscape with a Boar Hunt* (Dresden).

In contrast to the preoccupation with rendering space of contemporary Dutch landscape painters, Rubens' additive approach to composition is equally apparent in the *Shepherd with his Flock in a Wooded Landscape* (Plate 145). Here the make-up of the panel support reveals two distinct stages in the genesis of the work. At first Rubens confined himself to the more intimate and enclosed subject of the receding river bordered by trees and the shepherd with his flock. But in the way that his ideas tended to grow in the process of creation, he subsequently extended the original panel substantially on all four sides. The view was opened up on the left, and another tree was added before a vista of distant landscape. The sun was now moved to the open horizon instead of being partly hidden by the original tree. On the right the river bank and wood were further extended to include a wooden bridge which provides a link with the immediate foreground. But the artist did not

144. *Landscape with a fallen Tree*, late 1610s. Pen and brown ink over black chalk, 58.2 × 48.9 cm. Musée du Louvre, Paris.

127

remain satisfied with the completion of this composition, and, using it as the starting point for another landscape, known as the *Watering Place* (National Gallery, London), he greatly developed his original subject as the final statement of the theme.

In the same way that the style of Rubens' figure subjects were forged out of a combination of North and South, so his early landscapes depended on a similar mixture of traditions, even if the influence of the North remained the stronger. The thickly wooded scene which fills most of the landscape follows the pattern established by Gillis van Coninxloo at the turn of the century. But the organisation of the landscape reflects more of the style of Paul Brill and Elsheimer, both Northern artists who had turned to Italy. In Rubens' landscape there is a clear sense of direction as the river forcibly leads the eye diagonally into the middleground of the landscape. On one side the impenetrable wood is pierced by a distant vista while on the other the receding distance is established by the parallel lines of hedges leading to the sun low on the horizon, an almost invariable feature of his backgrounds. It was essentially an inhabited landscape and, apart from the pivotal figure of the shepherd looking out of the picture, the dense wood is enlivened by a huntsman with his hounds coursing through a clearing and a variety of birds dotted about the wood. Although more broadly painted, the final result comes close to the type of landscapes being produced by his near contemporary and friend Jan Brueghel.

Surprisingly, in view of the mutual jealousy among artists, Rubens met with immediate success within his own profession. He was welcomed at a special banquet given in his honour by Jan Brueghel in his role as the dean of the Romanists, a society for artists and intellectuals of which Rubens himself was shortly to become dean. Admittedly his relationship with his former master Otto van Veen is more ambiguous. When both men submitted *modelli* of the *Assumption and Coronation of the Virgin* for the high altar in the cathedral in 1611, it can have given the older man little pleasure that his erstwhile pupil was preferred. Owing to the reduction in Van Veen's salary from the city of Antwerp shortly afterwards, he decided to take the newly created post of director of the Mint in Brussels and reluctantly moved from his home city, no doubt with the sense that his reputation was waning while that of Rubens was rapidly rising. And, although De Piles says that the long standing friendship with Van Veen was not forgotten by Rubens or his family, there remains the curious and unexplained incident that when Rubens wanted to obtain a copy of 'a little anonymous work on the Universal Theory, or something of the sort'[92] written by Van Veen, he should have attempted to borrow a copy from Van Veen's brother living in The Hague rather than ask the author himself, much nearer at hand in Brussels. But if any estrangement existed between the two men, Van Veen, when questioned by Sweertius for a biography published in 1628, did not fail to mention his former pupil, whom he described as the 'Apelles of the Universe'.[93]

Rubens' almost exact contemporary Abraham Janssens, who had also contributed a picture to the Truce decorations in the town hall in 1609, saw Rubens' rise to fame as a direct threat to his own recently established position in Antwerp, and, according to Sandrart, challenged him to a contest in which each artist would submit a picture to an impartial judge. Janssens was confident that his picture with its truth to nature and powerful colouring would easily be victorious. Rubens, however, declined, observing that he saw no point in painting in competition and that each man would do better to continue in his own way. Later in his life Rubens appears to have been on bad terms with another Antwerp painter, Caspar de Crayer, and after Rubens' death the Cardinal-Infante Ferdinand, then governor of the Netherlands, wrote to the Spanish king that 'De Crayer, a master of great reputation . . . was hardly a friend of Rubens, who had not given him any of the pictures to be carried out expeditiously for the Torre de la Parada'.[94] But Janssens and De Crayer appear to have been rare exceptions and for the most part his relations with fellow artists were extremely cordial. When

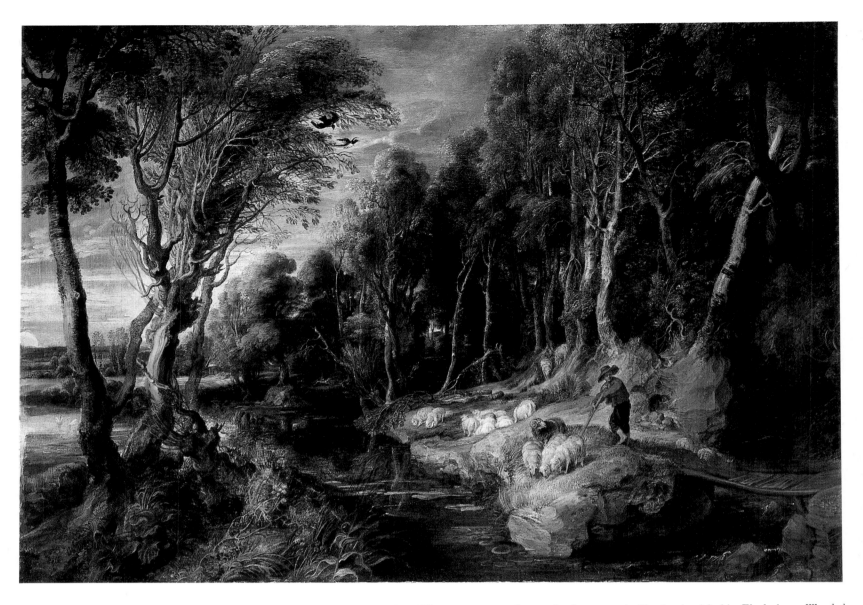

145. *A Shepherd with his Flock in a Wooded Landscape*, c.1615–22. Panel, 64.4 × 94.3 cm. National Gallery, London.

sending his picture of the *Horrors of War* (Plate 256) to Florence near the end of his life, Rubens wrote to Justus Sustermans, who had become court painter there, saying that 'I am afraid that a fresh painting, after remaining so long packed in a case, might suffer a little in the colours, particularly in the flesh tones, and the whites might become somewhat yellowish. But since you are such a great man in our profession, you will easily remedy this by exposing it to the sun, and leaving it there at intervals. And if need be, you may, with my permission, put your hand to it and retouch it wherever damage or my carelessness may render it necessary.'[95] This was a tribute indeed from someone who protected his artistic reputation as keenly as Rubens did, and is an unusual if happy example of his good relations with a fellow artist.

Earlier in his life Rubens formed a close relationship with Jan Brueghel and out of friendship found time to act as the latter's amanuensis in his Italian correspondence. In one letter Brueghel goes as far as to refer to 'my secretary Rubens'.[96] It is indicative of their mutual feelings that this arrangement continued from 1610 up to Rubens' departure for France in 1622, which covered a period in Rubens' life when he was becoming increasingly busy. Rubens was a great admirer and collector of the works of his father, Pieter Bruegel the Elder, and was commissioned by Jan to paint the *Giving of the Keys* (Bode Museum, Berlin) for the funeral monument of his parents in Notre Dame de la Chapelle in Brussels. In 1612 in company with Hendrick van Balen the two artists made a visit to Haarlem where a dinner in their honour was given by Hendrick Goltzius. For Rubens, who was at that time preoccupied in finding good reproductive engravers, the journey would have had a particular purpose.

About this time Rubens portrayed Jan Brueghel's second wife and their two surviving children (Plate 146). The husband appears behind, but both his position and the freer execution of his figure suggest that he was only added at a later date.

129

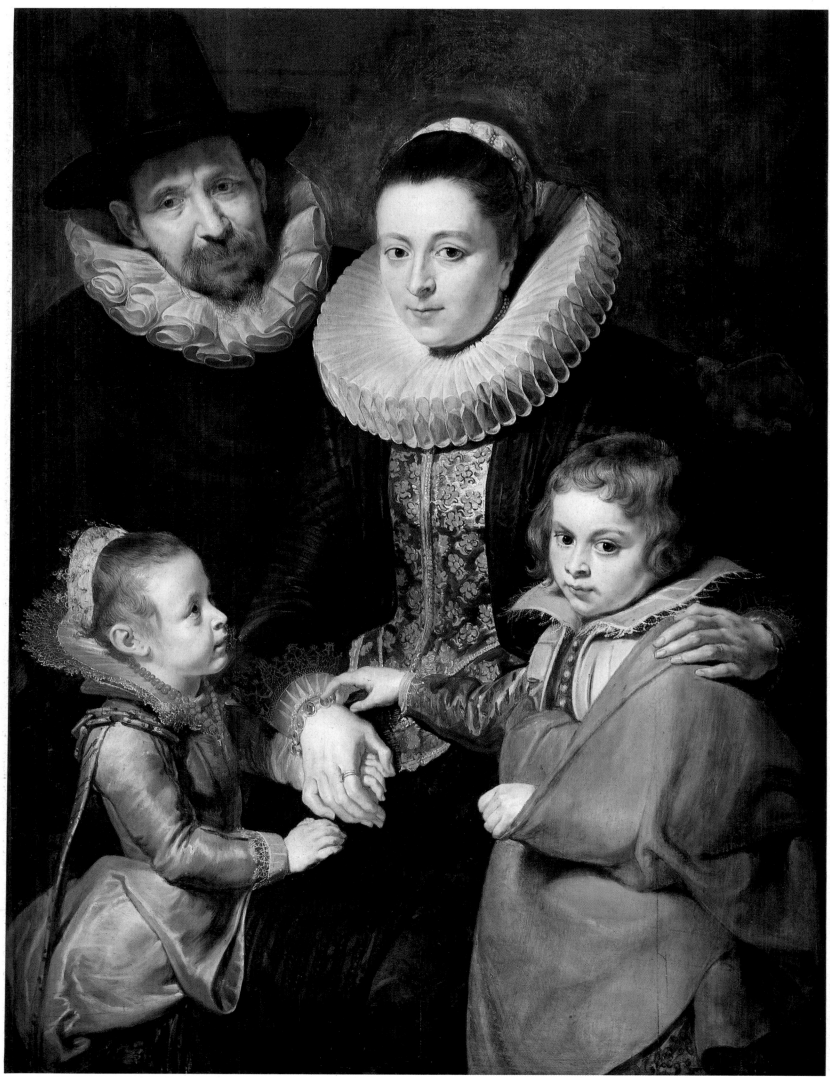

146. *Jan Brueghel the Elder and his Family*, c.1612–13. Panel, 124.5 × 94.6 cm. Courtauld Institute Galleries, London.

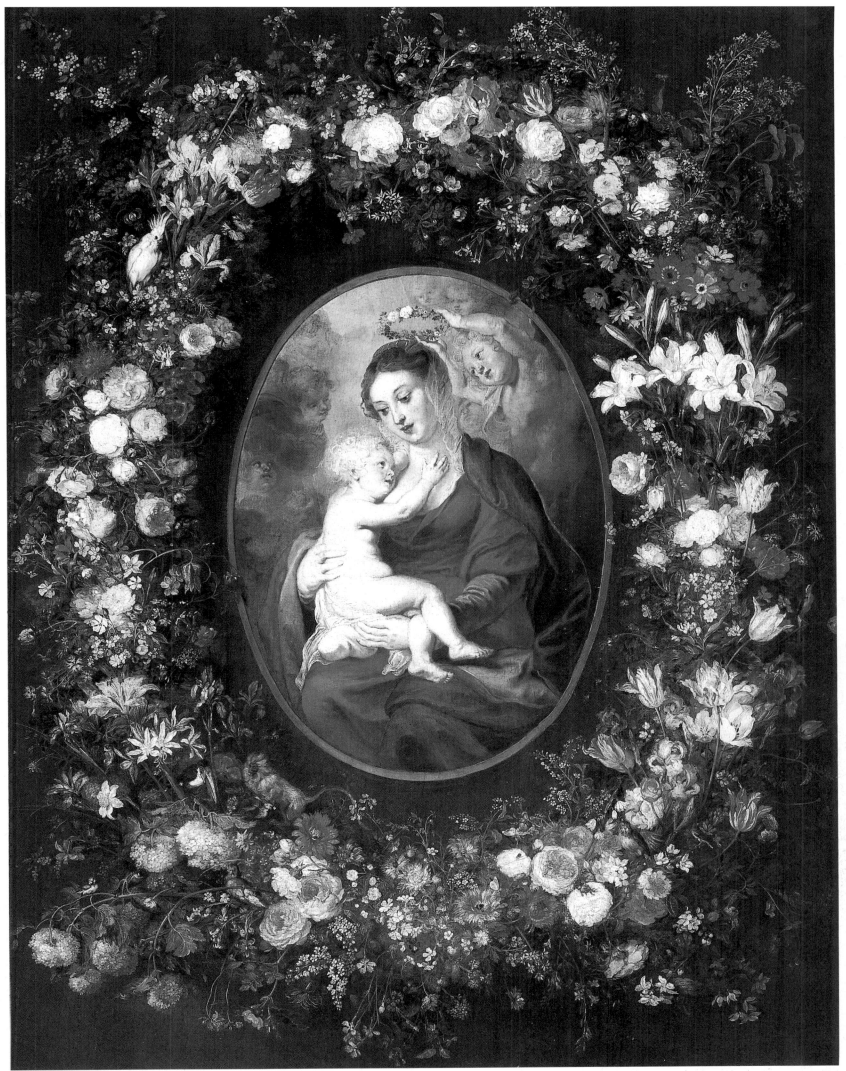

147. Rubens and Jan Brueghel the Elder, *The Virgin and Child surrounded by Flowers*, 1621. Panel, 85 × 65 cm. Musée du Louvre, Paris.

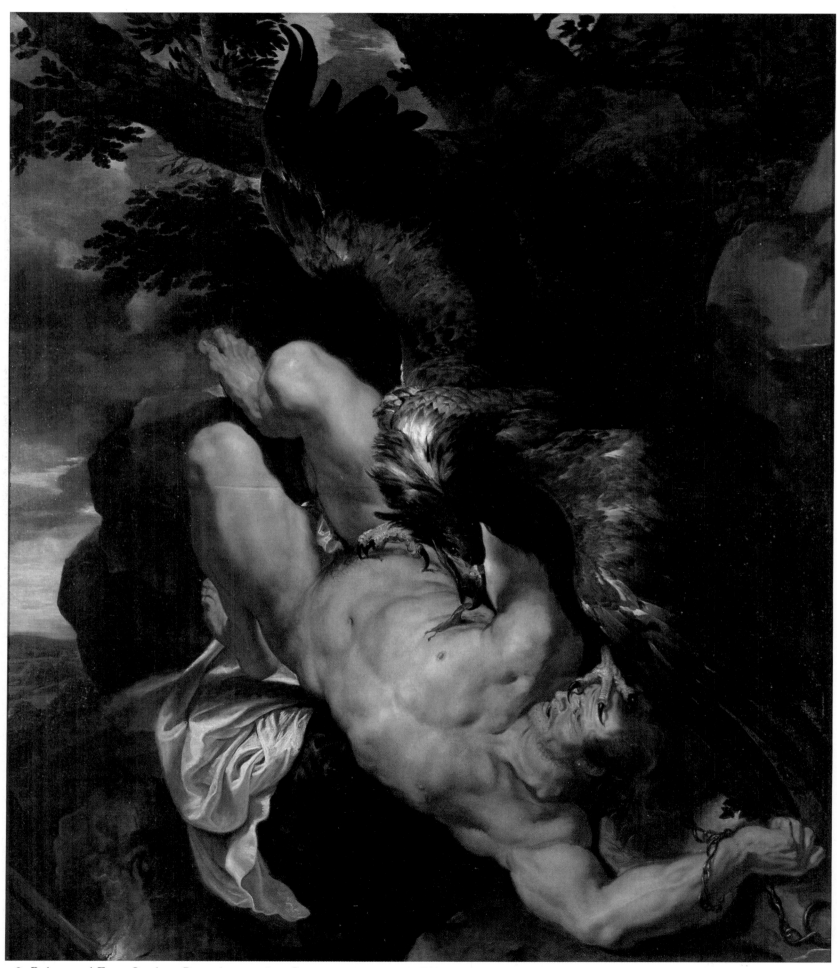

148. Rubens and Frans Snyders, *Prometheus*, c.1612. Canvas, 243 × 209 cm. Philadelphia Museum of Art.

Despite the unfinished background the picture is one of the most direct and sympathetic portrayals in which the intimate relationship between a mother and her two children is eloquently expressed by the intermingling of their hands. The warmth of the sitters' personalities, which emerges against the darkly coloured background, suggests the mutual empathy between artist and his subjects, making the commission one of pleasure rather than duty.

Even before Rubens' departure for Italy he and Brueghel had, as has been noted, collaborated on a picture with Otto van Veen. The collaboration between Rubens and Brueghel continued in a number of pictures painted after Rubens' return to Antwerp, in which the former executed the figures and the latter the landscape and still life of flowers. A number of these remained in Rubens' possession and were listed in the posthumous inventory. A letter of 1621 written to Ercole Bianchi, secretary to Cardinal Borromeo, describes one such case of collaboration over a picture to be given to the cardinal, which Brueghel claimed was 'the most beautiful and exquisite piece I have ever made. Rubens has also proved his talent in the painting in the middle, representing a Madonna. The birds and animals are studied from the life, based on those belonging to the Serenissima Infanta.'[97] What is probably to be identified as this picture (Plate 147) contains within the garland of flowers a number of exotic birds, a monkey and a baboon.

Rubens' success can be gauged above all by the popularity of his studio. Only two years after his return he wrote,

> From all sides applications reach me. Some young men remain here for several years with other masters, awaiting a vacancy in my studio. Among others, my friend and (as you know) patron M. Rockox has only with great difficulty obtained a place for a youth whom he himself brought up and whom, in the meantime, he was having trained by others. I can tell you truly, without exaggeration, that I have to refuse over one hundred, even some of my own relatives or my wife's, and not without causing great displeasure among many of my best friends.[98]

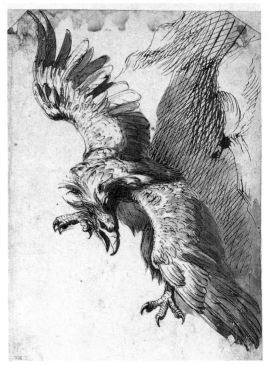

149. Frans Snyders, *An Eagle*. Pen and ink with brown wash, 28.1 × 20.3 cm. British Museum, London.

Although Rubens himself sometimes blurs the distinction, there remained a clear difference between assistants, for the most part young artists such as Van Dyck, who had just become guild members and who could carry out advanced work on the preparation and execution, and pupils proper, who would, at least to begin with, be confined to preparing pigments, panels and canvases and other basic preliminary work needed in the studio. Although freed from guild regulations Rubens maintained the time-honoured tradition by which pupils learnt from example rather than from any academic course of study. Unlike Rembrandt, Rubens never appeared interested in the process of teaching an artist.

The age of the large studio reached its height in the seventeenth century with Bernini in Rome, Lebrun at Versailles and Rubens in Antwerp, each of whom employed a team of artists to realise his grandiose projects. In the scale and abundance of decorative schemes, Rubens was very much a man of his time, and in running this thriving factory he showed himself a superb administrator. Rubens may well have been aware of the Tintoretto studio which was still functioning under the direction of Jacopo's son Domenico when he was in Venice, and he gathered together in no time a large group of assistants and pupils, whose help was increasingly called upon as the number and scale of commissions grew. But although Rubens signed himself responsible for everything issuing from his studio, he maintained, as his correspondence with Sir Dudley Carleton shows, a clear idea in his mind of the different degrees of his participation in a given work.

At the top of the hierarchy were those works 'entirely by my own hand'. Since, apart from a few isolated examples in the mid-1610s and one in 1625, Rubens never signed or dated his pictures, and in only a few cases referred to them in letters, his fully autograph works can only be determined by eye. As he had done with Jan Brueghel, Rubens on a number of occasions collaborated with artists who were specialists in a particular field. The inventory of his collection lists four

133

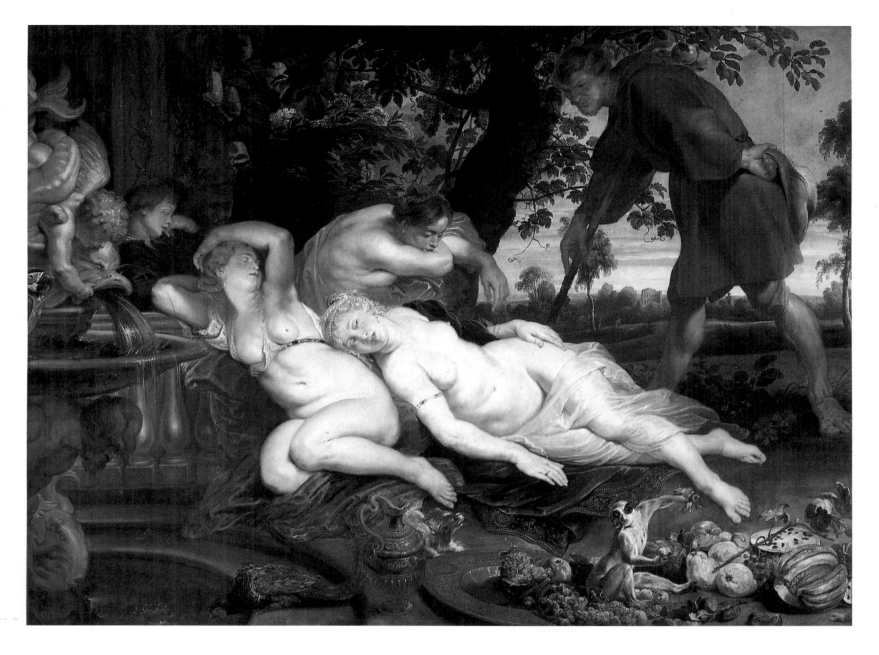

150. Rubens and Frans Snyders, *Cimon and Iphigenia*, c.1617–18. Canvas, 208 × 282 cm. Kunsthistorisches Museum, Vienna.

landscapes or peasant interiors by the Dutch artist Cornelis Saftleven in which Rubens had painted the figures. He also collaborated with the Flemish still life painter Osias Beert the Elder, and, speaking of a work executed with Jan Wildens, Rubens says that 'according to my custom, I have employed a man competent in his field to finish the landscapes'.[99]

One of the most profitable collaborations took place with Rubens' slightly younger contemporary Frans Snyders, a specialist in the painting of animals, especially of dead game and kitchen still life. But, though happy to employ Snyders' talents, Rubens was characteristically clear-headed about the latter's limitations, as Carleton and his agent were to discover when they assumed a work was entirely by Snyders. 'For in this Piece the beasts are all alive, and in act either of escape or resistance, in the expressing whereof Snyders does infinitely come short of Rubens, and Rubens said that he should take it in ill part, if I should compare Snyders with him in that point. The talent of Snyders is to represent beasts but especially Birds altogether dead, and wholly without any action.'[100] In the case of the *Prometheus* (Plate 148), not only do we have Rubens' word that the eagle was 'done by Snyders', but also the latter's preparatory drawing in pen and wash (Plate 149). For the large canvas of *Cimon and Iphigenia* (Plate 150) Rubens made a preparatory sketch (Plate 151), but he left the right foreground empty for Snyders to add suitable still life, birds and a monkey. And in this instance someone else, probably Jan Wildens, may have painted the landscpae in the background, which appears dull in execution compared to the rich vegetation surrounding the main participants in the story.

But in order to cope with the ever increasing demand, there was a third category

in which pupils or assistants played an important role, either by copying an existing work by the master such as the pictures offered to Carleton of 'The Twelve Apostles, with a Christ, done by my pupils from originals by my own hand' which 'need to be retouched by my own hand throughout'[101] or by executing the basic work such as the 'picture of an Achilles clothed as a woman, done by the best of my pupils [Van Dyck] and the whole retouched by my hand'.[102] Otto Sperling, on his visit to Rubens' studio at just about the time the canvases for the ceilings in the Jesuit church were delivered, gives a description of this process in action; in the pupils' studio, he saw 'a good number of young painters each occupied on a different work, for which M. Rubens had provided a chalk drawing with touches of colour added here and there. The young men had to work these up fully in paint, until finally Mr. Rubens would add the last touches with the brush and colours. All this is considered as Rubens' work; thus he has gained a large fortune, and kings and princes have heaped gifts and jewels upon him.'[103] Unfortunately the master's underdrawing is no longer visible beneath the layers of paint. But there can be little doubt that this covering up was intentional, and a contemporary, Turquet de Mayerne, whom Rubens portrayed in London, warns the artist in his treatise on painting to remove all traces of the chalk so as not to spoil the effects of the colour.

Since Rubens was absolved from registering his pupils with the guild, we have little idea about their identity, although one or two names, such as Deodat del Monte, who accompanied him to Italy, are recorded. By far his most distinguished assistant was Van Dyck, some twenty-two years younger than the master. At an early age he had been trained by Hendrick van Balen, and in 1618 aged nineteen he became a member of the Guild of St Luke. In the same year, Rubens was, as has been seen, referring to him as 'the best of my pupils' and Rubens may have taken some limited advantage of his help in the two major commissions of these years, the tapestry cartoons of *Decius Mus* and the paintings to be carried out for the ceiling of the Jesuit church. With Rubens so much in control in Antwerp, Van Dyck saw little future there and in 1620 left for England. Although the evidence might be interpreted as showing Rubens' unwillingness to paint portraits, Bellori in his life of Van Dyck infers that there was some jealousy on the part of the older artist: 'Being very wise, he took the opportunity of Anthony's having painted a few portraits to give him the highest praise and to propose him in his stead to whoever came for a portrait, so as to get him away from painting figures. For the same

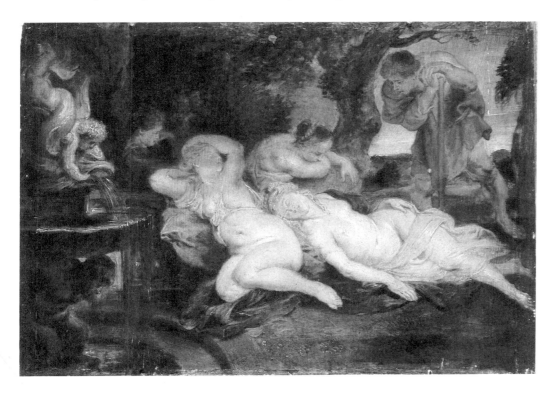

151. *Sketch for Cimon and Iphigenia*, c.1617–18. Panel, 29.8 × 43.5 cm. Earl of Wemyss and March, Gosford House.

135

reason, but more brusquely, did Titian rid his house of Tintoretto.'[104] In 1620 Arundel's secretary had written from Antwerp saying that Van Dyck's works were judged to be scarcely inferior to those of Rubens, sentiments which may have aroused in the older artist's mind the memory of what had happened to the unfortunate Van Veen.

Rubens' productivity was not entirely due to the organisation of his studio. He himself had a fertility and speed of thought and execution that were largely responsible for his astonishing output. Bellori graphically referred to his *furia del pennello*. His energy and powers of concentration greatly impressed Otto Sperling, who on his visit found 'the great artist at work. While still painting, he was having Tacitus read aloud to him and at the same time was dictating a letter. When we kept silent so as not to disturb him with our talk, he himself began to talk

152. *The Countess of Arundel and her Party*, 1620. Canvas, 261 × 265 cm. Alte Pinakothek, Munich.

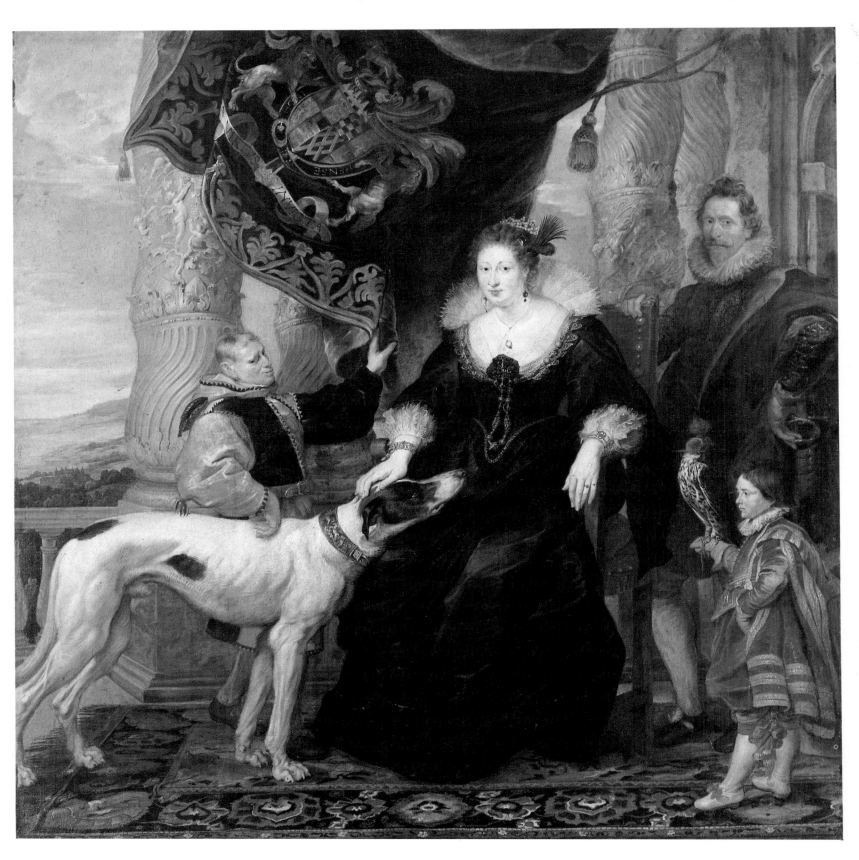

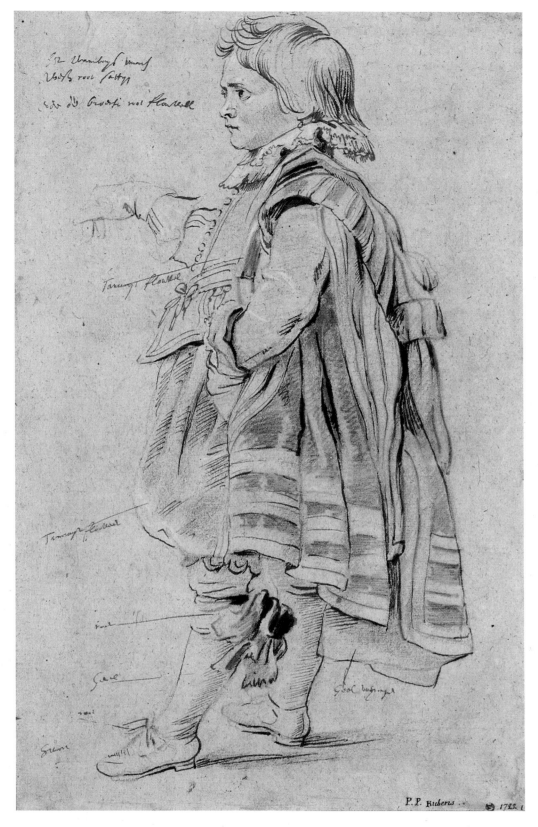

153. *Robin, the Dwarf of the Earl of Arundel,* 1620. Pen and brown ink over red, black and white chalk, 40.3 × 25.8 cm. Nationalmuseum, Stockholm.

to us while still continuing to work, to listen to the reading and to dictate his letter, answering our questions and thus displaying his astonishing powers.'[105] Though such Herculean powers of concentration may have been beyond even Rubens, the atmosphere of hectic activity is certainly correct in essence. And his habit of employing a reader, 'some good historian or Poet',[106] is confirmed by an English writer. A far more convincingly life-like portrait of the artist at work was given by a visiting Englishman, Sir William Sanderson: 'In a *draught of designe*, the Artist must *fancie* every circumstance of his matter in hand; as usually *Rubens* would (with his Arms a cross) sit musing upon his work for some time, and in an instant

in the liveliness of spirit, with a nimble hand, would force out his overcharged *brain* into description so as not to be contained in the Compass of ordinary practice, but by a violent driving on of passion. The *Commotions* of the mind, are not to be cooled by slow performance.'[107] This bursting energy is vividly suggested by many of his paintings or drawings in which the brushstrokes and the pen lines convey the speed of execution. Rubens was not the kind of artist to ruminate for hours before an unfinished canvas and then put it away untouched to wait for another more favourable day. Determination to complete the work in hand drove him on to a solution there and then. He often changed his mind, as different sketches for the same work show, but each work had an absolute conviction, as if it were to be the final result. There was no uncertain fumbling towards a yet unrealised goal.

We possess one other contemporary account of the artist at work, when he was faced with an unexpected demand for a portrait (Plate 152). In the summer of 1620 the Countess of Arundel, accompanied by her dwarf, jester, large greyhound and the earl's secretary, Francesco Vercellini, arrived in Antwerp. The last, presenting himself to Rubens, reports that the artist said that although he had 'refused to paint the portraits of many princes and gentlemen, above all here at the court of her Highness [the archduchess]', he would count it an honour to make an exception for someone he regarded as 'one of the four evangelists and patrons of our art'. 'The Countess should come the following day to pose, which she did, and he with great courtesy has finished her likeness, that of Robin the dwarf [Plate 153], the jester, and the dog, with only a few minor things still missing which he will finish tomorrow.' Because he 'lacked a picture canvas sufficiently large for his purpose, he portrayed the heads as they should be, and drew on paper the postures and the costumes; he portrayed the dog full length. But in the meantime he will have a canvas made to order and will copy with his own hand what he has done.'[108]

Whether what happened on this occasion, that is drawing or painting the heads separately, establishing the pose in a drawing and making notes of the costumes, represented Rubens' normal procedure or was his response to an unusual situation remains unclear. In view of Sperling's description of his practice with assistants, it seems more likely that Rubens would usually sketch the pose and make colour notes for the costumes directly on the canvas, which would of course be prepared and available.

The Rubens studio had another role to play in spreading the name of the master, of which one of the most important methods was the publication of engravings and woodcuts after his pictures. Such was the growing interest in the master's work throughout Europe that he was forced to go to considerable trouble to patent his designs in France, Holland and the Spanish Netherlands in order to prevent other engravers issuing them. His difficulties over prints were not only confined to the works themselves. From the beginning he was concerned to find the right person to work under him, and his first journey to Holland in 1612 was probably undertaken in order to consult Hendrick Goltzius, the famous engraver of the time, about a suitable candidate. By 1618 he had found someone nearer home. 'I should have preferred to have an engraver who was more expert in imitating his model, but it seemed a lesser evil to have the work done in my presence by a well intentioned young man, than by great artists according to their fancy.'[109] The young man in question was Lucas Vorsterman, then aged twenty-four, whom Rubens took under his wing. (When his first child was born, Rubens acted as godfather.) With patents established and Vorsterman trained to meet his exacting demands, Rubens was set by 1620 to start issuing prints. To begin with the two men worked most profitably and harmoniously, but very soon Rubens was lamenting that 'unfortunately we have made almost nothing for a couple of years, due to the caprices of my engraver who has to let himself sink into a dead calm, so that I can no longer deal with him or come to an understanding with him. He contends that it is his engraving alone and his illustrious name that give these prints any value.'[110] What exactly happened is not known, but seemingly

Vorsterman, forced to reproduce considerable refinements of tone and detail, was unable to meet his master's inexorable demands for both quality and speed of execution in what is essentially a slow medium. Breaking point appears to have been reached over the elaborate and complicated memorial portrait of the recently deceased general Charles de Longueval. On Rubens' preparatory oil-sketch (Plate 155) Vorsterman, expressing his feelings in a highly unusual manner, incised the actual paint with the words: 'This cost me, because of the bad verdict, worry and vexation, many nights of waking and great aggravation.'[111] In his anguish Vorsterman even threatened the life of his master, who had to be given court protection. (In 1622 a rumour circulated in Paris that Rubens was dead.) In coping with his engraver's mental breakdown, Rubens was facing the problems of an exacting employer, and he was made keenly aware that art was a down-to-earth business not practised in the solitude of an ivory tower.

Thereafter Rubens employed a wide range of both Dutch and Flemish engravers who worked on commission. The best-known and most prolific were the two Bolswert brothers and Paulus Pontius. Only in the last years of his life did Rubens once again employ in his service a young man, Hans Witdoeck, who ironically had been trained by Lucas Vorsterman. But Witdoeck never succeeded in matching the quality of workmanship of his master. Rubens also used a number of etchers, including Willem Panneels, who in addition was called upon to take charge of the studio when Rubens was away on diplomatic business in the late 1620s. Perhaps the most satisfactory prints, reproducing not only the tones but the softness and vigour of the originals, were the woodcuts made by Christoffel Jegher in the 1630s, which were conceived under Rubens' direct supervision.

As the unhappy Vorsterman learnt to his cost, Rubens knew exactly what he wanted from his printmaker and would usually make an exact drawing or oil-sketch as a model to be followed. (Bellori says that while Van Dyck was with Rubens he was employed on making such drawings.) The engraver would then sometimes make a line-by-line rendering for transfer to the plate, as happened in the case of Vorsterman's engraving of the *Descent from the Cross* (Plate 154), taken from the central part of the Arquebusiers' altarpiece (Plate 108). Working from his carefully drawn *modello* (Louvre, Paris), Vorsterman produced one of the best engravings made after Rubens, which shows the degree of refinement of tone of which he was capable. Much later in his life Rubens executed two large drawings (Plate 294) based on the *Garden of Love* (Plate 291) which were to be cut in wood by Christoffel Jegher (Plate 296); in these *modelli* the carefully drawn pen lines over black chalk underdrawing could be copied directly by the printmaker on to the wood block. The tones were indicated by the indigo, green and white bodycolour which the master had added to the drawing.

In later life Rubens tended to prepare for such work with an oil-sketch, as he did in the case of the portrait of Olivares (Plate 223), engraved by Paulus Pontius. When, a quarter of a century after he had painted the *Raising of the Cross* (Plate 100), he eventually planned a reproductive engraving, he used the same method of preparation (Plate 157) for his engraver, Hans Witdoeck. In this instance, prompted by his wish to present the three sections within a unified field, he extensively modified his original design at the same time as he brought it into line with his current style.

But his supervision did not cease there, and frequently when shown the first pulls of a print he would make corrections in order that nothing should be left to chance when the engraver printed an approved edition. As he said of one engraving, 'it has been retouched several times by my hand (as is always my custom)'.[112] The print rooms of the world contain a large number of such proof impressions corrected by Rubens, depending on whether detail or tone required improvement, in either pen or bodycolour. On a counterproof of the etching of *St Catherine of Siena* (Plate 156), taken from the figure of the saint on the Jesuit ceiling, sometimes attributed to Rubens himself but perhaps more convincingly to the young Van Dyck, Rubens has strengthened and corrected in vigorous pen lines.

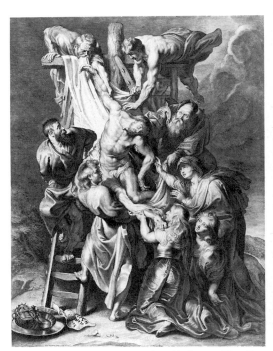

154. Lucas Vorsterman after Rubens, *The Descent from the Cross*, 1620. Etching and engraving, 57.2 × 42.4 cm. British Museum, London.

139

One lifelong friendship involved Rubens in commissions of a different nature from those usually associated with a great painter. Balthasar Moretus, the grandson of Christopher Plantin, had been known to the artist from their early days at Verdonck's school. Paralysed in one side from birth, he took consolation from his position as a much respected classical scholar. In 1610, after the death of his father, he and his brother Jan, who died in 1618, took over the direction of the Plantin Press. This was run as a thriving business, operating to very high standards. A complaining Spanish prelate was told in no uncertain terms by the printer himself: 'But if the friend of Your Reverence has hired labourers elsewhere that work at a lower price, we do not take it amiss. On the contrary, as we are snowed under with orders for book-printing, we gladly send people to some other printer, especially those who are more interested in a low price than in the quality of the work.'[113]

Moretus took over the family house attached to the printing press which with Rubens' house ranked as one of the sights of Antwerp. Friendship and business went hand in hand, and Rubens, apart from painting the commemorative triptych of the *Resurrection* for Moretus's father to hang in the cathedral, was in no time working for the Plantin Press painting historical portraits and above all designing title-pages and illustrations for books published by the press. The latter activity was not, however, allowed to interfere with his painting and was regarded as intellectual relaxation which engaged the artist's interest in symbol and allegory. Although the painter's strict attitude to such work may have been exaggerated for the benefit of an unwanted client, Moretus laid down the artist's conditions about title-pages in unequivocal terms: 'Rubens refuses to design them, if the design cannot be postponed for three months. I usually warn him six months in advance, so that he can think about a title and work it out fully in his free time and during

155. *Sketch for the Memorial Portrait of Charles de Longueval, Comte de Bucquoy*, 1621. Panel, 62.1 × 49.5 cm. Hermitage, Leningrad.

156. *St Catherine*, c.1620. Counterproof of an etching, retouched in pen and brown ink, 29.7 × 19.9 cm. Metropolitan Museum of Art, New York.

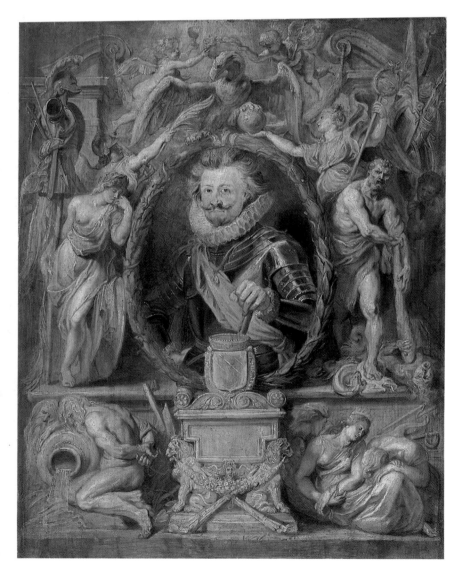

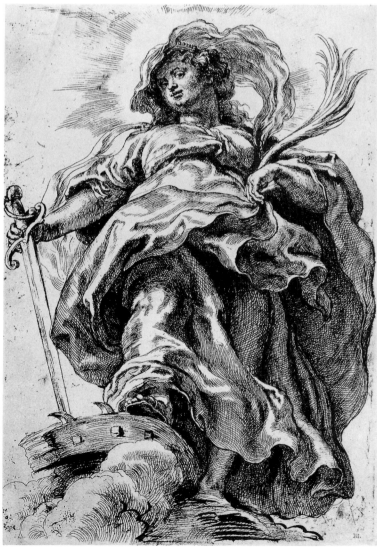

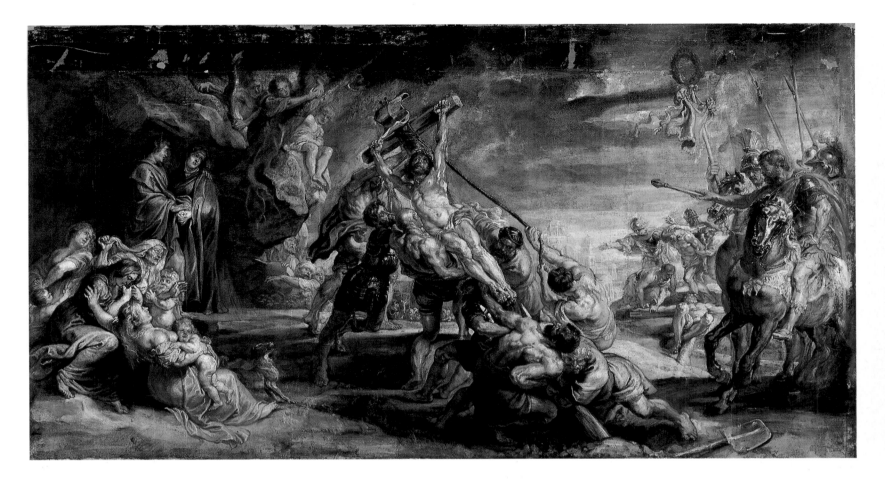

holy days. For he spends no working days on such work, or he would have to charge 100 guilders for one drawing.'[114]

157. *Sketch for the Raising of the Cross*, c.1637–8. Oil on paper, backed by canvas, 60 × 126.5 cm (original size). Art Gallery of Toronto.

At this period the Plantin Press was very active in publishing religious books and pamphlets by Catholic authors scattered throughout Europe. These were the direct outcome of the new spirit engendered by the Counter Reformation and served to establish Antwerp as a major European centre of religious publishing. The case for some pictorial adornment to make such works more appealing to the eye was eloquently expressed by the Jesuit Bernard Baudius in 1617. 'At the beginning of the book, my dear Moretus, many people would like to see some engraving . . . It amuses the reader wonderfully, it attracts the buyer, it decorates the book and it does not add much to the price . . . M. Rubens with his divine gifts will invent something to put on it which befits my poetry, the Order to which I belong, and the Faith.'[115]

Despite the participation of 'our inventive Rubens'[116] in the products of the Plantin Press, Moretus retained a controlling hand in the production of the books and their illustrations. It was a happy collaboration between two friends. Rubens was an employee but a highly honoured one, to be treated with respect and consideration. The final product was acknowledged as a joint creation. One author, Philippe Chifflet, when his proposals for illustrations to his edition of the decrees of the Council of Trent were rejected by Moretus, yielded gracefully: 'I am satisfied with everything you and Monsieur Rubens will decide and make you the masters of it . . . since I prefer his invention and your judgement to my ideas'.[117]

Although the Plantin Press was the best known, it was not the only printer in Antwerp and, moreover, not the only one to employ Rubens. One such commission from another firm came from Jacob Van Meurs, who in 1618 had become a partner of Balthasar Moretus on the death of the latter's brother, but had subsequently quarrelled and set up his own press in a house called The Fat Hen. As he did for Moretus, Rubens designed a personal printer's mark (Plate 158) for Van Meurs. Inscribed in Latin 'brooding by day and night', the oil-sketch depicts a hen with four eggs. On either side of her are profile heads of Minerva and Mercury, representing Learning and Commerce; above, the owl and the cock, the two birds traditionally associated with the two gods, flank an oil lamp, symbolising light and possibly wisdom. The sketch demonstrates Rubens' superb ingenuity in

158. *Sketch for the Printer's Mark of Jacob van Meurs*, c.1630–1. Panel, 20.2 × 21.5 cm. Museum Plantin-Moretus, Antwerp.

159. Theodoor Galle after Rubens, *Six Border Decorations with Scenes from the New Testament* from the *Missale Romanum* (Antwerp, 1613). Engraving, 30.3 × 19.8 cm. Museum Plantin-Moretus, Antwerp.

producing a compact design replete with symbolic meaning suitable for the title-page of a book.

For the most part Rubens' work for printers consisted of either illustrations or frontispieces. The former tended to be relatively straightforward representations of the matter in hand, and covered a wide range of subjects. Based on what he had seen in Rome, he had made several illustrations for his brother's book *Electorum Libri II* (Plate 49), which was published in 1608, and several years later he illustrated a book on optics (Plate 168). But his most extensive work of illustration was executed for the new editions of the Roman Missal (1613) and the Roman Breviary (1614), which were the two principal liturgical books used by the Catholic Church. These contained the revised texts recommended by the Council of Trent, for which Christopher Plantin, to his great financial advantage, had obtained exclusive rights of publication in the Netherlands, Spain and the Spanish colonies. His press had been busy printing editions since 1572. Apart from full-plate illustrations, Rubens made designs for a number of border decorations, which are a special feature of this new edition of the Roman Missal. One page of the book is surrounded by six New Testament scenes and representations of the four evangelists in vignettes (Plate 159). Designs for the six New Testament scenes of infancy (Plate 160), probably drawn on a single sheet of paper, show the artist's calligraphic and descriptive penwork, enriched by wash to convey light and form. The Roman Breviary contains eleven full-page illustrations including the *Assumption* (Plate 161), whose design closely relates to painted versions of the subject of these years. As in all these preparatory studies, the precise penwork and the wash applied in varying densities provided the engraver with an exact guide when he came to transfer the design to copper.

In addition to the illustrations Rubens also designed a title-page for the Roman Breviary (Plate 162). This represented a category of commission to which Rubens was to devote considerable energy and ingenuity over the rest of his life. He would

160. *Six Scenes from the New Testament*, c.1613. All in pen and ink with brown wash; the *Annunciation*, 5.3 × 11.7 cm; the *Visitation*, 9 × 4 cm; the *Nativity*, 10.2 × 3.8 cm; the *Annunciation to the Shepherds*, 9 × 3.8 cm; the *Adoration of the Shepherds*, 10.2 × 3.8 cm; the *Circumcision*, 4.6 × 11.7 cm. Pierpont Morgan Library, New York.

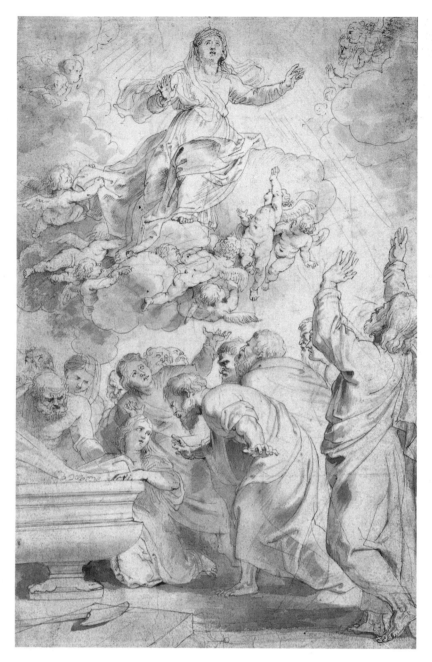

161. *The Assumption of the Virgin*, c.1614. Pen and ink with grey-brown wash over black chalk, 29.8 × 18.9 cm. J. Paul Getty Museum, Malibu.

162. Theodoor Galle after Rubens, Title-page to the *Breviarium Romanum* (Antwerp, 1614). Engraving, 34.8 × 22.5 cm. New York Public Library (Spencer Collection), New York.

of course have been familiar with the rich tradition of such works produced in the previous century, but in nearly fifty title-pages he designed he increasingly moved away from what had been done in the past towards a personal solution, combining a wealth of allegorical and symbolic meaning, some of which eludes us today. These designs reveal Rubens' genius in a different light from what he achieved in his painting, and although such work ranks low in the hierarchy of art forms it is evident that his willingness to perform was motiviated by intellectual stimulation rather than any financial gain. It represents a type of work in which meaning was paramount and form its handmaiden, and frequently one can see how the artist identified the various themes of the book and combined them in a richly allusive and compact design. Above all, this work offered an ideal vehicle for the exercise of his extensive classical learning.

It remains unclear how free a hand Rubens had in the overall design of the page, but with increased experience and authority he was probably allowed to do what he wanted by the printer. For the title-page of the Roman Breviary, a relatively early example of their collaboration, Moretus made at least three preliminary plans for the lay-out with the Biblical texts indicated in the appropriate places (Plate 163). But Rubens' final design (Plate 164) introduces modifications of his own, which suggests he was allowed the final say. Possibly inspired by Italian tomb sculpture, the title-page, which had to incorporate a good deal of text for both the title and the accompanying information favoured by publishers of the time, represents one of the simplest solutions, which Rubens was to employ again

144

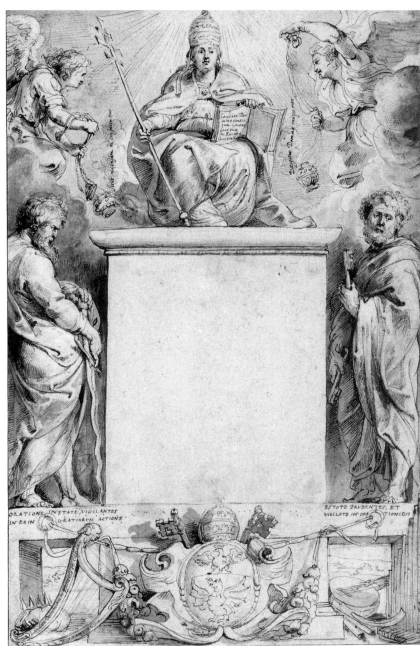

on a number of later occasions. Within a predominantly architectural framework, the design in shallow relief is divided into three zones of figures and text. The lowest, a base, includes the papal coat of arms in an elaborate cartouche and various musical instruments; in the middle zone Sts Peter and Paul stand on either side of a rectangular pedestal bearing the title of the book; at the top, the dominant figure representing the Church is seated below censing angels. Texts and inscriptions elucidate the meaning of the various figures and artifacts.

For the title-page of Lipsius's edition of Seneca's works (Plate 165), published by the Plantin Press in 1615, which also includes an illustration of the *Death of Seneca* based on the painting (Plate 92), Rubens devised an entirely different solution. The editor's portrait, based, as in Rubens' painting of *Lipsius and his Pupils* (Plate 93), on a lost painting by Janssens, is placed within an oval wreath with attached cornucopia resting on a plinth decorated with what appear to be Roman coins. A distant landscape stretches out behind. The engraving (Plate 166) includes a cartouche below as well as numerous inscriptions. Into this straightforward design Rubens packed an immense amount of allegory and other allusions. As Moretus explained in his foreword, the left-hand side, which lists the titles of Lipsius's principal publications, symbolises Doctrine, and the right side, with the cornucopia entwined by a snake, Prudence. Mercury's winged hat above may be intended as a reference to Lipsius's eloquence and reason. Further symbols and inscriptions add to the reader's understanding of 'the image of the most eloquent interpreter of wisdom'.

163. Balthasar Moretus's instructions for the title-page of the *Breviarium Romanum*, 1614. Museum Plantin-Moretus, Antwerp.

164. Title-page for the *Breviarium Romanum*, 1614. Pen and ink with brown wash over black lead or chalk, heightened with white, indented for transfer, 34 × 22.3 cm. British Museum, London.

165. *Portrait of Justus Lipsius*, c.1615. Pen and black and brown ink over black chalk, indented for transfer, 23.2 × 18.5 cm. British Museum, London.

166. Cornelis Galle after Rubens, Illustration to Justus Lipsius, *L. Annaei Senecae . . . Opera . . . omnia* (Antwerp, 1615). Engraving, 29 × 18.7 cm. Museum Plantin-Moretus, Antwerp.

In a much later title-page (Plate 167), for the collected works of the sixteenth-century Benedictine abbot Ludovicus Blosius, published in 1632, Rubens introduced yet another solution in which reality and image are nicely juxtaposed. Here the title is inscribed on an opened book which is being offered up by the author to Christ and the Virgin. As the dedication reveals, the book itself is being supported by the four monastic virtues of mystical contemplation, gentleness of bearing, humility and mortification of the flesh. These are symbolised by four women, one of whom is veiled, another accompanied by a lamb, a third looking down and the last carrying a scourge. The attributes carried by the angels above refer to the titles of various sections of the book as well as to its contents. Once again a relatively simple design has been made to bear a wealth of meaning. Consistent with the artist's manner of drawing at this period, the penwork has a softness and fluency emulating the effects of the brush, while the extensive play of light and shadow is suggested by profuse application of wash and bodycolour. The emphasis has changed from the linear precision of the earlier works to a preference for tonal richness.

How far Rubens identified with the content probably varied from book to book. Whereas his interest in some may have been limited to the artistic problem posed by the design of the title-page, in others he may have become more involved in the text itself. One of his earlier commissions was for a title-page and six illustrations to a lengthy book on optics written by the rector of the Jesuit college in Antwerp, Father Franciscus Aguilonius, and published by the Plantin Press in 1613. Aguilonius had been charged with teaching the exact sciences and his book was probably prepared in connection with this work. The city of Antwerp was sufficiently impressed by the importance of the work to award the author the sum of two hundred guilders on publication. For the only time in Rubens' career the

146

accompanying vignettes are specific illustrations of what is written in the text, rather than suitable accompanying subjects as he had done for the Roman Missal and Breviary.

Although two further volumes on refraction and reflection were planned, only that devoted to optics or direct sight was ever completed. In Rubens' illustration of the scenographic projection of shadows described in the sixth book (Plate 168), which the author regarded as the most significant part of his work, Atlas crouches on the ground studying the shadows cast by the armillary sphere on his shoulders, which is lit by a burning torch held by a flying putto. Two more putti, one armed with dividers, examine the relationship between a solid object and the shadow it casts on a flat surface. From various references he makes in the text, it is clear that the author was fully aware of the relevance of painting to the theories he was propounding. In his discussion of colour, he writes that 'nobody knows these things so precisely as painters'. What discussion there was between author and illustrator is not divulged in the text, but there can be little doubt that the subject would have been of absorbing interest to Rubens. At a later date his beautiful drawing studying the reflection of trees in water (Plate 169), which, as the artist inscribed on the sheet, 'is darker and more perfect in the water than the trees themselves', echoes Aguilonius's proposition that 'the closer the shadow is to an opaque body, the darker it is; and it appears to be even darker than the thing itself'.[118] This drawing can therefore be regarded as more than an acute observation of nature of the kind found in his earlier landscape drawings.

Rubens' scientific interests were not limited to those specifically connected with his art. He followed albeit with some detachment the preoccupations of the day. There are a number of references in his letters to the theory of perpetual motion and the machine for achieving it which the Dutch physicist Cornelis Drebbel had claimed to have invented. But in this instance, when Rubens finally had the

167. Title-page for L. Blosius, *Opera* (Antwerp, 1632). Pen and ink with brown wash over black chalk, heightened with white, indented for transfer, 30.8 × 21.1 cm. British Museum, London.

168. Theodoor Galle after Rubens, Vignette for F. Aguilon, *Opticorum Libri Sex* (Antwerp, 1613), Book VI (On Projections). Engraving, 10 × 14.6 cm.

147

169. *Reflection of Trees in Water*, 1630s. Black, red and white chalk, 27.3 × 45.4 cm. British Museum, London.

opportunity of observing the machine in operation in England where Drebbel lived, he wrote dismissively to his friend Peiresc, with whom he had discussed the subject six years earlier: 'As for the pepetual motion apparatus in the glass ring, that is just nonsense.'[119]

From such information as his daily attendance at mass, mentioned by his nephew, and from numerous references in his letters, it is clear that Rubens was a devout Catholic, who despite his interest in heretical sects such as the Basilidians and Rosicrucians was entirely orthodox in his own beliefs. His letters reveal his wide reading of the religious literature of the period. He counted a large number of men in holy orders among his friends, who as their portraits by him show were drawn from various orders such as the Carmelites, Franciscans and Capuchins. The Dominican Michel Ophovius (Plate 170), who was provincial of the order from 1611 to 1615 before his appointment as head of the Catholic mission in the United Provinces, was traditionally said to have been the artist's confessor. But if limited to no one order, his deepest contacts were with the members of the Society of Jesus, who as the favoured order of Albert and Isabella were playing the most active role in promoting the decrees of the Council of Trent. Already in Italy Rubens had been employed by the order both to paint altarpieces and to illustrate the biography of their founder, Ignatius of Loyola, and back home his contacts continued in a variety of ways. Apart from the illustrations he prepared for Fr Aguilonius, he collaborated in a number of pictures with the Jesuit flower painter Fr Daniel Seghers. He painted an altarpiece of the *Annunciation* (Vienna) for the chapel of the Jesuit Sodality in Antwerp very shortly after its foundation in 1609. He also became a member of this confraternity, later being appointed to the Council (1623) and the Secretaryship (1629), and through his association would have been kept closely in touch with the Society's progress.

His major work for the order was in connection with their new church in Antwerp. Although established in the city by 1585, the Jesuits only turned their attention to building their own church in the second decade of the seventeenth century. Begun in 1615 the main body of the church was consecrated amid much splendour six years later. Apart from being the first church to be dedicated to the founder of the order, its Italianate style of architecture and decoration offered much for admiration. Construction of the building had begun under the rector, Fr Aguilonius, but after his death in 1617 the design and supervision were assumed by another Jesuit, Pieter Huyssens, who was probably responsible for most of the architecture including the elevations. Although Brussels could boast of one or two Baroque churches, including one built for the Jesuits by Jacob Francart, the last

170. (facing page) *Michel Ophovius*, c.1618. Canvas, 104 × 82 cm. Mauritshuis, The Hague.

major public building in Antwerp had been the Flemish mannerist town hall completed over half a century earlier in 1565. This new building represented a complete break in style with traditional forms, and was in company with the Jesuit church in Brussels praised by Rubens, in his preface to the *Palazzi di Genova*, as magnificent examples of 'true symmetry in accordance with the rules of the ancient Greeks and Romans', which helped to banish 'the style of architecture known as barbarous or gothic'.[120]

Both the façade and the interior of the church contain many Italianate features. In general the former depends on Vignola's rejected design for the Gesù in Rome, which had already been copied more closely by Wenzel Cobergher in the Carmelite church in Brussels. The simple plan of the church with aisles and apse was essentially that of an early Christian basilica. Although their plans had to be submitted to the Jesuit authorities in Rome, neither of the architects had been to Italy and, though they could have learnt from drawings and engravings, the character of some of the detail suggests that Rubens, who as we know from a sketchbook now in Leningrad certainly made studies of architecture, may well have had a hand in some part of the design. Given his collaboration with Aguilonius, his opportunities for involvement in this major project need no explanation.

More definable is the part played by Rubens in designing much of the sculptural decoration. For both the figure and the decorative sculpture on the façade, he made several drawings, squared for transfer, such as the study for the cartouche supported by cherubs (Plate 172) immediately above the central doorway (Plate 171). He also prepared drawings (Plate 173) for the two high-relief marble angels, in poses derived from classical prototypes, which decorate the spandrels above the main door. In both cases the sculptors, probably members of the De Nole family, followed Rubens' designs exactly. In the interior, apart from designing the altar frames (Plate 129) with their sculptural decoration (Plate 125), he prepared a design for the stucco decoration with its various symbols associated with the Virgin for the ceiling of the Lady Chapel (Plate 181). (The motifs in the centre at either end were added by another hand.)

But Rubens' major contribution to the church was in the field of painting. His two large pictures for the high altar (Plate 126) had been executed early in the building's history. In March 1620, only eighteenth months before the consecration, Rubens signed a contract to finish before the end of the year thirty-nine paintings which were to decorate the ceilings of the upper and lower aisle galleries. The subjects were provided by the Father Superior, who retained the right to change them if he saw fit. Rubens contracted to prepare the designs with his own hand, but the execution was to be carried out by Van Dyck and other assistants, although the master was required to retouch where necessary. (Van Dyck was absent in England from November 1620 until March 1621, that is a month after the finished canvases were handed over, so could have played only a limited role.) In addition Rubens agreed either to paint another altarpiece for a side altar or to hand over, as he had done in the case of the paintings for the high altar, all his sketches. On this occasion he preferred the former, since he must have realised that they contained useful material either for reproducing the compositions in prints or for such future commissions as the Whitehall ceiling which had recently been mooted. His work for the Jesuit church, his first commission for decoration on a grand scale, reached him at the half-way stage between his report of 1614 that 'I am at present charged with more great works than I have ever had'[121] and his *cri de coeur* in 1625 that 'I am the busiest and most harassed man in the world'.[122] It was a major tragedy that in 1718 fire destroyed the nave and Rubens' ceilings. Apart from the choir, which was miraculously saved, our knowledge of the original appearance (Plate 175) depends on the existing oil-sketches as well as on copies of the final works by other hands.

The nave of the church was divided into nine bays. Although Rubens took no account of it in the chiaroscuro in his pictures, the galleries were strongly lit from

171. The central bay of the west front of the Jesuit church, Antwerp.

172. (facing page) *A Cartouche supported by Cherubs for the Jesuit Church*, c.1617–20. Pen and brush with brown ink over black chalk, heightened with white, squared for transfer, 37 × 26.7 cm. British Museum, London.

173. *An Angel blowing a Trumpet for the Jesuit Church, Antwerp*, c.1617–20. Pen and ink over black chalk, heightened with white squared for transfer, 24.5 × 28.3 cm. Pierpont Morgan Library, New York.

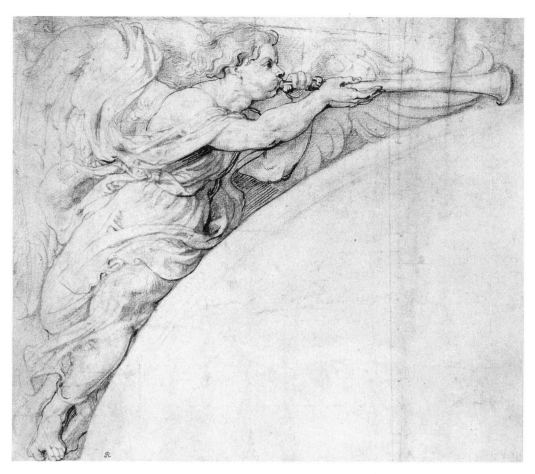

the side windows. In the vaults a sequence of alternating Old and New Testament subjects followed the traditional programme of type and antitype, in which certain subjects from the Old Testament were seen as prefigurations of persons or events in the New. The scene of *Esther before Ahasuerus* (Plate 179), in which the two protagonists were considered as the prototypes of the Virgin and Christ respectively, was, for example, paired with the *Coronation of the Virgin*. Following the pattern of the Sistine ceiling, the subjects started at the altar end and in alternating rectangular and octagonal frames progressed towards the west end. But given the height of the galleries it is doubtful whether the spectator would have been able to view the entire sequence from one standpoint. In the much darker aisles below, lit only from the nave, alternating rectangular and oval frames contained representations of the eight fathers of the Church (Plate 177) and eight female saints, who were, like *St Barbara* (Plate 176), mostly early martyrs. The fifth bay on each side was devoted to the glorification of the names or monograms of Mary (MAR) and Jesus (IHS, i.e. Iesus Hominum Salvator), which had been popularised by the Jesuits. To complete the series of thirty-nine scenes, canvases of three saints, including the patron saints of Albert and Isabella, Sts Albert and Clara, were placed under the organ loft.

In order to meet the terms of the contract Rubens was forced to work at a rapid pace, allowing him little time to meditate before he committed himself in his *modello*. This is perhaps reflected in the fact that there are only two existing drawings for the series, in each case for figures of the Church fathers (Plate 178). But he did produce at least seven small sketches in grisaille (Plate 176), which clearly served the same purpose. Probably executed hardly less rapidly than a drawing, the pictorial conception could more readily be transferred to the final oil-sketch. The sketch of *St Barbara* (Plate 176) shows the figure of the saint pursued by her father as she flees towards the tower where she is rescued by angels. The scene is brilliantly dashed in with brown and white paint over some preliminary drawing in black chalk in order to convey both form and chiaroscuro. Using this as a guide Rubens was able to work up the *modello* in both colour and detail to the

same degree of finish as the panel of *St Gregory Nazianzus* (Plate 177). Even here the fluidity of stroke and the relative summariness left much to be interpreted in the final canvas, and Rubens must have relied on the calibre of assistants such as Van Dyck to realise his conception. The oil-sketch rather than the drawing was increasingly to become the preferred method of preparation in later series of pictures.

The system of steep perspective of 45 degrees from below would have been familiar to Rubens from his study of ceiling decorations by Titian, Tintoretto and Veronese in Venice. The Venetian connection is especially apparent in the scene of *Esther before Ahasuerus* (Plate 180), in which there is an obvious dependence on Veronese's treatment of the same theme on the ceiling of S. Sebastiano (Plate 174), a work which was to influence Rubens even more fundamentally when he came to execute the Whitehall ceiling. Faced for the first time with the problems of decorating a ceiling, with its attendant problems of perspective and foreshortening, Rubens showed himself quick to learn within the brief period at his disposal. For the subject of *Esther before Ahasuerus* he produced two *modelli* which reveal the development of his ideas. In the first (Plate 179), which must be one of the earliest of the whole series and which was painted more richly than later *modelli*, he introduced a crowded composition with little space or architecture visible behind. In the more thinly painted reworking of the subject (Plate 180), apart from changing from a twelve-sided shape to an octagon, Rubens opened up the background to reveal the vast crowning dome of the hall with its balcony supported by columns, which provides a worthy setting for this regal scene. To accommodate the extra detail the figures were reduced in scale. The effect of Esther's lower position and more distinct separation from her supporters greatly increases her act of supplication. Whereas the figures weighed down upon the spectator in the first version, here they appear to float weightlessly above. Such additional refinements as the replacing of the dog beside Ahasuerus with the figure of a man lead to an even closer dependance on Veronese both in form and in function. The two *modelli* demonstrate how the foreshortening and perspective are more skilfully realised in the second version, followed in the final canvas, in order to create an image of space continued from the real world of the church below.

Rubens' paintings on the ceiling and the high altar with its accompanying

174. Paolo Veronese, *Esther before Ahasuerus*. Canvas, 500 × 370 cm. S. Sebastiano, Venice.

175. Sebastian Vrancx, *The Interior of the Jesuit Church*, *Antwerp*. Panel, 52 × 71 cm. Kunsthistorisches Museum, Vienna.

176. *Sketch for St Barbara pursued by her Father*, 1620. Panel, 15.5 × 20.7 cm. Ashmolean Museum, Oxford.

sculpture were, albeit the most important, only part of the decorative scheme in the church. With the combination of all the various elements in the design no longer visible, it is difficult today to appreciate the sheer sumptuousness which so impressed contemporaries. Something of the original effect of the interior on the viewer is vividly conveyed by a Jesuit writer: 'It is difficult to say what most strikes the eye, the brilliance of the gold or the polish of the marble. The floor, in blue and white marble, gleams like a mirror; the vault of the central nave is entirely covered with golden roses which shine between an uninterrupted series of gilded frames, giving the impression of a sky of massive gold'. And in a formulation of the ethos of religious Baroque art, he writes that 'The magnificence of the interior of the edifice turns the thoughts to the abode of heaven'.[123] But the opulence caused severe financial problems which eventually led to the dismissal of the superior for his continued expenditure on new buildings despite the growing debt, and to the general of the order forbidding Fr Huyssens from practising architecture for a period of time.

Built following the consecration of the church, the Lady Chapel (Plate 181 a–b), with its combination of painting, sculpture and architectural decoration lit by either direct or hidden lighting, established a pattern of Baroque decoration which was not only unique in the Netherlands but was in advance of what was happening in Italy, where such an ensemble of different media was only realised by Bernini in S. Pietro in Montorio fifteen or twenty years later. Surrounded by an old-fashioned style of architecture, it is hardly surprising that the Jesuit church became one of the most famous sights of the period. The Countess of Arundel, who paid a visit in the summer of 1620 before the paintings were completed, found it 'a marvellous thing'.[124] A year after Rubens' death John Evelyn on his journey

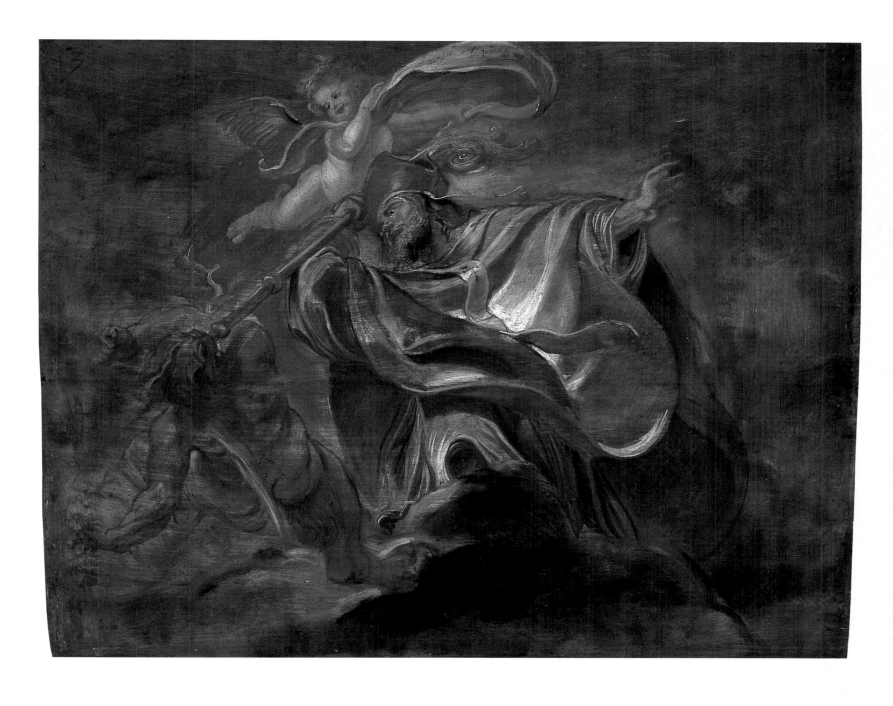

177. (above) *Sketch for St Gregory Nazianzus*, 1620. Panel, 49.4 × 64.8 cm. Allbright-Knox Art Gallery, Buffalo.

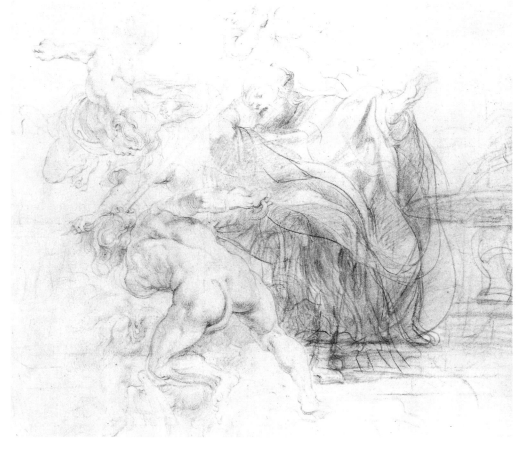

178. *St Gregory Nazianzus*, 1620. Black chalk with touches of white chalk, 41.1 × 47.6 cm. Fogg Art Museum, Cambridge, Mass.

through Antwerp wrote in his diary: 'I exceedingly admir'd that sumptuous and most magnificent Church of the Jesuites, being a very glorious fabrique without; & within wholly incrusted with marble inlayd & polish'd into divers representations of histories, Landskips, Flowers etc. . . . The Quire is a most glorious piece; and the Pulpet supported with fowre Angels, adorn'd with other carvings & rare Pictures wrought by the hand of Rubens now newly deceased.'[125] The day after the consecration of the church twenty years earlier, Rubens had written in connection with the decoration of the newly rebuilt Banqueting House in Whitehall to James I's agent in Brussels: 'regarding the hall in the New Palace, I confess that I am, by natural instinct, better fitted to execute very large works than small curiosities. Everyone according to his gifts; my talent is such that no undertaking, however vast in size or diversified in subject, has ever surpassed my courage.'[126] Although surely motivated by his recent success, Rubens may have also been expressing a more general truth about himself, one which, moreover, echoed what Fr Aguilonius had written in his book *Optics* in a passage equating the character of the artist with that of his work: 'those whose temperament is spirited and bold paint large shapes, noble gestures, profuse vestments, and render everything with greater power and energy'.[127] Since his return to Antwerp in 1609 he had given highly visible evidence of his temperament which increasingly came to match the image of the 'spirited and bold' artist described by Aguilonius.

179. *Sketch for Esther before Ahasuerus*, 1620. Panel, 48.5 × 56 cm. Akademie der Bildenden Künste, Vienna.

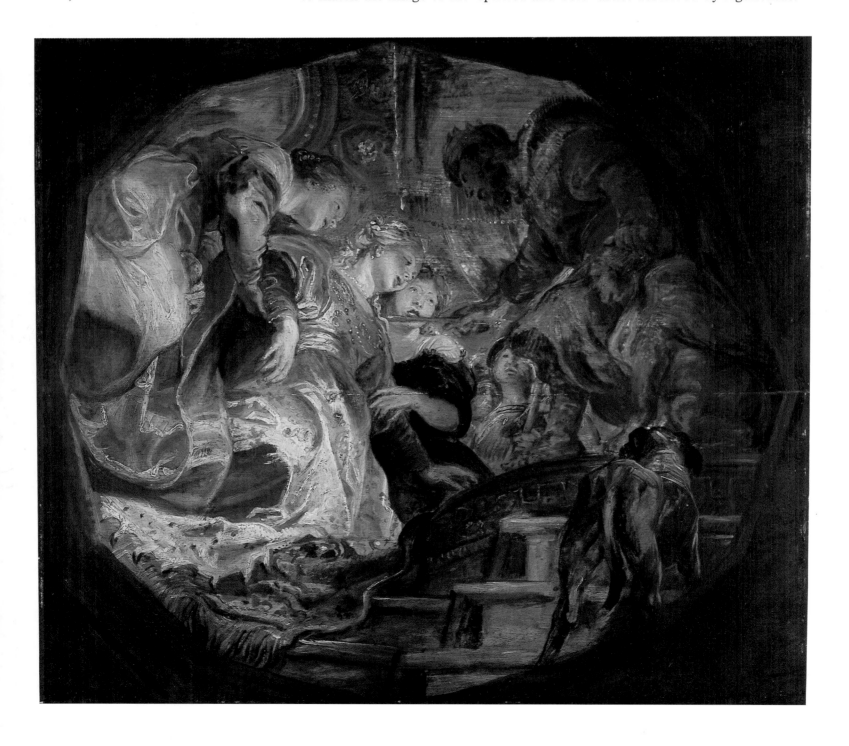

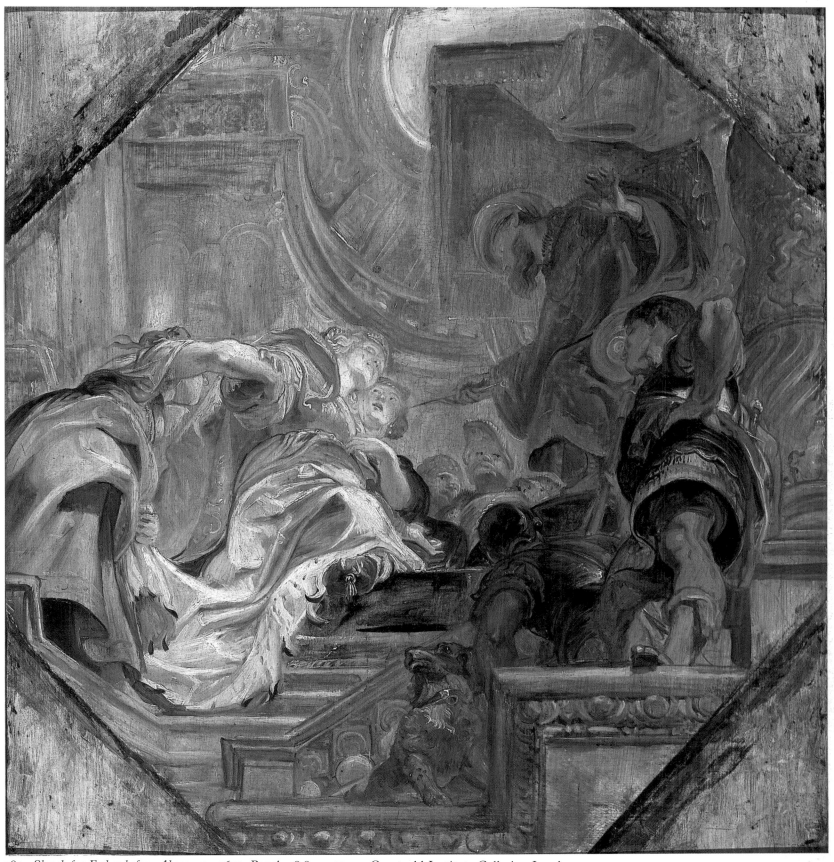

180. *Sketch for Esther before Ahasuerus*, 1620. Panel, 48.8 × 47 cm. Courtauld Institute Galleries, London.

181. *Study for the Ceiling of the Lady Chapel in the Jesuit Church, Antwerp*, 1620. Pen and ink with brown wash over black chalk, 48.5 × 35.3 cm. Graphische Sammlung Albertina, Vienna; and (below) the ceiling of the Lady Chapel.

182. Detail of Plate 180.

IV

'The whole world as my country'

IF THE British court did not at this stage avail itself of Rubens' services, a few months later another royal patron was to take him at his estimate of himself as an artist 'better fitted to execute very large works'. In January 1622 he was called to Paris by Maria de' Medici, widow of Henry IV of France, whose proxy marriage he had attended as a young man in Florence. Her quarrelsome marriage, which resulted in five children, abruptly ended with her husband's assassination in 1610, the day after her formal coronation as Queen of France. She then proceeded to reign as regent until her son Louis XIII came of age in 1614. With their respective favourites fuelling the fire, the new king and his mother soon quarrelled, and she was banished for several years to the provinces. In 1620 Maria de' Medici made peace with her son on his terms and was allowed to return to Paris largely through the skilful intervention of the rapidly rising Bishop Lucon, later Cardinal Richelieu. With the death in the following year of the king's favourite, the Duc de Luynes, her future looked rosy.

The queen mother immediately returned to the problem of embellishing her new home on the site of the *hôtel* of the Duke of Luxembourg on the Left Bank, designed by Salomon de Brosse (Plate 184). Although she had originally begun her building programme before her exile by asking her aunt, Cristina of Lorraine, to send her plans of the Pitti Palace, she settled in favour of a traditional French *château* consisting of *corps de logis*, two wings and a screen around a court. But the extensive rustication which decorates the elevations may have provided her with some reminder of her Florentine home. (Later in the century Bernini, generally critical of French architecture, was to declare that the building was 'the finest thing he had yet seen in France.'[1]) Like her ancestors, Maria de' Medici was keen to play the role of patron of the arts on a grand scale, and apart from commissioning painting and sculpture from various French and foreign artists to adorn the palace, she planned a major scheme of decoration consisting of two series of paintings to be placed in the two long narrow galleries running the length of the first floor of each wing. One cycle, adjoining the queen mother's private apartments, was to illustrate events from her own life, and the other from her late husband's. Had the project been fully realised, it would have consisted of forty-eight large canvases. It required not only a genius but a painter able to work on a grand scale, not readily available in Europe of this date.

A month after the commission had been given to Rubens in Antwerp, the queen's adviser, the Abbé de Saint-Ambroise, had publicly declared that 'two painters of Italy would not carry out in ten years what Rubens would do in four, and would not even think of undertaking pictures of the necessary size'.[2] Rubens' name was now well known in the courts of Europe, and apart from the fact that the queen mother's chief portrait painter was his fellow countryman and associate in Mantua Frans Pourbus the Younger, any necessary encouragement to entrust him with such a task would have been supplied by Maria de' Medici's friend and Rubens' patron the Archduchess Isabella. When the artist went to Paris to discuss

184. Israel Sylvestre, *The Luxembourg Palace, Paris*. Etching.

183. (facing page) Detail of Plate 185.

the project he bore gifts of a small dog and a necklace from Isabella to the French queen mother. The discussion lasted six weeks, during which time Rubens stayed on the Quai St Germain l'Auxerrois, just near the Pont Neuf. He then returned to Antwerp with a signed contract to decorate the two galleries, the first of which, devoted to 'the very illustrious life and heroic actions' of the queen, was to be completed in two years, and he set to work on what was the most diplomatic undertaking of his artistic career. The subject-matter of the Jesuit church cycle had presented no problems, but when he turned to the inglorious career of Maria de' Medici, considerable imagination, aided by an abundant use of classical allegory, was necessary to present the quarrelsome heroine as the embodiment of all the virtues. Rubens was equal to the task, but although he played a significant part in drawing up the incidents to be illustrated, taking great care to avoid contentious issues, the contract unequivocally gave the final decision to the queen herself. She could add or subtract subjects before they had been begun by the artist, and those that were finished could be altered according to her wishes. Although a number of the subjects presented no problems, there were, given the queen's history, some of a far more delicate nature, and debate about whether or how they should be treated went on up to the end. In the case of the *Flight from Paris*, when she had rapidly to escape arrest from Louis XIII, she decided at the last minute to suppress this subject entirely and Rubens was called upon to paint another more innocuous scene of the *Felicity of the Regency* (Plate 185). (Rubens himself rightly observed that if he had been allowed to devise more general allegories, as he was to do on the Whitehall ceiling, rather than records of specific events there would have been a great deal less trouble.) In other matters she was less intransigent, and she was talked out of her proposal to arrange the scenes by pairs across the gallery culminating at the end wall. The narrowness of the space made a continuous cycle starting at the left and continuing clockwise around the room a more satisfactory solution. But in a secret clause in the contract she reserved ten per cent of the total sum due to the artist, which would only be paid if she were fully satisfied with the final result.

To everyone's benefit the Luxembourg Palace took Maria de' Medici's mind off more tendentious political matters, and she occupied herself by maintaining a minute interest and general control over the building and decoration of her palace. As a permanent record of her creation she was planning to make up a commemorative album of all the drawings and plans connected with the building and the decoration both inside and outside, to which she naturally wished to add Rubens' designs for the cycle. Rubens himself saw only trouble from this proposal and was not prepared to hand them over unless he could be there to explain the meaning of each scene.

But the patron was not the only problem, and the artist had considerable difficulty in obtaining from the architect such basic information as the sizes of the larger spaces, as well as the positioning of doors and windows. Rubens was not to be blamed for the ultimate delay in completing the cycle. In the lengthy negotiations by letter, he must very quickly have realised the difference between dealing with the local Jesuits and coping with the complexities of a foreign commission from a monarch surrounded by advisers whose own interests often led them to offer conflicting advice. Compared with their constant machinations, the jealousy of the French painters which immediately surfaced after Rubens had departed for Antwerp must have seemed a forgettable irrelevance.

Bearing a now lost memorandum from the queen, Rubens left Paris in February 1622 with seven uncontroversial subjects agreed, and it may be with some grisaille sketches (see Plate 188) already executed to show the patron what he could do with the theme. At home, probably with the aid of many more drawings than we know today, Rubens immediately prepared coloured oil-sketches (see Plate 191) for all the subjects as they were agreed, in at least six cases making a revision in a second sketch. By May 1623 he was back in Paris with nine paintings completed. (The contract stated that Rubens was to paint all the figures in his own hand, although

185. *The Felicity of the Regency*, c.1625. Canvas, 394 × 295 cm. Musée du Louvre, Paris.

186. *The Death of Henry IV and the Proclamation of the Regency*, c.1621–5. Canvas, 394 × 727 cm. Musée du Louvre, Paris.

presumably he was allowed to employ his assistants on the background.) The queen mother made a special visit to Paris from Fontainebleau to see them, where they had to be kept in a specially locked room so that no unauthorised person could catch sight of them and start rumours about the content. The patron expressed 'a satisfaction for which words failed her, and she regarded Rubens as the first man in the world in his profession'. Even Richelieu could not but 'look at them and admire them'.[3] Perhaps more surprising was the fact that at this stage the French painters 'Vignon and Vouet admire you and your work ever more with each day'.[4]

Delays caused by the queen mother and the architect made the completion of the entire scheme very difficult, but the artist was hurried on by the queen who was very keen to have the decoration of the gallery completed in time for the festivities in connection with the wedding of her daughter, Henrietta Maria to the Prince of Wales. By the end of 1624 the cycle was at last finished, and, as commanded, the artist presented himself in Paris at the beginning of March 1625 to put the finishing touches to the works *in situ*.

The choice of the actual subject was not the only problem. As Rubens was aware from an early stage, subtle meanings conveyed by veiled allegory already caused misunderstandings and gave rise to different interpretations at the time. The delicacy of the situation can be inferred from the artist's praise for St Ambroise who on the occasion of the king's visit to the cycle 'served as interpreter of the subjects, changing or concealing the true meaning with great skill'.[5] A few years later when the series was celebrated in a descriptive poem, Rubens expressed 'annoyance that so great a poet . . . was not well informed in all the details of the subjects – details which are difficult to ascertain entirely by conjecture, without some explanation by the artist himself'.[6] And he goes on to say that 'I haven't the theme of those pictures in writing, and perhaps my memory will not serve as accurately as I should like'. If only three years after completion the artist himself was fearful of forgetting the finer points of the programme, it is hardly surprising that later generations have disputed the meaning of the whole cycle as well as the meaning of individual parts.

The series has been read as an elaborate act of propaganda celebrating the divine right of monarchy in an absolute age. It can also be seen as an illustration, in the

187. (facing page) Detail of Plate 186.

164

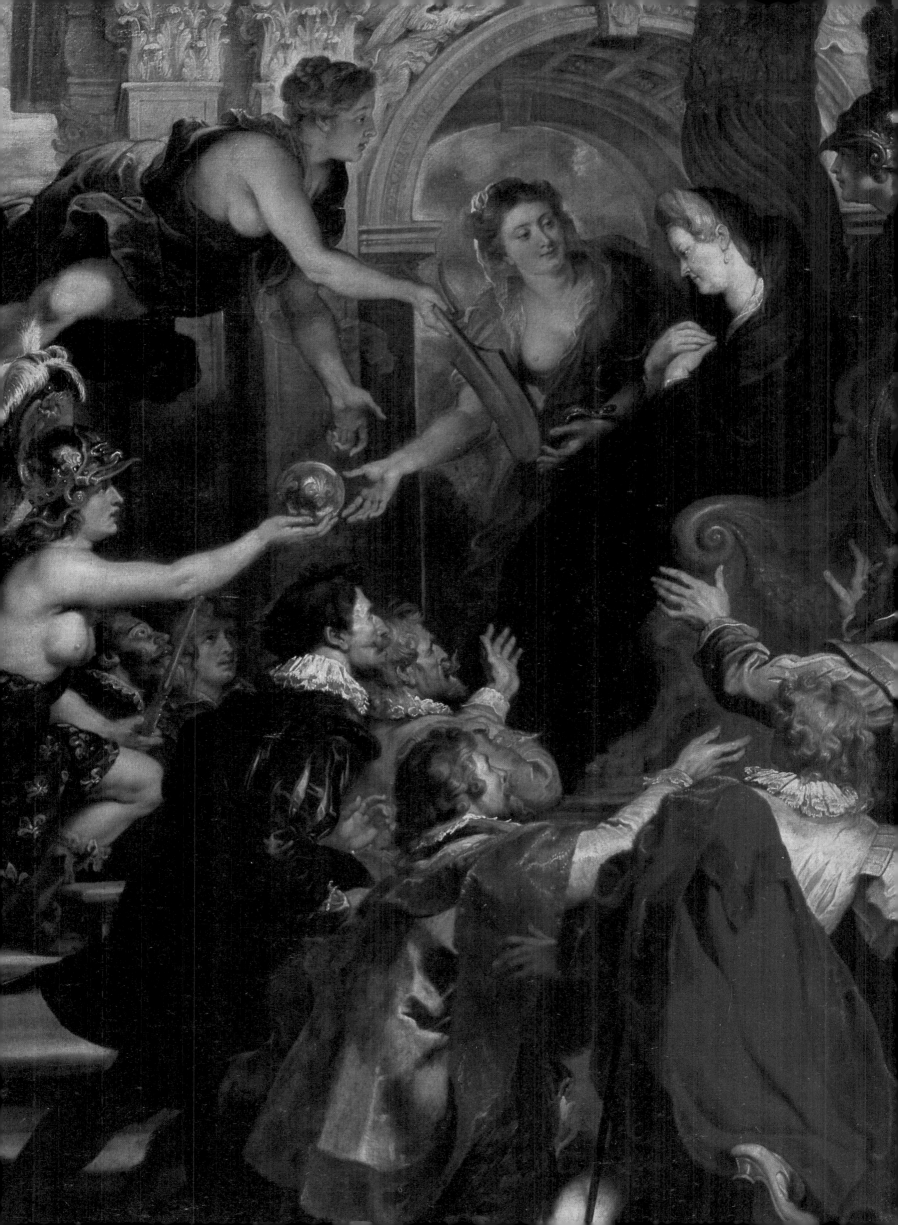

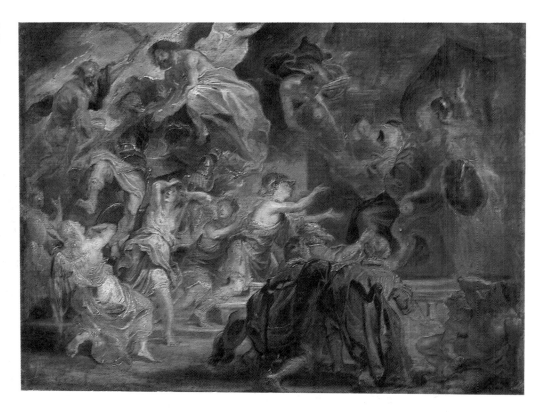

188. *Sketch for the Death of Henry IV and the Proclamation of the Regency*, 1622. Panel, 48 × 65 cm. Hermitage, Leningrad.

manner of Renaissance poetry, of a heroine whose strength of purpose leads her through adversity to a triumphant sequel. Clearly the inclusion of such inglorious events as her flights from Paris (finally suppressed) and from Blois would favour such an interpretation. Moreover, the queen herself proposed sculpted representations of consorts or mothers of great princes or figures of the past to be placed on the exterior of the dome over the entrance to the palace. But in view of the history of the commission it is probably wrong to expect a tightly defined theme to emerge. Numerous modifications were introduced as the work progressed. Originally the cycle was planned to end with the *Coming of Age of Louis XIII in 1614*, and was only later prolonged to include more contemporary events. Moreover, numerous minds – the queen mother, Richelieu, Peiresc, St Ambroise and Rubens himself – all played a part in devising the subjects, so that there was no overall begetter. In the end the successful portrayal of Maria de' Medici as a heroine could not but enhance her political power and pay tribute to the legitimacy of her position as a ruler , and hence made it necessary to deceive her son about the true meaning when he came to view the cycle.

Beginning at the entrance, the fenestration of the gallery provided a narrow upright field followed by eight uprights, approximately twelve by nine feet, on each wall, ending with a rectangular field identical to that on the wall at the far end. The chimney at the entrance end of the gallery provided space for three portraits, with that of Maria de' Medici as 'Queen Triumphant' in the centre establishing the keynote to the whole cycle. Following clockwise, the first wall depicted her early years and her marriage, and culminated in a large rectangular representation of her coronation. This adjoined the similar-sized scene combining the assassination of her husband, here diplomatically portrayed as an apotheosis, and the proclamation of her regency on the following day (Plate 186). These two events represented the turning point in her career and made a natural centre to the series.

The combination of the two subjects, which were conceived within one composition from the beginning, first occurs in a grisaille sketch (Plate 188), possibly executed on Rubens' visit to Paris when the contract was signed. The more upright format was probably due to the artist's ignorance of the eventual proportions of the wall. This was followed by a coloured sketch (Munich) which does not differ greatly from the final canvas (Plate 186). The progression of

166

Rubens' ideas in these three works reveals his concern for both the thematic and the formal balance between the group, with Henry IV raised up by two deities on the left and the queen with her entourage on the right. To begin with, the former was higher in the composition and therefore more visually dominating. Acknowledging the identity of the patron, the figure of the king was by the time of the finished canvas not only slightly lower than that of the queen but both he and his supporters had been placed further back in the composition. At the same time Rubens was preoccupied with creating a formal unity of the two very different groups. This was finally achieved through the two allegorical females in the centre, whose sorrowing faces are turned towards the king, but whose bodies begin the great arc of movement towards the queen, which echoes a similar flow created by the figures of the king and presiding deities above, repeated by the arc of the zodiac.

On the right of the composition the queen, dressed in black, is seated beneath Salomonic columns receiving the orb, a symbol of government, from a personification of France, surrounded by other personifications; a group of nobles, who in the first sketch were juxtaposed with naked beggars, plead on their knees, in defiance of historical truth, for her to accept. The design of this scene, especially the figures of the nobles with their arms outstretched, is very reminiscent of Caravaggio's *Madonna of the Rosary* (Plate 189), which Rubens had about this time helped to acquire for the Dominican church in Antwerp. This connection between the two works gives further strength to the 'Marian iconography' discreetly discernible in other parts of the series, which offers a characteristically Baroque play on the patron's name.

For the third scene, which began the sequence on the reverse wall, Rubens depicted the *Council of the Gods*. This gave him the opportunity for a classical allegorical scene of a kind that he was anxious to include and which he thought would be suitable for the series in general. And when he came to compose the subject he introduced a large number of clearly recognisable derivations from classical statuary. From the inception of the series Rubens had intended to 'retain in the larger compartments' the three subjects, adding that 'I believe that this would be very suitable'.

The continuous sequence of more controversial events from the later life of the queen, which had posed the greatest problems in drawing up the programme, was interrupted by the last minute substitution of the allegorical *Felicity of the Regency* (Plate 185) for the historically real and painful *Flight from Paris*. For this new picture we are fortunate in having Rubens' own description: 'This shows the flowering of the Kingdom of France, with the revival of the sciences and the arts through the liberality and the splendour of Her Majesty, who sits upon a shining throne and holds a scale in her hands, keeping the world in equilibrium by her prudence and equity.'[7] Probably seen in the role of Astraea, the just goddess of the Golden Age, she is flanked by Cupid and Minerva, with whom as goddess of peace she was often compared, as well as various allegorical figures with flattering connotations. At the left Saturn is shown leading the figure of France forward in anticipation of more peaceful times. A wealth of other figures and objects symbolise the happiness of the reign and the flowering of the arts and sciences. The unmistakeable echo in the composition of the traditional *Sacra conversazione* hints once again at the association of the Queen of France with the Queen of Heaven. It is a highly professional image of Baroque adulation at which Rubens was so adept. What understandably gave him particular satisfaction was the vindication of his arguments from the start in favour of general allegories rather than actual events: 'This subject, which does not specifically touch upon the raison d'état of this reign, or apply to any individual, has evoked much pleasure, and I believe that if the other subjects had been entrusted entirely to us, they would have passed, as far as the Court is concerned, without any scandal or murmur. [In margin:] The Cardinal perceived this too late, and was very much annoyed to see that the new [i.e., historically later] subjects were taken amiss.'[8]

189. Caravaggio, *The Madonna of the Rosary.* Canvas, 364 × 249 cm. Kunsthistorisches Museum, Vienna.

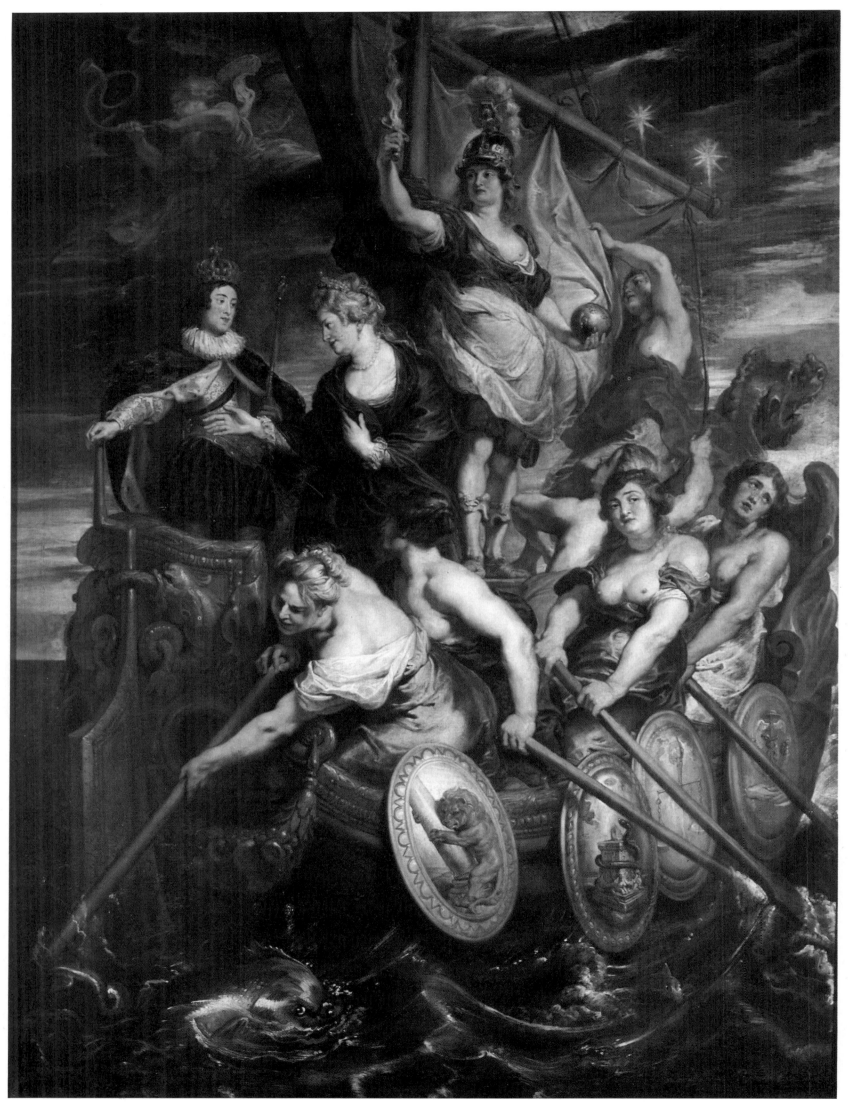

190. *The Coming of Age of Louis XIII in 1614*, c.1621–5. Canvas, 394 × 295 cm. Musée du Louvre, Paris.

For the next subject in the series, the *Coming of Age of Louis XIII in 1614* (Plate 190), we possess the only surviving drawing of a whole composition (Plate 192). It shows the kind of rapid aide-mémoire which Rubens working under intense pressure also probably made for other parts of the series. It contains the barely discernible essentials with identifications inscribed beside the allegorical figures. This initial idea was substantially modified in the following stage of the coloured *modello* (Plate 191) and the composition was reversed probably to take account of the fact that the spectator would approach this scene from the left. At the same time the artist increased and rearranged the figures. The two female oarsmen, personifications of virtues, were doubled in number, and shown facing outwards. (X-rays of the *modello* reveal that at first only three were included, two with their backs to the spectator and a third in the stern.) The figure of France watching over the event was placed beside the mast in the centre of the composition. More important for the iconographical subtleties, the figure of the queen mother is moved nearer her son, so that the gesture of her right hand becomes an invitation to share in the ruling of the country.

In the final canvas (Plate 190) Rubens not only spelt out the detail, such as adding emblems to the shields of the Virtues, but made further small but

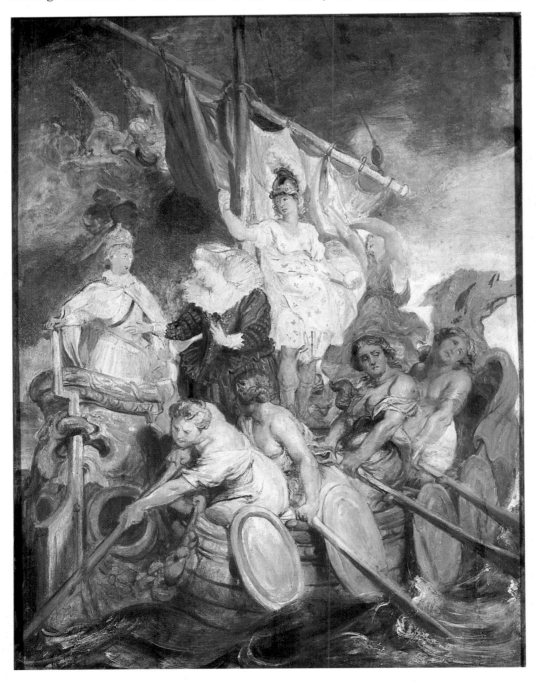

191. *Sketch for the Coming of Age of Louis XIII in 1614*, 1622. Panel, 64.9 × 50.1 cm. Alte Pinakothek, Munich.

192. *The Coming of Age of Louis XIII*, c.1622. Pen and brown ink, 21.8 × 21.6 cm. Musée du Louvre, Paris.

193. *Maria de' Medici*, c.1622. Black and red chalk, heightened with white, 34 × 24.7 cm. Victoria and Albert Museum, London.

significant alterations. Whereas the queen mother was previously dressed in a fashionable garment of the period, she is now shown in a timeless, draped costume. To heighten the impact on the spectator, the position of the boat was raised bringing the figure of France nearer the top of the canvas. The additional area of sea, which now includes a dolphin as an emblem of Louis as dauphin, gives increased perspective to the scene. As an aid to his portrayal of the queen mother, only summarily indicated in the oil-sketch, Rubens made a drawing (Plate 193), which tellingly describes her distinctive and far from beautiful features but which also conveys a lively expression not transposed to the canvas. Seemingly done from the life, the drawing might equally well have been based on the small bust of the sitter which, with that of her late husband, was sent to the artist to assist him in obtaining likenesses in their numerous appearances in the series.

The gradual development of this scene reveals the amount of careful preparation given to the series, which required shaping and moulding into an ideal balance of form and content. In approaching such a monumental task, Rubens must have recalled the experience of Primaticcio, who had worked in comparable circumstances for Francis I at Fontainebleau, and it is not surprising that there are reflections in the Medici cycle of the latter's equally grand cycle in the Galerie d'Ulysse (now destroyed). What only becomes apparent in the final canvases, with the exception of the last-minute *modello* for the *Felicity of the Regency* (Munich), is the sheer sumptuousness of colour and detail. The prevailing colours of red, blue, yellow and gold are beautifully varied throughout the cycle and are accompanied by a wealth of detail. With masterly skill and characteristic vigour Rubens successfully puts over scenes from an undistinguished and uneventful life in a varied mixture of history, portraiture, allegory and mythology with undertones of religion. It is perhaps the sheer magnificence of the whole series that impresses the spectator today. The queen mother's contemporaries would have regarded this reaction as entirely appropriate, since it was a quality she was widely recognised as possessing. Her funeral oration paid particular tribute to her liberality and magnificence, both of which are fully displayed in Rubens' series of paintings.

At the same time as he was working on the Medici cycle, Rubens received

another commission from the French capital for a series of twelve tapestry cartoons of subjects taken from the life of Constantine. These were to be woven in the St Marcel shop in Paris, which had been founded by Henry IV with the aid of two Flemish *tapissiers* and a team of Flemish weavers, who were later to receive a pension from the king's widow. As was the case with the *Decius Mus* series, Rubens' cartoons did not include designs for the borders, which were left to the invention of the shop. Four cartoons on paper executed by assistants from Rubens' *modelli* arrived in Paris in November 1622, followed by a second and probably final consignment in January of the following year. By 1625 seven of the subjects had been woven and were presented by Louis XIII as a farewell gift to Cardinal Francesco Barberini, who had been on a mission to France on behalf of his uncle, Urban VIII. Other complete sets were eventually woven.

What remains undiscovered is who was responsible for the commission. Credit for this is often given to Louis XIII; not only were the first four cartoons to arrive put aside for his inspection but the artist himself when complaining of non-payment in 1626 refers to 'those tapestries I did in the service of His Majesty'.[9] But other evidence including the fact that both Rubens' cartoons and his *modelli* became the property of the shop suggests that the commission was a speculative venture between the *tapissiers* and the artist with the intention of attracting the king. This venture may not be unrelated to the artist's thoughts in 1623 of making a permanent move to Paris, which could offer far greater prospects of royal patronage than Flanders, although his increasing awareness of the unstable political situation must have soon cooled his enthusiasm.

Although no direct parallels can be convincingly drawn between the lives of Constantine and Louis XIII, the former's position as the first Roman emperor converted to Christianity made him a highly suitable figure from the past through whom to praise a living monarch by association. The artist's literary source was probably Cardinal Cesare Baroni's *Annales Ecclesiastici*, a set of which Rubens had bought from Moretus in 1620. As had been the case with *Decius Mus*, this commission gave him the opportunity of realising in visual form his studies of Roman art and life. His new friend Peiresc, who inspected the first set of cartoons, 'greatly admired your deep knowledge of antique costume and the precision which you have applied even to the nails of the boots',[10] even if some of Peiresc's companions went on to voice some criticism about the excessive curvature of the men's legs. For Rubens it was an attractive invitation to turn his attention once again not only to antique sculpture but in certain cases to its Renaissance interpreters, Raphael and Giulio Romano. In the *Triumphal Entry of Constantine into Rome* (Plate 194) Rubens took both the figure of Constantine and those of the two kneeling men from a relief of the *Triumphal Entry of the Victorious General* on the Arch of Constantine in Rome, which shows the emperor on his way to the Palatine and the triumphal arch erected by the senate. But, as sometimes happens to tapestry designs, the format was altered when transferred to the loom and the balanced grouping in Rubens' *modello* was squeezed uncomfortably in the tapestry (Plate 195). The subtlety of tones seen in the *modelli*, which may already have been lost in the cartoons, is totally absent in the tapestry. The relative loss of quality in transferring his original designs makes Rubens' hard-headed attitude towards his work for the medium understandable.

By dint of hard work and the neglect of other people's commissions, the first Medici cycle was finished. Though the paintings were admired, Rubens was already the victim of political manoeuvres and personal jealousies. 'I am somewhat concerned about my own personal affairs, which certainly suffer because of the public events. In this pressure of public affairs I cannot make any requests without incurring the blame of fatiguing the queen with private matters.' Though he was kept away from Maria de' Medici, he consoled himself with the reflection that 'I am certain that the queen mother is very well satisfied with my work, as she has many times told me so with her own lips, and has also repeated it to everyone.'[11] Apart from natural jealousies of certain French courtiers and

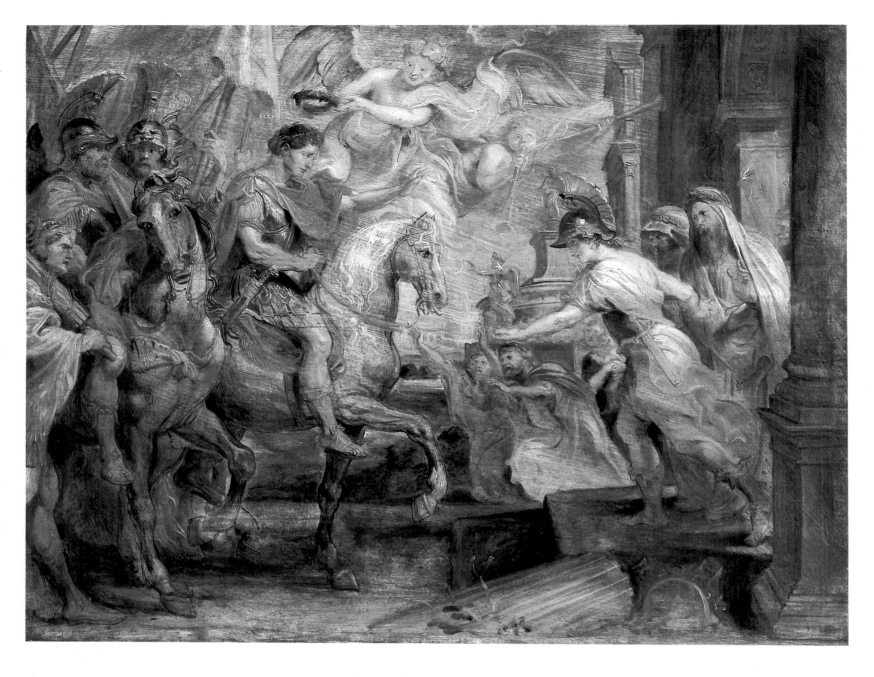

194. (above) *Sketch for the Triumphal Entry of Constantine into Rome*, 1622. Panel, 48.6 × 64.5 cm. Clowes Fund Collection, Indianapolis.

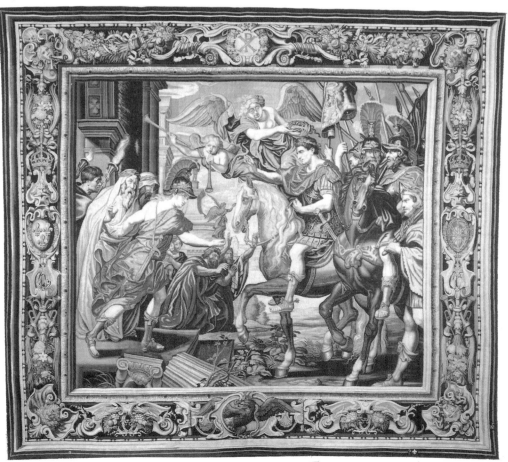

195. *The Triumphal Entry of Constantine into Rome*, 1623–5. Tapestry, 327.7 × 377.2 cm. Philadelphia Museum of Art.

artists, the prime cause of Rubens' disenchantment with the French court was none other than Richelieu. In the four years that Rubens had taken to execute the first part of the commission the cardinal had risen rapidly and become all-powerful. By 1625 he had begun to recognise Rubens as a political adversary, astutely identifying him as a future agent of the Hapsburgs through the person of the Archduchess Isabella, acting against the best interests of France. In a subplot, as the quarrel between Richelieu and the queen mother intensified, so the dislike between the two men increased. The favourable impression Rubens had of Richelieu when they first met rapidly deteriorated, and nearly ten years later in a rare bout of righteous anger at the news of the queen mother 'cast out by the violence of Cardinal Richelieu', he castigated the latter for having 'no regard for the fact that he is her creature, and that she not only raised him from the dirt but placed him in an eminent position from which he now hurls against her the thunderbolts of his ingratitude . . . surely we have in our time a clear example of how much evil can be done by a favourite who is motivated more by personal ambition than regard for the public welfare and the service of his king'.[12]

Where art was concerned Rubens must have found a teasing quality about Richelieu's patronage. At the time that most of the artist's energies were being devoted to finishing the Medici series, Richelieu wanted a small picture from Rubens in a furious hurry, whereas Rubens would have prefered it 'larger, for I guard against falling short in his service',[13] and to have painted it in reasonable time so the colours could dry. Subsequently one correspondent wrote that the cardinal wanted two more pictures from him, while the Flemish ambassador reported to the artist that 'the paintings of the second gallery of the queen are to be given to an Italian painter, notwithstanding the contract with me'.[14] Characteristically both reports were essentially true. The cardinal preferred the art to the artist.

For the present, Rubens was ignored at the French court. The programme for the second cycle, devoted to the life of Henry IV, had already been drawn up by the artist. The surviving sketches show that the active, warlike exploits of the king needed no disguising or decorating with allegory. The subject appealed far more than that of the first cycle and Rubens enthusiastically looked forward to its execution, but by this time he was well enough acquainted with French intrigue to 'believe there will not fail to be difficulties over the subjects . . . which ought to be easy and free from scruples'.[15] His forebodings were to some extent confirmed by the fact that the cardinal had the programme in his hands but refused to discuss it on the excuse that he was fully occupied with affairs of state. With a feeling of despair, Rubens exploded: 'I am tired of this court, and unless they give me prompt satisfaction, comparable to the punctuality I have shown in the service of the queen mother, it may be (this said in confidence, *entre nous*) that I will not readily return.'[16] And it was not the only court of which Rubens was to complain.

In retrospect, in his own country, Rubens was calmer but hardly less bitter: 'when I consider the trips I have made to Paris, and the time I have spent there, without any special recompense, I find that the work for the queen mother has been very unprofitable to me'.[17] And he could not help comparing the court of Flanders with the court of France. A relatively small and unimportant court had advantages: 'Here we go on in the ordinary way, and each minister serves as well as he can without overstepping his rank; and in this manner each one grows old and even dies in office, without expecting any extraordinary favour, or fearing disgrace. For our princess shows neither hate nor excessive love, but is benevolent to all.' But of course there was a price to pay: 'this Court is sterile and offers no news like that of France, which, by its great size, is subject to momentous changes'.[18] As Rubens himself was the first to own, his contacts with the Parisian court were not all loss. In the first place he made an important new acquaintance in the figure of the Duke of Buckingham, who was to play a large role in the artist's future. On a more intimate level, Rubens made a lifelong friend in Nicolas-Claude Fabri de Peiresc (Plate 196).

196. Lucas Vorsterman after Antony van Dyck, *Nicolas-Claude Fabri de Peiresc*. Engraving, 23.8 × 15.7 cm. British Museum, London.

D NICOLAVS FABRICIVS DE PEIRESE Regius in
Aquiseztienfi Curia Senator etc.

Peiresc, three years younger than Rubens, was a Provençal who had a rugged, uncouth appearance, with sharp eyes indicative of his keen intellect. Describing his face, Rubens spoke of 'a certain intellectual power, and that emphasis in the glance'.[19] Ostensibly studying law in Padua, he had become passionately attached to Italian art and history, both ancient and modern, and in his spare time he made himself into a distinguished Renaissance scholar. After his stay in Italy, he had travelled widely in Northern Europe, meeting and making friends with scientists, scholars and artists, before he settled in Paris in 1616. In 1619 he had been instrumental in helping Rubens to obtain copyright for his prints in France, and two years later the two men, introduced by their mutual friend Jan Caspar Gevaerts, were in correspondence over a subject which was to be of perennial interest to them, engraved gems and cameos. Their meeting in Paris in 1622 set the seal on their friendship, and shortly afterwards Peiresc wrote that Rubens 'is very erudite in every branch of Archaeology and so sweet in manner that one could not meet anyone more delightful',[20] while for his part the artist was later to recall 'the charm of his conversation'.[21] The personal contact limited only to Rubens' first two visits to Paris must have quickly established that they had sufficient in common to nourish a correspondence that lasted for a lifetime, only broken for a short period when Rubens was in political disfavour in France.

But their relationship was to some extent stimulated by their different attitudes. Peiresc was essentially a scholar and an antiquarian, who was often as much interested in works of art for the light they threw on the society that produced them, as for their intrinsic beauty. By comparison Rubens tended to maintain a strict sense of quality. In a long and eloquent letter written shortly before they met, Peiresc defined their differences: 'I am not surprised that you find more pleasure in looking at antique works of fine rather than mediocre workmanship; everyone is moved to like what is equal to his own capacities or which accords most closely to his own inclinations.' Although he started with the same viewpoint, Peiresc came to realise that for a complete understanding it was essential to value works of poor quality 'which help to fill the gaps in ancient history during the most barbarous or obscure periods'. In collecting terms it could be reduced to a straightforward division: 'You prefer precious stones; without doubt the value of the stone alone and the merit of the workmanship of a fine artist are incomparably superior to those of a medal; but for those who carry a torch to the history of antiquity, medals are far more important.'[22] On meeting him, Peiresc must quickly have discovered that Rubens was not limited by aesthetic considerations, as he had already proved in his joint book with his brother on Roman life and customs. If Peter Paul did not actually formulate it, he would certainly have agreed with Philip's opinion that antique coins and gems were especially valuable 'for a fuller understanding of antiquity'.[23] And shortly after their first meeting Peiresc was moved to say that 'In matters of antiquity he [Rubens] possesses the most universal and remarkable knowledge I have ever seen',[24] adding a decade later that he was 'well versed in speculating on ancient works'.[25]

In view of Rubens' secrecy about this part of his collection, it is difficult to discover exactly what coins and gems he owned. Despite his preference for gems, he possessed what Peiresc believed to be a substantial holding of coins and moreover was sufficiently engaged in the subject to make drawn copies of certain of them. Although in 1619 his keen financial sense led him to describe the collection of ancient coins and medals belonging to the deceased Duke of Aerschot as 'trinkets'[26] bought at the top of the market, he acquired several examples for himself. (Encouraged by Rockox, the principal agent in disposing of the collection, the artist took the majority with him on his second visit to Paris, where Peiresc helped find a purchaser.) His taste for rare gems had been nourished on the collections he studied in Rome, Florence and above all Mantua, where he not only saw the celebrated Gonzaga Cameo several times, but 'have even held it in my hands . . . I believe that among cameos it is the most beautiful piece in Europe.'[27] He was already collecting gems in Italy and continued to do so with the same

enthusiasm as other works of art. Apart from a few dating from the Hellenistic age, the majority of his gems were Roman imperial pieces with some from a later period. As one might expect, those with inscriptions were of far less interest than the gems with pictorial representations which could be treated primarily as works of art. He had a remarkable feeling and understanding for the indigenous qualities of the medium. Referring to the 'divine cameo [a Roman gem inscribed *Sostratus*] . . . which, because of its excellence, I kept from the sale of my antiquities to the Duke of Buckingham', he wrote to Peiresc that it 'consisted of nothing but the head of Octavius Augustus. The part preserved was white on a background of sardonyx, with a garland of laurel in sardonyx in high relief, of workmanship so exquisite that I do not recall ever having seen the like . . . This is my favourite gem, among the many that have come into my hands.'[28]

Before they met, Peiresc had also gathered together a large group of antique coins and gems. Shortly after their first meeting Peiresc sealed their friendship with a gift of gnostic gems to Rubens, who replied, 'I have never in my life seen anything that gives me more pleasure than the gems you have sent me',[29] and then proceeded to discourse eloquently on the erotic nature of the gem with 'the *diva vulva* with the butterfly wings'. (Ironically this appears to have been a fake.) Arising from their first exchange of letters about the two cameos mentioned below, and Rubens' plan to publish his own collection, the two men conceived an ambitious project to produce a study of the more important gems, illustrated by engravings made from drawings by Rubens and accompanied by a text written by Peiresc.

This publication was to involve others, including Nicolaas Rockox (whom Rubens found 'well disposed to participate, but', clearly showing himself to be a man of the world in these matters, 'on condition that it is certain to be carried out'),[30] and the famous Italian scholar and antiquarian Cassiano del Pozzo, who met Rubens in Paris in 1625 and was, according to Peiresc, one of his keenest admirers. The *clous* to the project, which would have described some twenty to thirty works, were the two great antique cameos, the *Gemma Tiberiana*,

197. *Copy after the Gemma Tiberiana (The Glorification of Germanicus)*, 1622. Pen and brush and brown ink, heightened with white, 32.7 × 27 cm. Stedelijk Prentenkabinet, Antwerp.

198. *Copy after the Gemma Tiberiana (The Glorification of Germanicus)*, 1626. Canvas, 100 × 78 cm. Private collection, England.

discovered in the Ste Chapelle in Paris in 1620 by Peiresc and reinterpreted by him, and the *Gemma Augustea*, then in the imperial collection in Vienna, both of which Rubens copied for the engraver, using a cast of the latter as his model. His drawn copy of the *Gemma Tiberiana* (Plate 197), made in Paris in 1622, did not reveal the variety of colours in the layers of sardonyx, and on their final meeting the following year Rubens promised Peiresc a coloured drawing as a companion to the painted copy by Niccolo dell'Abbate of the *Gemma Augustea*, which the Frenchman already owned. Reminded of his promise two years later, Rubens replied somewhat tartly, 'I find (if you will pardon me) that you speak much more of it than I should like, to a man of good intentions but limited capacity'.[31]

But, despite other pressures on his time, Rubens sent the finished copy (Plate 198) via Peiresc's brother in Paris the following year, accompanied by the following observations: 'In order to avoid the most serious difficulties it has been necessary to give up the attempt to observe so precisely all the variations in the stone which you probably remember, as, for example, the white, which becomes more pallid or grey in places. I have been obliged to represent only the white and the upper and under layers of the sardonyx.'[32] Peiresc was nevertheless delighted with the result, finding it 'astonishingly successful and of admirable effect', so that by contrast Dell'Abbate's copy appeared 'dead and valueluess'.[33]

But, as Rockox shrewdly suspected, nothing came of the proposed publication apart from a frontispiece and some engravings made under Rubens' supervision. Instead of keeping to the original modest plan which could have been realised by 1625, the project, probably due to Peiresc's antiquarian enthusiasm, developed into a major undertaking covering coins, bas-reliefs and other antique works as well as the original cameos, at which point Rubens appears to have lost some of his initial keenness. He was, moreover, becoming increasingly involved in diplomacy, and, writing about his painted copy of the *Gemma Tiberiana*, admitted that 'these are only matters of pleasure, but if my life depended on it, I could not do otherwise, with all these hindrances of so much travelling'.[34] It was left to his son Albert to take the project a stage further, but even then it never advanced as far as publication.

Allied to their joint studies of cameos and gems went the joys of collecting, and it is in this area that the artist and archaeologist differed in their tastes, even if they found enough in common in their respective collections to exchange casts of selected items. Peiresc had agents in Asia and Egypt who were busy procuring exotic plants, papyri and so on, indeed anything which would serve to illustrate the past, so that his house in Provence, which included an observatory, became a

199. *Agate Vase*, late 4th or early 5th century. Ht. 19 cm. Walters Art Gallery, Baltimore.

museum of entirely heterogeneous objects. It also housed a self-portrait by Rubens sent in exchange for a portrait of Peiresc. He spent the last five years of his life there, cut off from sympathetic friends but protected from loneliness by the vast volume of his correspondence, much of which was used as curling-papers by his niece after his death. It was above all to 'this pearl of honour' in Antwerp that he turned his thoughts; 'I hold there is no more lovable soul in the world than Mr Rubens'.[35]

Probably Rubens' most unusual possession was the late fourth or early fifth-century agate vase (Plate 199) decorated with the heads of pan and acanthus leaves and vines. It had belonged to the Duke of Anjou and later entered the royal collection at Fontainebleau from where it was stolen in 1590. It reappeared at the Fair of St Germain in 1619, where Rubens apparently bought it, although since he is not known to have been in Paris at the time the exact details of the purchase remain a mystery. In view of its rarity and history, it remains a mystery of a different kind that sometime between 1626 and 1628, when he was negotiating the sale of a large part of his collection to the Duke of Buckingham, he either chose or was persuaded to sell it to Daniel Fourment, his future father-in-law, who exported it to the East Indies, where as a result of a shipwreck it was confiscated by the Dutch East India Company. Despite his keen efforts Rubens was unable to retrieve it, and had to rely on a cast and his drawing when discussing it with

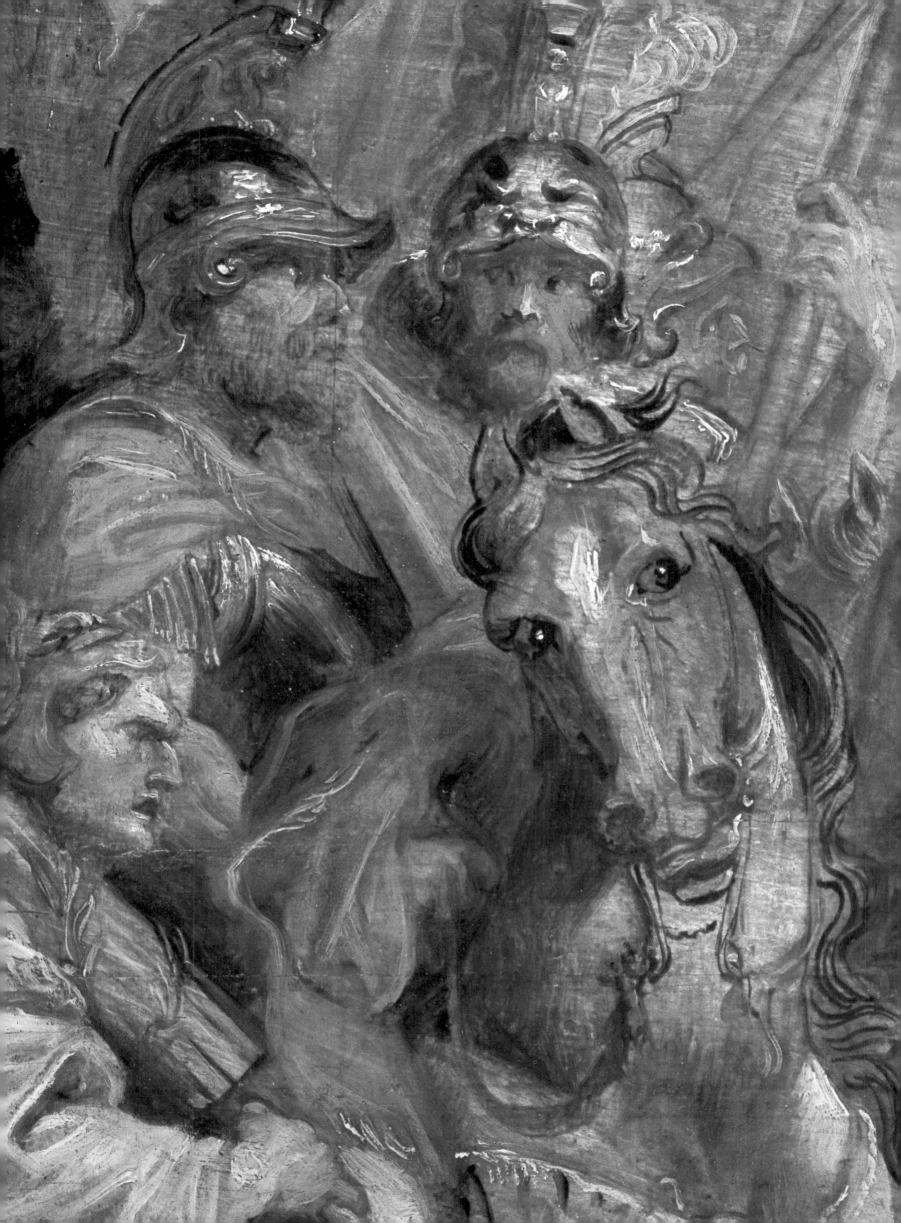

201. Detail of MS letter from Rubens to Peiresc with sketches of an ancient tripod, August 1630. Pierpont Morgan Library, New York.

202. *A silver Spoon or ancient Porringer*. Pen and ink with brown wash with touches of white body-colour, 22 × 28.5 cm. Bibliothèque Nationale, Paris.

Peiresc. Although attached to his possessions, Rubens does not appear to have been sentimental when parting with them.

Coins and cameos were not the only subjects in common. Except for Peiresc's first letter they corresponded in Italian rather than French, a language in which Rubens was markedly less fluent. They deciphered epigrams and exchanged drawings and learned opinions on such archaeological items as an Egyptian mummy in the artist's collection, an ancient tripod dug up near Aix-en-Provence (Plate 201), a Roman helmet in the Arundel collection, and ancient Greek methods of weighing still used in Spain. One cannot but smile at Rubens' response to the arrival of his friend's research on the subject of the tripod; 'I have had no time these days, either yesterday or today, to read your discourse on the tripod, which doubtless touches on all that falls under human intellect in this matter. Nevertheless, according to my accustomed temerity, I shall not fail to state my own views on this subject',[36] which he then proceeds to do at length without entertaining Peiresc's views. Peiresc was not the only recipient of these disquisitions. Rubens had been introduced by him to the apostolic nuncio in Brussels, Guidi di Bagno, and in a long letter to the latter, the artist, 'though deprived of books and my notes',[37] discoursed most eloquently on the Temple of Diana at Ephesus. Allied with his passion for works of art was the phenomenal memory so essential to the scholar and, one may add, to a painter so indebted to the art of the past. Twenty years after he had seen the *Aldobrandini Wedding* he was able to give Peiresc a detailed description of it, adding modestly that 'this is all I can tell you vaguely, *memoriter et ex tempore*'.[38] As these incidents show, Rubens could not resist the temptation of showing off to his friends.

While he was still in Paris Peiresc played an important role in soothing the artist's often ruffled feelings and solving difficulties over the thorny progress of the Medici cycle. He maintained consummate tact in conveying unwelcome news or voicing any criticism of his own or others. Even in their joint search for truth in antiquity he showed a touching concern for his friend's feelings. Near the end of their lives, the artist, in reply to Peiresc, confirmed 'that I still possess my ancient spoon or porringer', which he had bought in Paris in 1625. 'It is so light and easy to hold that my wife [Helena Fourment] was able to use it during her confinements, without doing it any harm.'[39] A drawing of the silver mercury spoon (Plate 202) must have followed and confirmed Peiresc's suspicions that 'it is undoubtedly a counterfeit of M. de Montaigu's. But please do not tell him, so as not to make anything disagreeable for him'.[40]

Their common interest in the theory of colour must have provided a less problematic topic of discussion. Peiresc, who was a keen observer of the optical effects of colour, was anxious to encourage Rubens to put his thoughts on paper. In 1635 the Frenchman reported that the artist had begun work on the treatise, and a year later Rubens enquired whether 'my essay on the subject of colours'[41] had been received. Unfortunately it has not survived, and apart from a brief remark in a letter we know nothing about the master's theories. As a friend of Peiresc said at the time, 'a discourse on colours by Rubens would be like hearing Brutus discourse on virtue'.[42] We may be sure that it would have been eminently practical, since colour was of profound importance to his method of painting. Judging from his works his approach was empirical and when his colouring coincides with contemporary theories this seems to have been more by chance than design. Following Venetian practice, Rubens expressed himself through colour rather than follow the example of other Italian painters employing it as an adornment to line and modelling. But unlike Titian, his prime mentor in this respect, Rubens, perhaps as an expression of his fundamentally optimistic character, continued to use bright colours to the end of his life.

Their correspondence did not only cover such learned topics as works of art and perpetual motion. The times were turbulent, with the balance of power constantly shifting and war ever threatening, and many of the letters were given up to relating the latest political events, with which Rubens was particularly well placed to

acquaint his friend, cut off in a small country town. Throughout Europe there must have been a constant thirst for news, which Rubens and Peiresc did their best to satisfy. When Peiresc left Paris in 1623 to return to his native Aix-en-Provence, he introduced Rubens to his brother, Palamède de Fabri, Sieur de Valavez, who became the artist's regular Paris correspondent. Without reaching the same intimacy, they liberally exchanged news as well as books and pamphlets on a wide range of topics. When it was Valavez's turn to depart from the French capital to join his brother, he handed Rubens on to his brother's close friend Pierre Dupuy, who was the royal librarian. To the latter Rubens wrote lamenting Valavez's departure from Paris.

> I feel the keenest regret, for I am in truth deprived of the best correspondent in the world . . . I should not like to have you assume such a burden but since you are pleased to honour me with your correspondence it will be enough for you to send me copies of various public news-sheets of the better sort, but at my expense . . . I am sorry we do not have the same convenience here, but we are not accustomed to news-sheets. Everyone informs himself as best he can, although there is no dearth of rumour-mongers and charlatans who print reports unworthy of being read by honest men.[43]

Dupuy and sometimes his brother, Jacques, willingly took up the challenge and in a weekly series of letters between Antwerp and Paris the latest events were discussed, while a similar exchange of books took place. Both Valavez and Dupuy were also important to Rubens for acting as a conduit for news and scholarly gifts to and from Peiresc.

At the time when Rubens' name as a painter was becoming known throughout Europe, political affairs were beginning to stir, and in no time he was to find himself caught up in events and forced to become an active diplomat on behalf of his country. In 1621 the Twelve Years' truce between the United Provinces and Spain came to an end, and the burning question was what was to happen next. Albert and Isabella, with ever-fresh memories of Flanders as a battlefield, wished for nothing more than a continuation of peace. Moreover, their avowed policy was to make Flanders as independent as possible from Spain, and they knew that any renewal of hostilities would result in the intervention of Spanish forces. Philip III, however, had other ideas and was all for subduing the northern Netherlands once and for all, a course of action suiting French policy, which wished for continued hostility between Spain and the United Provinces.

The balance of power was equitably divided. Britain, France and Spain were the main participants, each threatening war with one another and anxious to ally the second party against the third. To complicate this infernal triangle, the Emperor of Austria, the Elector Palatine, the United Provinces and Denmark all provided further treacherous plots with conflicting interests, and the basic enmities of all parties towards one another made complete chaos out of any attempt to discover a pattern in the alignments.

In the struggle between Spain and the United Provinces, Philip III made impossible conditions for resuming the truce. The opening of the Scheldt and therefore the port of Antwerp, which had stood deserted while Amsterdam prospered, was a reasonable request, but when he stipulated that the Dutch should withdraw from the East and West Indies, with whom they had developed a thriving trade, it was obvious that conditions were intended to provoke an outright refusal. After some abortive negotiations Philip III died in 1621, and was succeeded by his son, Philip IV, without any noticeable change of policy being adopted. Far more serious for Flanders was the death of Archduke Albert a few months later, which, according to the terms on which he and his wife had been appointed regents of the southern Netherlands, meant that the country now returned under the direct yoke of Spain, while the Archduchess Isabella was reduced to the position of governor. A month later Ambrogio Spinola, a professional Genoese soldier in the service of Spain, marched into the Spanish

Netherlands as leader of the Spanish forces and strengthened the country's position, already economically better than before the Truce, by boosting the morale of the army.

Perhaps as a legacy of his close relationship with his mother, Rubens had a particular understanding of widows. Though it is likely he was engaged on secret business at least two years earlier, by 1623 he was in close touch with Isabella on political matters. Two years later his position was summed up in a letter to Valavez: 'I am writing with one foot in the stirrup.'[44] Much of the six months from August 1625 was spent at an inn at Laeken, broken by visits to Dunkirk to wait on the archduchess and Spinola, as well as to the German frontier to meet the Duke of Neuburg, his earlier patron, now engaged in political affairs. Acting on Isabella's behalf as an intermediary between Spinola and the Dutch, the artist very rapidly gained her ear with his views as to the conduct of negotiations with the Dutch. Rubens saw himself clearly as the person most suited to direct operations, and with characteristic determination proceeded to take up the role, not without arousing the increasing jealousy and hostility of others, who saw his actions as self-interest against their self-interest. Quite apart from his skill as a diplomat, his ability to undertake undercover negotiations was greatly enhanced by his profession, which allowed him to travel freely under the guise of pursuing his work as a painter. Throughout the years of his diplomatic activities he succeeded, against all odds, in preventing his painting from becoming a subservient and merely useful pastime. Frequently he was placed in a considerable dilemma, with each activity pulling him in different directions. He was an excellent choice as a negotiator, since he was well known in name if not in person at the courts of Europe. The Abbé Scaglia, the ambassador of Savoy, went as far as to say a few years later, in tribute to his diplomatic ventures, that Rubens was 'a person capable of things much greater than the composition of a design coloured by the brush', sentiments which became accepted opinion in political circles at the time, and which were repeated almost word for word by both Spinola and De la Serre, the biographer of Maria de' Medici. Isabella was desperate for peace, and with his whole heart in such a mission, the artist acted on her behalf. But, in spite of extensive activity on the part of Rubens and others, the results were nil, and by 1625 matters were further bedevilled by the death of Prince Maurice of Nassau, commander of the United Provinces' armies, on whose head hopes of peace had been placed, though probably unwisely. His successor, Frederick Henry, was faced with a sharp setback shortly after his accession. Breda, a town near the frontier of Flanders, which was strategically placed and, from the point of view of morale, an important position, was forced to surrender to Spinola after nearly a year of siege. The news spread round Europe as a great victory for Spain and was later commemorated by Velázquez's imaginary portrayal of the event in a picture whose composition was appropriately influenced by Rubens. In the Spanish Netherlands the boost to morale was celebrated by a visit to the captured city by Isabella, who returned to her court by way of Antwerp. There, after lunch on 10 July, she visited the studio of Rubens, where she agreed to sit for her portrait dressed in the habit of the Order of Poor Clares, which she had worn since her husband's death. Given the reluctance of the archduchess and her family to pose for portraits, her willingness on this occasion can be seen as an intentional celebratory gesture. The painting (Plate 203) was soon engraved by Pontius and quickly became the first official likeness of her in her role as governor, which she had held for four years.

It is a curious fact that since Rubens' appointment as court painter to Albert and Isabella in 1609 they had given him no more than a few commissions for portraits. Although their benevolence towards the artist was never in doubt, their behaviour in this respect was a repetition of what had happened to Rubens at the court of Mantua. But whatever the reasons it does not appear that his work went unappreciated in Brussels. In 1623 after the death of Albert, Peiresc passed on to Rubens a report that 'your pictures have pleased the infanta [Isabella] and the

203. *The Archduchess Isabella as a Poor Clare,* c.1625. Canvas, 120.7 × 90 cm. Private collection, England.

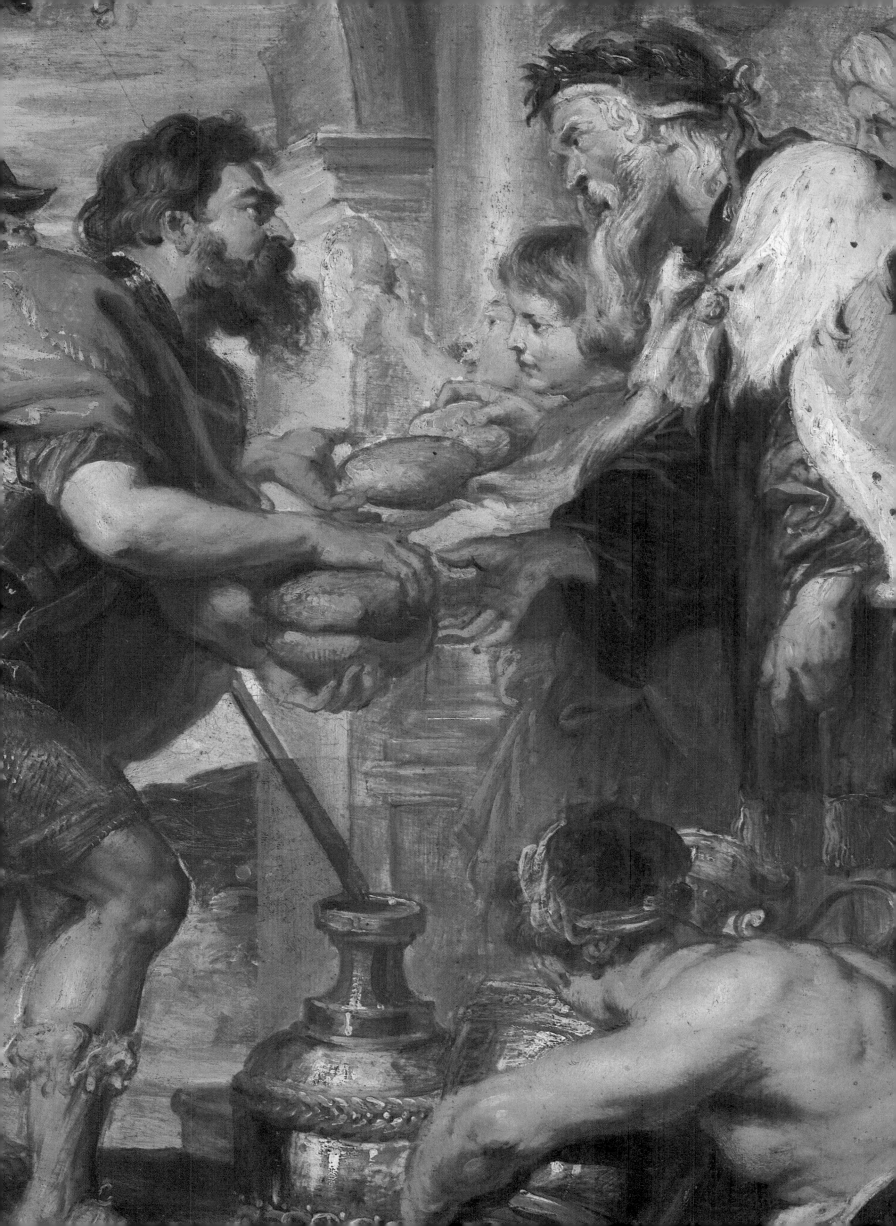

nobles of her court'.[45] It may possibly have been on her visit to the artist's studio two years later when she finally gave him a major commission of the calibre he had received from other patrons. The work requested was a series of twenty tapestry cartoons illustrating the theme of the *Triumph of the Eucharist* to be woven in Brussels and destined to decorate the Franciscan church attached to the convent of the Descalzas Reales in Madrid. This was the house of the Order of Poor Clares of which Isabella had recently become a professional member, although her connections with the convent, which was under royal patronage and whose members were drawn from the nobility, went back to her childhood. Not only was the chapel treated more or less as a court chapel, but the convent was often used by the queen and infantas when the king was absent from Madrid. Worship of the Eucharist played a central part in their devotions as it did with other members of the Hapsburg family. One of the three major feasts connected with the Eucharist was that of Corpus Christi (body of Christ), celebrating the institution of the blessed sacrament, which was observed with great splendour made all the more apparent in a Franciscan church by the basic poverty practised by the order and reflected in the austerity visible in the church for the remainder of the year. St Francis's stress on the need to worship the Blessed Sacrament had been strengthened recently by the Council of Trent in the emphasis they gave to observing the feast of Corpus Christi. The purpose of the tapestries designed by Rubens, which were the most outstanding gift the convent had received, was to decorate the church on the feast itself and during its octave. Rubens began work in 1625 or 1626 by preparing a set of three oil-sketches or *bozzetti* (Plate 205). The two for the side walls (cut up into individual subjects at a later date) were unusually, unlike the central scene, not reversed ready for the weavers; this may have been done to give the patron an idea of the final appearance of the tapestries. On the basis of these he made a larger *modello* for each subject (Plate 209), this time in reverse, which served as a model for the greatly enlarged cartoon painted on canvas by assistants in the studio, with some possible retouching by the master himself. The cartoons, seven of which still exist today, were then handed to the *tapissiers* in Brussels. There are remarkably few documents regarding the commission but Rubens' work must have been finished by the end of 1627 at the latest. In recognition of his work he received a gift of pearls from the archduchess in January 1628. In July two waggons left Brussels for Spain laden with the largest series of tapestries ever designed by Rubens. With the destruction of the Jesuit ceiling, these tapestries are the only major cycle of his church decoration to remain.

Although the commission came directly from the archduchess it is likely that the choice of subjects and their treatment were worked out by the artist himself without the aid of an iconographical adviser from her court. Following the pattern established by Raphael and Giulio Romano in both frescoes and tapestries so well known to Rubens from his time in Rome and Mantua, the decoration was all-encompassing, with the different subjects arranged within an elaborate architectural framework. Unlike earlier tapestry schemes Rubens was responsible for the design of the entire tapestry, framework included. As can be seen in the *bozzetto* for the altar wall (Plate 205), the only one painted in reverse, the scenes were arranged in two storeys flanked in the upper row by a Salomonic order and in the lower by a banded Tuscan order, both of which continued around the church. As a comparison of one subject from the upper row (Plate 209) with one from the lower (Plate 207) demonstrates, the compositions were designed with a consistent viewpoint from ground level. This is particularly apparent in *Melchisadek's Offer of Bread and Wine to Abraham*, which was originally intended to be above, and thus in the first *modello* (Plate 206) was designed with different perspective. As an additional enrichment of the illusionist scheme Rubens employed three different types of 'picture'. On the altar wall through a gap between the columns we see realistic representations of heavenly scenes in the upper level and terrestrial in the lower. Above, angels playing instruments flank the two angels holding up the

monstrance, while below, the ecclesiastical hierarchy in adoration are ranged on one side and the secular, namely the Hapsburgs, on the other. The walls of the nave were covered with eleven large scenes in two storeys, but in these the subjects are shown as tapestries held up by putti against the architecture, that is as tapestries within tapestries. It appears from some of the sketches that this feature was evolved only as Rubens was working on the project and represents an original invention. And finally a number of smaller scenes are treated as framed paintings hanging on the wall.

The altar wall (Plate 205) is devoted to the universal worship of the Eucharist. The central area not covered by tapestry probably contained a symbolic representation of the Eucharist itself. But it was the eleven large scenes in the nave which reveal Rubens' superb invention of rich allusive Baroque decoration. The

205. *Sketch for the Triumph of the Eucharist*, c.1626. Panel, 31.5 × 32 cm. Art Institute of Chicago.

subjects are divided between Old Testament prefigurations of the Eucharist such as *Melchisadek's Offer of Bread and Wine to Abraham* (Plate 207), allegorical scenes of victories and triumphs, such as the *Triumph of the Church* (Plates 209–10), and finally two groups, one containing the four evangelists and various teachers and the other saints, witnesses and defenders of the Eucharist. Although no record exists, the arrangement of the tapestries in the nave can be deduced; on the gospel or liturgically more important side, the spectator would have beheld actual representations of the Eucharist seen moving in triumph towards the altar, while subjects in which the Eucharist was only prefigured were displayed on the epistle side in compositions moving away from the altar. In representing all the various scenes in the series Rubens employed a whole panoply of architectural decoration – highly decorated orders with friezes containing metopes and triglyphs, swags and cornucopia with abundant fruit and flowers, cartouches,

206. *Sketch for Melchisadek's Offer of Bread and Wine to Abraham*, c.1626. Panel, 86 × 91 cm. Museo del Prado, Madrid.

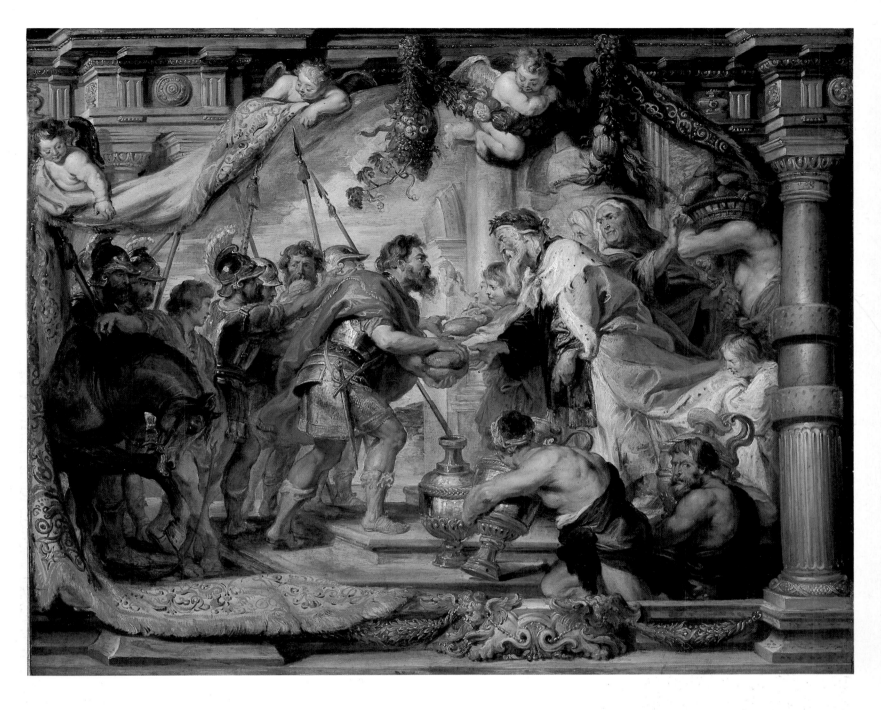

rams' heads, sphinxes, masks and various other sculptural elements, fleshed out with a plentiful supply of putti. Previous schemes of decoration, such as Giulio Romano's work in the Palazzo del Tè and Veronese's in S. Sebastiano at Venice, provided Rubens with useful models. But the details were intended to be more than pure decoration, and throughout the series Rubens achieved an intimate blending of form and content. Traditionally derived from the Temple in Jerusalem, the Salomonic orders appropriately border the heavenly scenes in the upper level. The columns are decorated alternately with twisted fluting and panels with scenes of harvesting putti entwined in vine tendrils and grapes, which are well-established symbols of the Eucharist. Below, the simplest of orders, the Tuscan, here enriched by banding, frames the earthly scenes.

Battle scenes and triumphs are among the most potent and regularly used images in Rubens' repertory. Here it is the triumph which provides the dominant theme. Rubens may well have known the series of religious allegorical triumphs painted by his former master Otto van Veen about 1615 (Plate 208), but whereas the latter produced staid processions in the manner of chambers of rhetoric, Rubens approaches his scenes through the language of antique triumphs, studied in either classical bas-reliefs or Renaissance reinterpretations, which he recreates with his habitual thrust and movement. Transporting aloft the personification of the Church with raised monstrance containing the host, the war chariot (Plate 209), which crushes the enemies of the Church beneath its wheels designed

207. *Sketch for Melchisadek's Offer of Bread and Wine to Abraham*, c.1626. Panel, 66 × 82.5 cm. National Gallery of Art, Washington.

208. Otto van Veen, *The Triumph of Ecclesia Christi*. Bayerische Staatsgemäldesammlungen, Bamberg.

209. *Sketch for the Triumph of the Church over Ignorance and Blindness*, c.1626. Panel, 87 × 106 cm. Museo del Prado, Madrid.

all'antica, is drawn by horses accompanied by female figures, probably personifications of the virtues; chained figures representing Ignorance and Blindness follow in the rear. Numerous other allegorical figures and symbols fill the composition and enrich the subject, which is inscribed in large letters in a cartouche above: ECCLESIAE TRIVMPHVS. When Rubens renewed work on the Henry IV series shortly after completing the commission this magnificently festive creation remained very much in his mind.

By this time Rubens, who was firmly in his stride as a diplomat, was Isabella's most trusted counsellor, advising her regularly, either in person or in long letters written while on his various missions. He had a deep admiration for her: 'She is a princess endowed with all the virtues of her sex; and long experience has taught her how to govern these people and remain uninfluenced by the false theories which all newcomers bring from Spain. I think that if her Highness, with the help of the Marquis [Spinola], could govern in her own way, and regulate affairs according to her wishes, everything would turn out very happily.'[46] For his devotion to the archduchess, he was repaid by being granted a patent of nobility by her nephew Philip IV in June 1624. Supporting Rubens' application, the bishop of Segovia, who had been confessor to Archduke Albert, wrote that 'Many sovereigns have tried to induce him to leave Antwerp by promises of great honours and large sums of money. He . . . unites to his rare talent as a painter, literary gifts

186

and a knowledge of history and languages; he has always lived in great style and has the means of supporting his rank.'[47] And three years later a more personal honour was conferred by Isabella herself, who advanced him from the position of court painter to that of gentleman of the household of Her Most Serene Highness.

The other person who played a dominant role in the Spanish Netherlands at the time was the Marquis Spinola. As an outcome of their frequent discussions, which took place in their joint role as counsellors to Isabella, Rubens and Spinola developed respect and admiration for each other. Spinola's view of Rubens has already been mentioned, but after his departure for Spain Rubens wrote of the former: 'he is the most prudent and sagacious man I have ever known, very cautious in all his plans, not very communicative, but rather through fear of saying too much than through lack of eloquence or spirit. Of his valour I do not speak, since it is known to everyone, and will only say that contrary to my first opinion (I had at first distrusted him, as an Italian and a Genoese) I have always found him firm and sound, and worthy of the most complete confidence.' But the general, like many of his profession, had his limitations, 'for he has no taste for painting and understands no more about it than a street porter'.[48] For Rubens, at this juncture of his political career, this was a surmountable failing, and a few years later, at Spinola's death, he lamented that 'I have lost one of the greatest friends and patrons I had in the world'.[49]

On the occasion of Isabella's visit to Antwerp after Breda, Rubens also took the opportunity to portray the Marquis Spinola (Plate 211). Dressed in armour, he is seen three-quarter length, one hand on his marshal's baton and the other on his sword hilt. The ostentatiously plumed helmet and hanging curtain behind add to the opulence one expects to find in a typical Baroque portrait. But despite the conventional aspects to the picture, Rubens succeeded in memorably conveying the withdrawn introspective character of the sitter which he himself had described in a letter. The careworn expression seems at odds with the splendour of military

210. *The Triumph of the Church over Ignorance and Blindness*, 1627. Tapestry, 480 × 750 cm. Convent of the Descalzes Reales, Madrid.

accoutrements in much the same way as can be seen in Rubens' portrait of himself in knightly garb in old age (Plate 318). But it appears to have been an accurate reflection of the man himself, whose death a few years later was, according to Rubens, 'brought on by work and worry' largely occasioned by Spanish hostility towards him. 'It seems that he was tired of living.'[50]

Although very reluctant to undertake portraits, except for personal reasons, Rubens was increasingly forced to agree to requests from those in commanding political or diplomatic positions with whom he found himself on terms of ever greater intimacy. As a means of wooing a favour or consolidating a professional relationship, the portrait served a highly useful purpose. But, unlike his protégé Van Dyck, Rubens never developed the flattering likeness which subtly imbued the sitter with a glamour and status not invariably according with reality. Although expressed in his own personal language, Rubens' portraits, despite some idealisation, have the feel of directness and deliberate observation, sometimes at odds with the accompanying accessories that are used as generalised expressions of power and position.

In March 1625, when he returned to Paris in order to install the series of paintings devoted to the life of Maria de' Medici, Rubens moved on to a more international stage in his diplomatic career. With justice he could write shortly beforehand 'that I regard the whole world as my country, and I believe that I should be very welcome everywhere'.[51] His visit to the French capital coincided with the arrival of George Villiers, Duke of Buckingham, who had come to act as escort to Henrietta Maria, whose proxy marriage to Charles I had taken place a fortnight before in the newly decorated Luxembourg Palace. The wedding was celebrated just a year after the abortive and discreditable attempts to arrange a match between Charles and the daughter of Philip III. If a marriage with Spain, intended to help James I's son-in-law, the Elector Palatine, to regain his property from the Spaniards, was to come to nothing, then union with France would do equally well. And very shortly afterwards, in 1624, an alliance was concluded between Britain, France, the United Provinces and Denmark against Spain and the emperor. In all these negotiations the Duke of Buckingham played an important part, which did not diminish with the death of James I, who had originally been responsible for picking him out as the latest good-looking favourite. Charles I immediately accepted him as part of his intimate circle.

In the course of two years Buckingham had reached a position of absolute power over the king. Contemporary opinion considered him totally unfit for this role, and that as both a statesman and a general he had proved himself completely corrupt and incompetent. Rubens was under no illusions about him and only a few months after meeting him wrote: 'When I consider the caprice and arrogance of Buckingham I pity the young king, who, through false counsel, is needlessly throwing himself and his kingdom into such extremity. For anyone can start a war when he wishes, but he cannot so easily end it.'[52] Only a month later the artist was foretelling the future: 'as for Buckingham, I am of your opinion that he is heading for the precipice'.[53] But the duke had his good side, and during the reign of his first patron he had developed a passionate taste for the arts which never abated, however low his personal fortunes were. As Balthasar Gerbier, the duke's confidant, put it to Rubens: 'All the machinations of the duke's enemies have never struck so near his heart as to divert his taste for pictures and other objects of art.'[54] This common interest gave a special fillip to Rubens' meetings with Buckingham in Paris, which later blossomed into a most fruitful relationship between artist and patron.

Probably on this occasion Rubens drew portraits of both the duke (Plate 212) and his wife (Vienna) and at the same time received commissions for a ceiling illustrating the *Glorification of the Duke of Buckingham* and a large allegorical equestrian portrait of the duke. Both these paintings, which were destroyed by fire in 1949, were ready to be installed in Buckingham's London residence, York House, by 1627. The portrait drawings executed in what was to become

211. *Ambrogio Spinola*, 1625. Panel, 117.5 × 85 cm. Herzog Anton-Ulrich Museum, Brunswick.

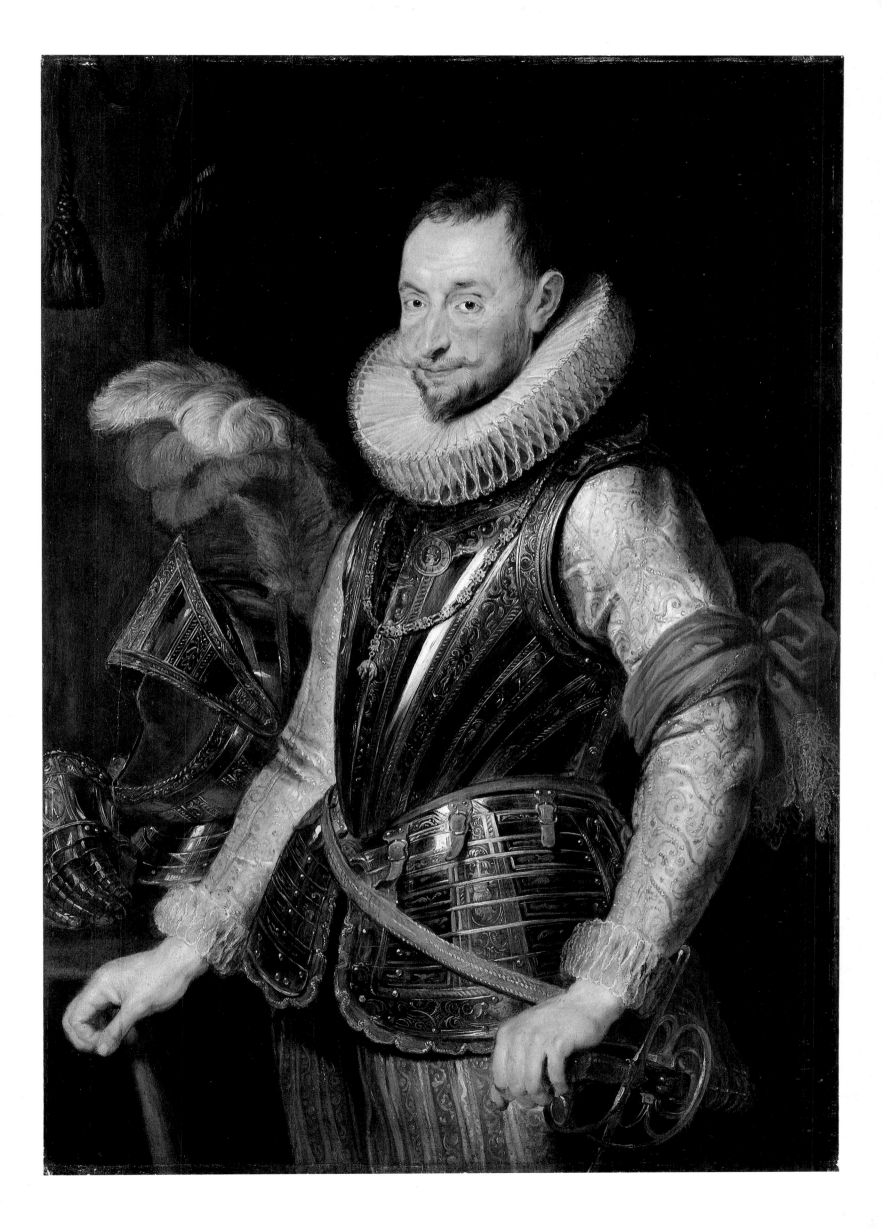

212. *George Villiers, 1st Duke of Buckingham,* 1625. Black, red and white chalk with brush and ink on the eyes, 38.3 × 26.6 cm. Graphische Sammlung Albertina, Vienna.

Rubens' preferred method for such studies, a combination of red and black chalk heightened with white, show only the heads with the shoulders barely outlined, and were clearly *ad vivum* studies for future reference. (In type they are reminiscent of the studies made by Holbein of his English sitters.)

The duke's study undoubtedly served for the likeness in the large equestrian portrait (Plate 213), in which he is depicted in his newly assumed role as general of the fleet; a genius, scattering flowers over him, flies behind, while Neptune and a naiad crouch below before a vista of a many masted fleet. The brilliant scarlet of the duke's flowing cloak and breeches is palely echoed in the distant sunset or sunrise over an expanse of blue sea. The finished work, possibly at the duke's request, was encumbered with more allegorical figures in flight around the duke, diminishing the vitality and spontaneity of the original image. In earlier

equestrian portraits, including the one in the Medici cycle, Rubens had favoured a pose with the sitter and horse seen head-on, advancing, but here he opted for a side view, an arrangement he had tried out in two no longer existing works, and which from now on he used on all such commissions. When installed, the duke's picture offered English viewers the first example of a Baroque equestrian portrait of a fellow countryman.

During their conversations in Paris, Buckingham must have learned, if he did not know already, of the outstanding collection of antiques and other works of art owned by Rubens. Negotiations, carried out by Gerbier (see below), were set in hand for the duke (who, like the king, was a great collector) to purchase a large part of the artist's collection. The printmaker and jeweller Michel le Blon was appointed as the duke's agent, but exactly what was sold and when remains uncertain. The deal can only have taken place after Isabella Brant's death in June 1626, since the inventory drawn up on that occasion states that Rubens 'sold directly and for the best price after the death of the mother [Isabella] to the Duke of Buckingham in England, several pictures, antique marbles, agates and other

213. *Sketch for George Villiers, 1st Duke of Buckingham, on Horseback*, 1625. Panel, 44.3 × 49.2 cm. Kimbell Art Museum, Fort Worth.

jewels for the sum of one hundred thousand florins'.[55] (In fact Rubens received only 84,000 florins, since he failed to deliver a commissioned painting of the 'Assumption of the Elect' and, moreover, a fee of 10,000 florins had to be paid to the agent.) Under the artist's supervision the antiques were shipped from Calais in December 1626. In the following September the artist wrote that 'The pictures of my Lord the Duke are all ready',[56] which could refer either to all the pictures in the sale or only to the equestrian portrait and ceiling painting specifically commissioned by Buckingham. In either event the new owner had only a very short time in which to enjoy them.

The marbles included those Rubens had acquired by exchange with Carleton in the previous decade, as well as those bought in Italy. We have it on the artist's own authority (see p. 71) that he retained some of his favourite gems, but in order to meet with the terms of the sale he bought others to add to the group. He made casts of the gems sold to Buckingham which he later gave to Peiresc. Unfortunately the only inventory of the Buckingham collection was drawn up in 1635, seven years after the duke's death, and does not mention provenance. It lists a very impressive assembly of paintings by the older masters, both Northern and Italian, but with the characteristic Caroline taste for the Venetian school. (There were no fewer than nineteen pictures by Titian, twenty-one by Bassano, thirteen by Veronese and seventeen by Tintoretto.) But in addition there were thirteen by Rubens, some if not all of which must have formed part of the sale. Among these were such outstanding works as *Cimon and Iphigenia* (Plate 150).

Equally unclear are Rubens' motives in agreeing to such a sale. The death of his wife might have prompted a wholesale disposal of their joint property, but the careful preparations for the sale, quite apart from what we know of the artist's character, argue against such an emotional response. Although there is no indication that he was in need of money, he may have been tempted by the substantial price offered, and if the seven houses he bought from the proceeds of the sale were already on offer, he may have preferred property to works of art. (At the same time he made another surprising sale when he parted with his agate vase; see p. 176.) But political pressures could equally well have been a prime consideration in persuading him to deprive himself of much he had so assiduously collected. His increasing diplomatic involvement made him acutely aware of his own power to play some beneficial role in helping his country to peace, and his nephew records that after Rubens' meeting with Buckingham in Paris 'the Infanta Isabella bade him cherish and nourish the benevolent favour of the Duke of Buckingham'.[57] And there was no better way to a collector's heart.

At the same time Rubens made the acquaintance of Balthasar Gerbier, who some years earlier, in a lengthy poem lamenting the death of Hendrick Goltzius, had not only placed Rubens, 'a shining Phoebus',[58] at the head of the imaginary procession of mourning artists, but had also praised him fulsomely through his description of a series of imaginary pictures. It was an auspicious introduction for a man with whom Rubens was to have numerous dealings over artistic and diplomatic matters for the rest of his life. Gerbier was a shady cosmopolitan, Flemish by birth, with a capacity for inventing indiscriminate and totally fictitious aristocratic connections in all parts of Europe. When he arrived in England he was a small-time portraitist, but on being taken up by Buckingham his fortunes were made. He was employed on various artistic commissions by his master and acted as secret agent as well on numerous negotiations, which brought him constantly into contact with Rubens. After a brief setback, at Buckingham's assassination, Gerbier was taken up by Charles I, both as a friend and as an agent for acquiring works of art. He was a man of versatile talents, but thoroughly unscrupulous and disloyal. As artist–diplomat, he was the counterpart of Rubens; while Rubens was known for his integrity, Gerbier was noted for his guile. He always, however, behaved correctly with Rubens, who retained a feeling of friendship for him, no doubt turning a blind eye to his more disgraceful deeds in the common cause of their art.

192

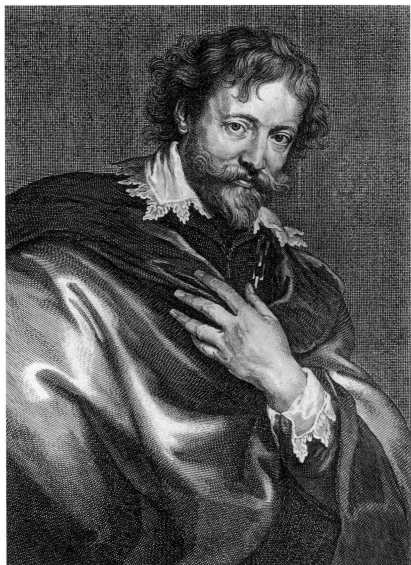

In his discussions with Buckingham in Paris, Rubens had attempted to play a peacemaking role by asking the Englishman to try to smooth over with his king the effects of their unhappy visit to Madrid, assuring him that both the Archduchess Isabella and Spinola much regretted the treatment meted out to them by the Spaniards. Though Buckingham may have sung Rubens' praises on his return to the English court, he cannot claim responsibility for introducing his work to Charles I. The mutual admiration of king and painter, which grew with the years, had already started. In 1623 William Turnbull told Carleton that he was commanded to commission a self-portrait from Rubens (Plate 214) 'to be placed in the Prince's Gallery',[59] and two years later, writing to his friend Valavez, the artist did not hide his enthusiasm; 'the Prince of Wales is the greatest amateur of paintings among the princes of the world. He already has something by my hand [a now lost painting of Judith and Holofernes], and, through the English agent resident in Brussels, has asked me for my portrait with such insistence that I found it impossible to refuse him. Though to me it did not seem fitting to send my portrait to a prince of such rank, he overcame my modesty.'[60] This personal seal to their relationship presents us with an image of the artist in his prime – elegant, dignified, serious, independent, but with all the air of the trustworthy ambassador he was so shortly to become.

Apart from several group portraits with friends or wives, Rubens painted only four or five self-portraits, made we may suppose on request rather than as an exercise in self-analysis. (Peiresc had to ask repeatedly before he received one.) In earlier examples Rubens had painted himself bareheaded. But his premature baldness may have induced him to add the wide-brimmed hat here, which apart from its cosmetic role adds immeasurably to the scale of the design. The contrasting pose of the head and bust combined with the angle of the hat gives the

214. *Self-portrait*, c.1623–4. Panel, 86 × 62.5. Royal Collection.

215. Paulus Pontius after Antony van Dyck, *Peter Paul Rubens*, c.1628 or later. Engraving, 23.8 × 15.8 cm. Ashmolean Museum, Oxford.

217. (facing page) *Isabella Brant*, c.1625. Canvas, 85 × 62 cm. Uffizi, Florence.

216. *The Twin Heads of Cupid and Psyche (Albert Rubens)*, c.1615. Pen and brown ink, 7.9 × 7.5 cm (max). British Museum, London.

portrait a sense of movement and vitality while the narrow format of the panel increases the sense of height. Apart from the *Artist with his Friends* (Plate 39) Rubens never showed himself, following sixteenth-century tradition, with his brushes in hand or made any reference to his profession. Conscious of the stigma of manual labour still attached to the artist in many places, Rubens invariably presented himself as a gentleman, a portrayal which reached its apogee in the last great example (Plate 318). As Charles I's surveyor already noted, the artist on this earlier occasion wears a gold chain around his neck, which we may presume was that given to him by Albert and Isabella on his appointment as court painter. In this self-portrait, Rubens set a fashion which was quickly picked up by that more socially conscious artist and former protégé, Van Dyck.

The portrait for the English court can be compared with that painted of the artist by Van Dyck three years later for his *Iconography* (Plate 215). In the latter Rubens is seen with head slightly bowed and hand to the breast in a pose used by Van Dyck in representations of other artists, which is possibly to be interpreted as an expression of artistic inspiration and depth of feeling. Apart from the flattering touch of a plentiful growth of windswept hair, Van Dyck portrays his sitter with a much squarer head with lower brow, more in accord with Rubens' own renderings of himself on other occasions than is apparent in the carefully manicured image of himself for 'the greatest amateur of paintings among princes of the world'.

After his return to Flanders in 1625, Rubens became further involved in detailed negotiations on behalf of the archduchess. The plague had struck Antwerp, and for six months when he was not undertaking diplomatic journeys he lived with his family at an inn at Laeken near Brussels. As he must have pondered the change taking place in his life, weighing personal ambition against his devotion to art, he received a grievous personal blow. In June 1626 Isabella Brant died, probably of the plague, possibly caught as a result of their premature return to Antwerp. It was one of those moments that reveal a person's true character. In the heartfelt reply to his friend Dupuy's condolences, already partly quoted (see p. 59), he continued: 'Such a loss seems to me worthy of deep feeling, and since the true remedy for all ills is Forgetfulness, daughter of Time, I must without doubt look to her for help. But I find it very hard to separate grief for this loss from the memory of a person whom I must love and cherish as long as I live.'[61]

Although Rubens never painted Isabella with her children, there are several portraits of her alone. What is probably the last example (Plate 217) shows her half-length, dressed in black; one hand is placed on her breast and the other holds a small book whose scarlet binding repeated in the background curtain provides the only note of bright colour in this sombre picture. But there is nothing sombre about the expression on her face, clearly based on the drawing made at this time (Plate 84), as her mouth breaks into a gentle smile. Her mourning costume combined with such details as the hand on the breast, which can be interpreted as a gesture of sorrow, and the vine leaves in the background, read as symbols of perpetual love or friendship even after death, suggest that the picture was painted after the death of their twelve-year-old daughter, Clara Serena, in the autumn of 1623. (It has also been identified as a posthumous portrait executed several years later.)

The two surviving children, Albert and Nicolaas, were aged twelve and eight respectively at the time of their mother's death. Like other artists with families, Rubens not only made superb portrait drawings and paintings of them but used them as models in a number of other works. No documented image of Clara Serena exists, although on the basis of the likeness to Isabella Brant, the painting of the *Head of a Girl* (Plate 218), remarkable for the fluency of the brushwork and the sparkling expression of eyes and mouth, has traditionally been identified as representing her.

The elder son, Albert, already made an early appearance as a baby in the artist's oeuvre in the drawing, based on an ancient herm, of a double-headed coin of Cupid and Psyche (Plate 216), on the left of which the artist wrote that the former

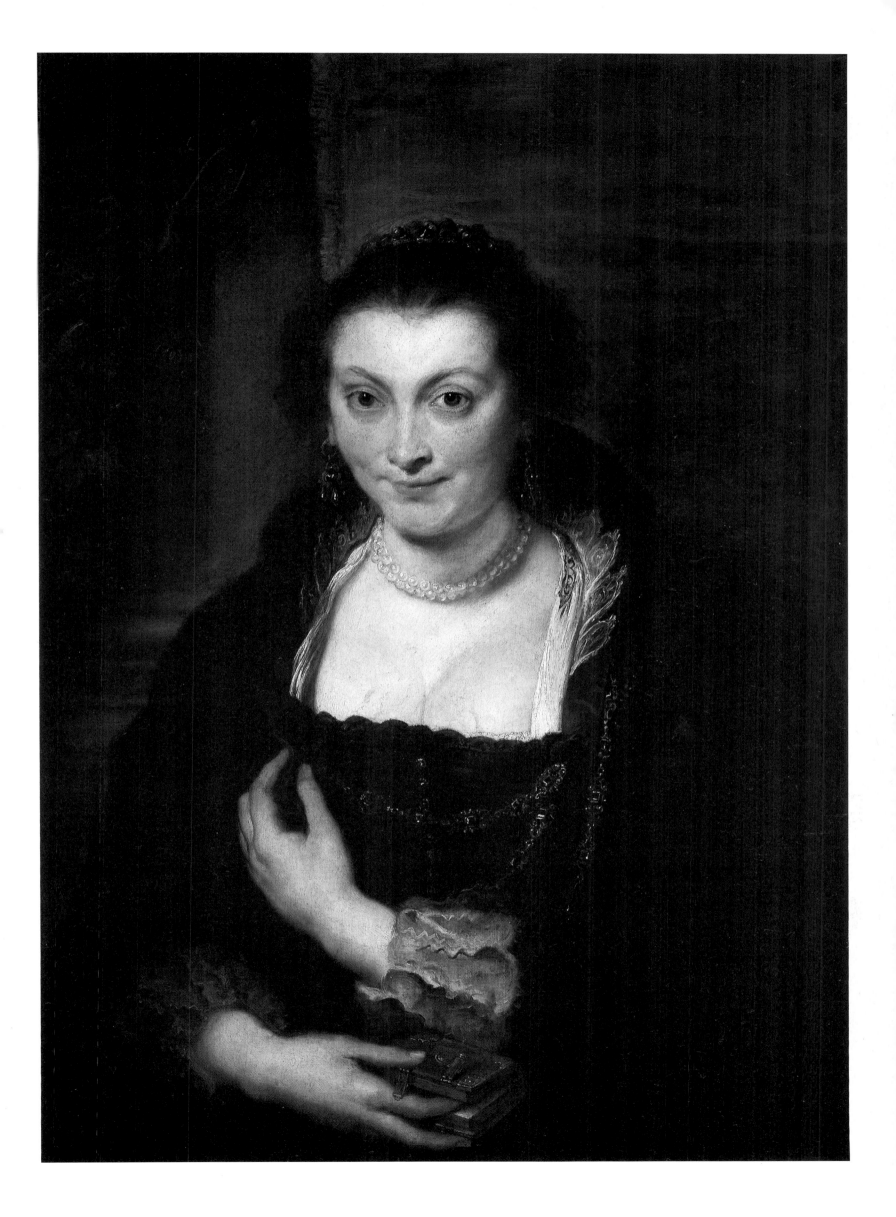

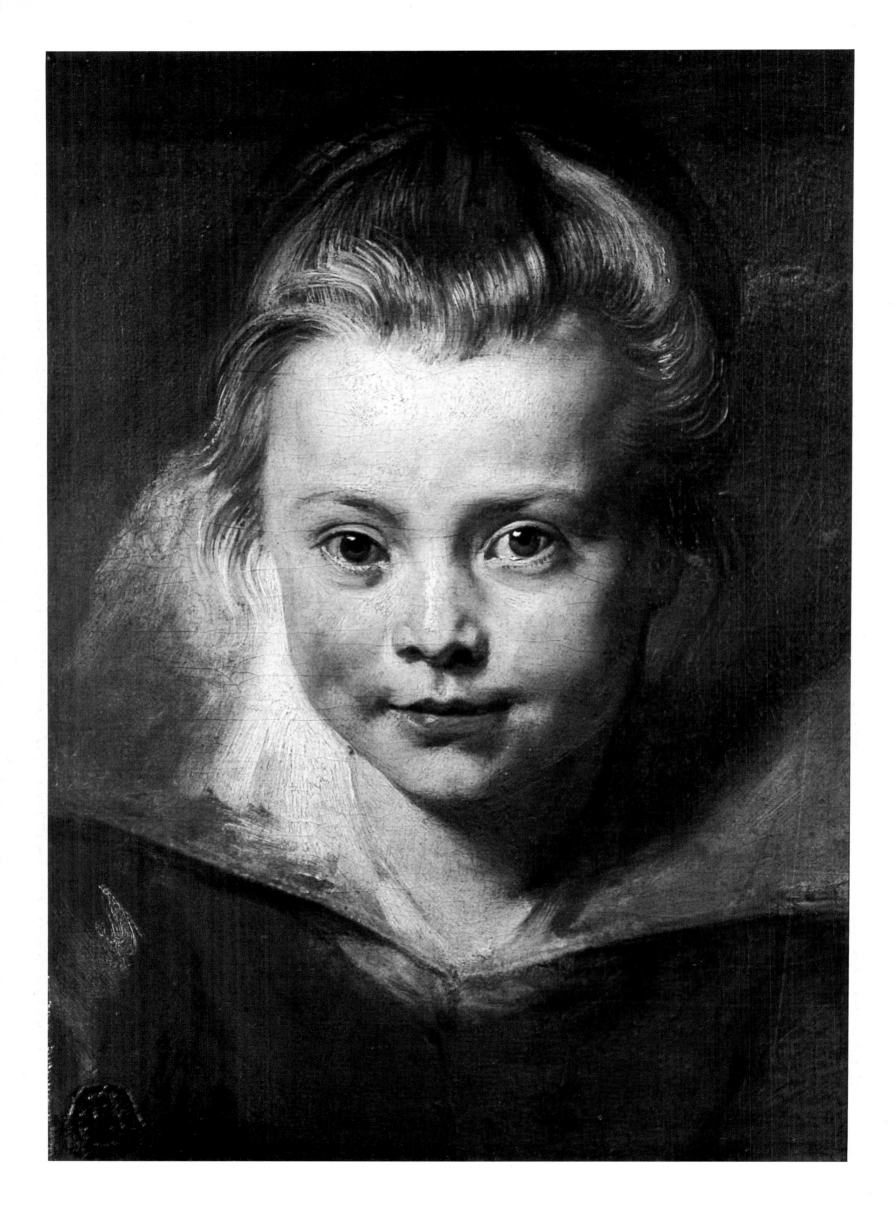

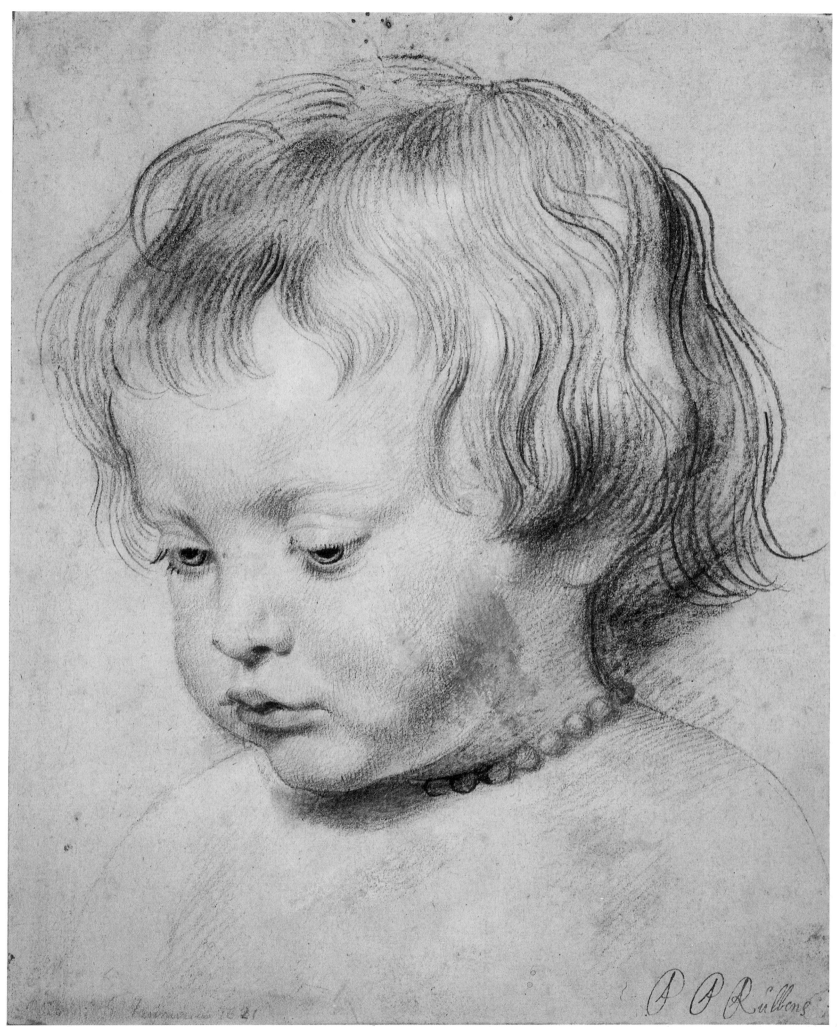

219. *A Boy in a Coral Necklace (Nicolaas Rubens?)*, c.1619. Black and red chalk, heightened with white, with black ink on the eyes, 25.2 × 20.2 cm. Graphische Sammlung Albertina, Vienna.

218. (facing page) *Head of a Girl (Clara Serena Rubens?)*, c.1616. Canvas on panel, 37 × 27 cm. Sammlungen des Fürsten von Liechtenstein, Vaduz.

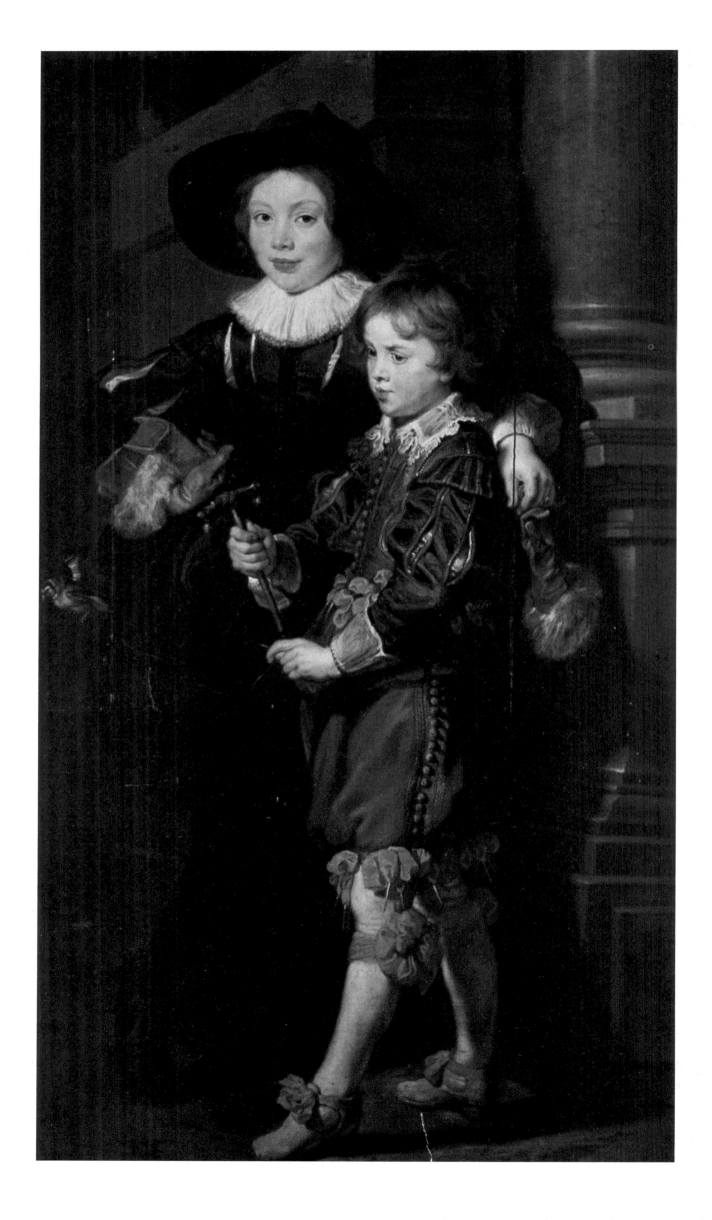

bears the features of his son. As the only child to take an interest in his father's studies of coins and gems, it was a prophetic portrayal. Already at the age of sixteen he was, as Rubens told Peiresc, 'seriously engaged in the study of antiquities and is making progress in Greek letters'.[62] A few years after his appearance as Cupid, he may well have been the model in, among other works, the sleeping boy beside the fountain in *Cimon and Iphigenia* (Plate 150).

As family records, the most spectacular works are the portrait drawings he made of the two boys, which share the same intimacy of portrayal and beauty of execution with that of the drawing of their mother (Plate 84). A *Boy in a Coral Necklace* (Plate 219) is usually identified as the younger son, Nicolaas. Using a mixture of black and red chalk and white bodycolour the artist builds up by means of delicate fluent strokes defining the hair and soft hatching to model the plump cheeks a fully realised image of the child. Although surely done as a portrait study, Rubens was not the artist to waste such a creation, and he used the drawing for the head of the Christ-Child in the painting of the *Madonna, Refuge of Penitent Sinners* (Cassel), which also contains a likeness of his brother Albert in the role of St John.

About the time of Isabella's death Rubens painted a full-length double portrait of the two sons (Plate 220), which later belonged to Albert. The latter, in a wide-brimmed hat, nonchalantly leans against a plinth with his legs crossed; one arm is placed around his brother's shoulders with the fingers dangling a glove. Two large books are tucked under the other arm as reminders of a dutiful schoolboy's preoccupation. The premature sophistication of the elder boy is contrasted with the childlike simplicity of the younger, who concentrates on the traditional game of a goldfinch attached to a perch. The picture offers a personification of two sides of childhood, study and play. Both boys are elegantly dressed, matching the formal surroundings of plinth and column. The brilliant blue of the younger boy's jacket rings out against the sober black costume of the elder brother. The unprecedented silky elegance of handling suggests that in this work Rubens may have picked up a hint from his erstwhile assistant Van Dyck. But, despite all the trappings of a portrait in the grand manner, the picture remains a touchingly informal study of their natural charm and youthful vitality. It may be that in painting this remarkable family record Rubens had at the back of his mind the description given by Pliny of the artist Parrhasius, who painted a picture of two boys 'whose features express the confidence and the simplicity of their age'.[63]

Seen beside the family portraits of other artists, this large panel contains implications of grandeur reflecting Rubens' unique social position. In a century in which upward mobility was feasible even for artists, Rubens had risen higher and more rapidly than any of his contemporaries. But there was nothing presumptuous in this as well as in other family portraits, when one considers that an archduke of the imperial family and a Genoese nobleman had both consented to give their names and act as godfathers to the artist's two sons, while his daughter may have been called after the Infanta Isabella, whose second name was Clara and who perhaps allowed herself to be accepted as honorary godmother. The untimely death of his much-loved wife may have stimulated him to take stock of his position in the world and to record in this affectionate portrait all that was left to him in human terms. Such family images may have provided him with a solace, made the more tangible by the likeness of the elder boy to his mother and the younger to his father, when faced with 'the necessity of Fate which does not comply with our Passions'.

As the result of the legal requirements of establishing their joint property in order to wind up Isabella's estate, we learn that Rubens owned a second house in the Wapper adjoining his land as well as another in the Jodenstraat. Moreover, in 1619 he had bought a farm of thirty-two acres at Zwijndrecht from Nicolaas Rockox. But with the money paid to him by Buckingham for his collection he promptly purchased another seven houses in the Wapper and the adjoining Lammenkensstraat (now Hopland), thus becoming a substantial owner of

220. *Albert and Nicolaas Rubens*, c.1625. Panel, 158 × 92 cm. Sammlungen des Fürsten von Liechtenstein, Vaduz.

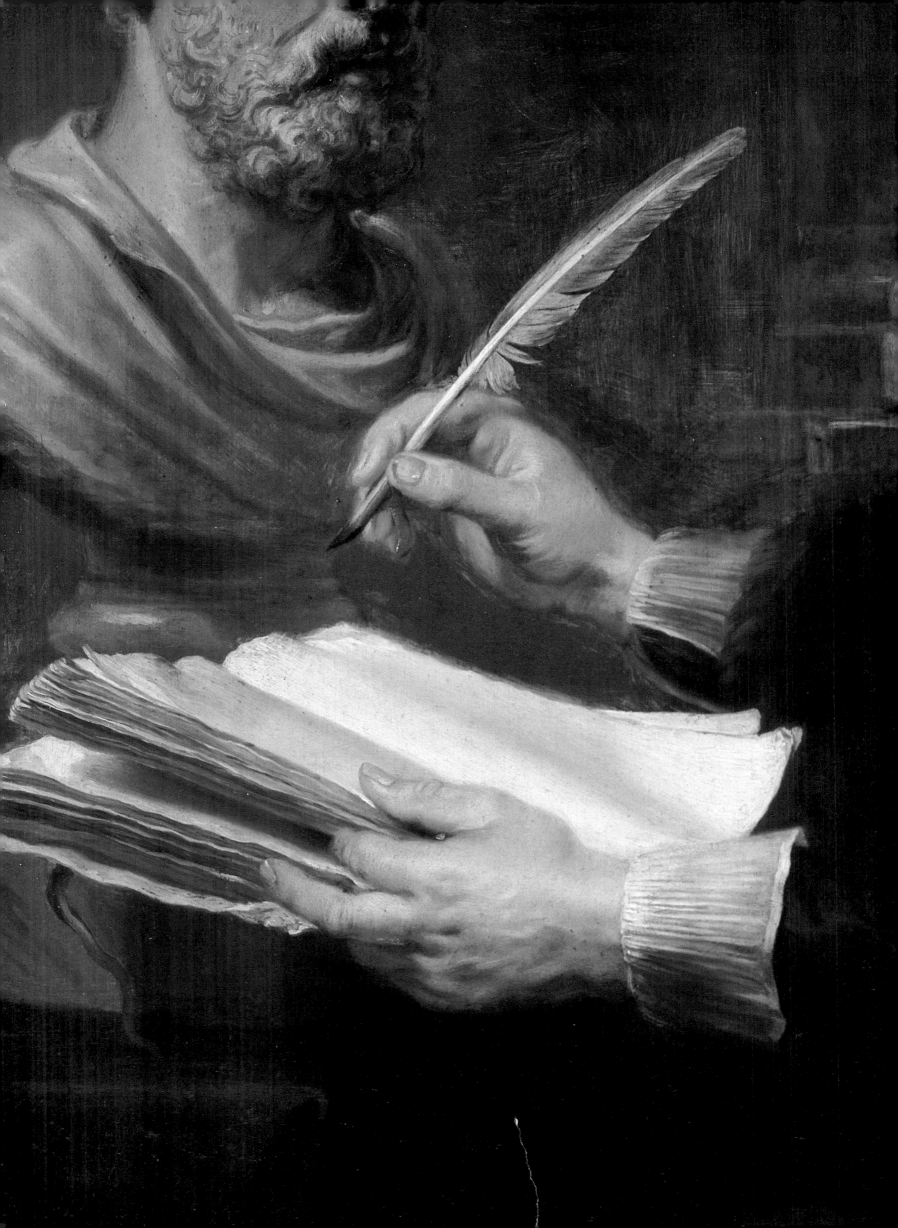

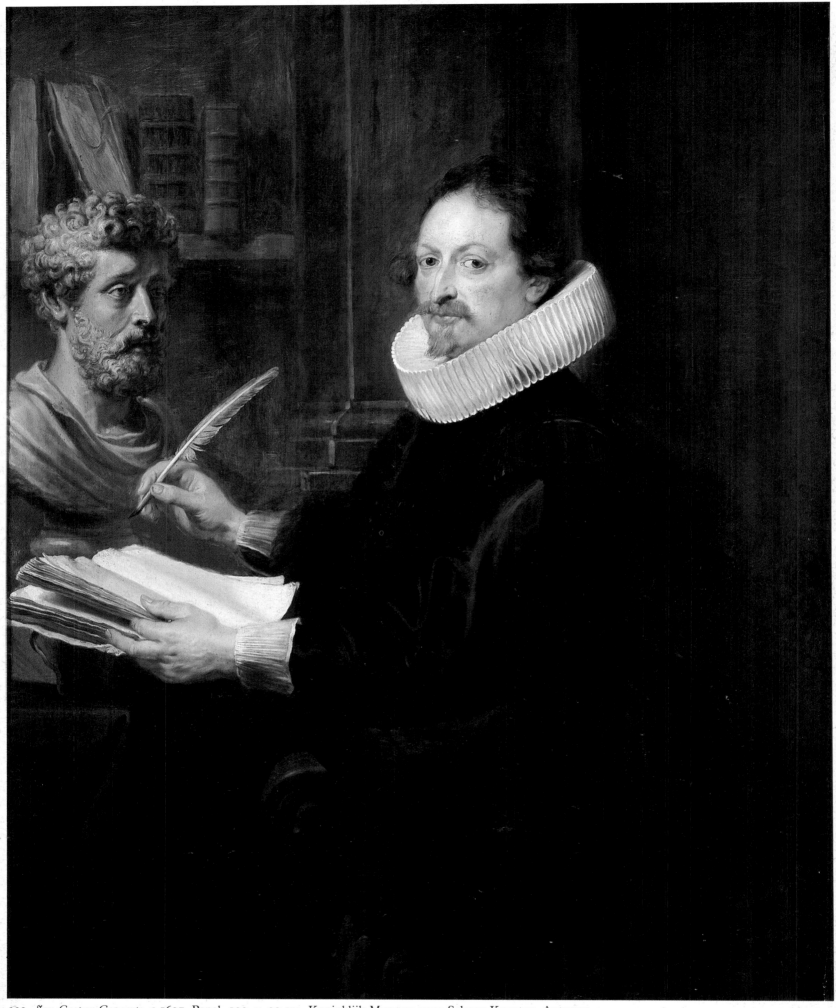

222. *Jan Caspar Gevaerts*, c.1627. Panel, 120 × 99 cm. Koninklijk Museum voor Schone Kunsten, Antwerp.

221. (facing page) Detail of Plate 222.

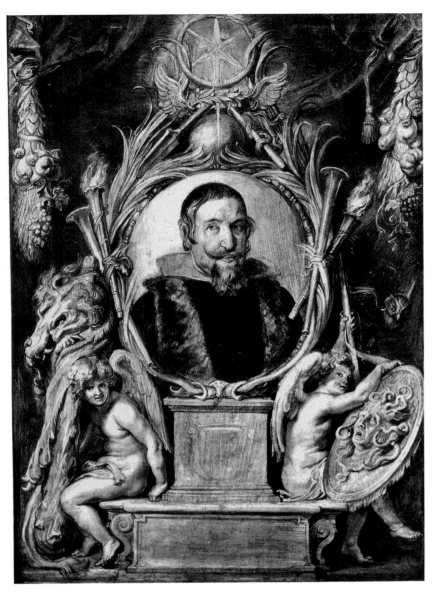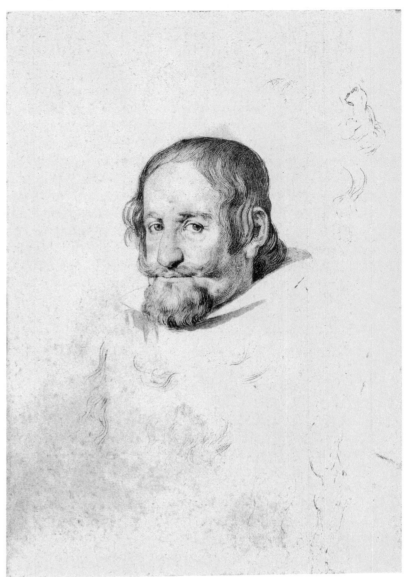

Antwerp property. The three adjoining houses were converted into two for letting and a coach house for himself, and their gardens were added to his. He also bought a second farm at Eeckeren with an attached residence called the Castle of Ursele, set in a polder to the north of Antwerp, which was rented out.

During these years, despite the varied pressures, Rubens continued to produce a wide variety of works. Apart from portraying his family he painted one of his closest friends, Jan Caspar Gevaerts (Plate 222), who had brought him together with Peiresc. Gevaerts was to play an important family role by acting as tutor and guardian to Albert when Rubens was abroad. Like many of his contemporaries he combined his professional life (as clerk to the city of Antwerp) with his classical interests. In the manner of the sixteenth-century humanist portrait, Rubens portrays him seated at his desk in his study. A bust of Marcus Aurelius before the bookcase provides a reference to the commentary which the sitter was preparing on the works of the Latin writer. But, unlike the traditional representations of the scholar absorbed in his work, Rubens depicts Gevaerts in a lively pose looking out at the spectator, his pen poised to write. Compared with Rubens' aristocratic portraits, this and other portraits of friends convey the serene middle-class atmosphere of scholarly contentment.

In 1626 Rubens was involved in a portrait commission of a different kind, when he was called upon to design an emblematic border to the portrait of the Spanish first minister, the Count-Duke of Olivares (Plate 223), taken from one painted by Velázquez, which was to be engraved by the young Paulus Pontius (Plate 224). In preparation, the engraver, presumably under Rubens' direction, made a precise drawing of the head (Plate 225). For this commission, which probably represents his first knowledge of the work of the young Spanish painter, Rubens produced a variation of the design he had carried out for the recently deceased Charles de

202

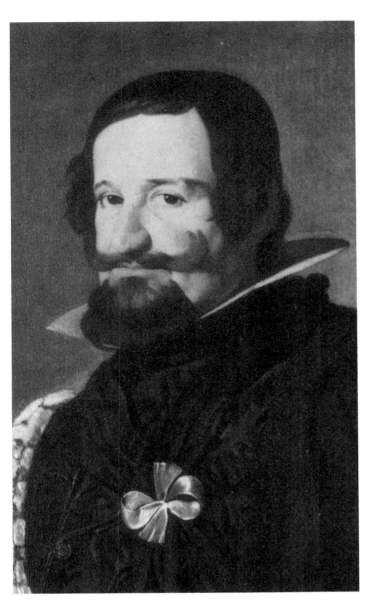

223. (far left) *Sketch for the Portrait of Count-Duke of Olivares*, c.1625–6. Musées Royaux des Beaux-Arts, Brussels.

224. (centre) Paulus Pontius, *Count-Duke of Olivares*, c.1626. Pen and brown ink, 32.5 × 22.5 cm. Museum Boymans-Van Beuningen, Rotterdam.

225. Detail from Velázquez, *Count-Duke of Olivares*. Canvas, 216 × 129.5 cm. Hispanic Society of America, New York.

Longueval (Plate 154), although in that case he had been responsible for the likeness as well. For Olivares, Rubens composed a skilful combination of allegories flattering his role as a ruler. At the bottom Strength and Wisdom are personified by winged genii holding the attributes of Hercules (club and lion's skin) and Minerva (lance, owl and aegis). At the top of the design Rubens incorporates a variety of emblems of, for example, wise and strong government, triumph, eternity and the benefits of peace. In the print, praise of the sitter was developed in a Latin poem specially written by Gevaerts. For his efforts Rubens received an unusually warm letter from Olivares, sharing with him the sorrows of bereavement, as well as expressing appreciation of his work. But with undue modesty Olivares thought that the meaning of the print should be regarded as an aspiration for the future rather than a record of achievement. And for posterity the resulting work offers a telling contrast between the cool, penetrating observation of Velázquez and the rich Baroque imagery of Rubens.

About this time Rubens executed another work with a more personal destination. His role as a designer for sculpture had been seen in the designs he made for the Jesuit church. On a very much smaller scale he made a design for an ivory salt-cellar which was carved by the German sculptor Jörg Petel, who lived in Rubens' house in 1624 and developed a close working relationship with the painter on his subsequent visits to Antwerp. At first the artist made an oil-sketch of the entire subject of the *Triumph of the Sea-born Venus* (Plate 226) in which Venus, who holds up a chain of pearls in one hand, and two accompanying nereids riding on dolphins, were preceded by two conch-blowing tritons, one of whom carries another nereid on his back; above, putti carry a continuous wreath while three wind-gods are hard at work. From this *modello* it seems that Rubens made at least one drawing (Plate 227), rapidly sketched in pen and ink, transposing the

228. (facing page) Jörg Petel, *Salt-cellar with the Triumph of the Sea-born Venus*, c.1628. Ivory, ht. 32 cm. Kungl-Husgerådskammeren, Copenhagen.

group around Venus into a form more easily realised in the round. In order to suggest the continuity of the scene, Venus is now shown more in profile, while the nereid behind looks over her shoulder at the triton following. The sculpture (Plate 228) simplifies the group by omitting one of the tritons and the three wind-gods, and, although similar to the rest of the design, transforms Rubens' sturdy sea-inhabitants into elegantly elongated figures natural to a carving realised from a section of ivory tusk. The piece, which was completed with a silver-gilt base and a bowl in the shape of a shell for the salt, was listed among Rubens' possessions at his death. It may well have been commissioned by the painter at the time, but, given the subject, with its hymn to the goddess of love, might equally well have been bought later from the sculptor on the occasion of Rubens' second marriage.

For the recently built church of the Hermits of St Augustine in Antwerp, Rubens painted one of his finest religious pictures (Plate 229), which was installed on the high altar in June 1628, only weeks before his departure for Spain. The subject of the *Virgin and Child enthroned with Saints* was suggested by the dedication of the church to Our Lady and all the saints. The variety of *dramatis personae*, acknowledging the number of religious brotherhoods connected with the church, led to modifications in the development of the work, about which we are unusually well-informed owing to the survival of oil-sketches and drawings. Following the example of Leonardo, Rubens started with a drawing working out on the paper the poses of the Virgin and Child (Plate 231); at this stage the group was completed with St John rather than St Catherine. Turning over the sheet of paper, the artist then drew in summary black chalk lines strengthened with pen and wash the entire composition (Plate 232). Already he envisaged the vast architectural framework to the figures which, with its platform at the top of steps before giant columns, makes such an impact when the picture is seen the length of the aisleless nave. At the top of the composition the Virgin and Child are now accompanied by St Catherine with a group of female saints in the lower left, while the foreground is filled by the three principal male saints, Sebastian and George on the left and Augustine on the right. The *mise en scène* was clearly a variation on Titian's *Madonna of the Pesaro Family* (Plate 230) in the Frari in Venice.

From this drawing Rubens turned his attention to the figures of St George and St Sebastian in two oil-sketches; in one of these (Plate 233) the self-absorbed downward glance of St Sebastian has been altered in favour of a pose which both in movement and in the upward glance of the head establishes a relationship with the central motif of the painting of the Virgin and Child. In what was to be the first *modello* (Plate 234) Rubens adumbrates the entire cast of saints, brilliantly arranged to create a circular or rhomboid movement around the Virgin and Child. The energetically pointing St John in the upper right and St Nicholas of

226. *Sketch for the Triumph of the Sea-born Venus*, c.1628(?). Panel, 34.5 × 48.5 cm. Private collection, England.

227. *Venus and Two Nereids*, c.1628(?). Pen and brown ink, 27.3 × 25.1 cm. British Museum, London.

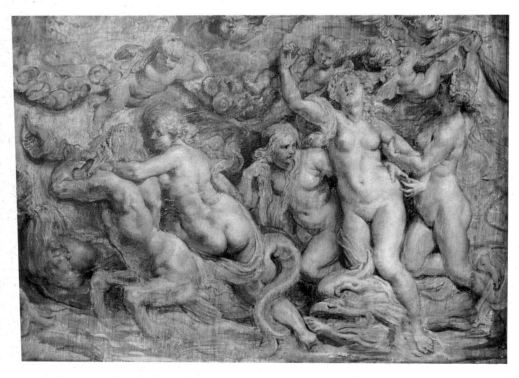

229. *Virgin and Child enthroned with Saints*, 1628. Canvas, 564 × 401 cm. St Augustine, Antwerp.

Tolentino beneath him are among the notable additions to the list of saints. To enhance his contact with the central group St Sebastian twists round more strongly so that his face is virtually lost to sight. A second *modello* (Berlin), which established the shape of the finished painting (Plate 229), augments the number of saints, perhaps at the request of the patrons, so that once again the group at the lower left had to be rethought in order to incorporate the figure of St William of Acquitaine between St George and St Sebastian. With the composition finally fixed, Rubens was able to turn his attention to individual figures, as can be seen from the beautiful study from the model for the figure of St Apollonia (Plate 235), who appears among the female group on the left-hand side.

In the genesis of the composition, a major change took place in the transformation of the circular grouping of the figures into a dynamic upward curving sweep of movement, commencing at the lower right and gradually culminating in the figures of the Holy Family above. The organisation of so many different figures is far more arrestingly dramatic in its final form. Yet the architectural framework is muted by the strong pictorial qualities of rich colour and flowing brushwork which show the freedom of painting that Rubens had adopted by the end of the decade. Like the composition, the colour shows an unmistakable turn towards Titian, with whose art Rubens was shortly to have such an intense new dialogue.

One other major work was to engage the artist's attention at this period, but events beyond his control prevented him from reaching a similarly triumphant solution. Returning from the unveiling of the Medici cycle in 1625 in Paris, Rubens was still without his programme approved for the concluding series dedicated to Henry IV. This unsatisfactory situation was made infinitely worse by rumours reaching Rubens, which were in fact true, that, urged on by Cardinal Richelieu for his own political reasons, the queen mother was toying with the idea of taking the commission away from Rubens and giving it to an Italian painter.

230. Titian, *The Madonna of the Pesaro Family.* Canvas, 484.8 × 270.5 cm. S. Maria dei Frari, Venice.

231. (below left) *Studies for the Virgin and Child and St George and the Dragon*, c.1627–9. Pen and ink with brown wash over black chalk, 56.1 × 41.2 cm. Nationalmuseum, Stockholm.

232. (below) *The Virgin and Child enthroned with Saints*, c.1627–8. Point of the brush and brown ink with brown and grey wash over black chalk, 56.1 × 41.2 cm. Nationalmuseum, Stockholm.

234. *Sketch for the Virgin and Child enthroned with Saints*, c.1627–8. Panel, 63.4 × 49.5 cm. Städelsches Kunstinstitut, Frankfurt.

233. (facing page) *Sketch for Sts George and Sebastian*, c.1627–8. Panel, 41 × 30.5 cm. Musée des Beaux-Arts, Caen.

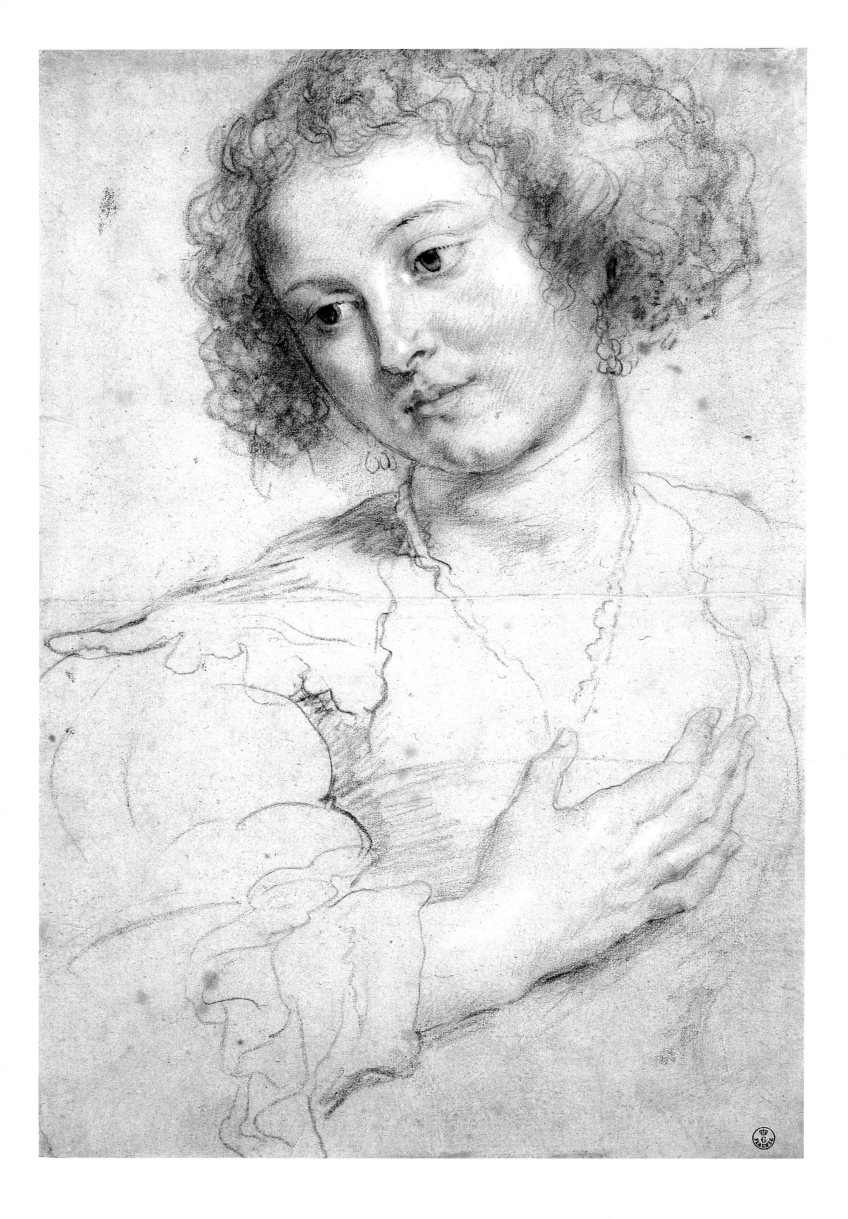

Unknown to Rubens when he was in Madrid in 1629, the names of the Cavaliere d'Arpino, Guido Reni and Guercino were all being considered as possible candidates. But a year earlier Rubens, unaware of this development, had written to Dupuy, 'I have now begun the designs for the other Gallery, which I believe, according to the quality of the subject, will be more splendid than the first, so that I hope to rise higher [in reputation] than to decline'.[64] It must be during this period that the existing *modelli* were executed. The original contract had called for illustrations of 'all the battles of the deceased King Henry the Great, the encounters he was engaged in, his combats, conquests and sieges of towns with the Triumphs of said victories in the manner of the triumphs of the Romans'.[65] As Rubens said in 1625, 'the theme is so vast and so magnificent that it would suffice for ten galleries'.[66] And Rubens set to enthusiastically, devoting particular attention to the subject of the *Triumph of Henry IV* (Plate 236), for which he made no fewer than three sketches.

It was probably about this time that Rubens produced his 'theme and variations' (Plate 238) on Mantegna's *Triumph of Julius Caesar* (Plate 239), which he had known from his days in Mantua. His immediate source remains unknown; he could have used Andreani's woodcuts or copies he may have made in Italy, or, perhaps more likely, the series of copies listed in his estate was already in his possession. The work started on the right as a straightforward copy of one section of Mantegna's original, but as he proceeded Rubens developed his own interpretation, reworking not only this part but also the adjoining section, and adding a connecting passage of his own between the two in order to arrive at a unified composition. As in so many of his adaptations the final result was entirely personal to Rubens and in this instance shows unmistakably the stylistic qualities of his works of the late 1620s. Such a creative exercise must have put Rubens in the right mood to deal with the triumphs of the French king, although a more immediate source for his *modello* for the *Triumph of Henry IV* (Plate 237), was provided by the *Triumph of the Church* (Plate 209), executed a few years earlier. In both works the chariot, drawn by four bay horses, carries the central figure accompanied by a winged genius above, while prisoners follow in the rear. In the hands of Rubens the basic repertory could be adapted from religious to historical allegory by modifying the detail.

Whereas the Maria de' Medici cycle read from left to right, the reverse order was used here, as this sketch demonstrates. One of the three large compositions, it was intended to hang on the end wall, probably following the canvas illustrating the king's last major victory, which took place at Ivry. Its central position would explain the extensive revision carried out in two subsequent oil-sketches (Bayonne and New York) before he executed the final canvas (Plate 236). Apart from increasing the emphasis given to the king, the composition was enlarged both literally and emotionally by including the crowd who actively participate in the victorious ride. The procession now leads towards a triumphal arch on the left-hand side, a clear allusion to the Roman practice of welcoming the victor with an arch erected in his honour. But one small yet important change indicates the subtle shift in emphasis to the meaning of the whole series. In the first representation Henry held a palm, the symbol of victory, but this was eventually replaced by an olive branch, the symbol of peace. This unmistakable reference to Henry as Prince of Peace is picked up in the final scene, a narrow upright, which depicts the *Union of Henry IV and Maria de' Medici* (Plate 240). Echoing the poses of the couple in Dürer's engraving (Plate 241) who are attended by the figure of Death, the king and queen walk lovingly together, his arm around her waist. Above, a love-god with a burning torch seeks to reinforce their union. In the opening scene on the opposite wall depicting the *Birth of Henry IV*, the infant king received a sword from the hand of Mars. In the closing scene he holds an olive branch, which was probably to be read as an allusion to the peacemaking role of his new bride. With this historical message clearly in mind the spectator was intended to proceed to the other wing of the palace and contemplate the life of the queen herself. Had the

235. *Study for the Head of St Apollonia*, c.1628. Black and red chalk, heightened with white, with pen and brown ink on the eyes, 33.5 × 23.2 cm. Uffizi, Florence.

211

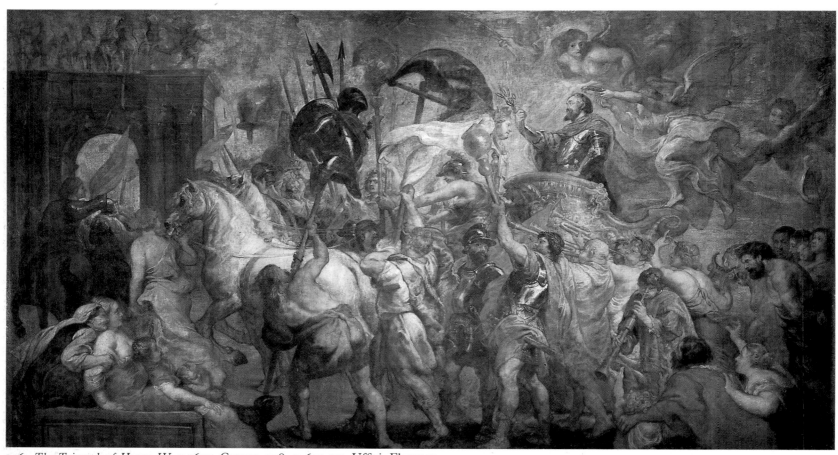

236. *The Triumph of Henry IV*, c.1630. Canvas, 378 × 690 cm. Uffizi, Florence.

238. (facing page) *A Roman Triumph*, c.1628. Canvas on panel, 86.8 × 163.9 cm. National Gallery, London.

237. *Sketch for the Triumph of Henry IV*, c.1628. Panel, 21.4 × 37.2 cm. Wallace Collection, London.

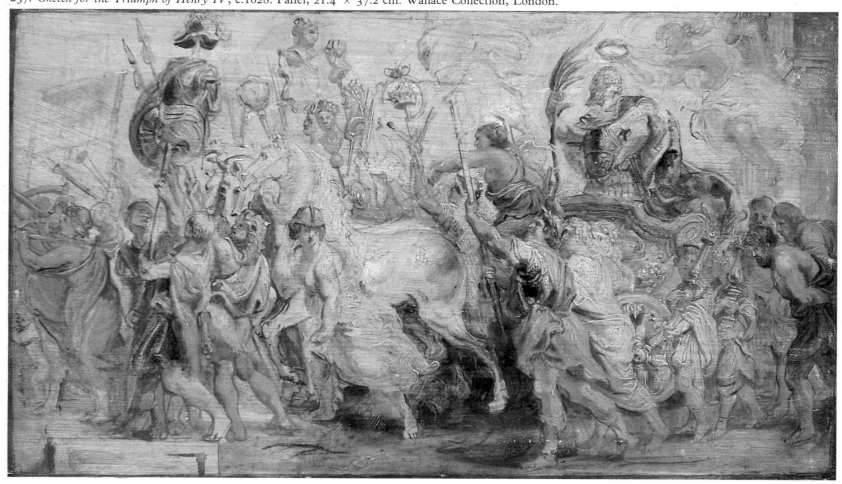

entire project been carried out, it would have offered a coherent and convincing exercise in rewriting history to suit the wishes of the royal patron. It was a very skilful exercise in propaganda, and with most if not all of the second scheme realised in *modelli*, Rubens may well have handed these over for royal approval as he passed through Paris on his way to Spain.

It was probably during this period that Rubens executed one of his occasional exercises in landscape. Unlike that with the *Shepherd with his Flock* (Plate 145), it illustrates a mythological subject, whose theme is vividly expressed through the landscape itself. In the *Landscape with Philemon and Baucis* (Plate 242), the *dramatis personae* are tucked away in the lower right of the picture. The elderly couple 'leaning on their sticks' have followed the command of Jupiter and Mercury 'to leave your home and climb up the steep mountainside with us'. Near the top 'they looked round and saw all the rest of the country drowned in marshy waters'. But in order to give a more dramatic depiction of the flood Rubens may well have conflated this account with the thunderstorm in the similar story of the

equally elderly Deucalion and Pyrrha, in which 'across the wide plains the rivers raced, overflowing their banks, sweeping away in one torrential flood crops and orchards, cattle and men, houses and temples, sacred images and all'. Like the *Odysseus and Nausicaa* (Florence), probably painted about this time, we see a landscape totally inspired by Rubens' reading of the classics, whose mountainous forms are, we may guess, recollections of the wilder and the more rugged parts of Italy and Spain.

The artist has used his imagination to wonderful effect to realise the essence of the story. From their refuge the elderly couple and the gods watch the elements at work in all the variety of mood of which they are capable. Over the distant hill-town a violent storm rages with torrential rain and flashes of lightning; its effects are clearly linked to the rushing torrent in the foreground carrying all before it. But this mood is contrasted with areas of blue sky and brilliant shafts of sunlight picking out patches of ground throughout the composition and creating a spectrum in the spray on the left of the foreground. Despite the initial impact of austere grandeur, it is an inhabited world into which numerous figures and animals at the mercy of the elements are tucked into pockets of the landscape. A

239. (top and bottom) Andrea Mantegna, *The Triumph of Caesar (Parts IV and V)*. Tempera on canvas; 267 × 278 cm and 267 × 277 cm. Royal Collection, Hampton Court.

240. *Sketch for the Union of Henry IV and Maria de' Medici*, c.1628. Panel, 23 × 12.2 cm. Wallace Collection, London.

bull is caught helplessly by the horns in the cleft of a tree trunk carried away by the torrent. A mother and child are hurled on their backs while another figure desperately attempts to climb a tree bending in the gale. But above, a stork or crane is seen flying calmly against the clear blue sky, surveying the chaos below.

Painted in a wide range of greens, browns and blues, with small accents of red scattered throughout the landscape, the picture attains a marvellous luminosity. The profuse richness of vegetation is welded together by the force and vitality of the brushwork which is often laid on so thinly, as in the sky, that the ground now shows through. Taking his impetus from the event recorded in the right-hand foreground, Rubens has created a dynamic and dramatic landscape rich in climactic and living incident. It is revealing of the pleasure that the artist derived from such re-creations of the ancient world that the picture stayed in his possession for the remainder of his life.

If Rubens had any doubts about the direction his career was taking, they were quickly resolved after the tragic event of Isabella's death. 'I should think a journey would be advisable, to take me away from the many things which necessarily renew my sorrow, "*ut illa sola domo moeret vacua stratisque relictis incubat*" [just as she (Dido) mourns alone in the empty house, and broods over the abandoned couch – *Aeneid*]. The novelties which present themselves to the eye in a change of country occupy the imagination and leave no room for a relapse into grief.'[67] For the next few years Rubens threw himself wholeheartedly into travelling and diplomatic work. Intense activity was to act as a balm to his feelings. By the end of the year he had been to Calais and Paris, in the vain hope of meeting Gerbier to further negotiations for an armistice between Spain, Britain and the United Provinces, which had been set in motion by the Archduchess. The next year, after several further attempts to meet Gerbier, the two painter–diplomats succeeded in coming together in Delft. To the world it was meant to appear that they were discussing the sale of the painter's collection to Buckingham, as well as looking at pictures and visiting artists in various Dutch towns. From the latter point of view, Rubens profited from his visit and was much fêted by Dutch artists, as we learn from Joachim von Sandrart, who was a pupil in Honthorst's studio in Utrecht at the time. The young German painter, deputed to accompany the master, described many years later how 'after a banquet organised in his honour by Honthorst he left for Amsterdam, then for other towns in Holland, where he spent a fortnight in visiting everything that was remarkable. I accompanied him all the time with much pleasure, for he was an artist who could teach me much by his conversation, his advice and his example.' In Utrecht he admired Honthorst's night scenes, the fine design in Bloemart's works, and Poelenburgh's 'lively small figures . . . in the style of Raphael, accompanied by delightful landscapes, ruins, animals and other accessories, several of which Rubens commissioned for himself'.[68] (Poelenburgh, two of whose landscapes were listed in Rubens' inventory, is supposed to have painted a commemorative portrait of the two men and the former's wife.) Such an innocent explanation for Rubens' visit to Holland did not fail to arouse the acute suspicions of the French and Venetian ambassadors even if they remained ignorant of its actual purpose. But then the English were no less suspicious, and with equally good reason, at the prolonged stay of the Spanish Marquis de Leganès in Paris.

The artist's diplomatic role, though accepted by the English, despite Gerbier's complaint that 'Rubens had brought nothing in black and white, and that all he said was only in words',[69] met with strong disapproval in Madrid. In a thoroughly ungracious letter, Philip IV rebuked his aunt: 'I am displeased at your mixing up a painter in affairs of such importance. You can easily understand how gravely it compromises the dignity of my kingdom, for our prestige must necessarily be lessened if we make so mean a person the representative with whom foreign envoys are to discuss affairs of such great importance.'[70] France and England had warmly welcomed 'so mean a person' as diplomatic representative, but Rubens had yet to soften Spanish pride and hauteur. Isabella defended her special envoy

241. Albrecht Dürer, *The Promenade*. Engraving, 19.2 × 12 cm. British Museum, London.

242. *Landscape with Philemon and Baucis*, late 1620s. Panel, 147 × 209 cm. Kunsthistorisches Museum, Vienna.

to her nephew: 'Gerbier is a painter like Rubens; the Duke of Buckingham has sent him here with a letter for Rubens written in his own hand, charging him to make a proposal. We cannot manage without mutual understanding.'[71] Though the Spanish court held their views firmly on this occasion, these were also used to deflect attention from a piece of political treachery. At the time that Gerbier and Rubens were negotiating on behalf of Britain and Flanders, Spain and France, unbeknown to both Charles and Isabella, had signed a treaty for a joint attack on Britain. With Leganès' eventual arrival in Brussels from Paris, the news of this secret alliance broke. It was therefore hardly surprising that Rubens' activities were abortive. Still unused to the treacherous behaviour of politicians, Rubens was distressed and dismayed. He was yet to learn, but never to endorse, the double-dealing of those who rule.

In spite of this failure, Rubens' interest in politics was now thoroughly engaged, and in his letters to the French royal librarian Pierre Dupuy which cover this period of the artist's life, he discourses at length on the course of events. He was clearly in a restless and expectant mood when he wrote to his French correspondent: 'Here we remain inactive, in a state of midway between peace and war, but feeling all the hardships and violence resulting from war, without reaping any of the benefits of peace. Our city is going step by step to ruin, and lives only upon its savings; there remains not the slightest bit of trade to support it.'[72] But he did not have to wait long before he was once again called upon to act as negotiator with Gerbier on behalf of the British crown. The hopeless situation created by the alliance of France and Spain had recently been offset by the disastrous failure of Buckingham's expedition to La Rochelle, which left the British keen to reopen peace talks. On her side, Isabella was no less desirous of peace, as she watched her

216

country suffer more and more from poverty and decay. After a great deal of aggressive intransigence on the part of Olivares, the Spanish first minister, agreement was finally given for peace negotiations to be opened between Britain and Spain. Madrid was now disillusioned with the French, who had done nothing to implement their combined assault on Britain. As Spain hedged about reopening talks, Rubens increasingly became the centre of attention in diplomatic circles. The ambassador of Savoy, the Danish minister to the United Provinces, and the Earl of Carlisle, acting as ambassador extraordinary for Charles I, were all in contact with the painter. Where others were suspected of deceit, Rubens had the unusual advantage of being trusted. After talking to him, the Earl of Carlisle admitted to Buckingham that 'he made me believe that nothing but good intentions and sincerity had been in his heart, which on my soul I think is true, because in other things I find him a real [reliable] man'.[73] Rubens had his finger very firmly on the political pulse, and the Spanish court grudgingly acknowledged this by acceding to his proposal that he should be summoned to Madrid to prepare the ground for the discussions.

As usual, Rubens' mission was clouded in secrecy, and he himself let it be known that he 'has gone to Spain, where he says he is summoned to paint the king'.[74] That the truth was otherwise, suspicious diplomatic observers were not slow to conclude, and in no time all kinds of rumours about his ultimate destination began to circulate around foreign courts. After his arrival in Madrid, observers quickly noted his long discussions with Olivares. The papal nuncio wrote home that Rubens 'often confers in secret with the Count-Duke, and in a manner very different from that which his profession permits'.[75] Twenty-five years had passed since his last visit to Spain, and Rubens must have greatly enjoyed the change of circumstances. Instead of being the Duke of Mantua's junior emissary, to be pushed from pillar to post by the duke's jealous agent, he was now an object of attention and speculation. With pride he must have noted the inquiring looks of senior diplomatic and political figures, who before would have scarcely deigned to give the young painter a glance. It must have seemed to him that his previous rough treatment was atoned for by his present reception. Shortly after Rubens, the two agents of the Duke of Buckingham, Gerbier and Endymion Porter, arrived in Madrid. After lengthy preliminaries, all was set fair for the opening of peace talks, when the news of Buckingham's assassination reached Madrid. Immediately doubts were raised whether Britain would continue the same policy. Previously Spain had been in a position to play Britain off against France, but now it was Britain's turn 'in the middle', and she proceeded to keep Spain guessing for a good six months about her intentions.

After the first hectic weeks of political meetings in Madrid, Rubens' life must have settled down to a waiting calm. Fortunately for him, there was much else to occupy his mind. The country and the people were of great interest to someone as aware of human nature as Rubens. In his comment on the disastrous defeat of the Spanish navy by the Dutch off Cuba, he conveyed something of the bitter and unhappy mood of the country: 'You would be surprised to see that almost all the people here are very glad about it, feeling that this public calamity can be set down as a disgrace to their rulers. So great is the power of hate that they overlook or fail to feel their own ills, for the mere pleasure of vengeance.'[76] More important for Rubens' career were his relations with the king and the first minister. For the artist it was a triumph of personality. He changed their previous attitude into one of admiration and trust. This achievement was all the more remarkable, given the very different characters of Philip and Olivares. The latter was austere, stern, quick-tempered and insulting, with a keen disapproval of worldly pleasures. His death-wish was strong, and he would frequently lie in a coffin surrounded by monks chanting the *De Profundis*. His energy and ambition for the position of Spain in the world were accepted by the idle hedonistic king, who left his first minister to run the country. The two men had only one thing in common, a love of the fine arts, and for this Rubens, better than anyone else, was able to provide fuel.

But, despite all the king's weaknesses, Rubens had a warm feeling for him. He 'alone arouses my sympathy. He is endowed by nature with all the gifts of the body and spirit, for in my daily intercourse with him I have learned to know him thoroughly. And he would surely be capable of governing under any conditions, were it not that he mistrusts himself and defers too much to others. But now he has to pay for his own credulity and others' folly, and feels the hatred that is not meant for him.'[77]

Intellectual life in Madrid was not rewarding. To Peiresc he wrote later that 'there is no lack of learned men there, but mostly of a severe doctrine, and very supercilious, in the manner of theologians'.[78] Moreover, 'up to now I have not met a single antiquarian in this country, nor have I seen medals or cameos of any sort'.[79] But there was one major compensation which kept the artist in good spirits. 'Here I keep to painting as I do everywhere and already I have done the

243. *Philip IV*, 1628–9. Pen and brown ink over black and red chalk, heightened with white, 38.3 × 26.5 cm. Musée Bonnat, Bayonne.

equestrian portrait of His Majesty, to his great pleasure and satisfaction. He really takes an extreme delight in painting, and in my opinion this prince is endowed with excellent qualities', which, it may be added, included the purchase of eight pictures Rubens had brought with him. 'I know him already by personal contact, for since I have rooms in the palace, he comes to see me almost every day.' He also reported that 'I have also done the heads of all the royal family, accurately and with great convenience, in their presence, for the service of the Most Serene Infanta, my patroness'.[80]

Apart from the equestrian portrait (destroyed in the Escorial fire of 1734), which, following the pattern of that of Buckingham (Plate 213), depicted the king from the side accompanied by allegorical figures of Faith and Justice, Rubens painted four other portraits of the king. These and the other family portraits were presumably taken back to Flanders, and either delivered to Isabella or kept in the studio for future repetition, but it is arguable if originals of any of these exist today. There is, however, a drawing of the king (Plate 243) clearly made *ad vivum* with the intention of recording a pose rather than the facial likeness. The informality of the occasion, corroborating what Rubens told Peiresc, is underlined by the sitter's wearing of his hat. The characteristic jutting chin of the king accurately recorded in the original chalk drawing was flatteringly reduced in the subsequent retouching with pen and ink to present a more idealised image.

Pacheco records numerous other commissions for both portraits and religious pictures, adding that 'it seemed incredible that he could have painted so many pictures in so short a time and in the midst of so much business'. But for Rubens' art as a whole, his most important activity was copying after Titian. (Pacheco goes so far as to say that 'he copied all the pictures by Titian in the king's possession'.)[81] As Rubens already knew from his first visit, the collection of Titian's work built up by Charles V and Philip II was unrivalled, and contained two categories of picture which were both to be of great significance for the future of Rubens' painting. An outstanding group of portraits numbered such powerful sitters of the previous century as Charles V and Philip II, and Rubens' copies of these were to prove to be not solely academic exercises. The collection also included such major *poesie* as *Diana and Callisto* and the *Rape of Europa* as well as the large *Adam and Eve*, copies of which by Rubens are known today. But this exercise, in itself unprecedented for a mature and busy artist, was not purely imitative and each of the copies is unmistakably Rubensian not only in handling but in the small but significant modifications he invariably introduced, so that one can more accurately describe them as reinterpretations.

Possibly the most beautiful and personal of his copies of Titian are the *Worship of Venus* (Plate 244) and its counterpart dedicated to Bacchus, the *Baccanal with the Andrians* (Stockholm), which remained in his possession until his death. He had seen the originals (Plate 245), which dated from the Venetian's early years when he was in Italy, but since they only reached the Spanish royal collection after 1628, it is generally assumed that Rubens used copies after Titian. Although following Titian's forms for the most part with precision, Rubens' handling of his brush is preeminently his own. Following the example of the later Titian, the overall Venetian *sfumato* is dissolved into a more sparkling surface of numerous small highlights, which by picking out the heads and limbs increase our sense of the sheer plethora of children, at the same time that shafts of sunlight break up the forms of the trees and enliven the depth of the landscape. Moreover, Rubens subtly alters the tone of the picture by such details as the change of sex from male to female of the standing child with arms raised on the left, who is about to feel the force of Cupid's arrow. But empathy with Titian went further than the painterly. Titian's paintings were pictorial reconstructions of Philostratus's *Imagines* (descriptions of ancient pictures), and it was such exercises in recreating the classical past that appealed so strongly to Rubens, as he demonstrated in many of his works.

Although both Tintoretto and Veronese did not fall far behind in his estimation,

244. Rubens after Titian, *The Worship of Venus*, c.1628. Canvas, 195 × 209 cm. Nationalmuseum, Stockholm.

Rubens already recognised Titian as his spiritual father from his earliest days in Venice and Mantua, and reflections of both manner and detail are to be found in numerous works thereafter. But for the most part his corresponding admiration for the qualities of antique sculpture and Michelangelo balanced the final result. The change already noticeable in certain works of the late 1620s was to be greatly accelerated by his renewed encounter with Titian – and it should be stressed with Titian alone – whose effects were fully revealed in the pictures Rubens produced during the last decade of his life. As his friend and fellow-artist Sustermans remembered, Rubens 'carried the image of Titian in his mind as a lady carries that of her beloved in her heart'.[82]

The arts in Spain were flourishing, with writers of the calibre of Lope de Vega and Calderon. But as far as painting was concerned Rubens' unfavourable view of a quarter of a century earlier was little modified. According to Pacheco, 'With our painters he communicated little; only with Don Diego Velázquez (with whom

he had corresponded) did he become very intimate, and he approved of his works because of his great virtue and modesty'.[83] The two men, both high in the king's favour and with rooms in the royal palace, had the opportunity to converse regularly. They apparently made a joint expedition to that granite treasure-house the Escorial, where they admired the contents, especially 'the original paintings by the greatest artists which have flourished in Europe'.[84] We may be sure that the works of Titian were scrutinised with particular attention and admiration. The combined effect of the pictures on the wall and Rubens at his side rekindled Velázquez's desire to visit Italy, which he finally did in the following year. Unfortunately there is not much visual evidence of contact or mutual impact, although a certain penetrating sobriety in Rubens' rendering of the Spanish royal sitters may be as much a tribute to Velázquez's portraits as a reflection of the society he was recording, while in the latter's work there are some clear references to his older colleague.

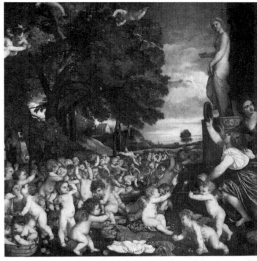

245. Titian, *The Worship of Venus*. Canvas, 172.8 × 173.8 cm. Museo del Prado, Madrid.

It may have been on their visit to the Escorial that Rubens climbed to the Sierra de Guadarrama and made a drawing of the view, which he recalled so vividly in one of his last letters:

> The mountain, which is called La Sierra de S. Juan en Malagon, is very high and steep and very difficult to climb and descend, so that we had the clouds far below us, while the sky above remained very clear and serene. There is, at the summit, a great wooden cross, which is easily seen from Madrid, and near by a little church dedicated to St John, which could not be represented in the picture, for it was behind our backs; in it lives a hermit who is seen here with a mule. I need scarcely say that below is the superb building of St Lawrence in Escorial, with the village and its avenue of trees, the Fresneda, and its two ponds, and the road to Madrid appearing above near the horizon. The mountain covered with clouds is called La Sierra Tocada, because it almost always has a kind of veil round its top.[85]

(The drawing later served for a painting by Pieter Verhulst (Plate 246), which, despite being told by Rubens that it was 'painted entirely by a very mediocre painter',[86] Charles I insisted on acquiring just before the master's death, perhaps as a recollection of *his* visit to Spain.)

246. Pieter Verhulst, *View of the Escorial*. Canvas, 155 × 254 cm. The Earl of Radnor, Longford Castle.

If, like Petrarch on Mont Ventoux, Rubens rushed down to earth again, it was not because of the vanity of the world, but because news had come that Britain was ready to exchange ambassadors. He was to be sent to London as envoy to negotiate the preliminaries, with the title of Secretary of Philip's Privy Council of the Netherlands, and a personal gift of a diamond ring. He left Madrid on 29 April 1629, having conquered yet another capital, on his way to a further triumph with a third great power. His hoped-for visit to Rome via Aix-en-Provence had to be forgone, but by way of consolation he had twenty-four hours in Paris, where he visited Dupuy and other friends, and looked once again at the Luxembourg Palace where one large gallery still awaited his canvases. Without delay he proceeded to Brussels, where he was immediately received by Isabella and learned the news that perfidious Albion had taken a leaf out of Spain's book and had concluded a treaty with France. His mission, therefore, took on an additional urgency, and in a few weeks he had set sail for England in company with his brother-in-law Hendrik Brant, arriving in London at the beginning of June. His life was now so occupied with diplomatic missions that only occasionally could he turn his thoughts to his two sons at home. An affectionate postscript to a letter to his old friend Gevaerts shows, however, that his young family was far from being forgotten by its busy father: 'I beg you to take my little Albert, my other self, not into your sanctuary, but into your study. I love this boy, and it is to you, the best of my friends and high priest of the Muses that I commend him, so that you, along with my father-in-law and brother Brant, may care for him, whether I live or die.'[87]

Like many a European, he approached England and its inhabitants with critical thoughts, though it must be admitted that the latest news had given him good

cause to complain. 'I am very apprehensive as to the instability of the English temperament. Rarely, in fact, do these people persist in a resolution, but change from hour to hour, and always from bad to worse.'[88] But, like many, he left, nearly a year later, an enthusiastic Anglophile. His admiration for the country was, moreover, entirely reciprocated by its inhabitants. Between his arrival and departure much was to happen, not only to please him but also to try him sorely. All his skill as negotiator was now put to the test. His previous assignment had been simple compared to the intricate web of different intrigues he met in London, each person acting entirely in his own interests with an unscrupulous disregard for the rights of others. Although causing a considerable stir of mixed emotions in political circles, his appointment as envoy had met with approval at the English court, and the chancellor of the exchequer, Sir Francis Cottington, wrote that the king is well satisfied, not only because of Rubens' mission, 'but also because he wishes to know a person of such merit'.[89] The day after his arrival Rubens records that 'the king summoned me to Greenwich, and talked a long time with me',[90] encouraging the proposed treaty. An eyewitness reported that the king 'used him graciously and gave him a fair and a full audience'.[91] But such a warm reception was not universal and one English diplomat wrote that 'I find they are here very jealous of Mons' Rubens' negotiation in England, many having spoken to me thereof'.[92] Before dealing with the conflicting interests of other powers, Rubens noted that England herself presented a maze of different beliefs: 'There are in this Court several factions. The first, which is headed by the Earl of Carlisle, wants peace with Spain and war with France; the second is much larger and wants peace with all. The third is the worst; it wants war with Spain and an offensive league with France against her.'[93] Beyond this, there were the French agents of Richelieu, who were naturally doing all they could to sabotage the progress of the talks. In the struggle for victory no holds were barred, as Rubens quickly realised: 'Public and private interests are sold here for ready money. And I know from reliable sources that Cardinal Richelieu is very liberal and most experienced in gaining partisans in this manner.'[94] The Dutch ambassador, Joachimi, who saw in the treaty the end of English aid to his country, was violently hostile, writing home that Rubens 'has brought with him no letter of credence, nor the least thing authentic or substantial; and yet that there are great ones, that maintain him in countenance, and will need make some thing out of no thing'.[95] The Venetian ambassador was hardly less antagonistic, describing Rubens as 'an ambitious and greedy man, who wants only to be talked about, and is seeking some favour'.[96] The future relations with Holland, the Huguenots, and above all with the Palatinate, and through it Austria, were complex by-products of any change in the *status quo* among the three major powers. Such were the vagaries of politics that Rubens found himself in the position of transmitting financial support, supplied by Catholic Spain, to the Protestant Huguenots in their religious struggle against Catholic France. To add to the complexity of Rubens' situation, he was not empowered to draw up a treaty, as Charles wished and pressed him to do, but only to negotiate a truce. From all sides, his own as well as others, he was hampered by double-dealing, inspired by the wish for the other side to play its hand first. Needless to say, such a positive person as Rubens was soon being rebuked for taking direct and constructive steps to achieve his purpose, a course of action that did not appeal to the Spanish taste for evasion and procrastination. To the remonstrations of Olivares, Rubens countered that 'I do not feel that I have employed my time badly since I have been here, or that I have overstepped in any way the terms of my commission'.[97] Like the other two powers, Spain also wished to weigh up the different advantages of making a treaty with either Britain or France.

For three months Rubens negotiated with Britain for the exchange of ambassadors, regularly sending back detailed reports of events to Olivares. At last his efforts were crowned with success, and agreement was reached. Being an active man, Rubens fondly imagined that his task was at an end, but a further three

222

months passed before the Spanish ambassador's arrival, and several more before Rubens was actually allowed to leave England for home. But in the end his uprightness paid and he was honoured on all sides. After trying him almost beyond endurance, Spain at last recognised the achievement of her envoy. Reporting to Philip IV about the successful outcome, the Junta gave Rubens 'approbation and thanks for what he had done and written and for the tact with which he had acted in this affair'.[98] A little later Philip urged Isabella to send him back to London: 'Rubens is highly regarded at the court of England and very capable of negotiating all sorts of affairs ... In such matters one needs a minister of proven intelligence with whom one is satisfied.'[99] And this was written by the man who had not long before described the painter as 'so mean a person'. Helping to encourage this volte-face were enthusiastic reports about the painter that were received in Madrid from both Sir Richard Weston, the lord treasurer, and Sir Francis Cottington, the chancellor of the exchequer, who was to be sent to Spain as ambassador and who, before his departure, gave a lavish entertainment in Rubens' honour. Cottington had written that Rubens 'is not only very clever and adroit in negotiating matters but also knows how to win the esteem of everyone and especially of the king'.[100]

Rubens' mission was largely completed by the end of September, though he had six months to fill in before he was allowed to depart for home. Writing to Gevaerts a week after the signing of peace between Britain and Spain, he said 'I should be happier over our peace or truce than over anything else in this world. Best of all, I should like to go home and remain there all my life.'[101] Making the best of the situation, he took the opportunity to cast a prolonged glance at the new country around him. Though he lamented that 'to see so many countries and courts in so short a time would have been more fitting to me in my youth, than at my present age ... nevertheless, I feel consoled and rewarded by the mere pleasure in the fine sights I have seen on my travels'.[102] He had lost none of his intellectual curiosity. Apart from a visit to Cambridge, where he was awarded a degree of Master of Arts, we know little of his actual movements. In London he stayed with his old friend and fellow painter-diplomat Balthasar Gerbier, who owned houses in Westminster and Bethnal Green, besides retaining a suite of rooms at York House by virtue of his former position of keeper of the collection for the late Duke of Buckingham. Now in political disfavour in London, Gerbier was to complain to the chancellor that he was merely left 'to be innkeeper to Rubens'. Moreover, 'the king has taken from Gerbier a cordon of diamonds and a ring to give to Rubens. God knows when Gerbier will be paid; as also for the charges of ten months' entertainment for Rubens. It is poor reward to be put to charges, and still be excluded from confidence'.[103] His fears about non-payment by the king proved to be unfounded, and probably as an act of gratitude Rubens started to paint the portrait of Mrs Gerbier and her children (Washington).

In London Rubens got to know Sir Robert Cotton, 'a great antiquarian, versed in various sciences and branches of learning',[104] and Sir William Boswell, poet, humanist and diplomat, as well as meet Cornelis Drebbel, the inventor, of whom he had a lower opinion. He could not, however, see John Selden, the scholar with 'such a distinguished and cultivated talent'[105] who was in prison for political activity. Rubens also visited a number of collections of works of art, including those of the king, whose taste for Venetian painting would have found a warm response. Of 'the Arundel marbles which you first brought to my attention', he told Dupuy that 'I confess that I have never seen anything in the world more rare from the point of view of antiquity'.[106] He visited York House, to the decoration of which he had made such a major contribution, and was clearly pleased to find that 'the collections of the Duke of Buckingham are still preserved intact, the pictures as well as the statues, gems, and medals. And his widow has kept the palace in the same state as it was during his lifetime.'[107] He was not slow to note 'that all the leading nobles live on a sumptuous scale and spend money lavishly, so that the majority of them are hopelessly in debt'. His remarks were not inspired by

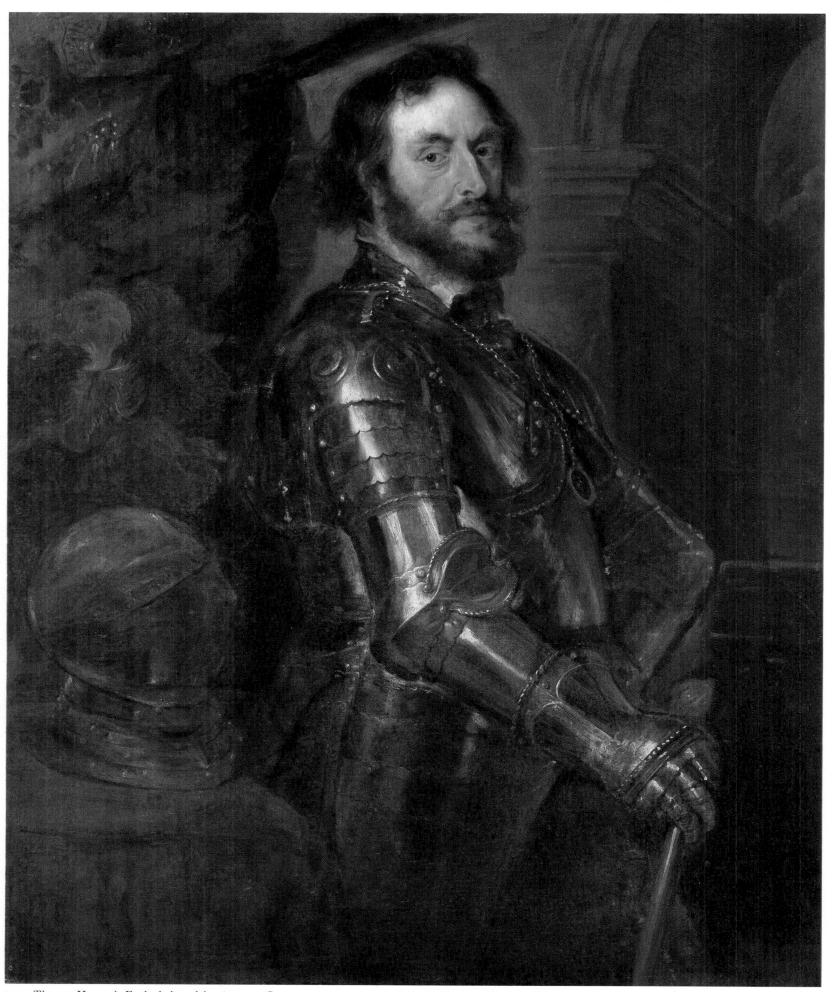

247. *Thomas Howard, Earl of Arundel*, 1629–30. Canvas, 122 × 102 cm. Isabella Stewart Gardner Museum, Boston.

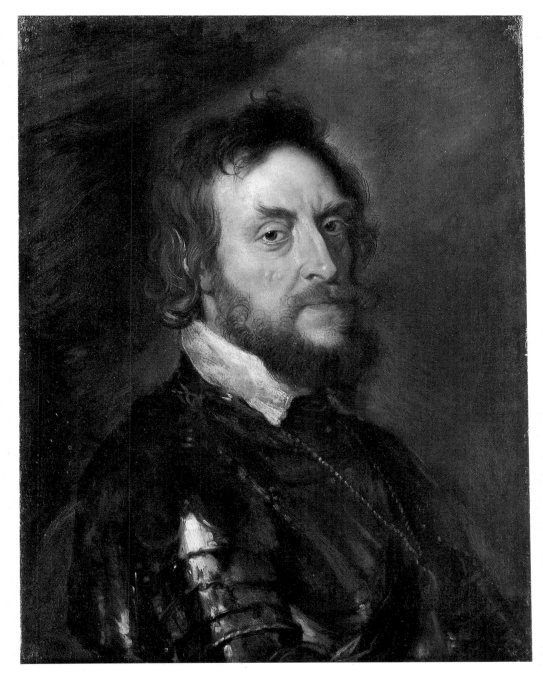

248. *Thomas Howard, Earl of Arundel*, 1629–30. Canvas, 66.5 × 52 cm. National Portrait Gallery, London.

any puritanical spirit, and his warm appreciation shines forth from another letter: 'This island seems to me to be a spectacle worthy of interest of every gentleman, not only for the beauty of the countryside and the charm of the nation; not only for the splendour of the outward culture, which seems to be extreme, as of a people rich and happy in the lap of peace, but also for the incredible quantity of excellent pictures, statues, and ancient inscriptions which are to be found in this court.'[108] To Peiresc he revealed his natural bias: 'Certainly in this island I find none of the crudeness which one might expect from a place so remote from Italian elegance.'[109]

Compared with his stay in Spain, Rubens had less time for painting in London. Apart from painting the Gerbier family, he made, doubtless as a gesture of friendship, a portrait of the royal physician Theodore Turquet de Mayerne, who was much interested in the technique of painting and wrote a treatise on the art of the miniature. The major portrait commission came from the Earl of Arundel, whose wife Rubens had portrayed (Plate 152) on such a grand scale a decade earlier in deference to his admiration for the patron. Restored to royal favour, Arundel cut an austere and aloof figure around the court. 'It was a common saying of the late Earl of Carlisle, Here comes the Earl of Arundel in his plain Stuff and trunk

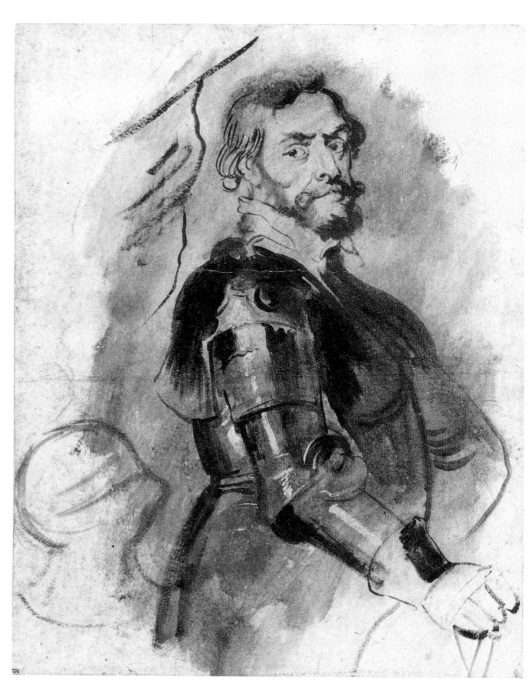

249. *Thomas Howard, Earl of Arundel*, 1629–30. Brush and brown and black ink, brown and grey wash, heightened with white and touched with red, 46.3 × 36.5 cm. Stirling and Francine Clark Art Institute, Williamstown.

250. Titian, *Francesco Maria della Rovere, Duke of Urbino*. Canvas, 114.3 × 100.3 cm. Uffizi, Florence.

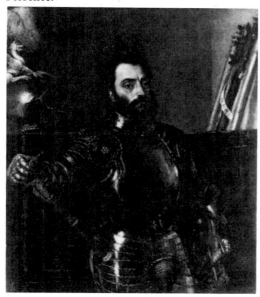

Hose, and his Beard in his Teeth, that looks more a Noble Man than any of us.'[110] During his stay in London, Rubens probably made two bust-length portraits of the earl. One of these (Plate 248) seems to have served as a study for the majestic three-quarter length portrait in armour (Plate 247) which was also preceded by the spirited brush drawing (Plate 249) establishing the pose and the detail of the armour. Compared with the bust-length study, Rubens has idealised the sitter both by removing the disfiguring warts on his face and by changing the direct gaze into a detached almost dreamy expression, made the more imposing by the placing of the head at the top of the canvas. But above all this picture shows a profound understanding of the Titianesque portrait, which he had been copying so recently. The pose, with the sitter in armour and the helmet on a table beside him, clearly derives from such a work as Titian's *Duke of Urbino* (Plate 250). The carefully modulated open strokes of the brush, and the rich combination of colours with red predominant, are an eloquent testimony of the Flemish artist's total absorption of Venetian technique within his own personal language.

Rubens' most notable personal success was with 'the greatest amateur of painting among the princes of the world'. From the moment Charles met the artist

226

at Greenwich their relationship flourished, whatever the political climate might be outside. Like everyone else, the king, obviously recalling the artist's close relationship with his favourite Buckingham, recognised him as somebody far above the run of politicians who inhabited the capital. Rubens must have been immediately attracted to the glittering life of the court, which numbered such people as Inigo Jones among its stars, as well as by its keen appreciation of painting. Though only the Banqueting House had been built, plans were afoot to make Whitehall one of the largest and most sumptuous royal palaces in Europe.

More to the artist's direct interest was the fact that not only was the scheme to decorate the ceiling of the Banqueting House, mooted eight years earlier, revived during his stay but planning in considerable detail as to both programme and appearance must have taken place between Rubens and those responsible. Even if he did no more, Inigo Jones would have had to provide the exact design and measurements of the carved ceiling. As a sampler for his royal patron, Rubens may well have painted during his stay in London the sketch (Plate 274) which adumbrates so much of the final design.

It remains a tantalizing mystery as to why Rubens never portrayed Charles. Various possible reasons are usually attributed to the reluctance of the artist, but had the king wished it Rubens would have been in no position to refuse. Recollections of his royal patrons do, however, occur in one picture he painted in London, *St George and the Dragon* (Plate 251), in which, following the taste of the times for portraits in costume, the saint in *profil perdu* and the princess are given the likenesses of the king and queen. This, according to the scholar Joseph Mead, writing just after the artist's departure, was painted 'in honour of England and of our nation from whom he has received so many courtesies . . . but the picture he has sent home into Flanders to remain there as a monument of his abode and employment here'.[111] (In January 1635 the painting was acquired from the artist by Endymion Porter, who sold it to Charles I.) This souvenir contained not only

251. *St George and the Dragon*, 1629–30. Canvas, 153 × 226 cm. Royal Collection.

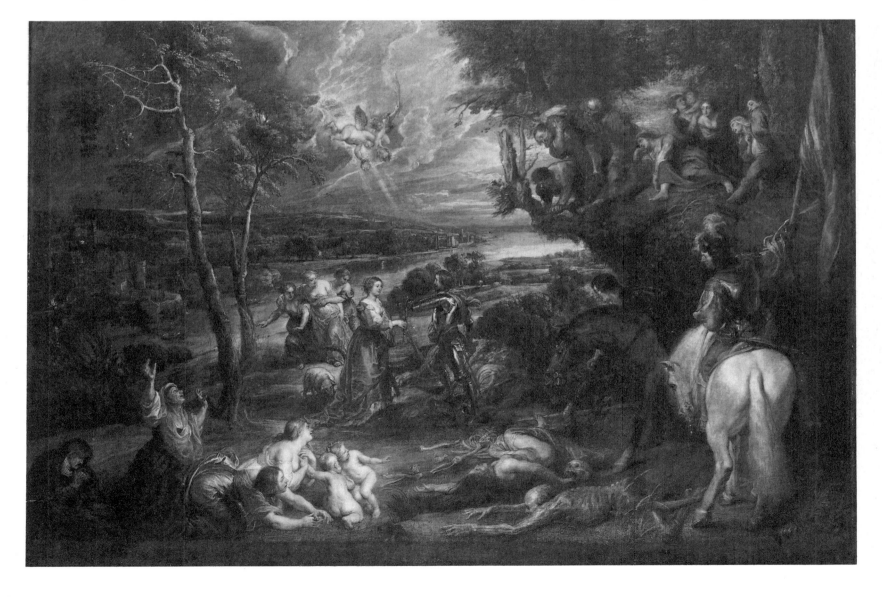

the royal likenesses but a poetic evocation of the Thames Valley and its characteristic misty blue light, probably seen from Westminster but with the architectural details reinterpreted. Thoughts for this composition occur on the sheet of studies (Plate 231) for the *Virgin and Child enthroned with Saints*, which must have formed part of a sketchbook the artist brought with him to London. X-rays reveal that the original composition was very much smaller and was limited to the scene of the rescue of the princess seen against the river landscape, that is the most realistically English part of the picture. Probably back in Antwerp, the canvas was enlarged extensively, notably at the right and bottom to include many more figures as well as the gory scene of mutilated corpses and skeletons. From a courtly masque with a graceful message, the picture was transformed, possibly not by Rubens' own hand, into a very real political allegory.

On the eve of his departure in March, Rubens went to Whitehall to take leave of the king, who knighted him and presented him with the jewelled sword used for the accolade, as well as a ring from his finger and a hat cord ornamented with diamonds, which he had bought for this purpose from Gerbier. The patent of knighthood specifically referred to 'the skill with which he has worked to restore a good understanding between the crowns of England and Spain'.[112] The admiration and affection were entirely mutual. But whereas Charles was most reluctant to let him go, Rubens felt the call of home: 'Although I enjoy every comfort and satisfaction here, and although I am universally honoured, more than my rank deserves, I cannot remain here any longer than the service of His Majesty requires.'[113]

At some time before leaving Rubens had presented the king with a political allegory (Plate 252), painted in London, whose theme explicitly sums up the purpose of his mission to England. Described by Van der Doort, the surveyor of the royal collection, as 'an Emblim wherein the differrencs and ensuencees

252. *Peace and War*, 1629–30. Canvas, 198 × 297 cm. National Gallery, London.

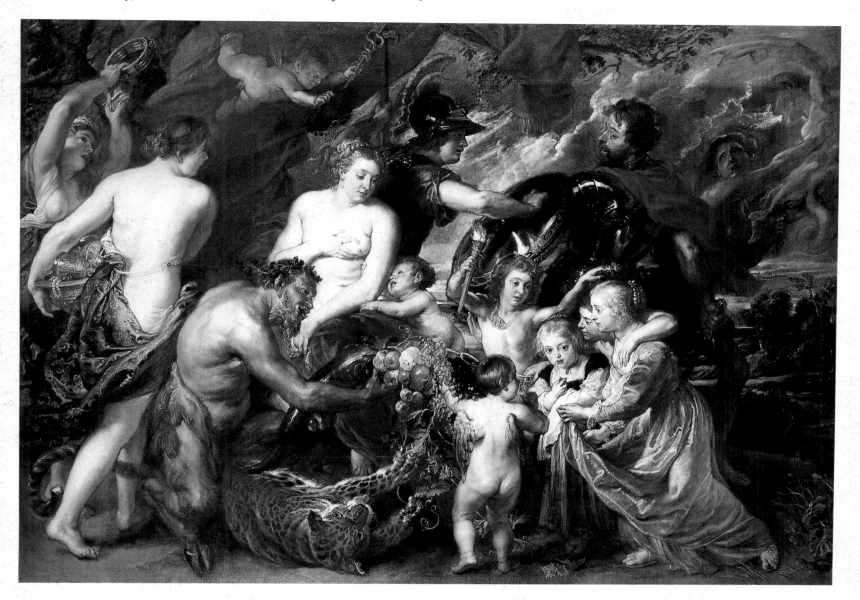

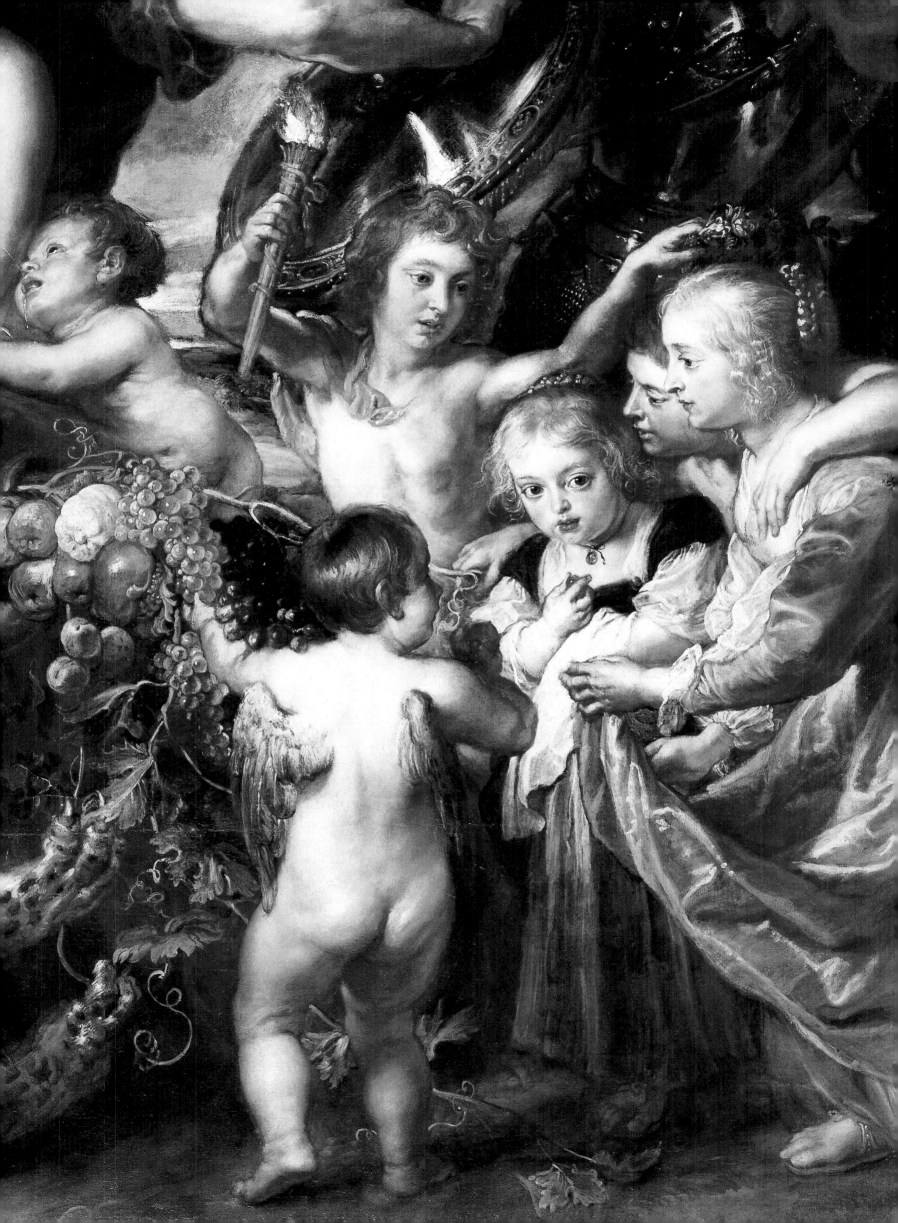

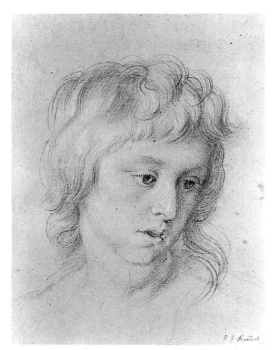

254. *George Gerbier*, 1629–30. Black and red chalk, heightened with white, the eyes and mouth strengthened with the brush, 28.8 × 21.9 cm. Graphische Sammlung Albertina, Vienna.

betweene peace and warrs is Shewed',[114] it depicts Mars, the god of war, driven off by Minerva, the goddess of wisdom, protecting a woman and child, who although without attributes can probably be identified as Pax suckling the infant Plutus, the god of wealth. The composition was clearly inspired by Tintoretto's *Minerva and Mars* in the Palazzo Ducale in Venice. The remainder of the picture is devoted to illustrating in numerous details the benefits of peace which lead to prosperity, matrimonial stability and universal happiness. To represent the second of these themes Rubens has left a personal record of his stay in London by employing three of the Gerbier children as models, studied before work on the canvas in three highly wrought chalk studies (Plate 254). Bearing a torch, George as Hymen, the god of marriage, crowns the elder girl, Elizabeth, while she, her sister, Susan, and a third child are presented with fruit from a cornucopia, a symbol of Peace and Plenty. Whether Pax can be identified as Mrs Gerbier is a more open question on grounds of both likeness and decorum.

The intended allusion to Charles I as peacemaker must have had further resonance, since the benefits of peace under his father, James I, were to be the central theme of the Whitehall ceiling, whose programme was probably by then established. In the future, Rubens' views were not to be nearly so sanguine, as he witnessed with increasing pessimism the deteriorating situation throughout Europe, which marked the development of the Thirty Years' War. The interaction of Mars and Minerva, already found in the Medici series, was to be a frequent subject in the 1630s. From the allegory celebrating the victory of peace in the picture presented to Charles I, Rubens turned, in the brilliant gouache on paper of several years later (Plate 255), to a representation of a more even match in which Minerva aided by Hercules struggles with Mars dragging a mother off by the hair. By 1637 or 1638 when he painted the large canvas generally known as the *Horrors of War* (Plate 256), Rubens proved to be prophetically correct in giving victory to the other side, as Mars successfully disentangles himself from a desperately restraining Venus while the lamenting figure in black, the personification of Europe, looks helplessly on. (Rubens sent a detailed description of the picture to Justus Sustermans, who commissioned it; see below.)

By the time Rubens left London, his intense political activity over the recent few years had opened his eyes to the true situation, and armed with such experience and knowledge he could not even in retirement but be acutely aware of the significance of events. The artist himself may not in these representations have been completely decided as to whether he intended a moral warning or a reflection of the status quo, or more likely a combination of the two.

256. (facing page bottom) *The Horrors of War*, c.1637–8. Canvas, 206 × 342 cm. Galleria Pitti, Florence.

> As for the subject of the picture, it is very clear . . . the principal figure is Mars, who has left the open temple of Janus (which in time of peace, according to Roman custom, remained closed) and rushes forth with shield and blood-stained sword, threatening the people with great disaster. He pays little heed to Venus, his mistress, who, accompanied by her Amors and Cupids, strives with caresses and embraces to hold him. From the other side, Mars is dragged forward by the Fury Alecto, with a torch in her hand. Nearby are monsters personifying Pestilence and Famine, those inseparable partners of War. On the ground, turning her back, lies a woman with a broken lute, representing Harmony, which is incompatible with the discord of War. There is also a mother with her child in her arms, indicating that fecundity, procreation, and charity are thwarted by War, which corrupts and destroys everything. In addition, one sees an architect thrown on his back with his instruments in his hand, to show that that which in time of peace is constructed for the use and ornamentation of the City, is hurled to the ground by the force of arms and falls to ruin. I believe, if I remember rightly, that you will find on the ground under the feet of Mars a book as well as a drawing on paper, to imply that he treads underfoot literature and other things of beauty. There ought also to be a bundle of darts or arrows, with the band which held them together undone; these when bound form the symbol of Concord. Beside them is the caduceus and an olive-branch, attribute of Peace; these also are cast aside. That grief-stricken woman clothed in black, with torn veil, robbed of all her jewels and other ornaments, is the unfortunate Europe who, for so many years now, has suffered plunder, outrage, and misery, which are so injurious to everyone that it is unnecessary to go into detail. Europe's attribute is the globe, borne by a small angel or genius, and surmounted by the cross, to symbolise the Christian world. (Rubens to Justus Sustermans, 12 March 1638).[115]

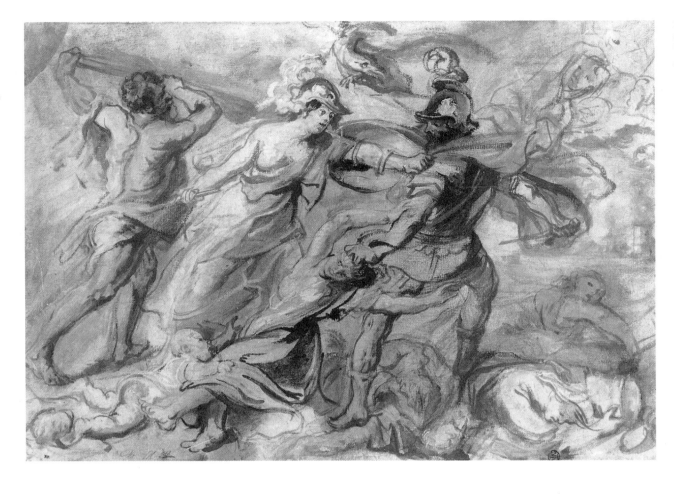

255. *Hercules and Minerva fighting Mars*, c.1635–7. Gouache over black chalk, 37 × 53.9 cm. Musée du Louvre, Paris.

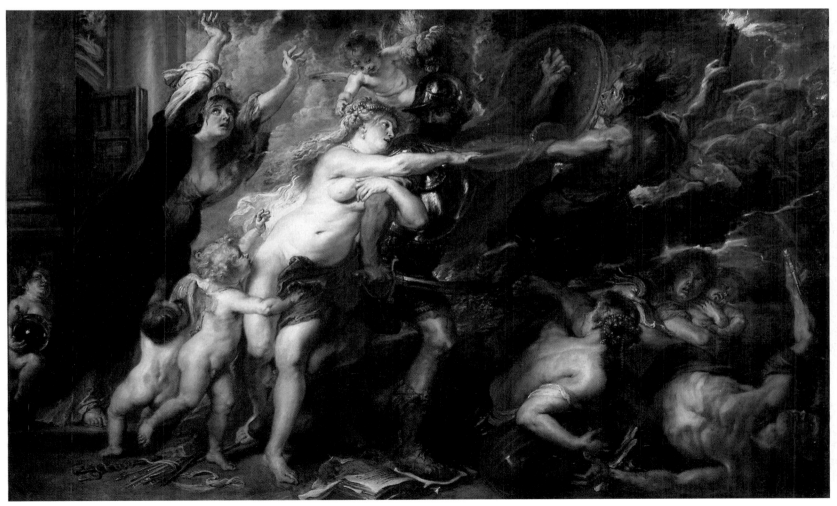

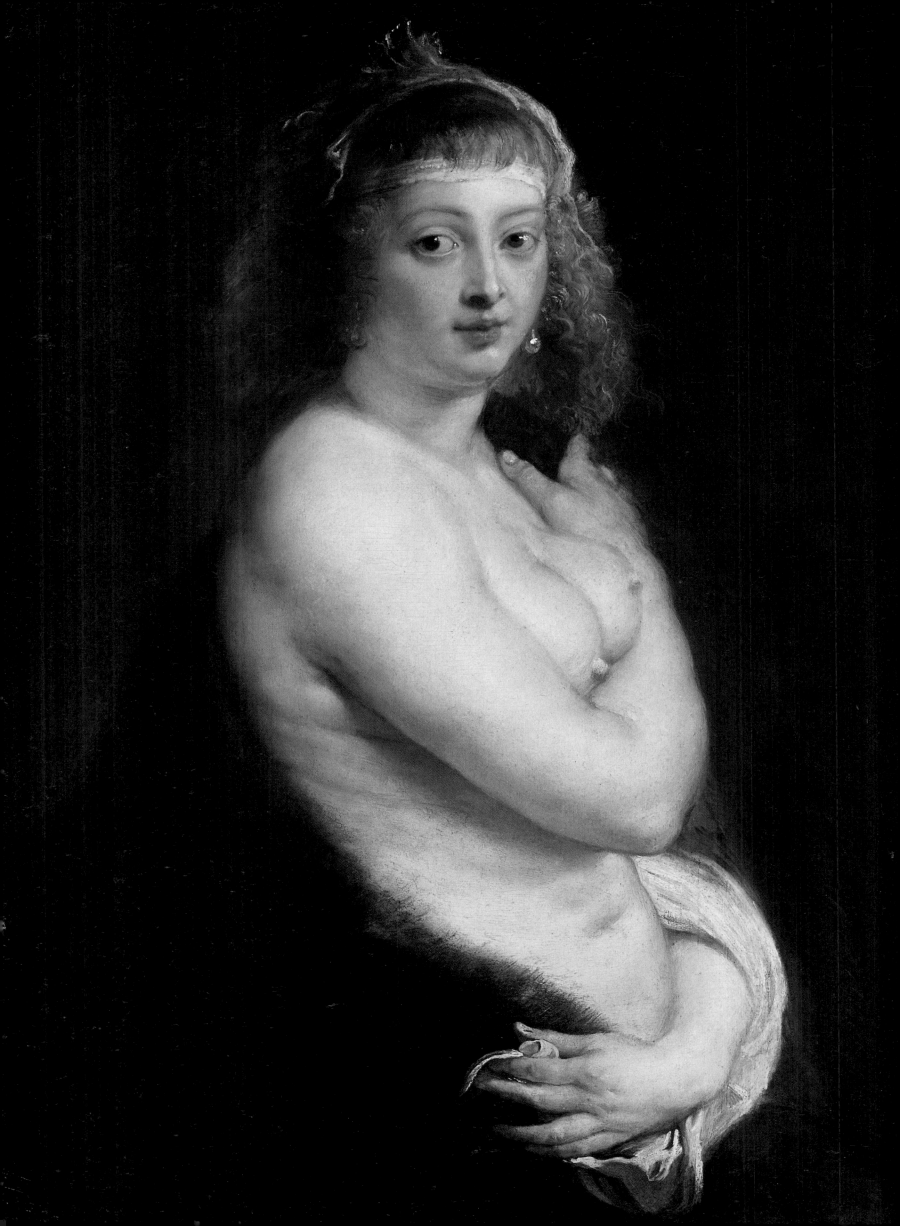

V

'At home, very contented'

RUBENS had been heavily involved during the last few years in diplomatic missions. So busy was he travelling from one country to another, conducting long and complex negotiations, that the time he had to devote to his art would have made a Sunday painter of a less determined and energetic character. But already in 1629 there were rumours of dissatisfaction with the life he was called on to lead. The negotiations in England with all parties procrastinating and changing their minds had wrung a heartfelt cry from the archduchess's ambassador: 'I am longing to return home.'[1] His immediate and ostensible reasons were partly domestic: 'I cannot postpone my departure any longer without great disadvantage to my domestic affairs, which are going to ruin by my long absence of eighteen months, and can be restored to order only by my own presence.'[2] His brother-in-law Hendrik Brant, who was with him, had, according to Rubens, less serious reasons for his restlessness: 'It distresses him to be so long deprived of the society of the girls of Antwerp. Probably in the meantime they will all have been snatched away from him.'[3] But, as future events were to show, Rubens' desire to return home revealed a far more fundamental urge.

One can attribute several motives to Rubens' desire to leave the world of politics. From a personal point of view he had achieved what he set out to do, while at the same time he must have had a gradual feeling of the futility of trying to influence the rulers of the world towards a peaceful and honourable course. At first he can have found it no hardship that his diplomatic activity rapidly increased about the time of Isabella's death. His continued absence from the home where so many happy years had been spent with his wife, and the constant preoccupation with travelling and negotiating, must have provided the necessary distraction. In addition, there was the more permanent driving force of ambition – Rubens himself used the word – which was spurred on by a deep wish to make up for the past. Perhaps his rough treatment as a young man in Spain occasionally came to mind as he ascended the ladder of success. Beyond that there was the memory of his father disgraced, and his mother humiliated. By his own achievements he was atoning for the sadder aspects of the family's past. Finally, the glamour that went with this way of life was clearly not displeasing to the ambitious artist.

The immediate 'rewards' for his active devotion to the Spanish cause over the past two years were both financially damaging and personally insulting. Writing to Jan Woverius nine months after his return home, Rubens said that 'even though, by divine grace, I find myself most contented in . . . the general happiness over the peace with England, I have occasion to lament my misfortune in ever having become involved in that affair. For I cannot obtain any reimbursement for what I spent in the service of His Majesty on the journeys to Spain and England.'[4] Having 'with great difficulty' obtained approval for repayment,

the Receiver now declares that the order has been countermanded: that he is not to pay me, but is to give it to the Councillors. This seems to me such an insufferable affront and insult that I could almost abjure the form of this

257. Detail of Plate 264.

233

government . . . I am so disgusted with the Court that I do not intend to go for some time to Brussels. Believe me, when I say that I have discharged and in part transferred to others the vast correspondence I had, and from which the greatest results have been realised, as Her Highness knows. My personal ill-treatment annoys me, and the public evils frighten me. It appears that Spain is willing to give this country as booty to the first occupant, leaving it without money and without any order.[5]

But it would be manifestly unfair to see Rubens' actions in an entirely personal light. As the end of this letter shows, his deeds were also dictated by more altruistic reasons. He combined a tremendous patriotic fervour, shown in his loyalty to Isabella, with a passionate love of peace. The world's fickle interest in peace, which to Rubens came before all else, was a frequent *cri de coeur* in his letters. In every instance his diplomatic role was on the side of peace. The unsettled and threatening atmosphere of Europe, with its inherent dangers for mankind, and above all the fate of his beloved countrymen constantly disturbed him, and the sight of the three great nations playing power politics of brinkmanship was to him a source of incomprehension and distress that people's lives and happiness could be bartered in such a cavalier fashion. But in this field Rubens' diplomatic ventures were ultimately a failure. He was an honest man, struggling in a world where honesty was a handicap, arguing from a position of weakness – his aim was peace not victory. Today's successes were tomorrow's reversals, and he left the world much as he had found it. He became more and more intolerant of the shifting, vacillating world of courts and politicians, where personal vanity and gain were more important than fundamental issues. The art of diplomacy as practised in Europe by three of the major countries was the art of saying yes and meaning no, and Rubens' upright character was no match. Even such a distinguished figure as Sir Henry Wotton could describe diplomacy as the art of lying abroad on behalf of one's country. For Rubens, who had left a world of which he was complete master, and in which he had reached positive and durable achievements, the quicksands of politics could provide no long-term satisfaction.

This applied not only to those with whom he dealt, but also to his creative urge. Unlike diplomatic manoeuvres, his pen and brush would lead him to certain tangible results, and as one abortive negotiation succeeded another his fingers must have itched with the desire to take up his tools and lose himself in his own totally absorbing world. Finally, with a decisiveness and intelligence for the right reasons and the right time so characteristic of Rubens, he took the appropriate action in accordance with his Stoic beliefs.

I made the decision to force myself to cut this golden knot of ambition, in order to recover my liberty. Realising that a retirement of this sort must be made while one is rising and not falling; that one must leave Fortune while she is still favourable, and not wait until she has turned her back, I seized the occasion of a short, secret journey to throw myself at Her Highness's feet and beg, as the sole reward for so many efforts, exemption from such assignments and permission to serve her in my own home. This favour I obtained with more difficulty than any other she ever granted me.

There were no regrets: 'Now, for three years, by divine grace, I have found peace of mind, having renounced every sort of employment outside of my beloved profession.'[6] A week later, Peiresc, to whom this letter had been written, reported that 'Rubens has taken up his usual work more assiduously than ever'.[7]

There was yet another factor besides art and diplomacy in his change of attitude. With superb candour and self-knowledge, he explained the recent events in his private life to his old friend Peiresc: 'I made up my mind to marry again, since I was not yet inclined to live the abstinent life of a celibate, thinking that, if we must give the first place to continence we may enjoy licit pleasures with thankfulness.' He explained his choice: 'I have taken a young wife of honest but middle-class family, although everyone tried to persuade me to make a court

234

marriage. But I feared pride, that inherent vice of the nobility particularly in that sex, and that is why I chose one who would not blush to see me take my brushes in hand. And to tell the truth, it would have been hard for me to exchange the priceless treasure of liberty for the embraces of an old woman.'[8]

As in the conduct of his professional life, so in his choice of partner, he now knew exactly what was right for him; in this case one must say that his head and heart were perfectly attuned, for this was no cool cerebral decision. By rejecting a middle-aged countess for a very pretty, very young bourgeoise he was turning against the milieu in which he had moved for the last five years. With the true self-acceptance that comes in middle age to those with self-knowledge, Rubens prepared to return to the setting in which he had been brought up, and as a result he was rewarded with a glorious Indian summer of peace and enjoyment.

His choice fell on Helena Fourment, the eleventh child of an Antwerp silk and tapestry merchant, Daniel Fourment, for whom Rubens appears to have made designs for a set of tapestries on the *Life of Achilles* about this time. She was no stranger, since he must have first set eyes on her not later than her fifth year, when one of her brothers married a sister of Isabella Brant, then very much alive. When Rubens and Helena Fourment married she was sixteen against his fifty-three years, so he would have watched her adolescence with almost avuncular interest.

The wedding took place on 6 December 1630, and two days earlier the contract was signed in the presence of Rubens' first father-in-law, Jan Brant, by virtue of his position as alderman. Testifying to the wealth of the bridegroom, Helena received a substantial gift of jewellery: five gold chains (two of which were decorated with diamonds and one with black and white enamel), three rows of

258. *Self-portrait with Helena Fourment and Nicolaas Rubens*, c.1631. Panel, 97 × 131 cm. Alte Pinakothek, Munich.

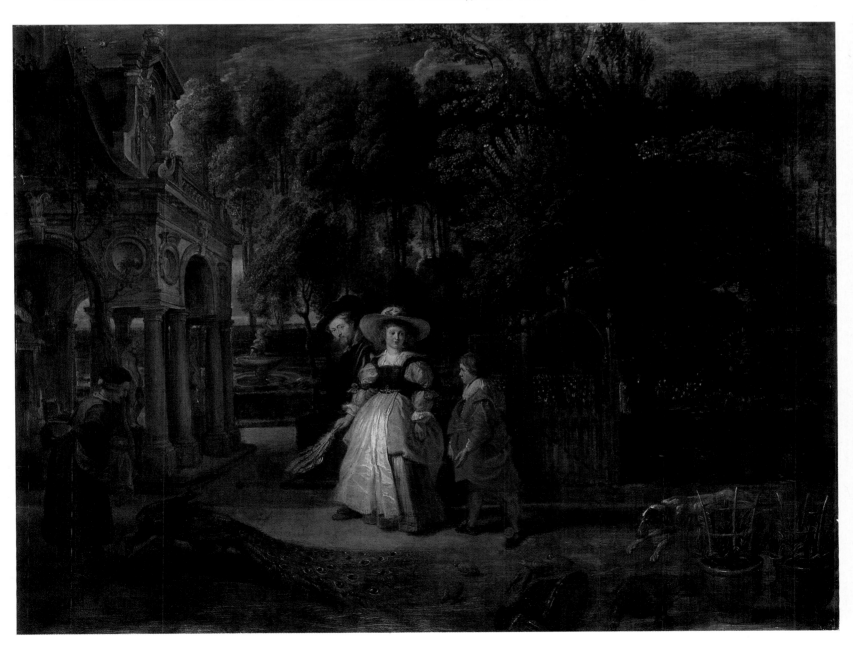

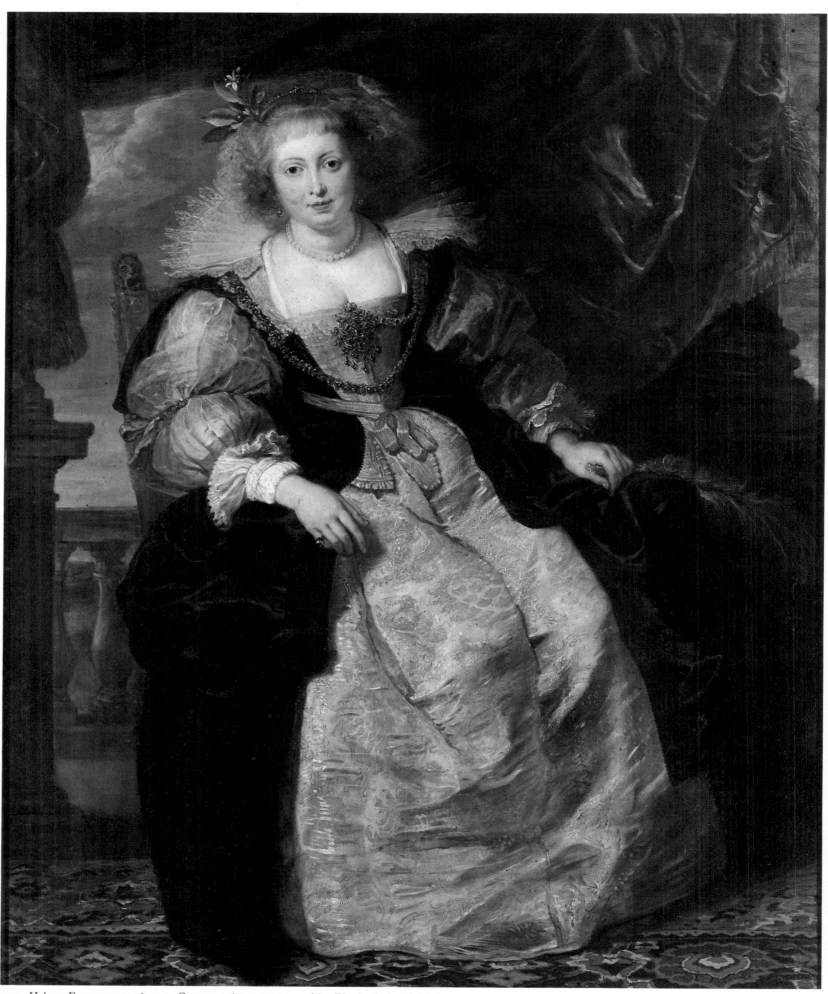

259. *Helena Fourment*, c.1630–1. Canvas, 160 × 134 cm. Alte Pinakothek, Munich.

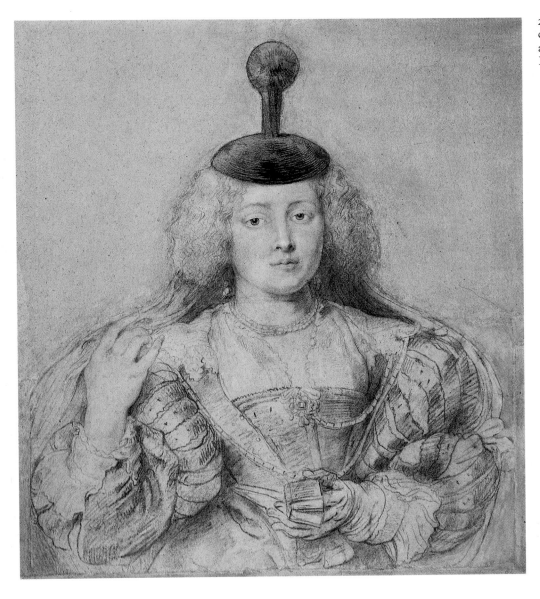

260. *Helena Fourment*, c.1630–2. Black and red chalk, heightened with white, with pen and ink and brown wash, 61.2 × 55 cm. Courtauld Institute Galleries, London.

pearls, a diamond necklace, a golden anchor with diamonds, a pair of diamond earrings, a large diamond ring coming from England (that given to the painter by Charles I?), as well as enamelled gold buttons and a purse with pieces of gold.

In a panegyric written for the occasion by Jan Caspar Gevaerts, we are told that, whereas Zeuxis had to distil the beauty from five maidens of Croton in order to paint Helen of Troy, Rubens for Helen of Antwerp required only one, who far surpassed her Grecian namesake. Paying tribute to her snowy bosom, the poet concludes that her physical beauty is nevertheless surpassed by her beautiful manners, her gracious simplicity and her chaste reserve. Her role in Rubens' life was quite different from that of Isabella. If one can liken Rubens' first marriage to that of Tamino and Pamina in Mozart's *Magic Flute* on their journey through fire and water, his second brings to mind the spirit of a very different story, that of Silenus awakened by the water nymph Aegle rubbing his face with mulberries so that he breaks into laughter and song (Plate 55). But if Helena gratified Rubens' senses and inspired his painting, she did not entirely remain the sweet young girl, even if she may at first have been swept off her feet by the intensity of passion she had unleashed. Though she was an excellent wife, one suspects more than a touch of an Aristotle–Phyllis relationship, which must have given a piquancy to their lives together. One drawing shows her pouting and sullen (Barber Institute, Birmingham) and her temperament is little hidden in this intimate moment as she sits to her husband. In 1635 there were rumours in Paris, subsequently denied, of soured relations between Helena and her stepchildren, then aged twenty-one and seventeen, which, in Peiresc's view, threatened to 'tarnish a substantial part of his

237

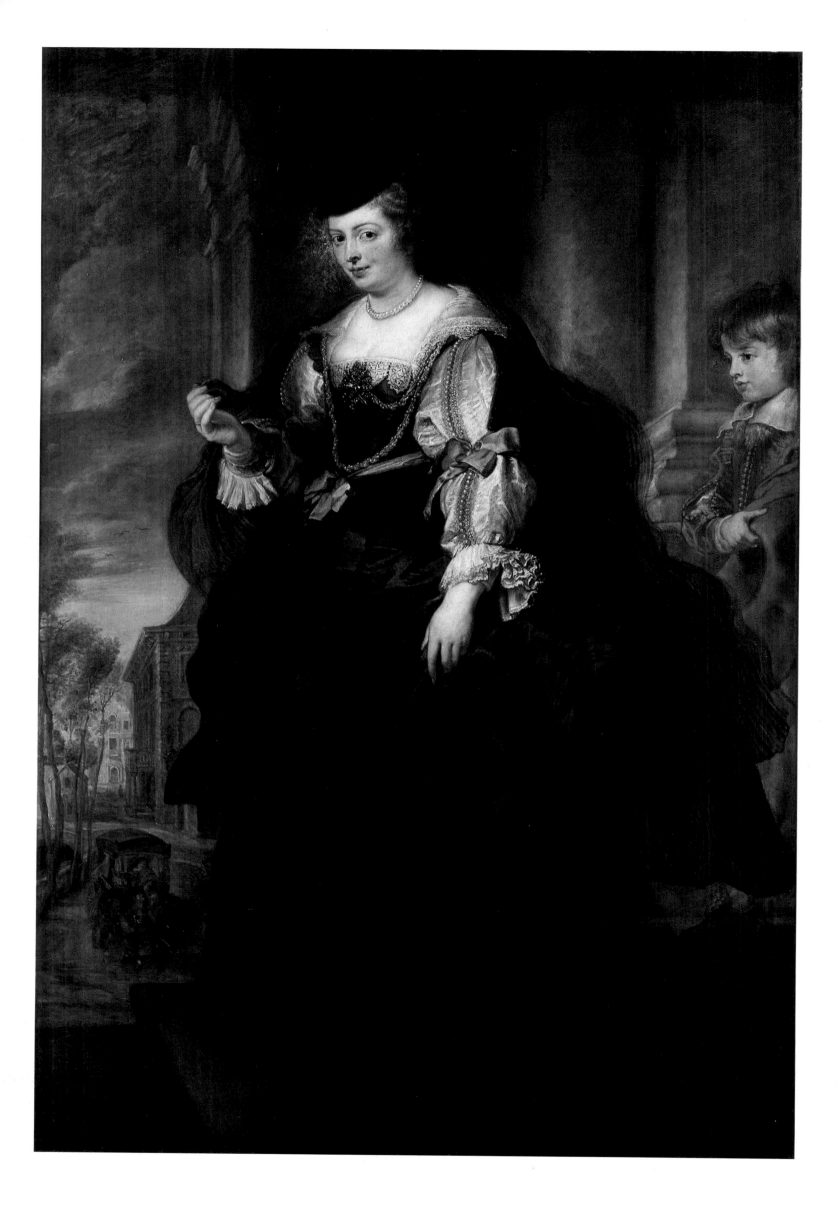

262. *Drapery Study*, c.1631. Black and red chalk, heightened with white, 41 × 32 cm. Graphische Sammlung Albertina, Vienna.

[Rubens'] reputation for generosity'.[9] After his death she was involved in litigation with Albert and Nicolaas. She also showed herself to be prudish by destroying certain paintings with nudes, and she undoubtedly preferred to consider herself the widow of the knight and Lord of Steen rather than one of the greatest painters of his century.

From his painting it is abundantly clear that Rubens was intoxicated by her. Whereas he expressed true love and admiration for Isabella, he was overcome by infatuation for Helena. If ever an artist put into practice Renoir's vivid dictum about painting it was Rubens during the last decade of his life. With Isabella at his side, life and art had largely remained separate, but now there was frequent overlapping so that personal feelings and interests can be read in a number of his later works, although many others prove that the detachment of the artist had not been completely eroded. As De Piles wrote, Helena 'was indeed a Helen for beauty and helped him very much in the figures of women which he painted'.[10]

Shortly after their marriage Rubens portrayed Helena as the chatelaine of her

261. (facing page) *Helena Fourment leaving 'her' House*, c.1631. Panel, 198 × 122 cm. Musée du Louvre, Paris.

239

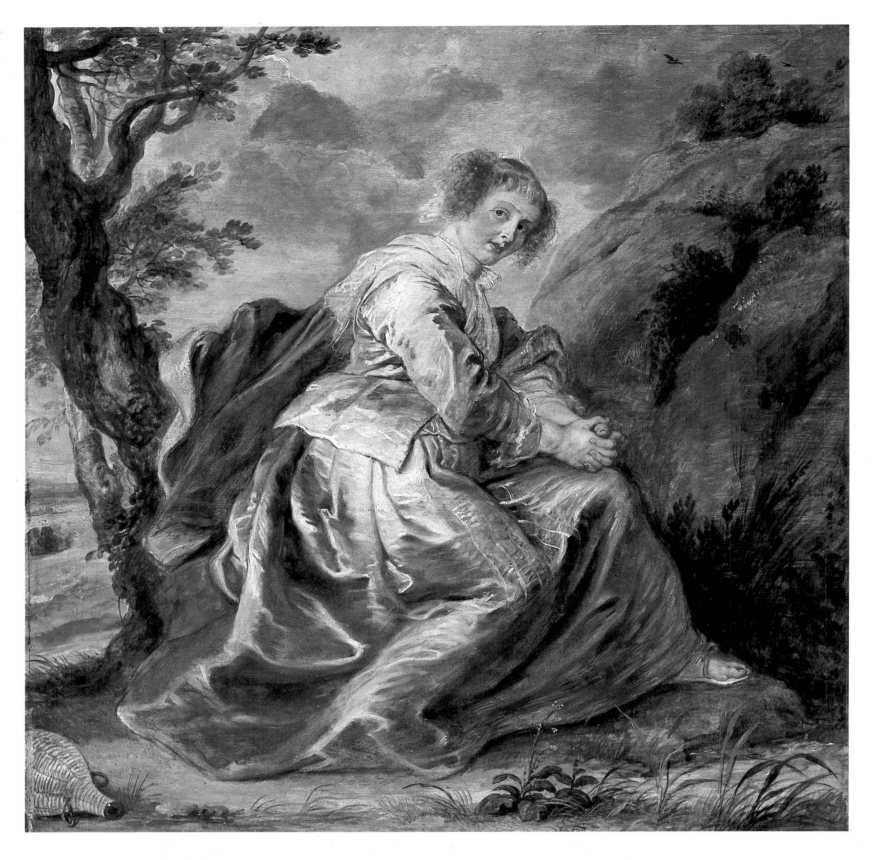

263. *Helena Fourment as Hagar in the Wilderness,* c.1635. Canvas, 73 × 73 cm. Dulwich Art Gallery, London.

264. (facing page) *Helena Fourment as Aphrodite ('Het Pelsken'),* 1630s. Panel, 175 × 96 cm. Kunsthistorisches Museum, Vienna.

new property, flanked by her husband and younger stepson, Nicolaas, in a picture (Plate 258) that offers an informal study of family life as they stroll towards the pavilion at the end of the garden. She is both the formal and psychological centre of the picture. The artist himself assumes a relatively obscure position, leaning forward from behind the figure of his wife, while Nicolaas follows deferentially behind. A peacock, the symbol of Juno, the goddess of marriage, figures prominently in the foreground. In contrast to this informal study he painted about the same time what, given the size and sumptuous appearance, can be described as a 'state portrait' (Plate 259), in which she is posed on a high-backed chair before a balustrade, flanked by columns and scarlet curtains. She conveys the image of a lady as much as the Countess of Arundel had done in a similar setting (Plate 152). Often said without reason to be portrayed in her wedding dress, she wears a gold

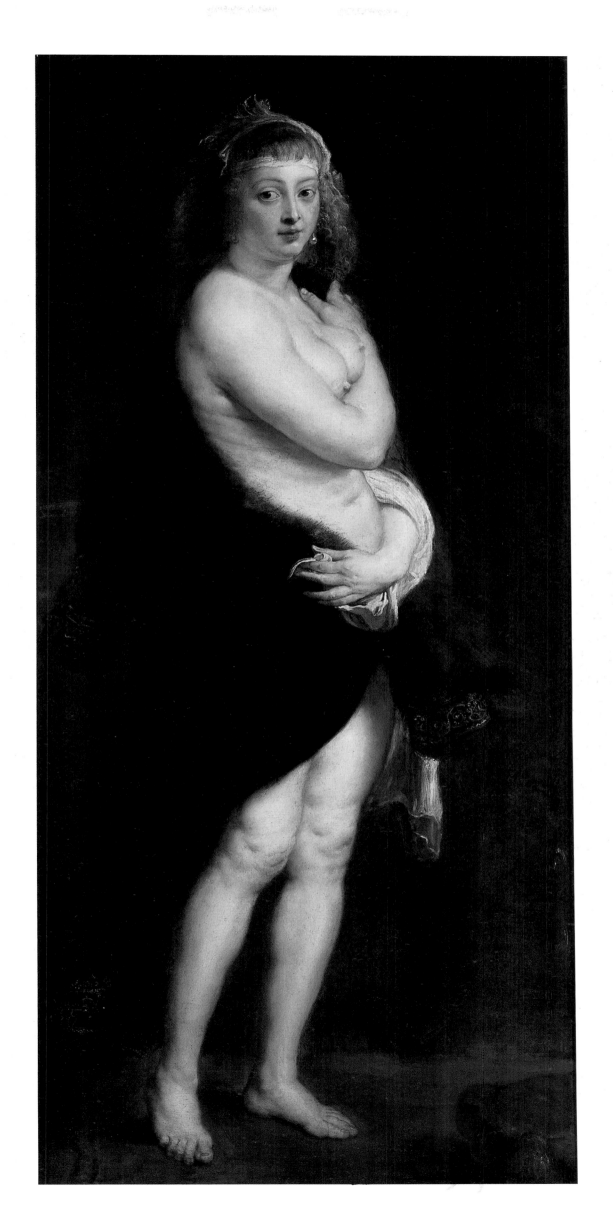

brocade robe and black overdress with white petticoat with puffed sleeves. Her pearl earrings and necklace are sober compared with the gold chain and elaborate brooch, both composed of numerous diamonds, and the large diamond ring on her little finger which was no doubt that given to her by her husband. But if the picture has all the trappings of a formal portrait, Rubens marvellously dissolves the convention of a static image by the vitality of her expression, matched by the suggestion of gently circling movement in the placing of the figure. A sprig of myrtle, the flower of Venus, attached to the gold band in her hair recalls the purpose of the picture. The richness of colour centred around the face – gold hair, green leaves, blue sky and scarlet curtain – and the freedom and fluency of handling are a direct recollection of Titian.

In a half-length drawing (Plate 260) made about the same time, she is similarly dressed but with the addition of a huke or mantle worn by fashionable women in the Netherlands as a protection against wind and rain. She touches the mantle on her shoulder in a gesture derived from classical art which Rubens frequently used to suggest dignity and modesty, while in the other hand she holds a small book, probably a prayer book. Drawn in a combination of three coloured chalks and pen and wash, the sheet is unprecedented in the degree of elaboration and might be considered a work of art in its own right. It may also have provided the preliminary idea for the full-length portrait of Helena, accompanied by Nicolaas, about to leave 'her' house (Plate 261), which her age suggests was painted about this time, rather than later in the decade as is often supposed. Directly connected with the latter is a drapery study (Plate 262) in which the soft broken accents of the material are conveyed with chalk in imitation of brushstrokes. As in the so-called wedding portrait (Plate 259), Rubens' wife, no less elegantly dressed, is presented in a grand setting, this time at the top of steps leading down from a massive portal flanked by columns, quite unlike, it may be added, the house in the Wapper, while her carriage approaches in the street below.

In nearly ten years of marriage Rubens painted considerably more portraits of Helena than he ever did during the seventeen years he was wedded to Isabella. Moreover, compared with the straightforward simplicity in his portrayal of Isabella, he presents Helena with the accoutrements and style of a fashionable lady rather than a prosperous bourgeoise. By virtue of her background Helena had no reasons for greater social pretensions than Isabella, but in 1630 she was marrying a rich and famed artist, who had, we are told, established the style of living of a 'cavalier'. From her subsequent social move upwards after Rubens' death, it is clear that she adapted easily to a life of grandeur, an attitude which must have been encouraged by the image created by her husband in his portraits of her.

The artist's intense feelings for his new bride are further revealed in her frequent appearance in other roles. How far the artist intended a recognisable likeness rather than a preference for a generic type of female model probably varies from picture to picture. Her features, or a distillation of them, occur in a number of pictures of widely differing subjects over the last decade, and in the agreeable but uncertain game of trying to spot her appearances, one can modify the time-honoured adage 'cherchez la femme' to 'cherchez *sa* femme'. She may well have been the model for St Catherine, as well as for the two other female saints, in the *Coronation of St Catherine* (Toledo, Oh.) and for *St Cecilia* (Berlin); the latter remained in the artist's studio and was given by his widow to a certain Heer van Ophem for negotiating the sale of twenty-nine pictures to Philip IV. In the *Garden of Love* (Plate 291) most of the girls are cast in her mould, as if one Helen was not sufficient. In the *Feast of Venus Verticordia* (Plate 296) the nymph on the left, who is swept off by an ageing satyr, bears her features, and perhaps, given the true nature of the subject (see p. 272), represents a private joke. Yet there is contemporary evidence that she was recognised as an occasional model in Rubens' pictures, since nine years after they were married, the Cardinal-Infante Ferdinand, in a letter about the *Judgement of Paris* (Plate 302) commissioned by his brother, wrote that 'the Venus in the centre is a very good

242

likeness of his wife, who is certainly the handsomest woman to be seen here'.[11] And it can have been no accident that in this context she plays the role of the goddess of love who wins the prize for her beauty.

Following the fashion found in such centres as The Hague, Utrecht and London, some of the pictures in which Helena appears were clearly intended as costume portraits in Biblical or mythological roles. In a small panel (Plate 263) she is seen, with her water-bottle beside her, playing the role of Hagar in the wilderness. (The figure of Ishmael was painted out later.) Instead of lifting up her voice and weeping, she gazes somewhat coyly at the spectator; the portrait element is established more strongly than the Biblical part she adopts, and at the time it would have surely been recognised as a fancy-dress piece. In the most remarkable painting of Helena (Plate 264), until recently accepted as a genre study of her on her way either to or from the bath, she is portrayed in the role of Aphrodite. Although she stands on a rug with a cushion at one side, a fountain with water gushing from a lion's mouth just visible in the background establishes that the setting is outdoors. Probably in emulation of the Cnidian Aphrodite of Praxiteles, which according to Pliny 'excelled all works of art in the world',[12] Rubens presents his wife as the goddess of love and beauty. But if the *donnée* was classical, the realisation owes a great deal to Titian. The latter's *Lady in a Fur Cloak* (Plate 265), in which one of her breasts is revealed, cradled in the joint of her upraised arm, was copied by Rubens (private collection), probably when both he and the picture were still in Mantua, and offers the most obvious source of inspiration, although it merely became the starting point for an entirely personal recreation. The immediate visual impact is made against a natural grey background by the sensuous contrast of the black fur-lined cloak and opulent naked flesh, projected so strikingly by the scarlet rug and cushion. The impressive scale of the panel with the figure life-size, or larger, is further accentuated by the narrow format. The major centre of interest lies in the turned head with abundant golden hair enclosed in a white hairband, and the motif of the raised arm cupping the breasts. But Rubens brilliantly keeps the whole surface alive by such details as the exquisitiely refined painting of her right hand and wrist framed by the encircling white chemise half-way down, and the glowing realism of the painting of the knees and feet, the latter highlit by the scarlet rug. The tingling vitality and realism of this overpowering presentation of the female nude were quite alien to the Italian tradition and in this instance were the personal expression of Rubens. The rejoicing in actual appearance, with all the supposed imperfections according to the classical canon, represented taste north of the Alps, and was seen most notably before in the work of Dürer. Ideas of beauty vary, and, whether overcome by admiration or repulsion, the beholder of this picture cannot remain unmoved. As Rubens painted it, perhaps he recalled the story from Herodotus of the ill-fated King Candaules, who was so in love with the beauty of his wife's body that he exposed her to one of his bodyguards. Even for the artist it was a work out of the ordinary, which retained special significance for him. Described as 'Het Pelsken'[13] or 'little fur' in his will, it was the only picture he specifically left to his widow. And, unlike some other nudes, she happily did not destroy it.

Upon his marriage Rubens was not to be let off immediately from diplomatic chores. Already he had escaped a return visit to London, ordered by Philip IV but ignored by Isabella, 'because I did not find him willing to accept this mission'.[14] (Despite all Rubens had achieved, prejudice died hard, and a Spanish councillor objected to the suggestion that he be appointed as envoy since he 'is a craftsman who works with his hands for money'.)[15] By the summer of 1631 he was involved once again, this time in the personal cause of Maria de' Medici, who had recently been banished from France by her erstwhile favourite, Cardinal Richelieu, and had fled into the Spanish Netherlands to try to raise an army. Rubens was called in to act as intermediary in the negotiations between the queen mother and Spain, and, though he must have accepted with a heavy heart, it was a cause for which he felt deeply. Quite apart from sharing Maria de' Medici's hatred of Richelieu, he

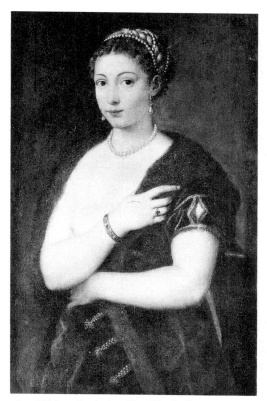

265. Titian, *Lady in a Fur Cloak*. Canvas, 95.9 × 63.2 cm. Kunsthistorisches Museum, Vienna.

was moved by his affection and admiration for her as a queen and a patron; she was yet another widow whose cause Rubens championed. Shortly before this event he could say: 'I sometimes think I ought to retire with my family to Paris in the service of the queen mother.'[16] That sacrifice was no longer necessary, and he could take her side nearer home, which he did actively for a year before giving up in disgust. In September, accompanied by Isabella, Maria de' Medici arrived in Antwerp where she took up residence for six weeks. Apart from a visit to the Plantin Press, she went to Rubens' house, where 'Her Majesty derived a keen pleasure from the contemplation of the spirited qualities of his pictures'.[17] But on this occasion it was Van Dyck, back from Italy and shortly to return to England, rather than Rubens who painted her portrait. The queen mother's ultimate purpose was to raise money on her jewels to support her cause. (Gerbier told Charles I that Rubens himself had lent her money on two pieces of jewellery.) But the balance of power made any immediate and effective aid to the queen mother impossible. When help eventually came it was too little and too late, and Richelieu had no difficulty in dispersing the small army raised against him.

During the summer when Rubens set out to help the queen mother, he received more positive recognition of his position in world affairs. Following his knighthood by the King of England, the artist must have felt that he had earned a similar honour from Spain, and in July the Supreme Court for Spanish Affairs in Madrid forwarded Rubens' application for the title of knight, which was strongly recommended by the Archduchess Isabella in acknowledgement of his status as an artist and his role as a diplomat. Adding their own support, the Council concluded with the words: 'The Emperor Charles V made Titian a knight of St James. It therefore appears to the Council that Your Majesty could bestow upon the supplicant the title which he seeks'.[18] Given the admiration of the younger man for the art of the older, it was a felicitous recognition that both artists had in their different centuries reached a special position in relation to the Spanish monarchy. Philip IV responded in the margin of the petition: 'Let it be done'. A suitably worded diploma was dispatched to the artist a month later.

After two other small and unsuccessful missions, including a visit of a few days to The Hague in December 1631, and one further intervention in 1635, Rubens' diplomatic career came to a close, but not before the artist had engaged in a thoroughly unpleasant correspondence with the irascible Duke of Aerschot, the leader of the States-General in Brussels, who considered that Rubens had the archduchess's ear and that he was being by-passed. The petty jealousy of those on his own side, which was inflamed by their sense that the artist was becoming more closely identified with the interests of Spain than with Flanders, caused Rubens as much disgust and difficulty as the wiles of his adversaries. He wrote to the duke with dignity and respect, yet yielded not one inch. In reply he got the kind of abusive letter which has always been the prerogative of the ill-tempered aristocrat, ending with the words: 'It is of very little importance to me how you proceed, and what account you render of your actions . . . All I can tell you is that I shall be greatly obliged if you will learn from henceforth how persons of your station should write to men of mine.'[19] The situation was put into perspective by William Boswell, by that time English ambassador at The Hague, who wrote home that the opposition of the Flemish Deputies is 'because he is none of their body, if not rather because he is an immediate Minister of their king, and having more spirit than any member of them, has acquired so much more envy among them'.[20] To Rubens it must have appeared differently. He had travelled a long way from his days at the court of Mantua, but the treatment meted out to him was often little better, and this must have amply confirmed him in his decision to return exclusively to painting and his new family.

At the same time as Rubens was trying to escape from his diplomatic work, he was painting what is probably the most inspired altarpiece of his career, and arguably of the seventeenth century, for the beloved patron for whom he had acted and whom he had advised for over twenty years (Plate 266). It was a remarkable

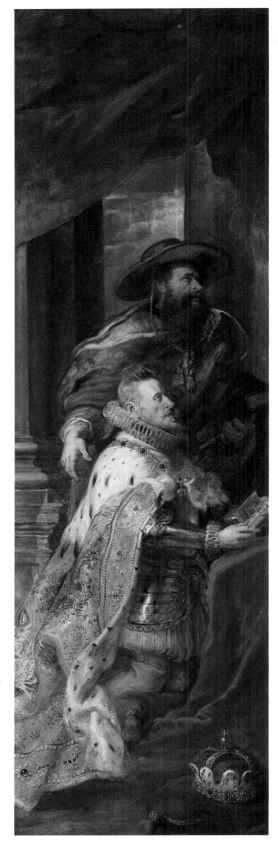

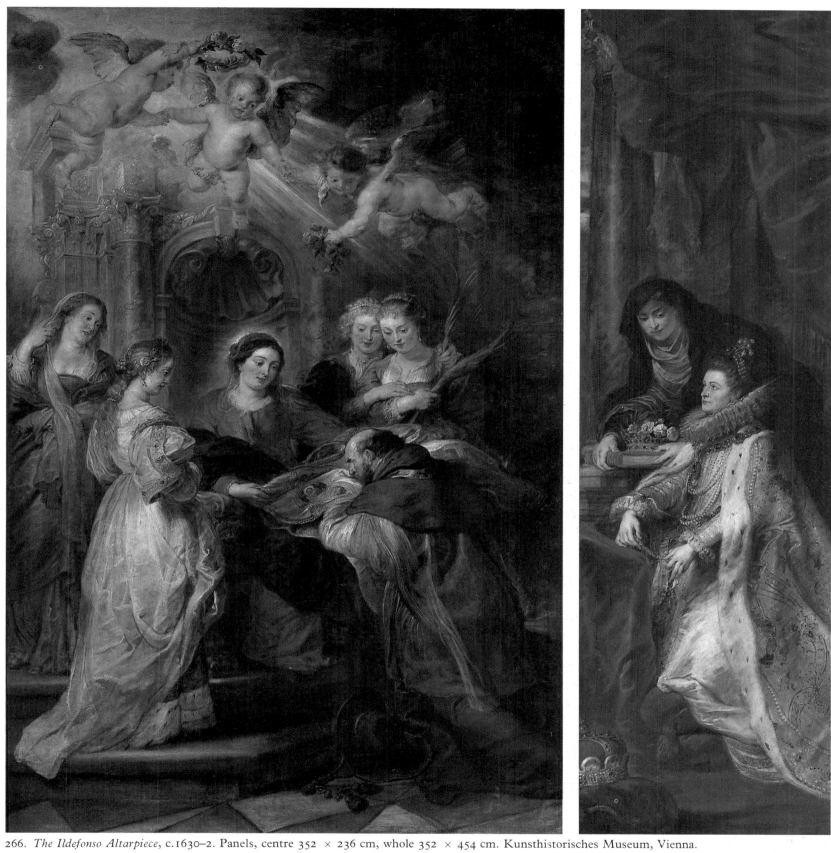

266. *The Ildefonso Altarpiece*, c.1630–2. Panels, centre 352 × 236 cm, whole 352 × 454 cm. Kunsthistorisches Museum, Vienna.

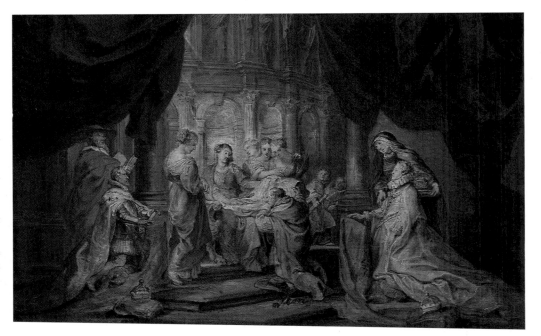

267. *Sketch for the Ildefonso Altarpiece*, c.1630–1. Canvas transferred from panel, 52 × 83 cm. Hermitage, Leningrad.

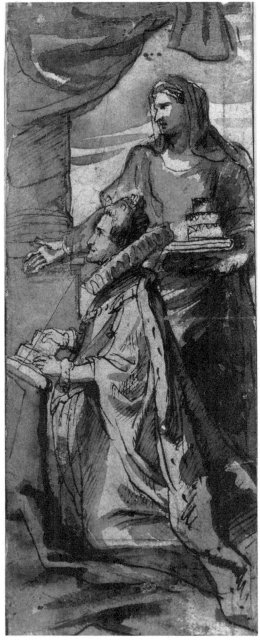

268. *Study for the Archduchess Isabella and St Elizabeth of Hungary*, c.1630–1. Pen and ink and brown wash over black chalk, 20 × 7.8 cm. Gemeentemusea, Amsterdam.

culmination of their friendship. The recipients of the triptych, paid for by Isabella, were the members of the Confraternity of St Ildefonso, which had been founded in Lisbon by Albert when he was governor of Portugal. After his move to Flanders he established a similar brotherhood in Brussels, whose chapel was in the church of St James on the Coudenberg. Membership was controlled by the archducal court. For Isabella it must have been a happy commission, commemorating her husband and his works by the hand of her trusted adviser and painter. As the occasion demanded, Isabella threw off her nun's garb in favour of the archducal robes she had not worn for a decade.

The central panel depicts the legend of St Ildefonso, a seventh-century archbishop of Toledo, according to which the saint on entering the church at night beheld a vision of the Virgin, who in recognition of his defence of the doctrine of the Immaculate Conception (by which Mary was born free from all taint of original sin), presented him with a chasuble. The event is witnessed, in the side panels, by Albert and Isabella accompanied by their patron saints. (On the outer wings, visible only when the altarpiece is closed, Rubens painted the *Holy Family under the Apple Tree, visited by St John and his Parents*.)

Mindful of what he had done in a similar altarpiece for the Gonzaga (Plate 45) at the beginning of his career, Rubens represents Albert and Isabella, kneeling at their prie-dieu and dressed in ceremonial robes, actively aware of the miracle. Their participation is especially clear in the *modello* (Plate 267), painted as a unified composition on one panel, in which the architecture is continuous, although curtains pulled aside above the archducal couple define the different 'realities'. In the *modello* the fact that, in contrast to Albert, Isabella was still alive is alluded to both by the compositional emphasis and the lighting. Subsequent drawings for the two wings (Plate 268) show Rubens' evolution towards the final solution, in which the donors, although now spatially separate in an outdoor setting with columns and drapery, are given greater prominence by their increased size and their position in the nearer foreground. They bear witness to the miracle from another world, unlike the arrangement found in earlier Flemish altarpieces in which heavenly and earthly inhabitants mingle. At the same time, Rubens was preoccupied with developing the relationship between the archducal couple and their respective patron saints. In the *modello*, St Elizabeth of Hungary, who looks towards the Virgin, behaves conventionally in her presentation of Isabella (i.e. Elizabeth). In the drawing, a rigidly upright figure, she directs the latter's gaze more positively with the gesture of her outstretched hand, but in the finished work she is seen turning solicitously towards her namesake. The interaction between

donor and patron saint has become closer and warmer in spirit. Recognition of Isabella's widowhood is made by the mourning colours of the saints' clothing and the archduchess's stoically sorrowing expression.

The arrangement of the central section, with the Virgin enthroned before a niche and surrounded by saints, recalls a work studied during Rubens' Italian years, Raphael's fresco of *Gregory IX approving the Decretals* in the Stanza della Segnatura in the Vatican (Plate 269). As he had done in the wings, Rubens introduced considerable modifications as he proceeded. The *modello* had included in the background a circular classical building in two storeys, the upper containing a row of sculpted figures, probably of saints. In the final work the architecture is reduced to a large niche flanked by columns with the upper storey replaced by the motif of three flying putti in a burst of light, alluding to the supernatural light which, according to the legend, flooded the church. To simplify the figure group and to give greater emphasis to the figures of the Virgin and St Ildefonso, Rubens not only omitted the recorded incident of the frightened choirboys running away, included in the *modello*, but rearranged the female saints. One of the latter, on the right, is omitted and replaced by the full-length figure on the left, seen adopting the so-called *Pudicitia* motif of hand to veil, who now completes the circle of beautiful women who surround the Virgin. (Between *modello* and finished work, Rubens made several studies *à trois crayons* for the heads of the Virgin (Plate 270) and her companions.)

269. Raphael, *Pope Gregory IX approving the Decretals*. Fresco. Stanza della Segnatura, Vatican, Rome.

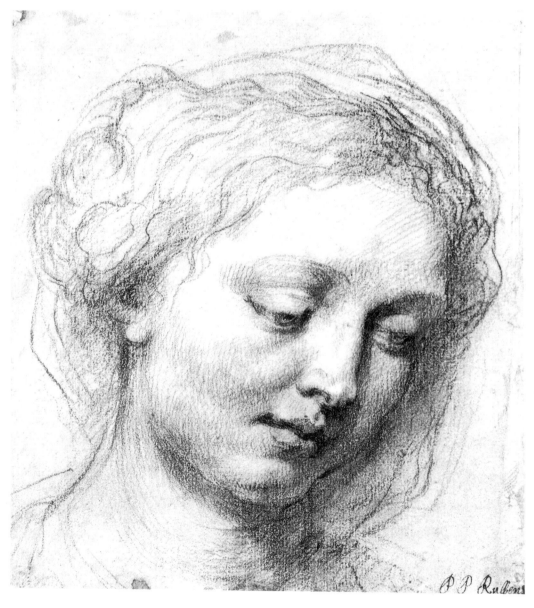

270. *Study for the Virgin in the Ildefonso Altarpiece*, c.1630–1. Black and red chalk, 19.3 × 16.7 cm. Graphische Sammlung Albertina, Vienna.

271. The interior of the Banqueting House, Whitehall, London.

272. Paolo Veronese, The ceiling of S. Sebastiano, Venice.

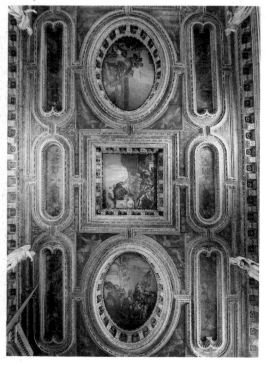

The transformation of these iconographical ingredients into a pictorial realm of its own is due to the artist, who, without stinting, gave of his very best. In the final work the sheer sumptuousness of the materials, noticeable above all in the ermine robes, adorned with gold embroidery, worn by Albert and Isabella, is fully realised in the execution. The overall quality of richness and splendour is conveyed by a range of several basic colours which echo throughout the composition, in the way that, for example, the predominant red is reflected on the armour worn by Albert or the gold of the embroidery on the niche behind the Virgin. The powerful simplicity of design, movement and colour belies the artist's seemingly effortless skill, the distillation of a lifetime's experience, in harmonising such a wealth and variety of detail. But the ultimate unifying factor depends on the brushwork, every stroke of which, placed so freely on the panel, bears the unmistakable touch of the master himself inspired 'by a violent driving on of the passion', so that the altarpiece attains a shimmering unity that marked the supreme achievement of his last works.

During his absence abroad Rubens had left the studio in the hands of one of his apprentices, the painter and engraver Willem Panneels, who, the master asserted

248

in a warm testimonial, 'had carried out his duty with the greatest fidelity and had rendered an account of his actions to the entire satisfaction of the undersigned'.[21] When Panneels went on to Germany to further his career, Rubens once again took up the reins in Antwerp. One of his immediate tasks was to resume the challenge of the Henry IV series, whose slow and unhappy progress had now dragged on for nearly a decade. By this time the *modelli* must have been approved and he and his studio set to work on painting the final canvases. But as with the entire commission nothing went straightforwardly and Rubens was subjected to further changes of mind from the French capital. In this instance the artist's tormentor was the Abbé de St Ambroise, the queen mother's chaplain, who had played an important role in the whole commission. Writing to Pierre Dupuy, Rubens not only explained the latest problems but summed up his feelings about the whole experience:

> Acting under his [St Ambroise's] orders, I have made considerable progress on some of the largest and most important pieces, like the 'Triumph of the King' [Plate 221] for the rear of the gallery. Now the Abbé de St Ambroise himself takes two feet from the height of the pictures, and at the same time he heightens the frames of the doors and portals, so they will in some places cut through the pictures. Thus, without remedy, I am forced to mutilate, spoil and change almost everything I have done. I confess that I felt this keenly, and that I complained to M. l'Abbé (but to no one else) begging him to grant me half a foot, so that I need not cut off the head of the king seated on his triumphal

273. *The Apotheosis of James I, flanked by Processions of Putti,* c.1634. Canvas. Banqueting House, Whitehall, London.

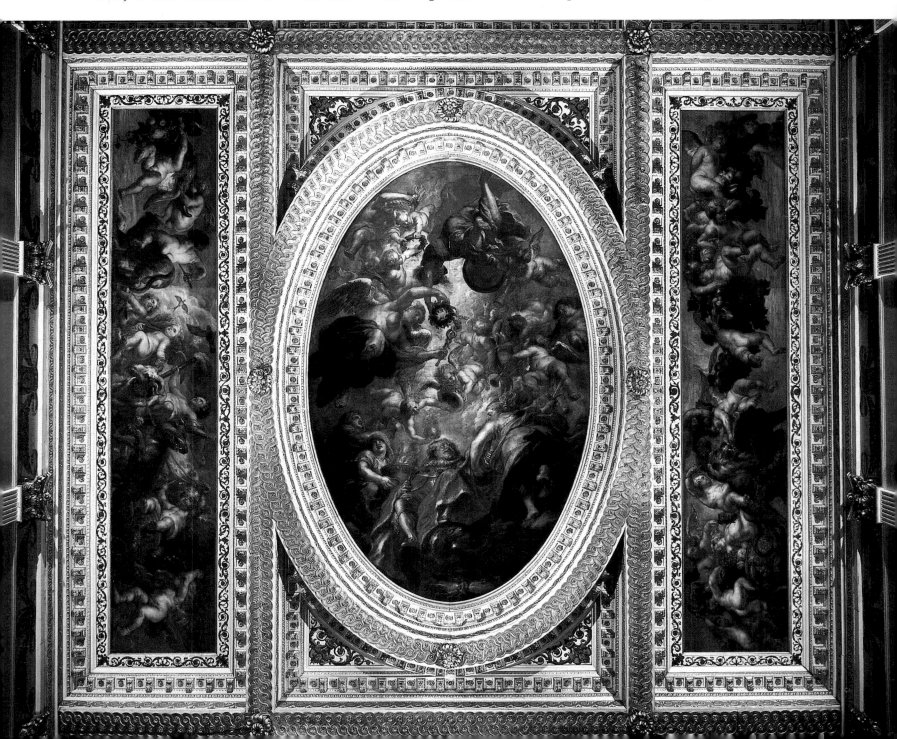

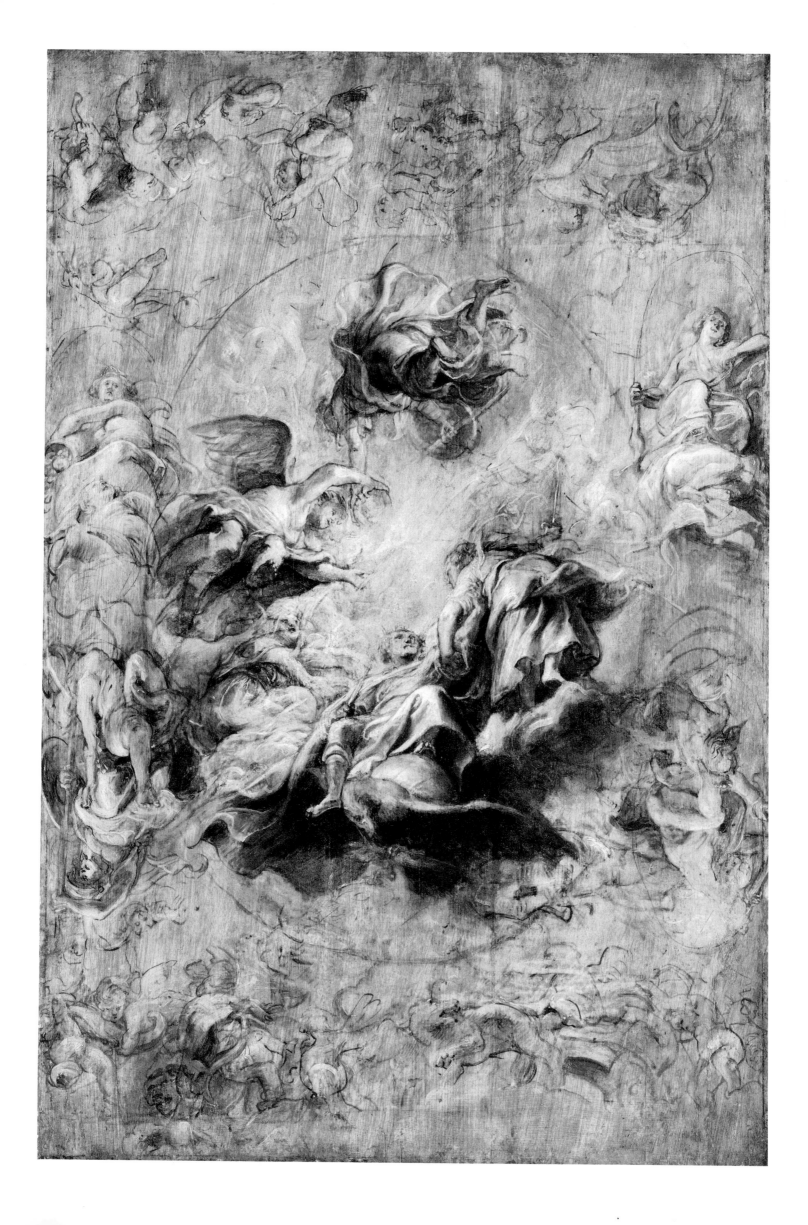

chariot . . . I said frankly that so many obstacles at the beginning of this work seemed a bad omen for its success, that I found my courage cast down.[22]

In the hope of a more satisfactory solution, Rubens stopped work on the canvases. A few months later, reacting to the news of the queen mother's banishment and the collapse of the whole project, Rubens wrote that 'I certainly consider all I have done as labour entirely wasted'.[23] And listed among the artist's estate were 'six large unfinished pieces depicting sieges of towns, field battles, and triumphs of Henricus IV, King of France'.[24]

Work on another major project was on the other hand to be triumphantly realised, and today the Whitehall ceiling remains the only existing scheme of decoration by Rubens in its original position. Although time and later restorations have somewhat dimmed the former richness of warm colour, to appreciate which one has to turn to the numerous preparatory oil-sketches, the overall effect of Rubens' canvases, set in Inigo Jones' carved ceiling, provides an example of Baroque decoration at its best and most sophisticated, which, moreover, would have appeared startlingly original in a country brought up on small-scale Tudor and Jacobean decoration, most of which was of indifferent quality. It immediately established Whitehall in the van of European princely settings over which it would arguably have reigned supreme had the projected plans for the entire palace been realised.

Under James I the previous banqueting house, burnt to the ground, had been replaced by 1622 with a new building in what for England was a revolutionary classical design by Inigo Jones. During both his reign and that of his son, Charles, the building was to play an important role in court life, and much of the ceremonial was conducted there. It provided a venue for the reception of foreign ambassadors, as well as for the annual procession of the Order of the Garter. Above all, it served as a theatre for the numerous masques and entertainments, which became such an active part of court life, and which under Jones's direction reached such a sophisticated level of stage production. As early as 1621 when Rubens was putting the finishing touches to the Jesuit ceiling, feelers were being put out to the artist to see how he would react to a grand scheme of decoration. The idea immediately took fire in Rubens' imagination and, as we have seen, he replied self-confidently. Nothing took shape until he went to London on his diplomatic mission, by which time Charles I was on the throne. After his experience in solving the pictorial problems of ceiling decoration in the Jesuit church and the complexities of modern historical allegory in the Medici cycle, Rubens was now supremely well qualified to undertake such a commission.

Respecting the basic harmony of the building, the ceiling was divided into nine compartments in unison with the interior and exterior elevations (Plate 271). The richly carved ceiling with interlacing bands of guilloche, painted gold and white, was clearly derived from Venice and from Palladio in particular, although Jones, in contrast to such Venetian prototypes as the ceilings in the Palazzo Ducale and S. Sebastiano (Plate 272), kept to a flatter, severer design, which provided a less competitive framework for Rubens' canvases. The principal compartments consisted of an oval in the centre of the ceiling with a rectangle at either end. The latter were flanked by smaller ovals, while the former by elongated rectangles, establishing a unifying pattern, which Rubens most skilfully maintained in the overall design of the canvases.

Following Venetian practice, seen notably in the obvious prototype for Whitehall, Veronese's ceiling in San Sebastiano, the individual canvases were arranged on the ceiling in different directions from one another so as to enable the spectator to view the ceiling comfortably at an angle of 45 degrees from different standpoints in the hall. This pattern was already established in the preliminary sketch (Plate 274) incorporating seven of the nine scenes, some of which are upside down in relation to the others. The central oval and the rectangle and flanking ovals at the far end were designed to be studied from the entrance end, while the rectangle and ovals above the latter were placed in the opposite direction so as to be

274. *The Apotheosis of James I and other Studies*, c.1630. Panel, 95 × 63.1 cm. Private collection, England (on loan to the National Gallery, London).

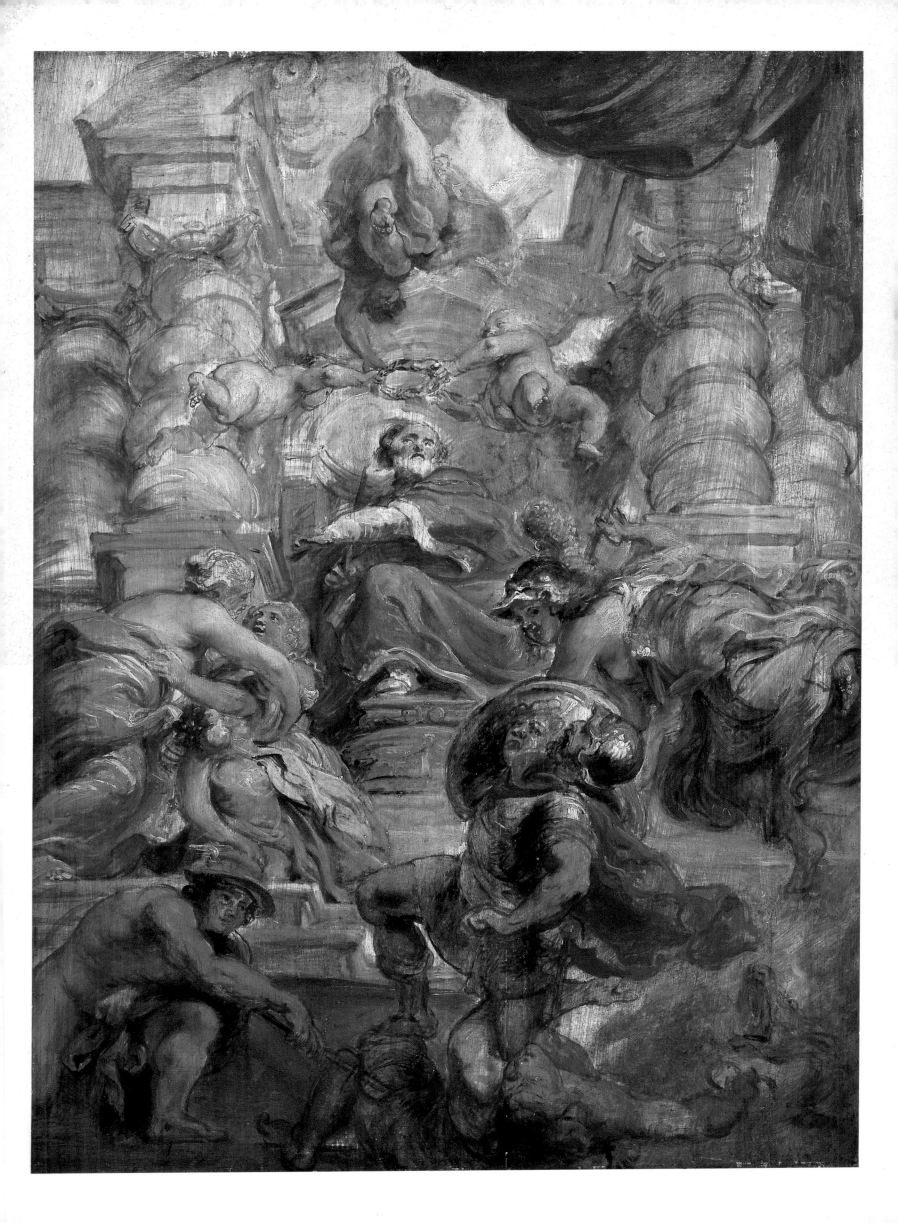

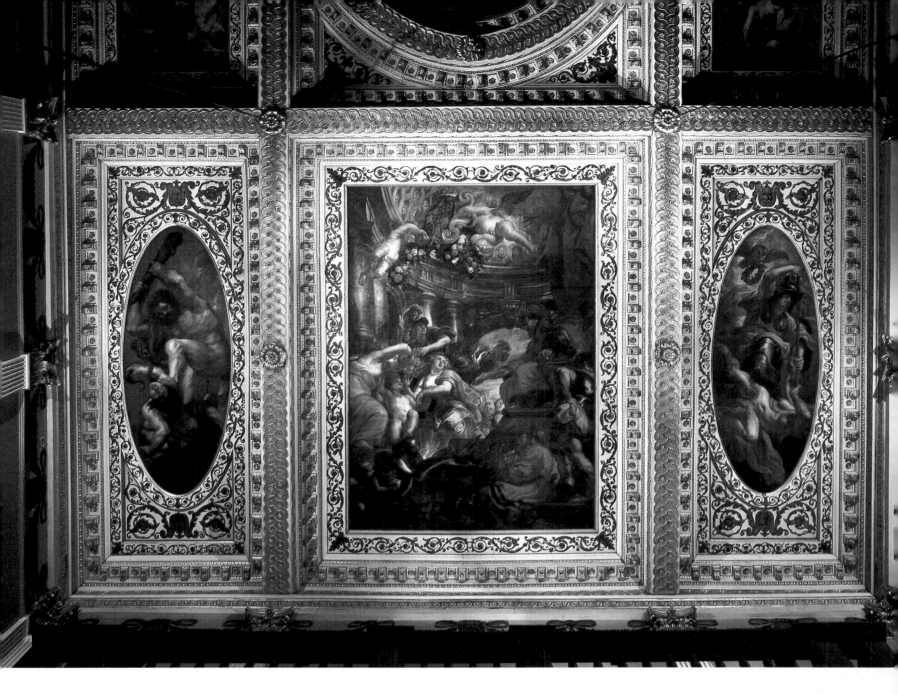

viewed from the other end. The long rectangular panels with their bases placed against the outside walls, which are on either side of the central oval, were designed to be studied from a position along the side walls of the building.

Even if some of the details remain open to differing interpretation today, the basic theme of the ceiling is, as was intended, abundantly clear, the glorification of the reign of James I and by extension that of his son, then on the throne. Neither the details of the programme nor the author or authors are recorded. Precise written instructions of the kind prepared in 1639, probably by Inigo Jones, for Jordaens' decoration of Henrietta Maria's 'cabinet' in the Queen's House, Greenwich, must have existed. Clearly the artist himself, with his experience, would have had much to contribute. Jones both as architect and as someone well versed in the elaborate court allegory of the contemporary masque must have played an important role, as he did later at Greenwich. The king if not involved in the finer points would have taken an active interest, both out of filial piety and for the element of propaganda inherent in the programme, which had become increasingly apposite in view of Charles's recent dissolution of parliament and assumption of absolute rule. As he sat enthroned beneath Rubens' ceiling, he may have recalled with more wishful thinking than reality James's proclamation to Parliament that 'The state of monarchy is the supremest thing upon earth. For kings are not only God's lieutenants upon earth and sit upon God's throne, but even by God himself they are called gods.'[25]

As well as affirming in allegorical language his possession of the necessary attributes for a wise and benevolent ruler, the ceiling celebrates James's greatest

276. *The Unification of the Kingdom, with* (left) *Hercules and Envy, and* (right) *Minerva and Ignorance,* c.1634. Canvas. Banqueting House, Whitehall, London.

275. (facing page) *Sketch for the Peaceful Reign of James I,* c.1632–3. Panel, 64.2 × 47.3 cm. Akademie der Bildenden Künste, Vienna.

political achievement, the unification of England and Scotland and the benefits to be derived from, despite fears to the contrary, the ensuing internal harmony. Recognised by his contemporaries as a latter-day Solomon, James in one of his favourite roles promoted himself as a prince of peace. In his first message to parliament he had promised peace at home and peace abroad. The arriving visitor looked first at the central oval with its scene of apotheosis, the reward of a just ruler (Plate 273). Beyond, he was able to study the rectangle with the king on his throne surrounded by symbols of his peaceful reign (Plate 275). To reinforce the point, the flanking ovals contain representations of *Royal Bounty overcoming Avarice* (Plate 279) and *Temperance* or *Reason overcoming Intemperance*. From the other end of the hall, where the king was enthroned, the viewer was able to see the scene of *Unification of the Kingdom* (Plate 276) above the entrance door, with allegories of strength (Hercules) and wisdom (Minerva) in the flanking ovals. Finally, spectators standing along the sides of the hall were able to look up and across at long panels containing processions with putti and animals indicating the 'happiness of the times', as Rubens was on another occasion to interpret the meaning given by antiquity to such 'a game of joyful and exuberant children'.[26]

As with all such undertakings, the design of the ceiling required intense thought and preparation. One sketch (Plate 274), unique in Rubens' oeuvre, contains no fewer than seven of the nine scenes. Around the central oval with the *Apotheosis*, the artist fitted in the four corner ovals as well as the two long rectangles at either end of the panel, but in an arrangement which disregarded the final layout. The overall arrangement must previously have been established, and here Rubens was concerned with the internal detail of each field rather than their inter-relationship. Painted in various shades of brown with warm white highlights, the degree of finish varies from the strongly modelled central scene to the summarily drawn figures around the perimeter of the panel, in some of which preliminary sketching in black chalk can be made out beneath the thin fluid drawing with the brush. As has been said, this panel may well have been executed during Rubens' stay in London, perhaps to show the royal patron. One can presume that a similar *bozzetto* or *bozzetti* were done to submit the two other principal subjects in the rectangular fields.

In preparation for the canvases in his studio at home, Rubens exceptionally does not appear to have made any drawings, but directed the whole of his creative energies to oil-sketches. In realising what was a highly complex subject, brushwork on panel served to work out the whole composition and the detail of a particular scene. Such densely packed compositions, containing such a wealth of meaning and *dramatis personae*, called for picture-making of a very high order, and certain parts required revision, such as the incident of the crowning of the infant Charles by Britannia (Plate 277) which was subjected to two detailed studies as well as the overall sketch.

One unusual feature to be found in some of the sketches, recalling what sometimes happened on paper but never so far on panel, was the combination of two or more unrelated or not immediately contiguous details. In the case of *Peace embracing Plenty* (Plate 278), the opulent female figures dressed in bright yellow and pink, who embrace so warmly, are depicted against a heavy niche flanked by bulging Salomonic columns. But the architecture, executed, as the varying colour shows, in two stages, which is out of scale with the figures, is more likely to have been intended for the background to the figure of the king, with the implied tribute to the new Solomon on the throne. The whole composition of this scene, seemingly inspired by such works as Tintoretto's *Allegory with Doge Priuli* and Veronese's *Triumph of Venice* on ceilings in the Palazzo Ducale, had already been established in a more thinly painted sketch (Plate 275), showing the massive architectural framework seen in steep perspective within which various allegorical figures are placed around the central figure of the king enthroned. With this established, Rubens was free to turn his attention to the elaboration of detail and colour. The harmonious range of warm colours, with yellow, pink and red

254

277. *Sketch for the Infant Charles I between Personifications of England, Scotland and Britain*, c.1632–3. Panel, 62 × 49 cm. Museum Boymans-Van Beuningen, Rotterdam.

predominant, are a notable feature of the oil-sketches, which would have given the ceiling a brighter, more glowing appearance than it has today.

Undoubtedly with the help of assistants, the canvases were finished in August 1634, but a whole year passed before Gerbier was told to accept delivery. By this time they had suffered from being rolled up, and Rubens had to retouch them extensively before they were finally shipped to London in October 1635. Although Gerbier reported that if his health permitted the artist might also go to London to assist in the installation, he was not to be lured from home. As he wrote to Peiresc,

> Inasmuch as I have a horror of courts, I sent my work to England in the hands of someone else. It has now been put in place, and my friends write that His Majesty is completely satisified with it. I have not yet received payment, however, and this would surprise me if I were a novice in the ways of the world. But having learned through long experience how slowly princes act in others' interests, and how much easier it is for them to do ill than good, I have not, up to now, had any thoughts or suspicion of unwillingness to grant me satisfaction.

He had learnt his lesson, and his resigned cynicism about his royal patrons and

278. (following pages left) *Sketch for Peace embracing Plenty*, c.1632–3. Panel, 62.9 × 47 cm. Yale Center for British Art, New Haven.

279. (following pages right) *Sketch for Royal Bounty overcoming Avarice*, c.1632–3. Panel, 54 × 31 cm. Courtauld Institute Galleries, London.

280. *Sketch for Achilles recognised among the Daughters of Lycomedes*, c.1630–2. Panel, 44 × 60.9 cm. Museum Boymans-Van Beuningen, Rotterdam.

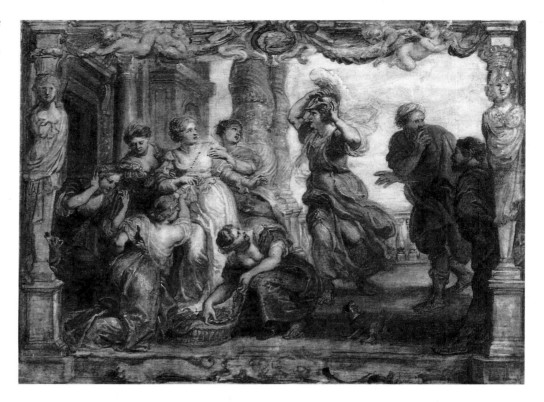

their courts allowed him to follow 'my desire for peace of mind and my determination to avoid, as far as it depends upon me, every disturbance and intrigue'. As he said at the beginning of the same letter in reference to a diplomatic mission he had also succeeded in avoiding: 'I have preserved my domestic leisure, and by the grace of God, find myself still at home, very contented.'[27] If King Charles was exceedingly slow in paying for the goods he had ordered (Rubens had to wait another two years for the final payment), he did at least appreciate them, and posterity will forgive the king for his tardiness in settling his debts in view of his genuine admiration. Charles presented the artist with a heavy gold chain and, a sign of real appreciation, gave orders that no masques were to take place there for three years 'by reason the room where formerly they were presented having the ceiling since richly adorned with pieces of painting of great value figuring the acts of King James of happy memory, and other enrichments; lest this might suffer by the smoke of many lights'.[28] (Gerbier later gave the 'capacities for Ecchoes'[29] as an additional reason.) It was a final irony that on the fatal day in 1649 the scaffold for the king's execution was erected in front of this very building.

Although no records of the commission exist, it is likely that shortly after Rubens' return to Antwerp he produced eight designs for tapestries illustrating the *Life of Achilles*. It appears that these were made for his new father-in-law, Daniel Fourment, and like the *Constantine* series were done as a speculative venture. Given the cost of weaving, a potential patron was doubtless already in mind. Of the two obvious candidates, Charles I seems the more likely at this time rather than Philip IV, who only assumed his role as Rubens' principal patron later in the decade.

With no supervising patron, the artist was free to work out the programme himself, a task he would have found much to his taste. He appears to have used a number of ancient writers from Homer to Statius, whose works had been edited by his friend Gevaerts, besides turning to contemporary commentaries. What is remarkable about the resulting choice of subjects, perhaps reflecting the artist's change of fortune at home, is the surprising emphasis on incidents in the hero's life which involve his relationship with women, rather than on the more manly heroic deeds. In the scene of *Achilles recognised among the Daughters of Lycomedes* (Plate 280) the hero, disguised as a woman, tries on the helmet, one of the gifts brought by Ulysses (disguised in a turban), and recognising his true destiny turns to

258

Deidameia, the fairest of the king's daughters, whom he has made pregnant. As the couple look at one another, Rubens marvellously conveys an intense exchange of differing emotions.

The scene takes place on a platform on a terrace before the palace. A pair of Salomonic columns serve to divide the composition between a 'female' half on the left and a 'male' on the right. As on the other designs for this series, each subject is framed by herms, who react like a Greek chorus. The upper and lower margins are decorated with putti and other detail such as animals, swags and cornucopia. For this series Rubens produced some of his wittiest and liveliest tapestry borders.

At the beginning of December 1633 the Archduchess Isabella died at the age of sixty-seven, leaving the Spanish Netherlands in a weak and exposed position. In the previous year, as the result of intense political pressure, an attempt had been made to treat once again with the Dutch for the reopening of the Scheldt, whose renewed closure at the end of the Twelve Years' Truce in 1621 was causing such economic hardship to the city of Antwerp. Rubens played his part in undertaking one or two secret missions but with no positive results apart from, as we have seen, arousing the jealousy of the Flemish deputies. At this time the military advantage lay with the Dutch and they saw no reason to boost the trade of Antwerp, which they regarded as a Spanish city, to the detriment of Amsterdam. The negotiations, which had been making little progress, completely collapsed with the death of Isabella. Plans had been under discussion for some time in Madrid to decide upon a successor to Isabella who could be familiarised with the ways of the Netherlands before she gave up office. The choice finally fell on Ferdinand, son of Philip III and brother of Philip IV. At first an ecclesiastical career had been chosen for him, and although he was never ordained as a priest he became a cardinal at the age of ten and, a year later, archbishop of Toledo. At the age of twenty, when he took his place for the first time at the Council of State beside his father, he pleaded with him to 'rid me of these cardinal's robes, that I may be able to go to war'.[30] He shared the pleasures of his brother in the arts, hunting and women, but unlike him was to become an active and able ruler. Velázquez's portrait of Ferdinand as a huntsman (Prado, Madrid), painted in 1632, the year he set off abroad, gives a truer image of the man than that painted in cardinal's robes (Munich) by Rubens when he was in Madrid. It was originally intended that he should rule jointly as governor with his ageing aunt, but when Isabella died he was not yet ready to assume her place, and only a year later did he set out for Flanders from Milan, where he had been studying war and politics. On the way he put theory into practice and made a highly successful début as a general in the field when the Swedes were routed at the Battle of Nördlingen. It was a warning to the Dutch that military action, the only option left to the Flemish, might not go their way.

Ferdinand was greeted as a hero on his arrival in Brussels at the beginning of November 1634, and within ten days the City Council of Antwerp had agreed to invite their new governor to make the traditional Joyous Entry into their city. Strictly speaking such an event was reserved for a ruler such as, for example, Albert and Isabella, but if the circumstances seemed to warrant it exceptions were made. It was to be a gala occasion, and to impress the cardinal-infante elaborate street decorations following a traditional pattern were to be erected along his triumphal route through the city. As chief designer and architect impresario who better could the city officials choose than their leading painter? Rubens wrote to Peiresc:

Today I am so overburdened with the preparations for the triumphal entry of the cardinal-infante (which takes place at the end of this month), that I have time neither to live nor to write. I am therefore cheating my art by stealing a few evening hours to write this most inadequate and negligent reply to the courteous and elegant letter of yours. The magistrates of this city have laid upon my shoulders the entire burden of this festival, and I believe you would not be displeased at the invention and variety of subjects, the novelty of designs and the fitness of their application.[31]

In his time Rubens had decorated a church, a palace and a banqueting hall, and he was now set to prove that an entire city was well within his compass. Not for mere effect had he claimed 'that no undertaking, however vast in size or diversified in subject, has ever surpassed my courage', and within the space of a few months he showed himself to be the supreme decorator when, armed with a programme of subjects devised in conjunction with his friends Nicolaas Rockox and Jan Caspar Gevaerts, he presented his plans for triumphal arches and stages throughout the city. The Grand Council felt that such luxury of invention and opulence of decoration ill-suited the present poverty-stricken state of the city, and cut down Rubens' plans to a certain extent. But time played into Rubens' hands, and the postponement of Ferdinand's intended visit by several months allowed the artist, with his team of painters, sculptors and carpenters all working overtime, to extend the scheme with an additional arch to conclude the procession as well as further decorative detail. As usual the budget, funded from a tax on beer, proved to be hopelessly inadequate, and the city was left with a substantial deficit. Yet, as the volume of commemorative engravings with commentary written by Gevaerts, no less than Rubens' own oil-sketches, dashed off in the heat of the moment, amply show, it was a display fit for at least a king, and probably no ruler received a more stylish welcome throughout the century. In April 1635 Ferdinand arrived by river, and the next morning entered the city to be greeted by wooden floats and arches alluding to his achievements, his virtues and the history of his House. He was saluted by salvoes of artillery and a fanfare of trumpets. From there the procession moved from one decoration to another, welcomed at each point by musicians. For two evenings in succession there were firework displays, the most spectacular of which came from the cathedral tower. Ferdinand stayed eight days, visiting and inspecting the decorations and the more permanent sights of the city, including none other than the house of Peter Paul Rubens, and its owner, who, it seems, had lain in bed suffering from gout and unable to take part in the celebrations he had done so much to create. No doubt they ended in the usual Flemish way. As Ferdinand was to describe a few years later after the Kermesse held in the same city: 'After the procession they all went to eat and drink, and to end with they were all drunk, for without that they did not think it a festival here.' And he concluded savagely, 'the people here live like beasts'.[32]

In the Low Countries the Joyous Entry signified much more than the kind of popular festival celebrated in French or Italian towns on the occasion of a royal visit. It came to be recognised as a form of contract between the new ruler and the people; while the latter offered an oath of allegiance, the former was expected to acknowledge the rights and privileges of the city. Apart from contributing to the

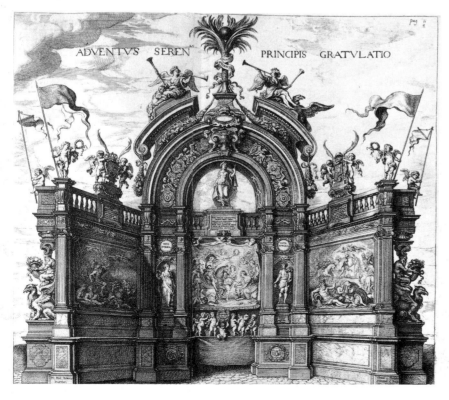

festive nature of the occasion, the programme was carefully devised to underline this general understanding, illustrated in either historical or allegorical terms. Probably no Joyous Entry was more politically charged than that which greeted Ferdinand in Antwerp, largely conceived as it was by someone with such worldly

283. *Sketch for the Voyage of the Prince from Barcelona to Genoa*, 1635. Panel, 48.8 × 64.2 cm. Fogg Art Museum, Cambridge, Mass.

281. (far left) Theodoor van Thulden after Rubens, *The Stage of Welcome*. Etching, 54.1 × 61.5 cm. British Museum, London.

282. (middle) *Sketch for the Stage of Welcome*, 1634. Panel, 73 × 78 cm. Hermitage, Leningrad.

284. Theodoor van Thulden after Rubens, *The Portico of the Emperors*. Etching, 57.1 × 85.1 cm. British Museum, London.

experience and sophistication. Compared with the generalised allegories prepared under the direction of Otto van Veen for the entry of Albert and Isabella in 1599 (Plate 5), the message was very much more pointed. In the unfolding series of decorations that greeted Ferdinand as he rode through the streets, he was at first warmly welcomed with suitable deference and then with his family and his forebears extravagantly praised. It was only when he was softened up by the full recognition of his position as governor that he was presented with a very different theme. Despite the opulence of the festivities, he was to be made fully aware that the city was in a parlous financial state and required his active assistance, above all in the reopening of the Scheldt, still under the control of the Dutch. He could have been under no illusions when he left the city to return to Brussels.

The route, which wound its way through the city and took Ferdinand two hours to cover on horseback, was decorated with a series of stages or *pegmata*, set up beside the road, and arches through which the procession passed, as well as floats, cars and other decorations. The Stage of Welcome (Plate 281), or as it was called by Gevaerts 'The rejoicing over the arrival of the Most Serene Prince', set the tone with a timber structure decorated with paintings on canvas and carved and painted wood, including cut-outs, which with banners were used extensively throughout the decorations to create highly ornamental silhouettes. Originally confined to a simple arch containing a painting of the *Advent of the Prince* (Plate 282), the stage was, because of the extra time available, extended at the sides in order to display two paintings, one a mixture of history and allegory in the *Meeting of the two Ferdinands at Nördlingen*, and the other an allegory depicting Neptune calming the storm, illustrating the *Voyage of the Prince from Barcelona to Genoa* (Plate 283), at the outset of which his fleet was scattered by the north wind. (Boreas is here shown being driven away.)

Passing through the Arch of Philip, dedicated to the cardinal-infante's brother and containing family portraits as well as paintings of historical events, the procession reached the most elaborate structure of all, the Portico of the Emperors (Plate 284), which was made up of a curved arcade one hundred feet across culminating with a triumphal arch surmounted by an obelisk in the centre. Here the decoration consisted of twelve over life-size statues sculpted in stone (originally planned as only cut-outs) of the emperors (see Plate 285), alternating with twelve cut-out terms attached to the flanking pilasters and representing the deities. Ferdinand was sufficiently impressed by this edifice to doff his cap as he passed through and afterwards reported that of all the decorations this pleased him most.

The adulatory part of the programme continued with the Stage of Isabella and the Arch of Ferdinand, designed in allusion to his recent victory as a classical triumphal arch, which complemented the arch dedicated to his brother. But with the Temple of Janus (Plate 286) the mood changed as the city of Antwerp sent its message to Ferdinand. The key to the latter is the fact that the doors of the temple, 'which', as Rubens said on another occasion, 'in time of peace, according to Roman custom, remained closed'[33] (and represented thus in previous Joyous Entries), are here shown open. The central scene, depicted as taking place on a stage, illustrates the fearsome figure of the Fury of War, blindfold and brandishing a sword and a flaming torch, bursting out of the open doors of the temple. In the porticoes are contrasting scenes of peace with happiness and plenty on one side and war with its evil consequences on the other. It was yet one more re-enactment of a theme that had preoccupied Rubens since the late 1620s. The allusion was made more specific in the subsequent Stage of Mercury, from which Ferdinand was able to catch his only glimpse of the river and harbour. Here the theme was Antwerp's decline as a port, combined with expressions of hope for the opening of the Scheldt under the new governor. But, unlike earlier more optimistic representations of the river already liberated, Rubens, recognising the now long-term reality of the situation, chose Mercury's departure *from* Antwerp as the subject of the principal canvas. An upward beat can be felt in the Arch of the

Mint with its fanciful suggestions for financial alleviation, which continues in the final arch, only added at the last moment, in which Ferdinand is likened to both Hercules and Bellerophon (who slayed the Chimaera) as virtuous hero and victor over evil. As a piece of propaganda the programme was most skilfully devised by Rubens and his two friends and far outshone all previous such occasions.

Although recognised as general impresario, Rubens was not responsible for all the decorations, but with four Stages and five Arches, the latter requiring decoration on both sides, he could claim to have created the lion's share. It posed no problem to him that he was called upon to make designs for architecture and sculpture as well as painting. Much of his time was given up to contracting out work to a series of painters, sculptors and carpenters. With the exception of Van Dyck, temporarily back from England, and the disliked De Crayer, virtually everyone in the artistic community of the city was called upon to play a part. Working under him, Rubens had artists of the calibre of Jordaens and Cornelis de Vos, as well as the sculptors Hans van Mildert and Erasmus Quellinus the Elder. The organisation of such a team of artists and craftsmen was to become a characteristically seventeenth-century exercise under the direction of Bernini in Rome or in the teams of decorators who worked together on many of the major palaces and large houses throughout Europe.

Above all, the limited time available called for swift decisive action. In preparing his designs Rubens demonstrated his speed of creation. Abandoning his usual habit of making preliminary drawings and monochrome *bozzetti*, he drew in black chalk directly on the prepared panel, and then worked up his subject in sufficient detail and colour for the artist who was to make the canvas or the architectural draughtsman who was to prepare working drawings. Where one side of the design duplicated the other, he omitted it, as with the right hand pilaster,

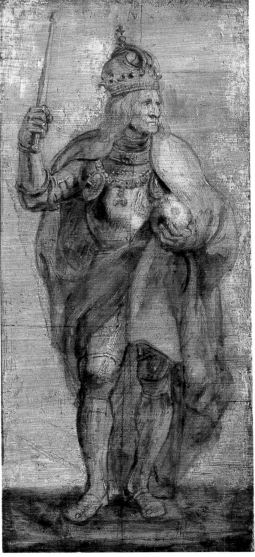

285. *Sketch for Maximilian I*, 1634. Panel, 38.7 × 17.5 cm. Ashmolean Museum, Oxford.

286. *Sketch for the Temple of Janus*, 1634. Panel, 70 × 68.8 cm. Hermitage, Leningrad.

putti and cartouche in the sketch for the Stage of Welcome (Plate 282). In no other work is one made more aware of the aptness of Bellori's description of Rubens' '*furia del penello*' (the frenzy of his brush), as lines, forms and colours take shape before our eyes. Although he signed responsible for all the decoration under his direction, he was only paid for the execution of the two finished canvases added at the last moment to the Stage of Welcome, but even in these, which still exist (Vienna and Dresden), it is difficult to recognise more than a collaboration between master and assistants. For a full sense of Rubens' mastery one has to turn to the *modelli*. The difference in quality between sketch and finished work was an old factor, which here necessarily became more apparent.

With a wide repertory of allegory, mythology and history at his command, Rubens was able to ring the changes with remarkable invention. Apart from a careful perusal of the records of previous Entries, so many of the sources he had studied over the years came readily to hand. The brilliantly spontaneous sketch for the *Voyage from Barcelona to Genoa* is a distillation of Raphael and the antique, besides revealing his familiarity with the description in the *Aeneid* of Neptune's command to the winds after the dispersal of Aeneas's fleet in a storm. Antique coins, whose imagery was so helpful to him in the whole project, assisted the artist in his design of the details on the Temple of Janus. And faced with the demand for so many portraits, Rubens was readily able to turn to such artists as Titian and Dürer for likenesses. The sources of all this information had to be already in his head or at hand, since there was little time for research. It is a tribute to Rubens' sheer professionalism, as well as to his pride in his native city, that he should have devoted so much creative energy and ingenuity to what was only a temporary scheme. After remaining *in situ* for six weeks, much of the decoration was sold for no more than the value of the materials of which it was constructed. But, responding to Ferdinand's request for works of art rather than a gift of money which the city could ill afford, some of the better paintings, cleaned and retouched, and the sculptures of the emperors were presented to the new governor for his palace and gardens in Brussels two years later.

Three years later Rubens, was called upon by his native city to honour the cardinal-infante once again when within the space of a few days his Spanish troops had defeated the attacking Dutch army at Calloo and had won a similar victory over the French at St Omer. To celebrate the revived fortunes of the Flemish under their new governor, the city of Antwerp commissioned a triumphal car as part of the annual procession or *Ommegang*. Four brightly caparisoned horses pulled the massive chariot filled with allegorical figures in appropriate costume. In the centre a tall mast supporting banners and trophies culminated in a laurel tree and the Spanish royal arms. The whole decoration was replete with references, many following Roman tradition, to the Spanish king and his brother, as well as to the cities of Antwerp, Calloo and St Omer. In his fluently executed design (Plate 287) for the carpenters and painters, Rubens both represented the chariot in profile with all the figures identified and arranged in their allotted positions, and provided in the upper left a plan with similar instructions. Although spectacular in appearance, its top-heavy design must have made progress slow and hazardous.

During this decade Rubens was no less occupied in painting single works either on commission or for his own purposes. His remarriage and resettling in Antwerp seems to have inspired a renewed love of his homeland now viewed against his experience of foreign countries. Seen most obviously in both the type and the number of landscapes he painted, this mood is also apparent in several genre subjects produced during these years. Clearly painted in homage to Pieter Bruegel the Elder, yet mindful of his own much-admired contemporary Adriaen Brouwer, the *Flemish Kermesse* (Plate 288) portrays a hectic orgy puslating with earthy vigour reflecting the kind of event witnessed with disgust by Ferdinand. But this was clearly nothing new in local behaviour, since Guicciardini describes how 'At all hours one sees weddings, feasting, dancing and recreations. On all

287. *Sketch for the Triumphal Chariot of the Victory at Calloo*, 1638. Panel, 105.5 × 73 cm. Koninklijk Museum voor Schone Kunsten, Antwerp.

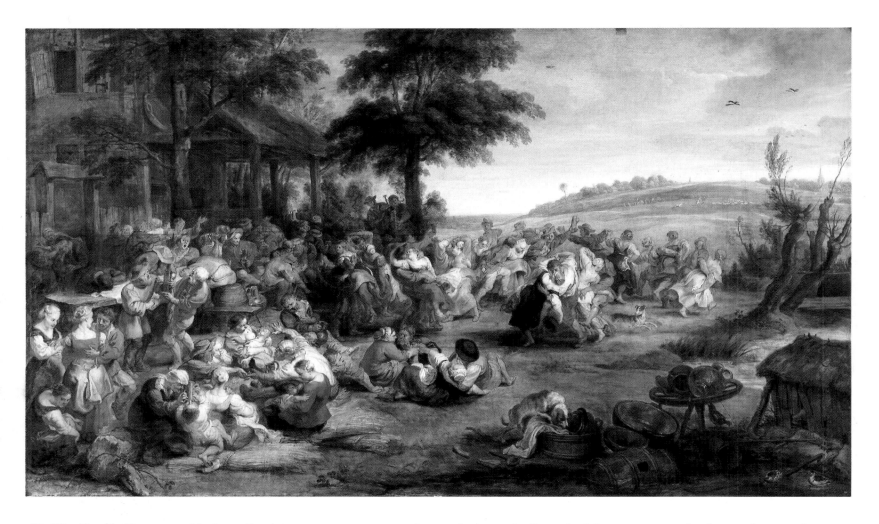

288. *The Flemish Kermesse*, mid-1630s. Panel, 149 × 261 cm. Musée du Louvre, Paris.

street corners one hears the sound of musical instruments, singing and general rejoicing.'[34]

Against a landscape possibly painted for him by the Dutch artist Cornelis Saftleven, with whom Rubens is known to have collaborated, and who could well also be responsible for the foreground still life, Rubens has created a compendium of peasant entertainment *al fresco*, ranging from the feeding of infants by the elderly to uncontained drinking and lovemaking, all of which is finally caught up in celebration of the dance. The artist may well have recalled the words of Horace in his *Odes*: 'Now is the time for drinking, for stomping the ground with an unrestrained foot.'[35] This throbbing mass of uninhibited humanity is superbly welded into a unified composition, the force of whose inner movement defies the eye in its wish to linger over individual detail. The brightness of colour with predominant accents of red and yellow highlights helps to add to the festivity of the occasion.

In connection with this picture Rubens produced one of his most remarkable drawings, covering both sides of a large sheet of paper. On one side (Plate 289) he made a number of studies in chalk mostly redrawn with the pen. At the left are three variations of figures eating, drinking and talking around a table, while studies of more amorous and inebriated behaviour can be seen on the right; in the centre foreground a dancing group forms a circle with a young bride and groom on the right. These studies done from life or more likely from memory provided the raw material for his picture, and not all were eventually used, nor without modification. The higher viewpoint in the drawing, as if studied from the gallery of an inn, was brought down to ground level in the painting. A few colour notes were added against several figures, as well as the word *vrolyk* (in fun) beside the figure of a man slapping another on the back; below, a note reminded the artist of the omission of beggars and other figures.

More unusual is the other side of the sheet (Plate 290), on which seventeen pairs of dancers, some clearly the same group, twist and turn in a frenzied measure. Some of the pairs were first drawn in black chalk, but in freely reworking them in pen the artist appears to have been inspired by the vitality of his subject to create yet more variations on a theme, whose only constant is the fulcrum of joined lips of

266

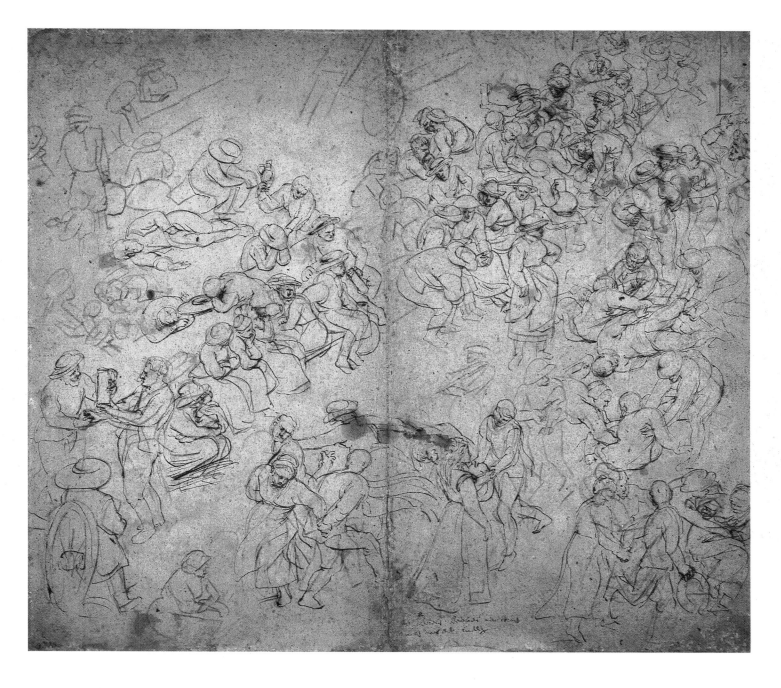

289. (above) *Studies of Peasants dancing, eating, etc.*, mid-1630s. Pen and brown ink over black chalk with touches of red chalk, 50.2 × 58.2 cm. British Museum, London.

290. *Studies of dancing Peasants*, mid-1630s. Pen and brown ink over black chalk with touches of red chalk, 58.2 × 50.2 cm. British Museum, London.

each pair as the limbs and bodies twist and turn in endless formations in a natural expression of the basic rhythm of the music. Both sides of this inexhaustable sheet of studies, containing more figures than ever before incorporated by Rubens in one drawing, reveal the inner energy released by the artist in the act of creation, which here assumes a life of its own beyond the call of its immediate purpose.

For the life of the artist himself the spirit of these bucolic years is best caught in that marvellous subject, now known as the *Garden of Love* (Plate 291), but whose composition was described in the artist's inventory as *Conversation of Young Women* or *à la mode*. As a modern subject in contemporary dress, whose precise theme still eludes us, it might loosely be considered as a pendant to the more lowly *Kermesse*. Taking its inspiration from such sources as the medieval love-garden, and the Venetian *fête champêtre*, it offers a hymn to love which was to be echoed one hundred years later by Watteau in his *Departure from the Island of Cythera*. Instead of the never-never land of Watteau's invention, Rubens shows his *conversation* taking place on a terrace before a richly sculpted pavilion or grotto with rustic banded columns, whose interior harbours a fountain with the Three Graces. In the centre three beautiful girls accompanied by winged putti listen to the sound of the lute mingled with the noise of water flowing from the ample breasts of a sculpted woman on a dolphin into the basin of the fountain below, while those lucky enough to have found escorts engage in amorous conversation. An elegantly dressed couple approaches from either side; the female companion on the right holds up an ostrich feather, while her counterpart on the left requires the active encouragement of a winged putto carrying a yoke. Further symbols of love and marriage, a pair of turtle doves, a burning torch, a crown of roses and a bow, are flown in from above by further *amoretti*, while the dog, the symbol of fidelity, appears between the legs of the young man on the right. The picture is a joint celebration in honour of both Venus, the goddess of love, and Juno, the goddess of marriage, whose peacock on the extreme right looks down from its perch on the rim of the basin. It is hardly surprising that some of the girls are readily recognisable as variations on the theme of Helena Fourment. Yet the scene that he presents to us is no honeyed fantasy of his own but reflects contemporary customs. A disapproving Jesuit described the habits of the upper classes: 'They used to sit under a green arbour or go on the water to get an appetite, or again in the afternoon they would mount their carriages and make the pilgrimage of Venus, the fashionable walk; when evening came they sang or danced the whole night and made love in a way that cannot be told.'[36] It was Rubens' genius that he did tell it, and we are enchanted.

Apart from the subject itself, much of the enchantment stems from the beauty of each figure, conceived so harmoniously in relation to the others. The sumptuous materials of the fashionable dresses, each varied in colour – silver, aquamarine, gold, pink, red and black or dark blue – glow against the grey of the stone in the background, broken only at the left by a vista of Titianesque sky. How much thought was required to realise each part is clear from the existence of nine exquisite drawings in coloured chalks for either single figures or pairs. As in the *Kermesse*, drawings rather than oil-sketches appear to have provided the necessary preparation, although the drawings themselves are very different in character. Where a sense of movement was paramount in the *Kermesse*, here with the composition established, presumably in some other study, the artist concentrates on realising the individual detail, paying particular attention to the rendering of the play of light over the surfaces of rich materials, as in the study (Plate 292) of the young woman kneeling with her head resting on her hands, a pose slightly modified in the painting. In another study (Plate 293), for the couple on the left, also changed in the painting, the woman is only adumbrated in outline, while Rubens concentrates on the figure of the young man in a wide-brimmed hat and a cloak with slashed sleeves. Apart from conveying the quality of the materials in fluid strokes of the chalk which imitate the handling of the brush, Rubens beautifully realises the expressions on the faces, the tender concern on the part of

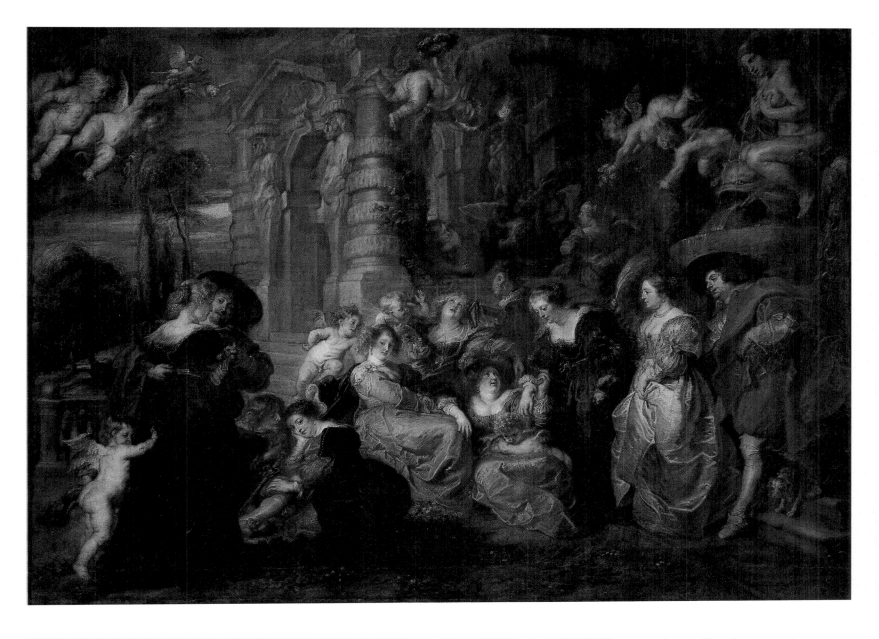

291. (above) *The Garden of Love (Conversation à la mode)*, mid-1630s. Canvas, 198 × 283 cm. Museo del Prado, Madrid.

292. *A young Woman kneeling*, c.1632–5. Black and red chalk, heightened with white, on light brown paper, 40.3 × 47.4 cm. Gemeentemusea, Amsterdam.

293. *A young Man embracing a young Woman*, c.1632–5. Black and red chalk, heightened with white, on light brown paper, 32.3 × 30 cm. Gemeentemusea, Amsterdam.

294. (below) *The Garden of Love* (left half), c.1635. Pen and brown ink with coloured wash over black chalk, 48 × 71 cm. Metropolitan Museum of Art, New York.

the man caught in a strong sidelight, and the coy charm of the young woman with her inviting look. (It is hardly surprising that the latter invention much appealed to him and was repeated in several pictures.) In making such full-scale studies from the model, Rubens was returning to an earlier practice, which he had little time or necessity to follow in the previous decade. In these new studies we feel the conscious pleasure of the artist, stimulated by his renewed opportunity to immerse himself in such an exercise, with which he imbues the drawings with more beauty and perfection *per se* than a working study strictly required.

The subject clearly gave the artist much satisfaction, and, apart from making a painted variant with a more extended composition (Waddesdon Manor), he decided to translate it into the medium of woodcut, which, with the availability of the services of Christoffel Jegher, he now favoured. Unlike earlier examples, the print was not just a reproduction of the painting, but represented a newly thought-out composition divided over two blocks. With this purpose in mind he made two magnificent large drawings (Plate 294) whose neat pen strokes gave the printmaker the precise instructions he could follow in transferring the design to the woodblock. Always acutely aware of the function of his drawing, he here exchanges the fine hatching required for the intaglio print for the more open, weightier line of the woodcut. Extending the original composition horizontally he transformed his figures in both parts of the new work. On the left he isolates the two couples, one standing and the other seated, but brings forward the grotto so that the game, played out to the amusement of a seated couple, of three girls drenched by surprise water jets now assumes greater prominence. (In the painting it is not easy to make out what is happening.) His remembrance of a similar feature installed in the gardens of Marmirolo by Giulio Romano may have prompted the inclusion of it here. Despite the elaborate technique of both preparatory drawings in a combination of pen over chalk, enriched with bodycolour, further changes were introduced before the blocks were finally cut by Jegher (Plate 295). To acknowledge the exact source of the print, the credit line reads *P. P.Rub. delin.[eavit]* and not *pinxit*.

The ultimate hymn to love is found in the painting of the *Feast of Venus Verticordia* or *Changer of Hearts* (Plate 296), which contains elements of both the high life of the *Garden of Love* and the low life of the *Kermesse* translated into an imaginary classical setting. Where the elegantly dressed girls who approach from the right recall the former, the poses of the two dancing couples on the left are directly related to the sheet of studies with dancing figures (Plate 290). As has been shown, the present picture is a pictorial recreation, enriched by other classical

295. Christoffel Jegher after Rubens, *The Garden of Love* (two blocks). Woodcuts, 45.5 × 60 cm and 45.5 × 58.5 cm. British Museum, London.

topoi, of the passage in Ovid's *Fasti* describing the feast which inaugurates Venus's month of April, at which three different categories of women are exhorted to worship the goddess. One of the matrons, following the poet's instructions, solicitously washes the statue, while the other prepares an offering of incense to Fortuna Virilis. At the same time Venus is presented with a silver mirror by a nearly naked woman who holds a comb in the other hand; she and her companion are probably courtesans 'who wear not the fillets and the robes' and who seek very different favours. Bearing their dolls, which were traditionally offered as gifts to invoke the goddess's blessing at the Temple of Venus Verticordia outside Rome, two beautiful 'brides' eagerly rush forward, while on the left 'the satyrs, a wanton crew', dance and sport lasciviously. Behind the satyrs, Venus's temple is situated on a hill beyond a grotto, whose tumbling water was used for the required ablutions, and where Ceres and Bacchus, without whom Venus, as in the classical proverb, grows cold, can be seen with their customary gifts. From above, putti come laden with the fruits of the earth, the apples of Venus, the grapes of Bacchus and the sheaves of corn of Ceres, while others obey the poet's command: 'Now give her other flowers, now give her the fresh-blown rose.' Below, many more of their number encircle the statue of Venus in a vivid dance, the rhythm of which grows more frenzied among the nymphs, fauns and satyrs on the perimeter. At the bottom right two putti are engrossed in a succulent kiss. The setting with its leafy grove is clothed in morning or evening light which glows on the horizon. Like *Midsummer Night's Dream*, the picture presents a world where mortals and imaginary spirits mingle in an enchanted atmosphere, all in their several ways united in a paean to love.

296. *The Feast of Venus Verticordia*, mid-1630s. Canvas, 217 × 350 cm. Kunsthistorisches Museum, Vienna.

In his inspired imagination of the ancient world, Rubens' interest in

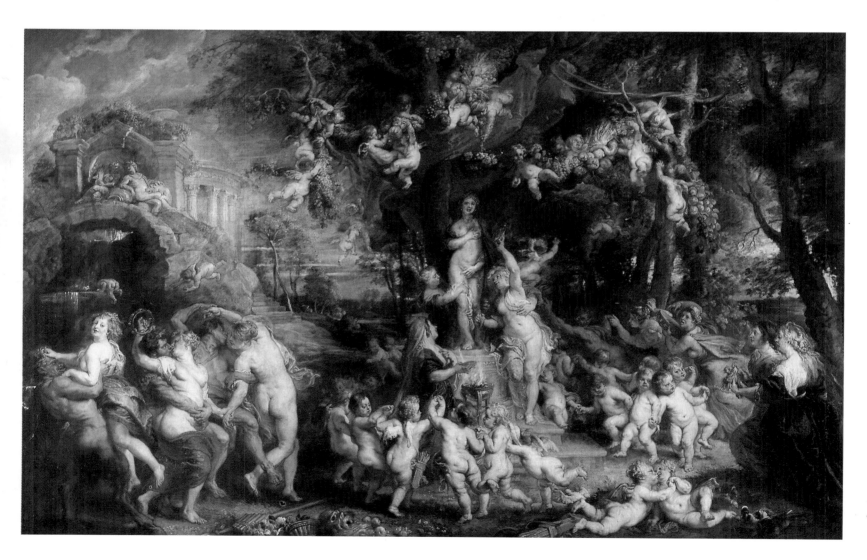

272

archaeology played a part in some of the detail. The tripod which holds the fire for the incense recalls those that were the subject of an illustrated correspondence between the artist and Peiresc in 1630 (Plate 201), while the idea of the grotto, only added in the course of painting, seems to have come from the engraving of an ancient nymphaeum sent by the Frenchman. But far more pervasive is the spell exercised by Titian specifically through Rubens' loving copy of the *Worship of Venus* (Plate 244). Apart from the obvious parallels in the treatment of the subject, both in the adult figures and in the myriad world of infants in unrestrained celebration, the execution of the picture represents Rubens' most wholehearted declaration of admiration for the technique of the Venetian in his later years. Juxtaposing form and colour, which blend at a distance, the open brushwork builds up a range of rich hues which throb against the silvery-grey tonality of the background. Green, blue and gold are dominated by red, the accents of which spread across the surface of the canvas and, echoing on the skyline, provide an overriding unity to the composition. Although unashamedly Titianesque in inspiration, the picture is an entirely personal re-creation. It perfectly illustrates the words of Cornelis de Bie: 'How wonderfully has the light of Rubens' mind taken fire from its contact with Titian's brush.'[37]

During the artist's last years he received a number of orders for altarpieces from churches in and outside Antwerp, as well as a number of private commissions, some of which show a darker side to Rubens' Indian summer. The painting of the *Horrors of War* (Plate 256), painted in 1637 or 1638 for Justus Sustermans, the Antwerp artist who had become court painter to the Duke of Tuscany, has already been mentioned. In 1637, through the mediation of George Geldorp, a Cologne painter who had settled in London, Rubens received a request for an altarpiece (Plate 297) to be presented to the church of St Peter in Cologne by the banker and collector Eberhard Jabach. For an artist who had achieved such a privileged position, his behaviour is revealing. To Geldorp Rubens wrote:

> As regards time, I must have a year and a half, in order to be able to serve your friend with care and convenience. As for the subject, it would be best to choose it according to the size of the picture: for there are subjects which are better treated in a large space, and others which call for medium or small proportions. But if I might choose or wish for a subject according to my taste, relating to St Peter, it would be his crucifixion, with his feet uppermost. It seems to me that that would enable me to do something extraordinary, yet according to my means. Nevertheless, I leave the choice to the one who will pay the expenses, as soon as we know how large the picture is to be.[38]

Just over eight months later, he wrote again that 'it is already well advanced, and I hope that it will be one of the best pieces that has ever left my hands. You may freely tell this to your friend. However, I should not like to be pressed to finish it, but ask that this be left to my discretion and convenience, in order to be able to finish it with pleasure. For even though I am overburdened with other works, the subject of this picture attracts me more than all the others I have on hand'.[39] But when the artist died three years later it remained unfinished in the studio. By this time Jabach too was dead, but the canvas was bought on behalf of 'a man from Cologne' and set up in the church for which it was painted.

By far the most important patron now was Philip IV of Spain. There were already twenty-five paintings by Rubens in the king's collection at the time of Ferdinand's arrival in Flanders, and from then on commissions came thick and fast. Between 1636 and 1640 Philip ordered at least eighty-two pictures from the artist. Ferdinand must have had instructions from his brother that one of his roles as governor was to act as agent in acquiring works of art, above all by Rubens, for the Spanish royal collection. On the occasion of Ferdinand's Entry into Antwerp, his first thought on seeing the Portico of the Emperors was to enquire whether the statues of the emperors could be sent as a gift to Philip. The king needed little telling that he had a superb decorator for the asking, and, having built him-

297. *The Crucifixion of St Peter*, c.1637–9.
Canvas, 310 × 170 cm. Peterskirche, Cologne.

self a hunting-box just outside Madrid, known as the Torre de la Parada, he lost
no time in asking Rubens to provide a large number of pictures to decorate
the rooms.

The two-storeyed hunting box was constructed around an old watch-tower 'like
a hoop-skirt around the body',[40] as one contemporary described it. Prepared to
tolerate bare walls for as short a time as possible, the king was in an impatient
mood. Velázquez, who may possibly have been in charge of the decorations, was
certainly involved in producing a number of pictures of mythological subjects.
But most were to come from Antwerp. Some sixty animal pictures were to be
painted by 'Esneyre', who can be identified as Frans Snyders, while slightly more
than that number, illustrating themes from the *Metamorphoses* and from other
classical writers, were to be the responsibility of Rubens. Instructions to the latter
have not survived, but it was clearly agreed that he would make the designs or
modelli, and although he would execute several of the finished compositions
himself, the majority were to be handed out to other Antwerp painters, whose
names were in fact inscribed on the canvases. They included not only such well-
known figures as Jordaens, Jan Cossiers, Cornelis de Vos and Erasmus Quellinus,

but also lesser known artists such as Jan van Eyck and J.-B. Borrekens. As might be imagined, the results are extremely variable in quality, and removed from their original setting they make a dismal impression in the galleries of the Prado. As with the Joyful Entry, but with less reason, one has to turn to Rubens' *modelli* to appreciate the true artistic worth of his creation.

By the end of November 1636 Rubens had received the commission, and then, as we learn from Ferdinand's letters to Philip, the hustling really started. On 6 December Ferdinand could report that Rubens was much preoccupied with the project and that the work had been shared out among the best painters, but by the end of January 1637 the governor was referring to 'those beasts of painters' who were not keeping up with the desired schedule. He met with opposition from Rubens above all, who with characteristic firmness would 'give no precise answer and confines himself to promising that neither himself nor the other painters will lose a minute'.[41] In April 1637 Ferdinand went to Antwerp, where he found some pictures far advanced and others begun. 'Those by Rubens, who, as Your Majesty knows, is very active, will be finished before the others.'[42] Although the commission for the animal pictures was advancing more slowly, all the works under Rubens' direction were finished by the end of the year, but then Ferdinand wrote with irritation that 'I have had a slight quarrel with Rubens, because although he says they are all finished, we must wait until they are really dry'.[43] And that might take up to a month. Finally in April the pictures were on their way to Madrid and were installed by October 1638 when they were seen by Francesco d'Este, Duke of Modena, on a visit.

Although Rubens received instructions from Madrid about the subjects to be treated, there does not appear to have been a carefully conceived programme. Most though not all of the subjects were taken from the *Metamorphoses* and were

298. *Sketch for Cephalus and Procris*, 1636. Panel, 26.5 × 28.5 cm. Museo del Prado, Madrid.

299. *Sketch for the Fall of Phaethon*, 1636. Panel, 28.1 × 27.6 cm. Musées Royaux des Beaux-Arts, Brussels.

300. *Sketch for the Origin of the Milky Way*, 1636. Panel, 26.7 × 34.1 cm. Musées Royaux des Beaux-Arts, Brussels.

presumably chosen as appropriate and agreeable themes. The world of mythological make-believe suited Philip's tastes and provided a delightful escape from the sombre surroundings in which he lived most of his life. The Torre was a place where the senses could reign undisturbed by religious or political matters. Rubens was very familiar with Ovid's poems and had taken subjects from them in earlier works. It is also clear that he was well acquainted with previous illustrated editions of the *Metamorphoses*, which helped him to form the images in his mind. But, as had been his experience before, he had little time to ponder his treatment if, as we assume, he produced over sixty *modelli* in a period of about two months. Despite some initial dependence on earlier representations, whether his own or by others, the sketches wonderfully convey the sense that they are the artist's direct response to reading the poems themselves. It cannot have been fortuitous that in January 1637 he purchased what we must assume to be yet another edition of Ovid from his friends at the Plantin Press.

The *modelli* testify to the reality which the mythological world held for Rubens and to the sheer vitality with which he was able to imbue his interpretations. The unfortunate Phaethon (Plate 299), all too visibly aware of his fate, really hurtles towards the earth on his back at breathtaking speed, his limbs thrashing the air as he screams in desperation; meanwhile, in the words of the poet, 'the horses get confused and jump in opposite directions as their necks escape the yoke'. In his illustration of *Cephalus and Procris* (Plate 298), by choosing the psychologically crucial moment before the fatal deed, Rubens marvellously contrasts the assured glance of Cephalus, happy in his hunting and secure with Diana's javelin beside him, as he calls for the refreshing breeze which gives rise to his wife's jealousy, with the intensely loving but tormented look of Procris hidden in the undergrowth. In the *Origin of the Milky Way* (Plate 300), one of the themes not taken from Ovid, Juno is seated on the clouds, four-square like a peasant woman feeding her child, as she proffers her gushing breast to the infant Hercules. Behind, her chariot awaits, pulled by two peacocks one of whom glances back at the nursery scene so incongruously taking place in the heavens. As one of the subjects executed by Rubens himself (Plate 301), he not only takes the opportunity to introduce the meditative figure of Jupiter with his eagle seated beside the chariot, but with a more elegant pose and more graceful expression transforms his earthy model into a more seemly if less individual goddess. Although clothed in the imaginary dress of mythology, Rubens was treating the human emotions of jealousy, pride, sorrow, anger and, above all, love in its many aspects. A lifetime's experience of humanity blended with his total empathy for the classical world served to produce works which in their initial expression in *modelli*, some of which are no more than a few inches each way, still amaze one by

276

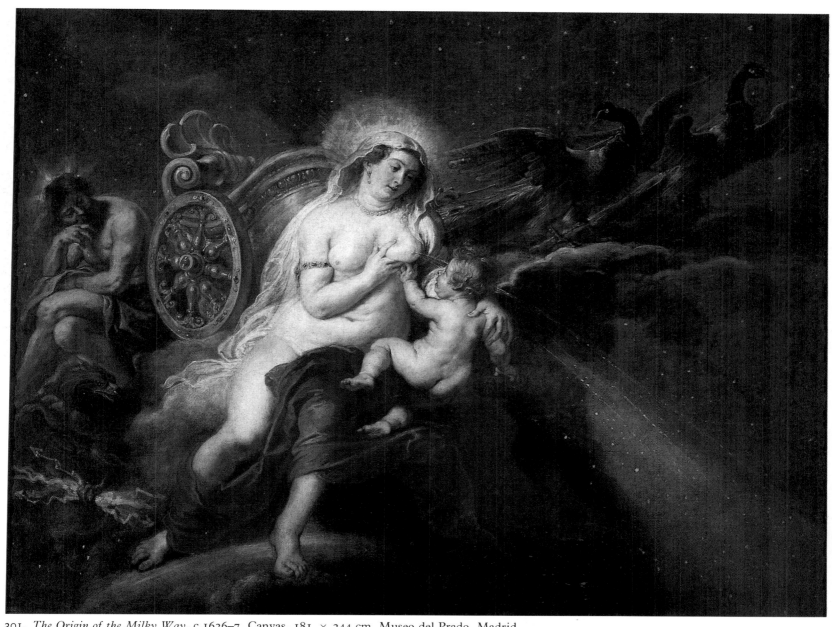

301. *The Origin of the Milky Way*, c.1636–7. Canvas, 181 × 244 cm. Museo del Prado, Madrid.

302. *The Judgement of Paris*, 1638–9. Canvas, 199 × 379 cm. Museo del Prado, Madrid.

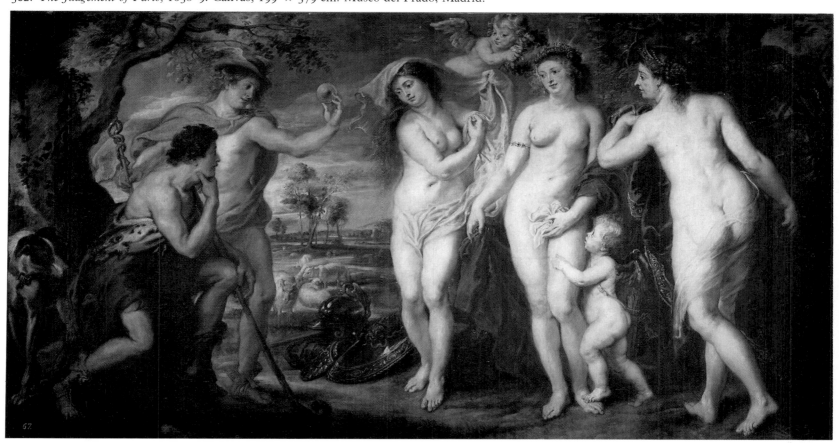

303. *Landscape with the Tower of Steen*, c.1635–7. Panel, 24 × 30 cm. Gemäldegalerie, Berlin-Dahlem.

304. *The Château de Steen*, c.1635–8. Panel, 131.5 × 229.5 cm. National Gallery, London.

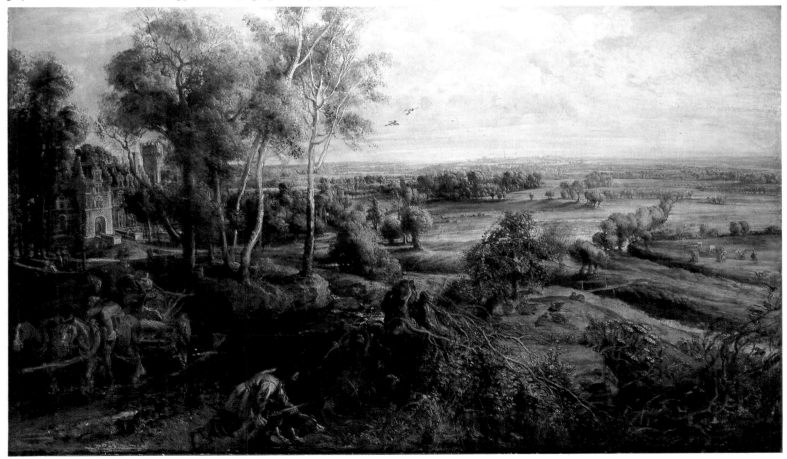

their immediacy and zest for life, allied with the penetrating psychological observation of a great master.

Pictorially, the effects of Titian's *poesie* still echo through the various compositions. Most remarkable is the way, following Venetian practice, the artist models in pure colour alone. In the sketch of the *Fall of Phaethon* (Plate 299), against the startling white of the horses, the artist confines himself to bright colours, the pinkish-red of the garment and the gold of the throne, with touches of both colours added to the summarily brushed-in coastline below; only the more rapidly descending horse beneath Phaethon is painted in a darker shade of grey. Although also modelled in pure colour, there is more contrast in the *Origin of the Milky Way* (Plate 301). Here the accents of the white of Juno's flesh, the red of her garment and the gold of her chariot stand out against the darker blue-grey of the clouds and the brown of the peacocks. Much of the brightness of colour was lost in elaborating the final canvases with darker backgrounds, although Rubens himself in such a work as the *Milky Way* was able to retain the richness and glow but in a darker key.

This series of pictures was no sooner delivered than the Spanish king instructed his brother to commission further works from the artist. It was about this time that Rubens' health gave cause for concern. The cardinal-infante wrote at the end of June 1638 that the artist 'has been much troubled by gout and has been unable to finish the *Judgement of Paris* [Plate 302], but the picture is well advanced'.[44] Rubens himself was more specific to his friend Philippe Chifflet: 'the gout very often prevents my wielding either pen or brush – and taking up its usual residence, so to speak, in my right hand, hinders me especially from making drawings on a small scale'.[45] But the Spaniards allowed him no respite. In October 1638 Ferdinand wrote that he had been pressing hard for completion of the *Judgement of Paris*, and two months later that although the artist had received extreme unction he was now promising to work again after Easter. 'I am doing all I can to make sure that Rubens makes up for lost time; God knows how much I regret the delay, seeing your Majesty's wish for rapid completion.'[46] At last at the end of February he could say that, despite its omission from the last shipment owing to its size, the picture was now ready. Moreover, he was able to reassure the impatient king, 'it is without any doubt the best picture Rubens ever painted', even though he went on to voice one small criticism: 'The goddesses are too nude; but it was impossible to induce the painter to change it, as he maintained that it was indispensable in bringing out the value of the painting.'[47]

The *Judgement of Paris* was another variation on a favourite theme, with Helena Fourment serving on this occasion as the model for Venus. In one of his earliest pictures (Plate 10) he had eventually opted for the moment when Paris, to Juno's chagrin, handed the prize to Venus. Here the fair competitors assume seductive poses as Paris still ponders his decision and Hermes holds up the golden apple. Only the putto crowning Venus with flowers appears to give the game away. In the landscape background the figures of Eros and War foretell the inevitable outcome of Paris's choice. In his later works, Rubens often chose to arrange his figures across the picture surface with little suggestion of spatial depth. Here the participants are extended from one side of the canvas to the other in a manner reminiscent of a classical bas-relief, which enhances a lucid reading of the story. The tonal key to the picture is established by the brilliant white flesh of the goddesses, and one can readily understand Rubens' objection to any reduction in their nudity. Both literally and figuratively their beauty is the point of the picture. The landscape, instead of providing a logical continuation of space, is treated as a backcloth to the drama in the foreground.

Despite the arrival of this and other pictures, there was no satisfying the king's impatience for more, and subsequent communications from the cardinal-infante reveal a constant struggle between the latter's pressure for completion of the king's orders and the artist's increasing infirmity. Without Rubens' often demonstrated ability to look after himself one might well accuse the patrons of hastening his end.

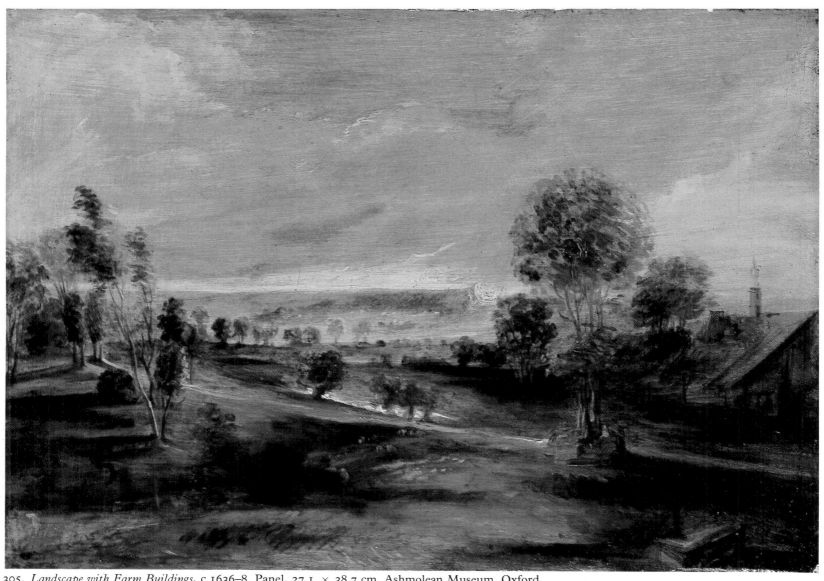

305. *Landscape with Farm Buildings*, c.1636–8. Panel, 27.1 × 38.7 cm. Ashmolean Museum, Oxford.

306. *Landscape with a Shepherd and his Flock*, c.1638. Panel, 49.5 × 83.5 cm. National Gallery, London.

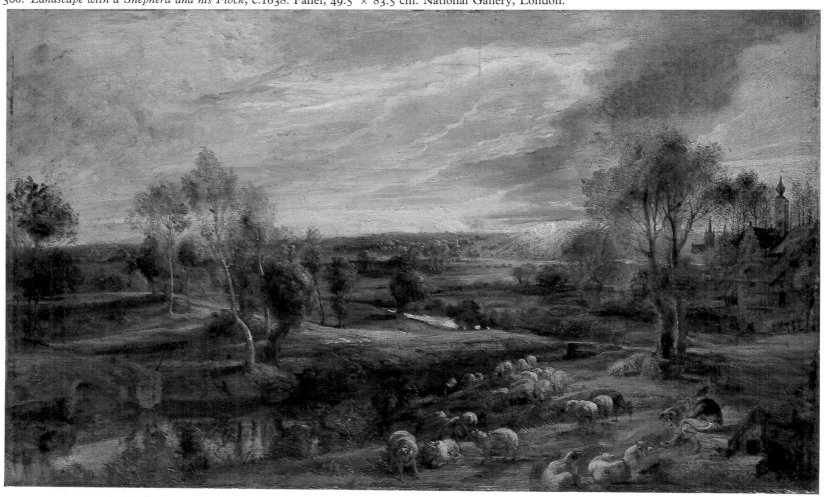

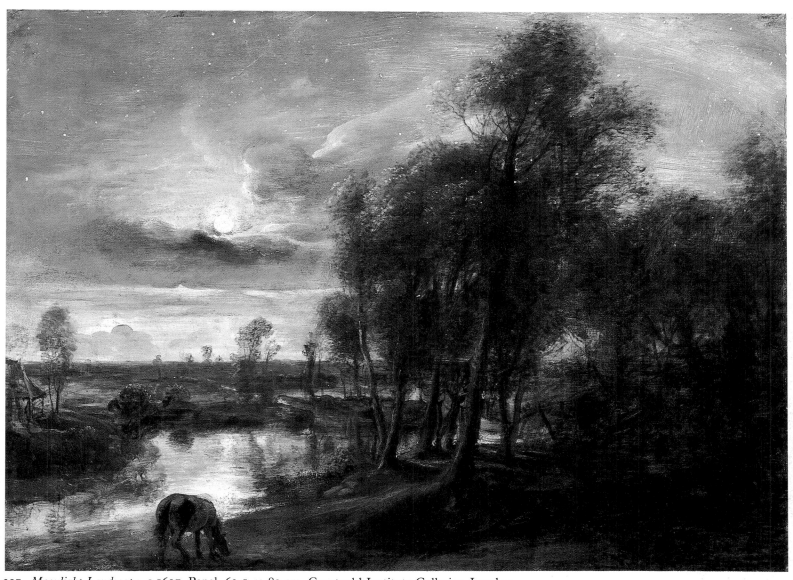

307. *Moonlight Landscape*, c.1637. Panel, 63.5 × 89 cm. Courtauld Institute Galleries, London.

308. *Tournament in front of a Castle*, c.1636–8. Panel, 73 × 108 cm. Musée du Louvre, Paris.

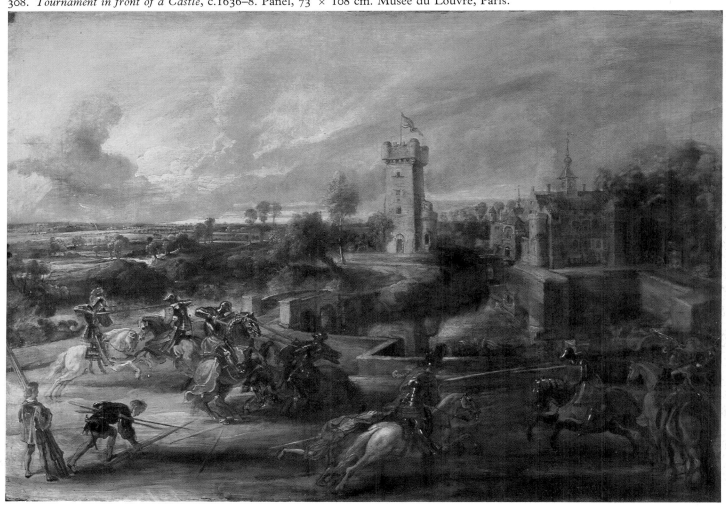

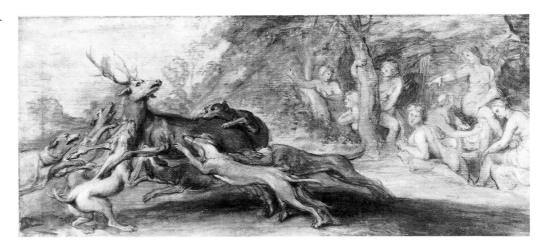

In June 1639 Ferdinand reported that paintings for yet another decorative scheme were begun, this time for a room in the royal palace in Madrid. It was to be another collaborative scheme, with the *modelli* prepared by Rubens and Snyders and the execution of the final canvases carried out with the assistance of other painters. The underlying theme, which recognised the specialist limitations of Snyders, was hunting, although Rubens for his part opted for relevant mythological scenes as well as straightforward representations of the hunt. In the oil-sketch of the *Death of Actaeon* (Plate 309) Rubens, perhaps in deference to the theme of the series, depicts Actaeon entirely transformed into a stag instead of in the usual manner of leaving his body partly human. In a composition unmistakably divided into two parts to enhance the reading of the story, Actaeon, attacked by hounds, looks back piteously at the pointing figure of Diana attended by nymphs in a grove, which creates a viewing enclosure like that for spectators around the bullring. As in the other four or five known sketches for this series, Rubens worked in thin translucent areas of paint over rapidly drawn-in details in black chalk. To adumbrate the subsidiary detail of trees he used an expressive shorthand occasioned by hurry. Yet even in these summary sketches he was splendidly able to convey the entire composition for another artist to follow in the finished canvas.

Although the Spanish court could claim the largest share of the products of the artist's studio, other princely collectors remained no less anxious to obtain Rubens' services. Flemish art was much in vogue in the court at The Hague, and in July 1639 Constantijn Huygens wrote on behalf of the Stadholder, Frederick Henry, to ask whether Rubens would paint as decoration for a chimney 'some picture the invention of which would as usual be your own; he [Frederick Henry] would only ask for three or four figures at most and that the beauty of the women should be realised *con amore, studio e diligenza*'.[48] It may be that a picture mysteriously entitled *Sylvia*, bought from the artist's estate on behalf of the Prince of Orange, was the never-finished result of this request.

Later that year Charles I was occupied with commissioning the decoration of Henrietta Maria's 'Cabinet' in the Queen's House at Greenwich, recently completed by Inigo Jones. Although the commission had been given to Jordaens, Gerbier, agent for the project and resident in Brussels, was anxious to change the king's mind in favour of Rubens: 'they are both Dutchmen and not to seek to represent robustrous boistrous drunken headed imaginary Gods, and of the two most certain Sir Peter Rubens is the gentlest in his representations; his landscapes more rare, and all other circumstances more proper'.[49] Negotiations, made the more complicated by Charles I's wish to keep his name secret from the painters, dragged on between the various parties, with much time given to haggling over the price. Moreover, as Gerbier reminded Inigo Jones, prompt payment was desirable since 'painters' pencils [i.e. brushes] move not without its music'.[50] At one point the former wrote in exasperation to Norgate: 'Rubens is said to smell a

282

rat, and to express disgust; in my Litany I could say, of Painters deliver me.'[51] A compromise was proposed by which Jordaens would paint the walls and Rubens the ceiling, but the latter, 'having considered the trouble, which cannot be avoided in the foreshortenings',[52] wanted twice the sum paid to Jordaens. In the end nothing was decided before Rubens' death, and the commission was eventually carried out by Jordaens, but not before he had been told to make 'the faces of the women as beautiful as may be, the figures gracious and svelte'.[53] Dispersal of the contents of the house at the time of the Commonwealth unfortunately does not allow posterity to judge how far the artist was able to satisfy more refined English taste.

By this time Rubens was only an intermittent visitor to Antwerp. He had already announced the change in his life three years earlier: 'To tell the truth I have been living somewhat in retirement for several months, in my country house which is rather far from the city of Antwerp and off the main roads.'[54] The place of his retreat was the Château de Steen, situated between Malines and Brussels, which he purchased in March 1635, although he apparently did not take possession until November of that year. He was no newcomer to the country. As we have seen he already owned a farm bought from Nicolaas Rockox in 1619 and another after the sale of his collection to the Duke of Buckingham in 1627, but there is no evidence that he lived or spent much time in either. The latter was at the time of its purchase rented out and was clearly bought as an investment, as may have been the case with the first farm. Since neither was mentioned in his will, one must presume that they had been sold before his death, perhaps in order to raise money to meet his requirements of a property not too far from Antwerp which would accommodate him with his expanding family in a style to which wealth and success had accustomed him. A later advertisement for the sixteenth-century property of Steen shows that it was enough to tempt anyone in search of a country retreat: 'A Manorial residence, with a large stone house and other fine buildings in the form of a castle, with garden, orchard, fruit trees and drawbridge, and a large hillock with a high square tower standing on the middle, as well as a lake and a farm with farmhouse, granges, various stables and outbuildings, the whole surrounded by moats.'[55] (Rubens clearly made additions to the house, as his will speaks of new buildings erected since his purchase of the property.) In addition he acquired farmland and woods around the neighbouring villages. With the ownership of a feudal estate, he assumed the title of Lord of Steen, which he held as his favourite honour and which figures prominently on his tombstone. From the beginning the auguries were good for someone so immersed in the past. In 1636 he wrote to Peiresc from the Château de Steen that 'I cannot pass over in silence the fact that in this place are found many ancient medals, mostly of the Antonines, in bronze and silver. And although I am not very superstitious, I confess that it did not seem to me a bad omen to find on the reverse of the first two that came into my possession: *Spes* and *Victoria*. They are medals of Commodus and his father, Marcus Aurelius.'[56]

The house with high-stepped gable ends and dormer windows is a typically Flemish Renaissance building, constructed in red brick with white stone dressings. The front door opened onto a bridge crossing the surrounding moat. At the back there were lakes and a square crenellated tower (Plate 303), none of which exists today. The well-irrigated land was rich and fertile, and the house was encircled by oaks and other large trees. Unfortunately, although the house and grounds remain, later restorations have removed much of its original character. To see it as it was in the artist's day, we have to turn to one major landscape he painted there (Plate 304), even if he gave it quite another aspect from that which greets the literal-minded visitor. Instead of a stretch of unrelieved flat terrain, Rubens imagined his house set in open gently rolling country lit by warm beams of sunlight, the lines of the pollarded willows and ditches leading the eye into distant and extensive views. The barely perceptible town on the horizon is probably Antwerp. Expressing the artist's fundamental humanism, the life of the country

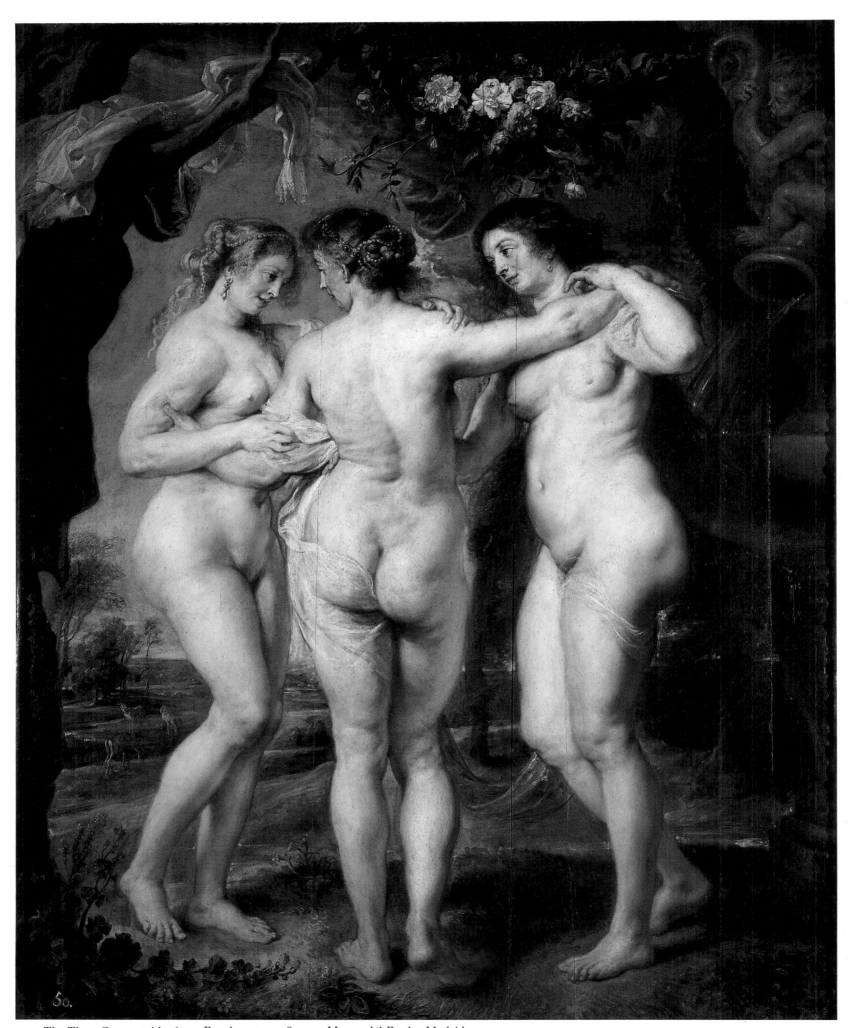

310. *The Three Graces*, mid-1630s. Panel, 221 × 181 cm. Museo del Prado, Madrid.

proceeds on its leisurely course around the house. The sun rising in the east establishes the time of day as early morning. The farmer and his wife set out for market; their cart laden with produce, including a barrel and a calf, is pulled through the stream by two sturdy cart-horses. Behind the cover provided by blackberry bushes and other flowering plants, a huntsmen, with features reminiscent of the artist, and his dog stalk with almost mock solemnity a covey of partridges which, blissfully unaware of their fate, shake their feathers in the morning sunlight. Other birds, magpies and a pair of goldfinches and a sole kingfisher, add to the ornithological life of the land. The entire setting represents a perfect country idyll which must have offered peace and refreshment to the city dweller, especially one devoted to enjoying the happiness of a new domestic life, uninterrupted by involvement in political affairs. Philip Rubens reported to De Piles that his uncle took great pleasure in living there in solitude in order to devote himself to painting the surrounding landscape.

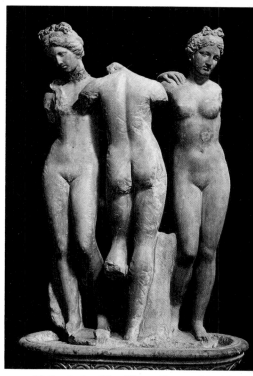

311. Hellenistic, *The Three Graces*. Marble, ht. approx. 90 cm. Cathedral, Siena.

Steen became not just a way of life but a new language of art, as for the first time he consistently studied the countryside in all its variety, mood and season. Previously for him landscapes tended to be occasional exercises, constructed in the studio essentially of recalled details of nature, but now he was able to give wholehearted attention to portraying the *genius loci*, albeit shaped and moulded to express his own artistic purpose. The pulsating vitality which was the driving force of the painter's usual subjects, sacred and profane, is here expressed through the representation of lush farmland. Rubens was trained in the tradition of a landscape divided by colour into fore, middle and background, and he continued to use this basic pattern in his earlier works. But in this picture, starting with a very clearly established foreground full of human interest and natural detail of both fauna and flora, the artist succeeded by his control of dynamic sweeping lines as far as the horizon and far more subtle modulation of colour changes from brown to green to blue in abolishing the conventional middleground altogether. There is nothing of the detached vision of the camera as the spectator is led resolutely through the landscape by the commanding accents of sunlight, waterways and lines of trees all depicted with his forceful brushwork, so that every part of the scene is inspected by the eye. There are no dead corners; all the land is presented for scrutiny and delectation. Real countryside it may essentially be, but carefully built up, as the complex structure of the panel support proves, to achieve an ideally composed view.

In the artist's inventory, the *Château de Steen* can probably be identified as the item preceding the *Landscape with a Rainbow* (Wallace Collection, London), a richly activated image of high summer before the harvest. Since the two works are of the same size and have compositions that balance harmoniously, the latter may well have been developed as a pendant. Both works appear to have been valued by the family, since there is evidence that one was bought by Albert Rubens after the artist's death, while the other may have remained in possession of Helena Fourment at Steen.

Although Rubens' nephew claimed that he painted *au naturel* at Steen, it seems unlikely, judging by existing works, that he ever took up his brush in the open before a motif. Even a drawing of the period, the *Landscape with Wattle Fence* (Plate 312), which depicts a slice of nature rather than the individual details studied in his earlier drawings, has a composure which may represent a spontaneous shaping of the scene before him, but could equally well be a recollection afterwards. Unlike earlier drawings (Plate 144), in which outline was emphasised sometimes with the addition of pen and ink, this sheet executed in black chalk, with a little red, beautifully conveys the softening effect of light playing over the forms of the landscape. The positive features of fence and thicket in the foreground and row of willows beyond assume a less dominant role in relation to the open space of the empty fields. This atmospheric blending of the scenery is even more apparent in the drawing of *Reflection of Trees in Water* (Plate 169), done about the same time. During these years Rubens grew into a true

312. *Landscape with Wattle Fence*, c.1635–8. Black chalk with touches of red chalk, 35.3 × 51.4 cm. British Museum, London.

landscape artist, aware of the entirety of nature, an attitude of mind even more developed in his paintings.

About this time Rubens painted several small oil-sketches which reveal a similar preoccupation with the balance of form with strong light effects. The *Landscape with Farm Buildings* (Plate 305), which comes nearest to what one would expect of a work painted *sur le motif*, portrays a typical stretch of countryside in the vicinity of Steen, seen probably at sunset rather than sunrise, which, as Philip Rubens observed, were 'with their horizons'[57] the artist's favourite times of day. But, although this small panel is concerned with the slanting rays and long shadows of sunset, it is also about the shaping of the landscape. In other words, it is as much a compositional sketch as a study in optical effects. Whether originally intended or not, it adumbrates even down to the detail of seated shepherd and sheep the larger, more finished panel of this subject (Plate 306), which as usual was developed in stages by adding further pieces to the original panel support. Although he extended the view to the left, Rubens retained the basic composition of the sketch, which is now echoed in the pattern of the cumulus clouds above. Within this framework he introduced much more detail and a greater range of colour, so that, although painted in the smaller format favoured by him at Steen, it surely represents a finished work. The picture, skilfully composed by accents of raking light, long shadows and stretches of water, explores such natural phenomena as the setting sun on the horizon and the reflections of trees in water in the foreground, recalling his drawing on the same theme (Plate 169). Both the scenery and the time of day produce an elegiac mood, enhanced by those bucolic inhabitants of shepherd and flock, who recall the Venetian landscapes of Giorgione and Titian. But in its remarkable understanding of nature itself, the picture looks unmistakably forward to the future.

About this time Rubens, recalling his early admiration for Elsheimer, produced a *Moonlight Landscape* (Plate 307), which before he painted out the various unidentifiable figures beneath the tree in the centre and on the right must have been even closer to his German model or such early exercises by Rubens in his manner as the *Flight into Egypt* (Plate 142). It offers a most poetic rendering of a gleaming night landscape, devoid of inhabitants apart from a horse grazing by the riverside. The full moon emerging from a bank of cloud floods the solitary scene with an amazing range of observed light and colour – silver, blue, pink, red and green – and achieves in nocturnal terms very similar effects to the sunrise and sunset landscapes. On the left the extent of the distant fields can be made out while on the other side the clump of trees is reduced to a silhouette whose mass is broken only by some of the stars which fill the sky with further radiance. For once Rubens must have concluded that humanity disturbed the mood of nature so precisely observed.

Quite the contrary was the case with the *Tournament in front of a Castle* (Plate 308) in which Rubens could indulge his nostalgia for the past and its imaginary relationship with the new world of Steen in which he was now living. Using a seemingly accurate topographical oil-sketch of the tower at Steen and its surroundings (Plate 303) as the basis of the left-hand background, Rubens developed a large composition in which knights in shining armour accompanied by their heralds furiously joust on open ground at sunset; behind them are a wide moat and the castle itself. The latter, a large Renaissance building with turrets and a dominant lantern, can only be an imaginary and aggrandized version of the castle at Steen itself. His pleasure in such make-believe, which he kept for his own collection, can perhaps be viewed in the same light as his delight over the discovery of Roman coins in the vicinity, recollections of ages when chivalry and wisdom were not dead, and to which he as Lord of Steen was now spiritual heir.

One major factor in Rubens' enjoyment of the last decade of his life can be deduced from the contents of his studio at his death. Some of the pictures are the kind of works one would expect: unfinished commissions, such as the *Crucifixion*

of St Peter (Plate 297), and portraits of famous people kept as patterns for repetition when required. But even in the latter category several were probably retained for more personal reasons as images of friends or of people he admired. Besides these there were no fewer than seventeen landscapes, a number of which, apart from the *Landscape with Philemon and Baucis* (Plate 242) and the *Prodigal Son* (Plate 138), can be identified with those painted at Steen. He also left behind some of his most beautiful late subject pictures, often treating the subject of the female nude, and of the calibre of the *Andromeda* (Berlin), *St Cecilia* (Berlin), *Bathsheba* (Dresden) and the *Three Graces* (Plate 310), all of which were painted entirely by his own hand but with no known destination in mind. Despite his well-ordered, almost calculating attitude towards painting where his patrons were concerned, he seems to have made a clear distinction between time devoted to fulfilling his commissions and to painting other pictures which we assume were undertaken solely for his personal pleasure. Given his hectic timetable the latter occupation could only delay the completion of the former, however much such patrons as the cardinal-infante might fulminate with impatience. Moreover, he must have been aware that, having pleased himself, his many admirers would be only too ready to buy these 'private' pictures, as they proved immediately the works became available after his death. Thus it is fair to conclude that from the beginning the artist intended to reserve them for his own personal pleasure, along with the portraits of his family. (Much earlier in his career Rubens had spoken of 'pictures which I have kept for my own enjoyment'.)[58] Since such writers as Sandrart and Bellori say that he hung his own pictures with other works of art on the walls of his house, we can assume that these special works were not hidden away from daily view and were probably to be considered as part of his museum. De Piles is specific in stating that the empty spaces on his walls occasioned by the sale of much of his collection to the Duke of Buckingham were filled with his own works.

Both the works themselves and their subsequent circumstances make it abundantly clear that the act of painting and the results were a source of unquenchable satisfaction to Rubens. Painting without commission, and by extension for oneself, became prevalent in certain parts of Europe, notably Holland, in the seventeenth century, but at the time Rubens was doing so the practice would seem to have been rare. For an artist so steeped in sixteenth-century tradition, he would have found it fitting that Michelangelo's *Rondanini Pietà* and Benvenuto Cellini's *Crucifix*, both works of the artists' later years, were, according to the testimony of Vasari and the sculptor respectively, created entirely 'for pleasure'.[59]

The *Three Graces* (Plate 310), listed in the posthumous studio inventory, was one of the pictures bought by Philip IV. It was a theme that occurred quite often in Rubens' work either on its own or as part of another subject such as the *Education of Maria de' Medici*, the *Glorification of the Duke of Buckingham* and, in stone, in the background of the *Garden of Love* (Plate 291). And in the *Horrors of War* (Plate 255) the drawing which Mars treads underfoot represents the 'Three Graces' as symbols of 'things of beauty'. Here they are composed in a group that recalls the famous Hellenistic sculpture (Plate 311) found in Rome in the fifteenth century and familiar to Rubens. (He may also have seen Raphael's more literal interpretation of the same theme, then in the Borghese collection.) But the stone figures of his prototype have become living flesh, disguising, as the artist himself recommended, their sculptural ancestry. Instead of the total self-absorption of each of the Hellenistic figures, Rubens' Graces, whose recently discarded clothes hang over the branch of the tree, look at and, with their arms entwined, touch one another, in an expression of mutual love. This sense of intimate communication is enhanced by the flowing movement of bodies and limbs which indissolubly links the three figures, depicted before a glowing blue sky and warm Titianesque landscape, with a garland of roses and scarlet drapery providing an arch at the top. In this picture Rubens has painted some of his most beautiful and personal

313. (following pages left) *Helena Fourment with Two of her Children*, c.1636. Panel, 113 × 82 cm. Musée du Louvre, Paris.

314. (following pages right) *Helena Fourment with her eldest Son, Frans*, c.1634. Panel, 165 × 116 cm. Alte Pinakothek, Munich.

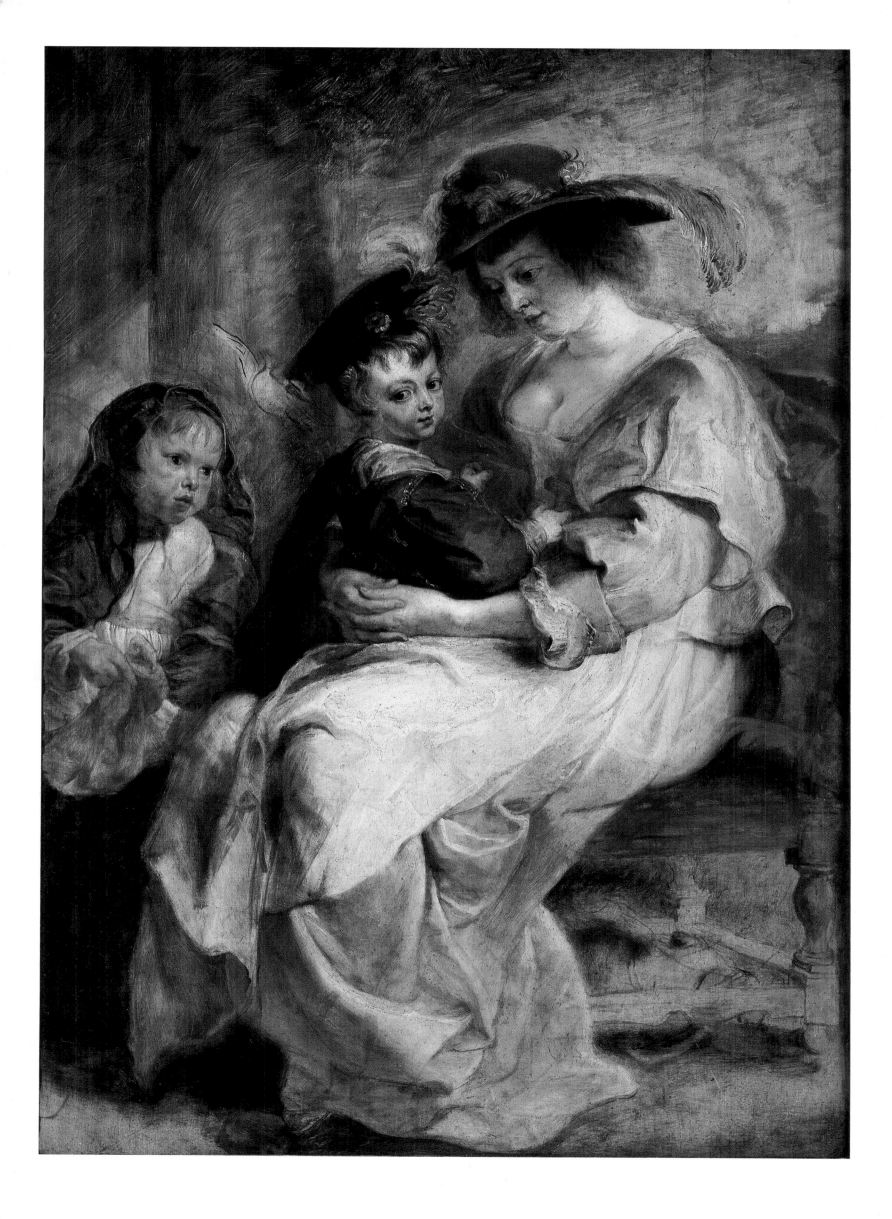

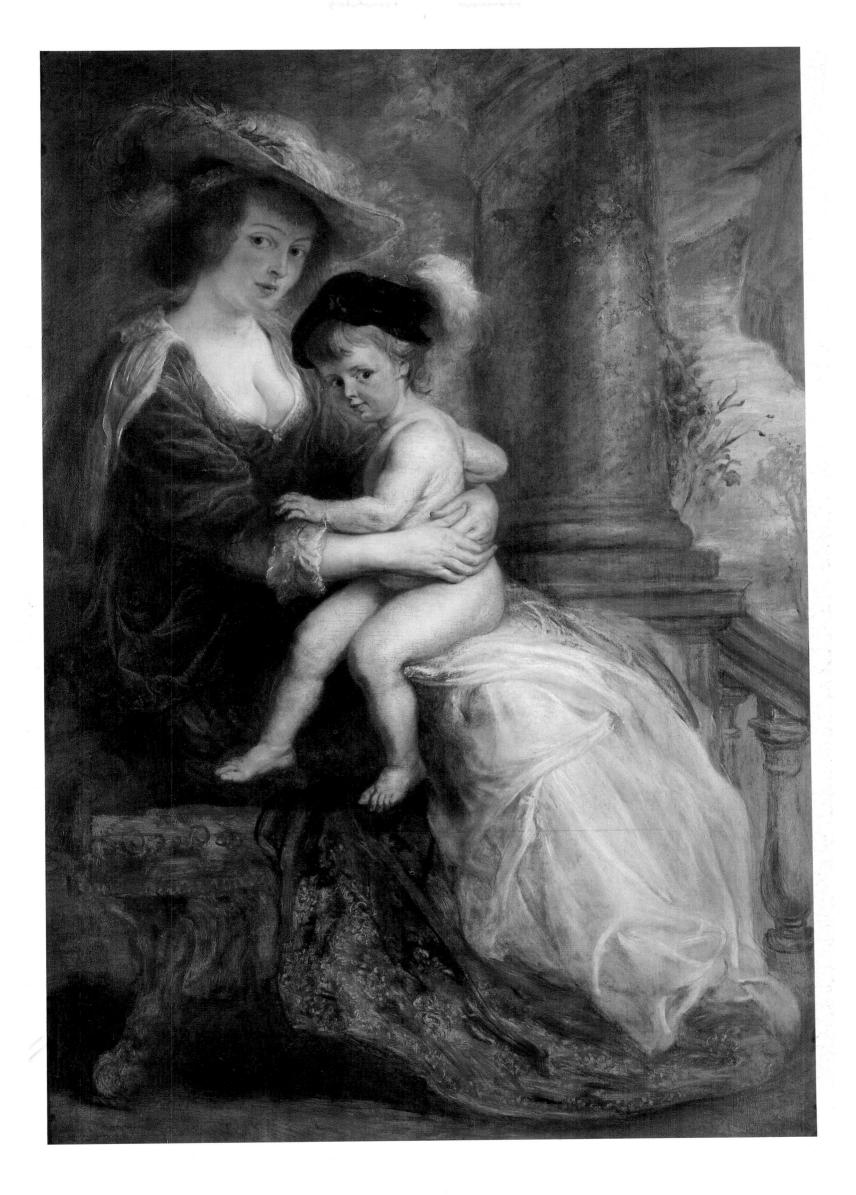

portrayals of the female nude, for which Helena Fourment may well have provided the general inspiration. (The face of the left-hand figure resembles hers.) It is easy to believe that such an inspired and spontaneously executed masterpiece was painted for its creator's own pleasure.

Even though Rubens lived on a grand scale with a town and a country house, attended by three servants, a valet, a colour-grinder, two grooms and three horses, the course of his life was simple and regular. No doubt the calm and detachment from the *va-et-vient* of everyday life, which he had always sought, was increased during his last years when his health gave him a further reason for spiritual isolation. Apart from his work, the company of a few close friends engaged in discussion of serious topics combined with the study of his gems provided all the recreation he needed. Reading was still clearly a source of pleasure and enlightenment, and despite his extensive library he still continued to purchase books regularly from Balthasar Moretus at the Plantin Press. His taste in reading matter became historical, and histories of the German peoples, imperial Rome, Byzantium, Persia and so on were added to his shelves. He had created his own personal world around him, and he wished nothing to break the even tenor of his daily existence. To date he had offered his life up to the outside world, but now the time had come to sacrifice his privacy and rich inner life no longer. He provided his own interests and his own momentum, and anything beyond that orbit was merely a tiresome distraction.

To share his enjoyment Rubens had the companionship of his wife and his increasing family. To add to the children he had by Isabella, Helena Fourment gave birth to five: Clara Joanna in 1632, Frans a year later, Isabella Helena in 1635, Peter Paul in 1637, and finally Constantina Albertina, who was born eight months after her father's death. Like his rural surroundings, their frequent appearance in his work gives us visible evidence of his affection and happiness. In an unfinished painting (Plate 313) executed during the spring or summer of 1636, Helena Fourment is seated on a stool, with the family dog curled up in sleep below, lovingly clasping her son Frans, who looks out with the satisfied air of one who is fully aware of his favoured position as her first-born male, his pet bird hovering at his shoulder. Rather wistfully, Clara Joanna, perhaps with birdseed in her apron, stands beside them, unable to attract any of the mother's devoted gaze, while the year-old Isabella Helena is represented in the panel only by a pair of hands. Her eventual appearance in the picture, however, is known to us from a beautiful chalk study (Plate 315) which portrays the plump baby with hands outstretched and supported on her feet by reins probably held by a nurse. The underdrawing in chalk is clearly visible beneath the loosely applied brushstrokes on the panel, which may well have been cut down at a later date to the size of the relatively finished parts of the group.

The introspective gaze of the young mother is in distinct contrast to the more worldly look of the lady, once again wearing a wide-brimmed hat adorned with an ostrich feather, who looks out directly at the spectator in another family portrait (Plate 314), also unfinished in parts but possibly executed a year or two earlier. On this occasion she is seen alone with her son Frans, who sits naked, apart from his elegant cap with a feather, on his mother's lap. This fashionably presented pair has the appearance of a fancy-dress Virgin and Child.

Although a background column is common to both pictures, it plays a more dominant role in the earlier work, skilfully creating the grand aura of a terrace leading down steps to a garden. Nature surreptitiously encroaches as a branch grows up around the column. A different variation of rich colour within a restricted palette is used in both panels. Although we do not know the final appearance of Helena's dress in the more unfinished work, it was clearly light in tone to be set off by the scarlet cloak arranged loosely around the back of the chair. In the other panel her dark olive-green velvet dress is combined with the pink felt hat which casts warm reflections over her face. In both works Rubens plays with a juxtaposition of two shades of pink or red, in the hat and drapery around the

315. *Isabella Helena Fourment*, c.1636. Black and red chalk, heightened with white, 39.8 × 28.7 cm. Musée du Louvre, Paris.

column in one, and in the cloak and chair cover in the other. Once again the memory of Titian has not been dimmed.

Although never much given to the practice of self-portraiture, the proud and devoted possessor of such a family consciously did not neglect to leave one magnificent image of himself (Plate 318). It is not a study of the family man or the artist, but an imposing statement of his position as knight and gentleman to be handed down to posterity. He presents himself standing beside a column in an aristocratic pose which would have served for a state portrait at any of the European courts of the time. About fifteen years had passed since his last formal self-portrait (Plate 214), painted on command from Charles I, when Prince of Wales, and the experience of the intervening years is clearly revealed in the change from the lithe, deeply serious face of the earlier work to the ageing appearance in this last example of the genre. It reflects the esteem in which he was held by the world around him. The artistic superiority of the South over the North had at last been challenged and Rubens could justifiably claim to have attained the social status that had been accorded to such great artists of the past as Raphael and Michelangelo. Princes and rulers throughout Europe pleaded for paintings. The Cardinal-Infante Ferdinand, following the example of his predecessors, had made him his court painter in 1636. Charles I, in addition to previous honours, presented him with a gold chain and a medal in 1638. Their acceptance and admiration was a pleasing reward, which he had no intention of forgetting, but one senses that it was no longer an essential ingredient of his daily life. The poignancy of the careworn face, studied in a moment of melancholy introspection, is cleverly masked by the panache of the wide-brimmed hat set at an angle and full cloak, combined with the knightly gesture of one hand resting on his sword-hilt and the other dangling his glove. Painfully reminded by his frequent attacks of gout, he must have been keenly aware that not much longer was left to him. As he sorted out his affairs so he must have decided to leave behind this monumental but human remembrance. With its low viewpoint and sombre colour scheme of black and white, grey and brown, it is a portrait which leaves the spectator in a mood of reverential awe for the dignity of the man.

In his preparatory study (Plate 316), Rubens had made greater play between the head and the voluminous folds of the cloak but had eventually settled for a greater emphasis on the silhouette of the latter. The head, with the quizzical look of someone in the act of self-study, is a vivid likeness, but an even more revealing psychological study (Plate 317) occurs on a sheet of various studies later cut down. The self-portrait head is loosely sketched in black and white chalks, and contains numerous corrections particularly to the eyes. The introspection induced by age and infirmity is movingly apparent in this haunting image and it presents a darker side to the artist's last years.

As if to complement the images of the man offered by the self-portrait painting and drawings, fate has allowed that only now, in the autumn of his life, are we able to gain an insight into the more intimate aspect of his character. In several personal letters to his favourite pupil and assistant, Lucas Fayd'herbe, who had been with him for at least three years, the warmth of his personality breaks through his usual reserve. 'My dear and beloved Lucas', he wrote from Steen to the young sculptor left in charge of the studio in Antwerp,

> I have urgent need of a panel on which there are three heads in life-size, painted by my own hand, namely: one of a furious soldier with a black cap on his head, one of a man crying, and one laughing. You will do me a great favour by sending this panel to me at once, or, if you are ready to come yourself, by bringing it with you . . . We think it strange that we hear nothing about the bottles of Ay wine; that we brought with us is all gone.

He signed himself, 'with all my heart, dear Lucas, your devoted friend', and then added in a postscript:

> Take good care when you leave that everything is well locked up and that no

316. *Self-portrait*, late 1630s. Black chalk, heightened with white, 46.1 × 28.7 cm. Musée du Louvre, Paris.

317. *Self-portrait*, late 1630s. Black chalk, heightened with white, fragments of sketches in pen and ink, 20 × 16 cm. Royal Library, Windsor Castle.

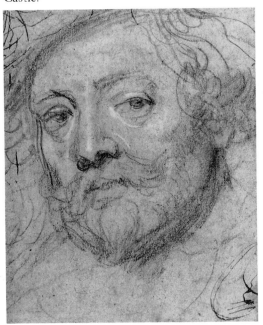

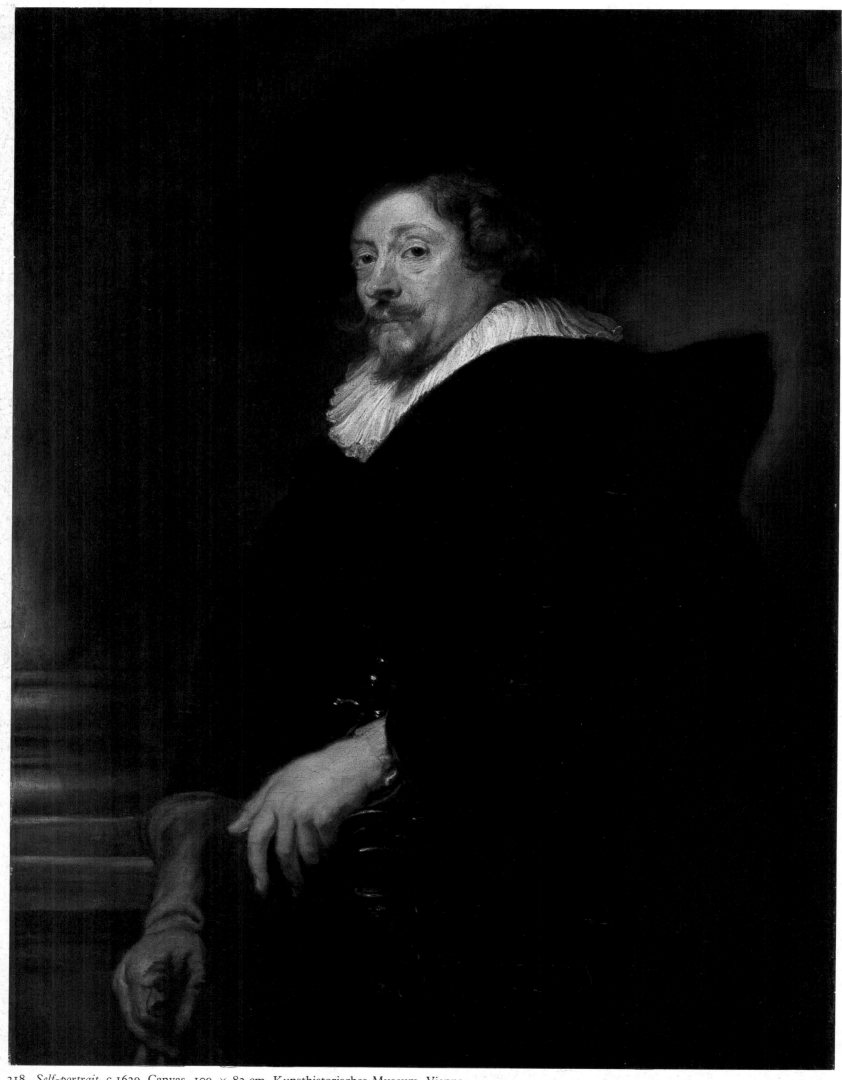

318. *Self-portrait*, c.1639. Canvas, 109 × 83 cm. Kunsthistorisches Museum, Vienna.

319. (facing page) Detail of Plate 320.

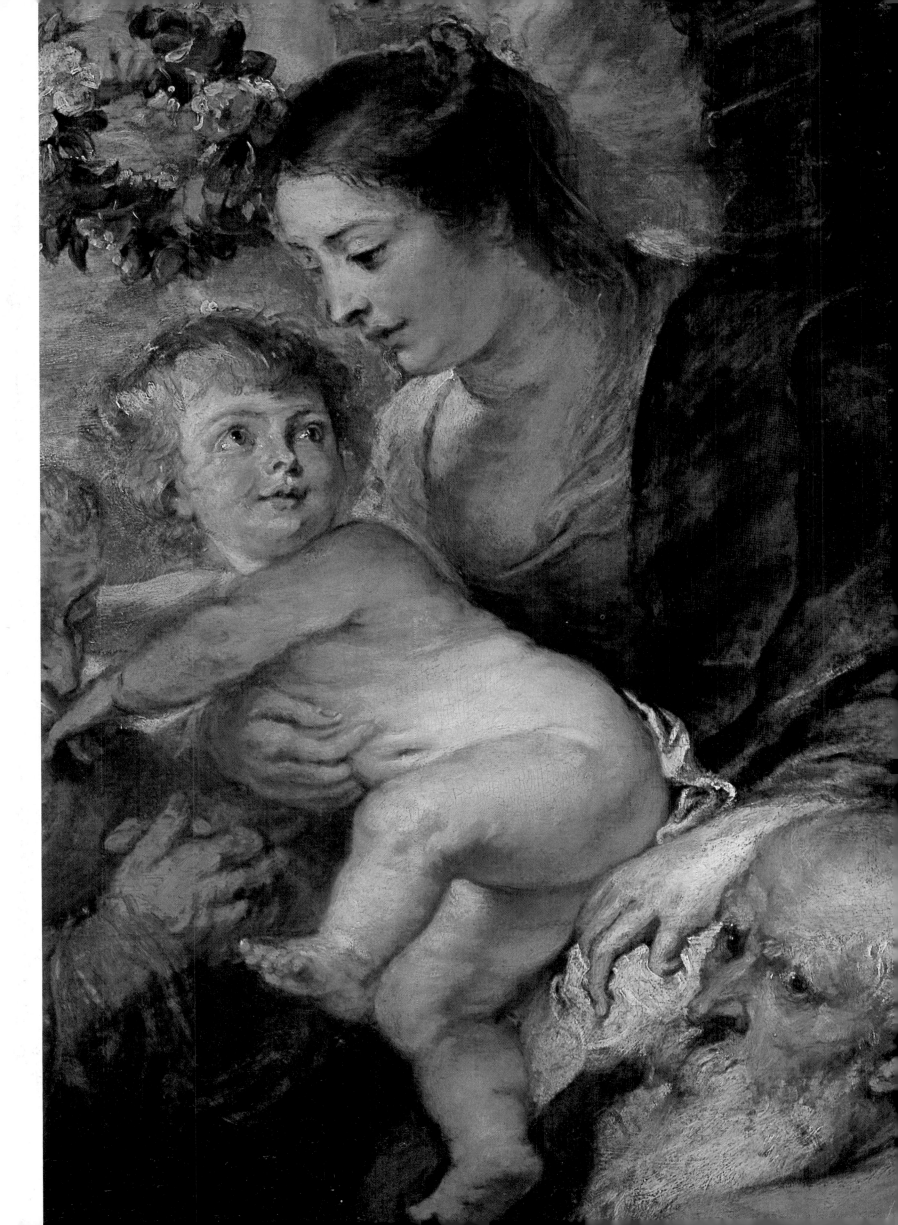

originals remain upstairs in the studio, or any of the sketches. Also remind William the gardener that he is to send us some Rosile pears as soon as they are ripe, and figs when there are some, or any other delicacy from the garden. Come here as soon as you can, so the house may be closed; for as long as you are there, you cannot close it to the others. I hope that you have taken good care of the gold chain [probably that given to him by Charles I], following my orders, so that, God willing, we shall find it again.[60]

320. *Madonna and Child with Saints*, late 1630s. Panel, 211 × 195 cm. St Jacques, Antwerp.

Perhaps compensating for the lack of artistic interest in either Albert or Nicolaas, the relationship with Lucas was more that of a father and son than master and pupil. Their association marks the nearest Rubens ever came to assuming the role of teacher. When the young man was engaged to be married, Rubens wrote him a highly commendatory testimonial in which he concluded, 'I do not think there is a single sculptor in all the land who could do better'. Revealing of the master's own attitude and practice is the statement that 'through the relationship that exists between our arts of painting and sculpture, he has been able, by my instruction and his own diligence and good disposition, to make great progress in his art. I declare that he has done for me various works in ivory, very praiseworthy and well executed, as the pieces prove.'[61] The testimonial was accompanied by a letter sending the master's affectionate wishes: 'I pray also that God will grant you, as well as your beloved, every sort of blessing. I beg you to kiss the hands of your dear one on my behalf and on that of my wife; we shall always be ready at her service and for your advancement.'[62] A few weeks later he wrote: 'I have heard with great pleasure that on May Day you planted the may in your beloved's garden; I hope that it will flourish and bring forth fruit in due season. My wife and I, with both my sons, sincerely wish you and your beloved every happiness and complete, long lasting contentment in marriage. There is no hurry about the little ivory child; you now have other child-work of greater importance on hand. But your visit will always be very welcome to us.'[63] This letter, his very last, was written only three weeks before his death, and its unparalleled warmth and generosity belie the intense pain he was probably suffering. His own life was ebbing away, and the future, as he recognised, lay with the younger generation.

Gout had first attacked him long ago when on a diplomatic journey in 1627. In vain he hoped to leave it behind at the French border, but a year later he was afflicted by it again, this time in Madrid: 'these last few days I have been very sick with gout and fever, and to tell the truth, I could hardly draw a breath between groans and sighs'.[64] He was cured by a Sicilian doctor, Fabrizio Valguarnera, whose name and address had been written by Van Dyck on the fly-leaf of his 'Italian sketchbook' and who was later to be involved in shady art-dealing. But now 'familiarity with this domestic enemy and its wiles'[65] became increasingly frequent, so that, instead of merely temporarily impairing the use of his hands, it now completely crippled him. He spent part of the summer of 1639 at Steen, where he suffered another attack and had to summon doctors from Malines. The numerous bulletins sent by Ferdinand to Philip IV took on an increasingly pessimistic note. Only a few weeks before Rubens' death Ferdinand announced that he was completely paralysed in his hands and would never be able to wield a paintbrush again. Shortly afterwards Balthasar Gerbier gave the same verdict to Charles I. Such was their opinion of Rubens that the royal courts wished to be kept fully informed of his progress. A temporary recovery allowed him to write or dictate one or two letters, including the one quoted above, though he must have realised that death was near. On 27 May he summoned a notary and made a new will. Four days after he had signed it, Gerbier wrote to William Murray that 'Sir Peter Rubens is deadly sick; the physicians of this town being sent to him try their best skill on him'.[66] On the same day Gerbier added a postscript to a letter to Charles I: 'Since I finished this letter news is come of Sir Peter Rubens' death.'[67] As he explained in a letter to Inigo Jones a few days later, Rubens' death was caused by 'a defraction which fell on his heart, after some days' indisposition of

ague and gout'.[68] With more sentiment, the Abbé de St Germain wrote that 'he has departed from us to go and see the original of many beautiful pictures he has left behind'.[69]

The same evening Rubens' body was laid out in the coffin and placed in the Fourment family vault in his parish church, St Jacques. The funeral service was celebrated three days later 'with sixty tapers, crosses of red satin and the music of the church of Our Lady'.[70] The procession was headed by the clergy of St Jacques and several orders of poor to whom he had given charity; sixty orphan boys flanked the bier, which was followed by the chief officers of the city, noblemen, merchants and members of the Academy of Painting, in other words *le tout Anvers*. Following the custom of the time, several banquets were given; apart from the private one at home at which his favourite Ay wine was served, the city commemorated the life of the deceased at the town hall, the Romanists at the Golden Flower inn and the Confraternities of St Luke and the Gilliflower at the Stag inn. During the next six weeks some eight hundred masses were celebrated in Antwerp for the repose of his soul. In the little parish church of Elewijt, near Steen, they said twenty-four masses. Due honour was paid to the most illustrious citizen of Antwerp. The painter's coffin was temporarily left in the Fourment family vault, while a more imposing memorial was erected.

A few days before he died Rubens was asked whether he would agree to a memorial chapel erected in his honour. 'With his innate modesty', he replied 'that if his widow, his grown son, and the guardians of his children who were not yet of age considered that he had deserved such a monument, they could have the said chapel built without further authorisation on his part, and that they could use for this a picture of the Holy Virgin'.[71] In the following year permission was given to build a funeral chapel behind the choir of St Jacques (Plate 321) and not long afterwards the chapel was installed as the dying artist had wished. One of his last pictures, the *Madona and Child with Saints* (Plate 320), was placed over the altar, and above that a marble statue of the Virgin (Plate 322) carved by his 'dear and beloved Lucas'. Four new windows were engraved with the arms of the deceased. An epitaph composed by his friend Jan Caspar Gevaerts was inscribed on a stone laid in the floor of the chapel. It was dedicated to 'Peter Paul Rubens, knight . . . Lord of Steen, who, among the other gifts by which he marvellously excelled in the knowledge of ancient history and all other useful and elegant arts, deserved also to be called the Apelles, not only of his own age but of all time, and made himself a pathway to the friendship of kings and princes . . .'[72] Although expressing admiration and affection suitable for the occasion, Gevaerts' words do not depart from the basic truth, and they represent a eulogy which could have been pronounced over no other painter of the century.

The picture over the altar, following the tradition of the Italian *Sacra conversazione*, represents the Virgin and Child seated on a throne receiving an unidentified saint or cardinal, who is supported by a closely knit group of St Mary Magdalen and two other female saints, with the figure of St George triumphantly bringing up the rear; in the foreground, accompanied by an angel, St Jerome is seen from the back kneeling, while above, further angels crown the Christ-Child with a wreath of roses. In his rendering of Christ looking back lovingly over his shoulder at the Virgin, Rubens has painted one of his most intimate and lyrical representations of the relationship between mother and son, which he had studied so often in his life. It remains a mystery whether this particular configuration of saints, who have no relevance for Rubens or his family, was carried out with a destination in mind or whether it was one of those works we assume that the artist painted during his later years for his own pleasure. It was certainly painted *con amore*, and every brush-stroke reveals the master at his most masterly. Seen in the morning light the picture, with its brilliant gold on St George's skirt, its warm blue of the Virgin's dress and distant sky and its range of reds spread over the canvas, refulgently glows against the black marble altar frame, supported by reddish-brown columns made of raunce, and decorated by white marble figures

321. Rubens' funerary chapel in St Jacques, Antwerp.

322. Lucas Fayd'herbe, *The Virgin*. Marble. St Jacques, Antwerp.

and festoons of flowers above. As an ensemble the chapel offers a perfect mixture of richness and austerity which characterised the artist himself. One is tempted to think that he painted the picture with his own memorial in mind.

Gerbier announced Rubens' death as laconically as a proclamation of the royal herald. 'Sir Peter Rubens is deceased three days past, so that Jordaens remains the prime painter here.'[73] (Jordaens immediately put up his prices and Van Dyck was shortly to rush back to Flanders to seize the crown, only to follow Rubens to the grave the very next year.) But the direction of Gerbier's thoughts soon became transparently plain. Already in a postscript announcing the news of the painter's death to Charles I, he had promptly followed with the comment that 'many fine things will be sold in his auction',[74] and in letters dispatched two days later to the Earl of Arundel, William Murray and Inigo Jones the main purpose of writing was the same. To Jones, a fellow-artist, Gerbier was a little more humanly expansive: 'he is much regretted and commended, has left a rich widow and rich children'.[75] But to the earl he was business-like and to the point: 'all his rarities of Pictures, Statues, Agates, Ivory cut works, and Drawings will be sold out of hand. If his Majesty or your Lordship would have any of his said rarities bought, bills of credit would be necessary to make good the payment; since without money nothing can be made sure.'[76] Ferdinand in breaking the news to his brother was equally laconic and far more concerned about what should be done over the question of the unfinished pictures on which the artist had been working for Philip IV. Soon, however, his thoughts also turned to the disposal of the artist's collections, although he appears to have been more interested in Rubens' own paintings. He reassured the king that there was no hurry and that 'it is intended to print the list and circulate it throughout Europe'.[77]

Rubens' will was detailed and specific. His bequests were not limited to his family, but included people from all stations of life, even down to the gift of a copy after his painting of a *Nymph and Satyr carrying a Basket of Fruit*, to 'Peter outrider of the Clarenstraat', for his help in buying a horse. To Helena Fourment, Rubens left the customary half share, as well as his portrait of her in a fur cloak. She took the opportunity to buy nine others from the estate, mainly family portraits but also a *Conversation à la mode*. To her and all his children, who were specifically granted equal rights, he left all the family portraits of both marriages. To his eldest son, Albert, who showed promise of becoming a scholar, he left his books and to both him and his brother Nicolaas his agates and medals, except the vases of agate, jasper and other precious stones. The Château de Steen was divided equally between the widow and her two stepsons. He stipulated that the pictures, statues and other works of art should, on the advice of Snyders, Wildens and another painter, Jacques Moermans, be sold either at auction or privately. An inventory was drawn up the following month and consisted of 314 specified items, plus various other items such as copies after Rubens' drawings, ivories carved after his designs and antique busts. Thirty-two pictures, fourteen by Rubens and eighteen by other artists, were sold directly to Philip IV, and others were disposed of to the family or various purchasers. The remainder of the collection was put up for auction in a series of sales the following year. But, despite the testator's careful instructions, litigation between Helena Fourment and her stepsons took place during the following years over the division of the estate.

Yet when it came to disposing of the vast collection of his own drawings, which contained the wisdom and experience of a lifetime, the true artist in him ordained that they should not be sold until the youngest of his children was eighteen, and only then if none of his sons had become a painter and none of his daughters had married one (Frans Pourbus the Elder had made a similar arrangement). But such is the chance of heredity that Rubens, a painter through and through, was unable to produce a glimmering of artistic inspiration among any of his eight children. And so, with the eventual disposal of his drawings in 1657, when his youngest daughter was enclosed in a nunnery, the remaining works of Peter Paul Rubens became hostages to fortune.

Notes to the Text

ABBREVIATIONS

CDR M. Rooses and C. Ruelens, *Correspondance de Rubens et documents epistolaires concernant sa vie et ses oeuvres*, 6 vols. (Antwerp, 1887–1909)

CRLB *Corpus Rubenianum Ludwig Burchard* (Brussels and London, 1968–)

Judson and Van de Velde J. R. Judson and C. van de Velde, *Book Illustrations and Title-Pages*, CRLB, Part XXI, 2 vols. (1978)

Letters R. S. Magurn, *The Letters of Peter Paul Rubens* (Cambridge, Mass., 1955)

Original Papers W. N. Sainsbury, *Original Unpublished Papers illustrative of the Life of Sir Peter Paul Rubens* (1859)

Rooses, *Oeuvre* M. Rooses, *L'Oeuvre de Rubens*, 5 vols. (Antwerp, 1886–92)

Vita L. R. Lind, 'The Latin Life of Peter Paul Rubens by his Nephew Philip: A Translation', *Art Quarterly*, IX (Detroit, 1946), pp. 37–43

NOTES TO CHAPTER I

1. R. Bakhuizen van den Brink, *Het Huwelijk van Willem van Orange met Anna van Saxen* (Amsterdam, 1853), p. 163; quoted by M. Rooses, *Rubens* (Philadelphia and London, 1904), pp. 9–10
2. *Letters*, p. 406; to George Geldrop, 25 July 1637
3. *CDR*, I, p. 1; 3 November 1600
4. *Letters*, p. 293; 29 December 1628
5. *Hyperbolimaeus* (Mainz, 1607), p.110; quoted in *CDR*, II, p. 4
6. *Vita*, p. 37
7. J. van den Gheyn, *Album Amicorum de Otto Vaenius* (Brussels, 1911), p. 47; quoted by F. Baudouin, *Rubens* (New York, 1977), p. 48.
8. *Conversations sur la connaissance de la peinture* (Paris, 1677), p. 185
9. P. Genard, *Rubens* (Antwerp, 1877), p. 373
10. *Rubens Bulletijn*, II (Antwerp and Brussels, 1883), p. 166
11. F. van den Branden, *Geschiedenis der Antwerpse Schilderschool* (Antwerp, 1883), p. 409

NOTES TO CHAPTER II

1. *Vita*, p. 38
2. Ibid., p. 38
3. *Original Papers*, p. 330; Daniel Nys to the Earl of Carlisle, 9 February 1629
4. *Letters*, p. 269; to Pierre Dupuy, 15 June 1628
5. Ibid., p. 367; to Peiresc, August 1630
6. Ibid., p. 53; to Faber, 10 April 1609

7. Bellori, *Le vite de' pittori, scultori et architetti moderni*, I (Rome, 1672), p. 247
8. *Inleyding tot de Hooge Schoole der Schilder-Konst* (Rotterdam, 1678), p. 193
9. *Dissertation sur les ouvrages des plus fameux peintres* (Paris, 1681), p. 35
10. *Abregé de la vie des peintres* (Paris, 1699), English trans. (1750?), p. 252
11. *CDR*, I, p. 43; 25 January 1602
12. P. M. Felini, *Trattato nuovo . . .* (Rome, 1610), p. 25; quoted by H. Vlieghe, *Saints, CRLB, Part VIII*, II, p. 61
13. *CDR*, I, p. 38; 13 December 1601
14. *Letters*, p. 33; to Chieppio, 24 May 1603
15. Ibid., p. 27; to Chieppo, 29 March 1603
16. Ibid., p. 31; to Chieppio, 17 May 1603
17. Ibid., p. 30; to the Duke of Mantua, 17 May 1603
18. Ibid., p. 32; to Chieppio, 24 May 1603
19. Ibid., pp. 32–3; to Chieppio, 24 May 1603
20. *CDR*, I, p. 80; 5 March 1603
21. *Letters*, p. 36; to Chieppio, 15 September 1603
22. Ibid., p. 149; to Jacques Dupuy, 22 October 1626
23. Ibid., p. 33; to Chieppio, 24 May 1603
24. Ibid., p. 36; to Chieppio, 17 July 1603
25. *CDR*, I, p. 81; to Iberti, 5 March 1603
26. *Letters*, p. 37; to Chieppio, 15 September 1603
27. *CDR*, I, p. 159; to the Duke of Mantua, 6 July 1603
28. Ibid., I, p. 213; 19 October 1603
29. Ibid., I, p. 222; Iberti to the Duke of Mantua, 23 November 1603

30. Ibid., I, p. 60; 15 July 1602
31. *Letters*, p. 38; to Chieppio, November (?) 1603
32. *Dissertation*, p. 8
33. *Nova plantarum animalium et mineralium mexicanorum historia* (Rome, 1638); quoted by Rooses, *Oeuvre*, IV, no. 154
34. *Letters*, p. 39; to Chieppio, 2 December 1606
35. *CDR*, III, p. 368
36. *Cours de peinture par principes* (Paris, 1708); English trans. (1743), pp. 86–92
37. *Dissertation*, p. 36
38. *CDR*, I, p. 366; Giovanni Magno to Chieppio, 7 April 1607
39. *Letters*, p. 39; to Chieppio, 2 December 1606
40. Ibid.
41. *Arch. Arcivesc. Fermo*; quoted by M. Jaffé, *Rubens and Italy* (Oxford, 1977), p. 92
42. *Letters*, p. 41; to Chieppio, 9 June 1607
43. Ibid., pp. 42–3; to Chieppio, 2 February 1608
44. Ibid., p. 41; to Chieppio, 9 June 1607
45. *Palazzi di Genova con le loro piante ed alzati* (Antwerp, 1622); quoted in *CDR*, II, p. 422
46. J. Evelyn, *Diary*, ed. E. S. de Beer (Oxford, 1955), II, p. 172
47. Ibid., pp. 170–1
48. See no. 45; *CDR*, II, pp. 422–4
49. *Letters*, p. 265; to Pierre Dupuy, 19 May 1628
50. Baglione, *Le vite de' pittori, scultori et architetti . . .* (Rome, 1642), p. 263
51. Evelyn, *Diary*, p. 178
52. *CDR*, I, p. 401; to Chieppio, 2 February 1608
53. *Letters*, p. 42; to Chieppio, 2 February 1608
54. Ibid., p. 43; to Chieppio, 2 February 1608
55. Ibid.
56. *CDR*, I, p. 410; to Giovanni Magno, 15 February 1608
57. *Letters*, p. 45; to Chieppio, 23 February 1608
58. Ibid., p. 44; to Chieppio, 23 February 1608
59. Ibid., p. 46; to Chieppio, 28 October 1608

NOTES TO CHAPTER III

1. *Letters*, p. 46; to Chieppio, 28 October 1608
2. Ibid., p. 42; to Chieppio, 2 February 1608
3. Ibid., p. 52; to Faber, 10 April 1609
4. Ibid., p. 53; to Faber, 10 April 1609
5. Ibid., p. 323; to Peiresc, 9 August 1629
6. Ibid., p. 53; to Faber, 10 April 1609
7. *Original Papers*, p. 11; Sir Dudley Carleton to John Chamberlain, 15 September 1616
8. *Letters*, p. 185; to Pierre Dupuy, 28 May 1627
9. Ibid., p. 52; to Faber, 10 April 1609
10. *Vita*, p. 38
11. *CDR*, II, p. 7; Patent issued by the archduke and archduchess, 23 September 1609
12. *Vita*, p. 39
13. Ibid., p. 38
14. *Letters*, p. 52; to Faber, 10 April 1609
15. Ibid., p. 136; to Pierre Dupuy, 15 July 1626
16. *Vita*, p. 39
17. *CDR*, II, p. 156; 1621
18. *Opere*, X (Milan, 1812), p. 224; quoted by J. Muller, 'The *Perseus and Andromeda* on

Rubens's House', *Simiolus*, XII (Amsterdam, 1981–2), p. 131
19. *Letters*, p. 70; to Peter de Vischere, 27 April 1619
20. *Vita*, p. 39
21. *Letters*, p. 411; 17 August 1638
22. Bellori, *Vite*, I, p. 245
23. *Letters*, p. 394; to Pieresc, 18 December 1634
24. *Vita*, p. 39
25. *Dissertation*, pp. 13–14
26. Bellori, *Vite*, p. 245
27. J. P. de la Serre, *Histoire cvrieuse . . .* (Antwerp, 1632), p. 68
28. *CDR*, II, p. 254; 1 October 1620
29. *Letters*, p. 55; to Jacob de Bie, 11 May 1611
30. *Original Papers*, p. 53; to Sir D. Carleton, 25 November 1620
31. *Letters*, p. 59; 17 March 1618
32. *Original Papers*, p. 275; undated
33. Ibid., p. 300; Sir D. Carleton to John Chamberlain, 20 February 1617
34. Ibid., pp. 31–2; 7 May 1618
35. *Letters*, pp. 60–1; to Sir D. Carleton, 28 April 1618
36. Ibid., p. 60; to Sir D. Carleton, 28 April 1618
37. Ibid., pp. 59–60; to Sir D. Carleton, 28 April 1618
38. Ibid., p. 67; to Sir D. Carleton, 1 June 1618
39. *CDR*, II, p. 167; to John Chamberlain, 23 May 1618
40. Ibid., IV, p. 264; to Chifflet, 21 May 1627
41. *Original Papers*, p. 245
42. *Letters*, p. 394; to Peiresc, 18 December 1634
43. *Conversations*, pp. 211–12
44. *Teutsche Academie* (Nuremberg, 1675); ed. A. R. Peltzer (Munich, 1925), p. 175
45. *CDR*, I, p. 1; to Philip Rubens, 3 November 1600
46. *Conversations*, pp. 213–15
47. Bellori, *Vite*, p. 246
48. *Calendar of Venetian State Papers*, ed. A. B. Hinds (1919), XXII, p. 130; quoted by G. Martin, *National Gallery Catalogues: The Flemish School* (1970), p. 122
49. *CDR*, V, p. 332; Moretus to Balthasar Corderius, 23 August 1630
50. Ibid., II, p. 78; to Philip de Peralta, S.J., 9 April 1615
51. *Letters*, p. 54; to Faber, 14 January 1611
52. Ibid., p. 60; 28 April 1618
53. Ibid., p. 403; to Peiresc, 16 March 1636
54. Ibid., p. 323; to Pieresc, 9 August 1629
55. Ibid., p. 212; to Pierre Dupuy, 25 November 1627
56. Ibid., p. 102; to Valavez, 10 January 1625
57. Ibid., p. 392; to Peiresc, 18 December 1634
58. J. Knowles, *The Life and Writings of Henry Fuseli* (1831), II, p. 119
59. *Letters*, p. 400; to Peiresc, 16 August 1635
60. Ibid., pp. 135–6; to Pierre Dupuy, 15 July 1626
61. Ibid., p. 337; 15 September 1629
62. Ibid., pp. 130–1; to Valavez, 20 February 1626
63. R. de Piles, *Cours de peinture par principes* (Paris, 1608), English trans. (1743), pp. 86–7
64. *Hyperbolimaues* (Mainz, 1607), p. 110; quoted in *CDR*, II, p. 4

65. Ibid., II, p. 44; 4 October 1611
66. Ibid., II, p. 82; 1 June 1616
67. *Letters*, p. 62; 12 May 1618
68. *Original Papers*, p. 37; 22 May 1618
69. *CDR*, II, p. 156
70. Ibid., II, p. 317; 23 December 1621
71. Ibid., IV, p. 290; Peiresc to Pierre Dupuy, 1 August 1627
72. Ibid., VI, p. 303; to B. Moretus, 6 June 1640
73. *Histoire cvrieuse*, pp. 68–9; quoted by H. Gerson and E. H. ter Kuile, *Art and Architecture in Belgium, 1600 to 1800* (Harmondsworth, 1960), p. 71
74. *Pompa Introitus Ferdinandi* (Antwerp, 1642), p. 171; quoted by J. Held, 'Rubens and Aguilonius: New Points of Contact', *Art Bulletin*, LXI (New York, 1979), p. 257, n. 3
75. A. Monballieu, 'P. P. Rubens en het "Nachtmael" voor St.-Winoksbergen...', *Jaarboek Koninklijk Museum Voor Schone Kunsten Antwerpen* (Antwerp, 1965), p. 196
76. *CDR*, V, p. 431; Judson and Van de Velde, p. 428; to Antoine de Winghe, 11 September 1631
77. F. Prims, 'Rubens' Antwerpen', in *Rubens en zijne Eeuw* (Antwerp, 1927), p. 18; quoted by Baudouin, *Rubens*, p. 65
78. *Vita*, p. 38
79. Rooses, *Oeuvre*, II, pp. 79–80; quoted by J. R. Martin, *Rubens: The Antwerp Altarpieces* (1969), p. 55
80. *CDR*, V, p. 296; certificate for Willem Panneels, 1 June 1630
81. See n. 79
82. De Piles, *Cours*, pp. 91–2
83. *Letters*, pp. 122–3; to Valavez, 3 July 1625
84. Ibid., p. 56; 19 March 1614
85. Ibid., p. 77; 13 September 1621
86. Ibid., p. 67; 1 June 1618
87. Ibid., p. 63; to Sir D. Carleton, 12 May 1618
88. H. Peacham, *The Compleat Gentleman* (1634), p. 110
89. *Recollections of Rubens*, ed. H. Gerson (1950), p. 157
90. St Luke, XV, 16
91. *Letters*, p. 54; to Faber, 14 January 1611
92. Ibid., p. 88; to Pieter van Veen, 19 June 1622. The book is possibly *Conclusiones physicae et theologicae...* (Orsselis, 1621)
93. F. M. Haberditzl, 'Die Lehrer des Rubens', *Jahrbuch der Kunsthistorischen Sammlungen in Wien*, XXVII (Vienna, 1908), p. 191; quoted by Baudouin, *Rubens*, p. 61
94. *CDR*, VI, p. 304; to Philip IV, 10 June 1640
95. *Letters*, p. 409; 12 March 1638
96. *CDR*, II, p. 334; to Ercole Bianchi, 11 February 1622
97. Ibid., II, p. 292; 5 September 1621
98. *Letters*, p. 55; to Jacob de Bie, 11 May 1611
99. Ibid., p. 65; to Sir D. Carleton, 26 May 1618
100. *Original Papers*, p. 18; Toby Mathew to Sir D. Carleton, 25 February 1617
101. *Letters*, p. 61; to Sir D. Carleton, 28 April 1618
102. Ibid., p. 61; to Sir D. Carleton, 28 April 1618

103. *CDR*, II, p. 156; see also K. Downes, *Rubens* (1980), p. 140
104. Bellori, *Vite*, I, p. 254
105. *CDR*, II, p. 156
106. Peacham, *Compleat Gentleman*, p. 110
107. *Graphice* (1658), p. 34
108. M. Hervey, *The Life of Thomas Howard, Earl of Arundel* (Cambridge, 1921), p. 175; to the Earl of Arundel, 17 July 1620. See also J. S. Held, *Rubens, Selected Drawings* (1959), I, p. 31
109. *Letters*, p. 69; to Pieter van Veen, 23 January 1619
110. Ibid., p. 87; to Pieter van Veen, 30 April 1622
111. J. S. Held, 'Rubens and Vorsterman', *Art Quarterly*, XXXII (Detroit, 1969), pp. 119–21
112. *Letters*, p. 398; to Peiresc, 31 May 1635
113. *CDR*, II, pp. 78–9; Judson and Van de Velde, p. 413; to P. de Peralta, 9 April 1615
114. *CDR*, V, pp. 335–6; Judson and Van de Velde, p. 385; Moretus to Balthasar Corderius, 13 September 1630
115. *CDR*, II, pp. 112–13; Judson and Van de Velde, p. 367; 1 August 1617
116. *CDR*, II, p. 110; Judson and Van de Velde, p. 405: Moretus to L. Lessius, 15 July 1617
117. *CDR*, VI, p. 247; Judson and Van de Velde, p. 379; to Moretus, 15 December 1639
118. *Francisci Agvilonii e Societate Iesv Opticorvm Libri Sex* (Antwerp, 1613), p. 427 E-F; quoted by Held, 'Rubens and Aguilonius'. p. 261
119. *Letters*, p. 323; to Peiresc, 9 August 1629
120. *CDR*, II, p. 422
121. *Letters*, p. 57; to the Archduke Albert, 19 March 1614
122. Ibid., p. 101; to Valavez, 10 January 1625
123. Quoted by Rooses, *Rubens* (1904), p. 239
124. Hervey, *Thomas Howard*, p. 175
125. Evelyn, *Diary*, II, pp. 63–4
126. *Letters*, p. 77; to William Turnbull, 13 September 1621
127. *Francisci Agvilonii*, p. 194D

NOTES TO CHAPTER IV

1. P. F. de Chantelou, *Diary of the Cavaliere Bernini's Visit to France*, ed. A. Blunt (Princeton, 1985), p. 31
2. *CDR*, II, p. 343; Peiresc to Rubens, 11 March 1622
3. Ibid., III, p. 180; Peiresc to Guidi di Bagno, 16 June 1623
4. Ibid., III, p. 194; Peiresc to Rubens, 10 July 1623
5. *Letters*, p. 109; to Peiresc, 13 May 1625
6. Ibid., p. 231; to Pierre Dupuy, 20 January 1628
7. Ibid., p. 109; to Peiresc, 13 May 1625
8. Ibid., p. 109; to Peiresc, 13 May 1625
9. Ibid., p. 131; to Valavez, 26 February 1626
10. *CDR*, III, p. 85; to Rubens, 1 December 1622
11. *Letters*, p. 109; to Peiresc, 13 May 1625
12. Ibid., p. 374; to Olivares, 1 August 1631
13. Ibid., p. 99; to Valavez, 26 December 1624
14. Ibid., p. 127; to Valavez, 12 February 1626
15. Ibid., p. 109; to Peiresc, 13 May 1625
16. Ibid., p. 110; to Peiresc, 13 May 1625
17. Ibid., p. 122; to Valavez, 26 December 1625

18. Ibid., p. 142; to Pierre Dupuy, 1 October 1626
19. Ibid., p. 367; to Peiresc, August 1630
20. *CDR*, II, p. 340; to Aléandre, 7 March 1622
21. *Letters*, p. 321; to Pierre Dupuy, 8 August 1629
22. *CDR*, II, pp. 316–19; to Rubens, 23 December 1621
23. *Electorum Libri II* (Antwerp, 1608)
24. *CDR*, II, p. 336; to Guidi di Bagno, 26 February 1622
25. Ibid., VI, p. 96; to Jacques Dupuy, 26 December 1634
26. *Letters*, p. 73; to the Duke of Neuberg, 7 December 1619
27. Ibid., p. 200; to Pierre Dupuy, 9 September 1627
28. Ibid., pp. 353–4; 1630(?)
29. Ibid., p. 90; 3 August 1623
30. Ibid., p. 112; to Valavez, 3 July 1625
31. Ibid., p. 116; to Valavez, 19 September 1625
32. Ibid., p. 133; to Valavez, 24 April 1626
33. *CDR*, III, p. 443; Peiresc to Aléandre, 19 June 1626
34. *Letters*, p. 116; to Valavez, 19 September 1625
35. *CDR*, III, p. 349; to Valavez, 17 March 1625
36. *Letters*, p. 365; August 1630
37. Ibid., p. 126; 1 February 1626
38. Ibid., p. 264; 19 May 1628
39. Ibid., p. 393; 18 December 1634
40. R. Lebègue, *Les Correspondants de Peiresc* (Brussels, 1943), pp. 48–9; quoted in *Letters*, p. 504, n. 5; to Guyon, 15 April 1636
41. *Letters*, p. 404; 16 March 1636
42. *CDR*, VI, p. 112; Luillier to Peiresc, 1 June 1635
43. *Letters*, p. 141; 17 September 1626
44. Ibid., p. 116; to Valavez, 19 September 1625
45. *CDR*, III, p. 158; 28 April 1623
46. *Letters*, pp. 276–7; to Jacques Dupuy, 20 July 1628
47. *CDR*, III, p. 266; to Philip IV, 29 January 1624
48. *Letters*, p. 234; to Pierre Dupuy, 27 January 1628
49. Ibid., p. 369; to Pierre Dupuy, October (?) 1630
50. Ibid., p. 368; to Pierre Dupuy, October (?) 1630
51. Ibid., p. 102; to Valavez, 10 January 1625
52. Ibid., p. 123; to Valavez, 26 December 1625
53. Ibid., p. 124; to Valavez, 9 January 1626
54. Ibid., p. 138; to Pierre Dupuy, 24 July 1626
55. E. Bonnaffé, 'Documents inedits sur Rubens', *Gazette des Beaux-Arts*, VI (Paris, 1891), p. 388
56. *Letters*, p. 204; to Gerbier, 18 September 1627
57. *Vita*, p. 40
58. *Eer ende Claght Dicht* . . . (The Hague, 1620), p. 5; quoted by D. Freedberg, 'Fame, Convention and Insight: On the Relevance of Fornenbergh and Gerbier', *Ringling Museum of Art Journal* (Sarasota, 1983), p. 242
59. *CDR*, III, p. 134; 1 March 1623
60. *Letters*, pp. 101–2; 10 January 1625
61. Ibid., p. 136; 15 July 1626
62. Ibid., p, 367; August 1630
63. XXXV, 170; cited by J. S. Held, 'Rubens' Het Pelsken', in *Essays in the History of Art Presented to Rudolf Wittkower* (1967), p. 191
64. *Letters*, p. 234; 27 January 1628
65. *Rubens Bulletijn*, V (Antwerp and Brussels, 1910), pp. 216ff; quoted by J. S. Held, *The Oil-Sketches of Peter Paul Rubens* (Princeton, 1980), I, pp. 89–90
66. *Letters*, p. 110; to Peiresc, 13 May 1625
67. Ibid., p. 136; to Pierre Dupuy, 15 July 1626
68. *Teutsche Academie* . . ., ed. R. A. Peltzer (Munich, 1925), p. 157
69. *Original Papers*, p. 93; July 1627
70. *CDR*, IV, pp. 82–3; 15 June 1627
71. Ibid., p. 85; 22 July 1627
72. *Letters*, p. 279; to Pierre Dupuy, 10 August 1628
73. *CDR*, IV, p. 220; 6 June 1628
74. Ibid., IV, p. 456; P. Chifflet to Guidi di Bagno, 1 September 1628
75. Ibid., IV, p. 233; G. B. Pamphili to the Cardinal Secretary of State, 1628
76. *Letters*, p. 295; to Gevaerts, 29 December 1628
77. Ibid., p. 295; to Gevaerts, 29 December 1628
78. Ibid., p. 322; 9 August 1629
79. Ibid., p. 293; to Peiresc, 2 December 1628
80. Ibid., p. 292; to Peiresc, 2 December 1628
81. Pacheco, *Arte de la Pintura*, ed. F. Sanchez Canton (Madrid, 1956), I, p. 153
82. M. Boschini, *La carta del navegar pitoresco* (Venice, 1660), p. 62; quoted by J. S. Held, 'Rubens and Titian', in *Titian, His World and Legacy*, ed. D. Rosand (New York, 1982), p. 286
83. Pacheco, *Arte*, I, p. 154
84. A. Palomino, *Biografias* (1724, ed. Madrid, 1960), pp. 41–2
85. *Letters*, p. 414; to Gerbier, April 1640
86. Ibid., p. 412; to Gerbier, 15 March 1640
87. Ibid., p. 295; 29 December 1628
88. Ibid., p. 301; to Olivares, 30 June 1629
89. *CDR*, V. p. 42; to Don Carlos de Coloma, 22 May 1629
90. *Letters*, p. 299; to Olivares, 30 June 1629
91. *CDR*, V, p. 62; Sir John Coke to Jacques Han, 15 June 1629
92. *Original Papers*, p. 137; Sir Thomas Edmondes to Lord Dorchester (formerly Sir D. Carleton), 4 July 1629
93. *Letters*, p. 304; to Olivares, 30 June 1629
94. Ibid., p. 314; to Olivares, 22 July 1629
95. *Original Papers*, p. 131; Dudley Carleton (nephew of Sir D. Carleton) to Lord Dorchester, 11 June 1629
96. *CDR*, V, p. 72; Alvise Contarini, 8 June 1629
97. *Letters*, p. 318; 22 July 1629
98. *CDR*, V, p. 165; 20 August 1629
99. Ibid., V, p. 374; 6 April 1631
100. Ibid., V, p. 113; to Olivares, 20 July 1629
101. *Letters*, p. 350; 23 November 1629
102. Ibid., p. 320; to Pierre Dupuy, 8 August 1629
103. *Original Papers*, pp. 144–5; to Lord Carleton (formerly Sir D. Carleton), 5 April 1628
104. *Letters*, p. 322; to Peiresc, 9 August 1629

105. Ibid., p. 322; to Peiresc, 9 August 1629
106. Ibid., pp. 320–1; 8 August 1629
107. Ibid., p. 354; to Peiresc, 1630(?)
108. Ibid., p. 320; to Pierre Dupuy, 8 August 1629
109. Ibid., p. 322; 9 August 1629
110. Sir E. Walker, *Historical Discourses* (1705), p. 214; quoted by Hervey, *Thomas Howard*, p. 358
111. *CDR*, V, pp. 287–8; Joseph Mead, 16 March 1630
112. *CDR*, V, p. 348; 15 December 1630
113. *Letters*, p. 333; to Olivares, 2 September 1629
114. 'Abraham van der Doort's Catalogue of the Collections of Charles I', ed. O. Millar, *Walpole Society*, XXXVII (1960), p. 4
115. *Letters*, pp. 408–9

NOTES TO CHAPTER V
1. *Letters*, p. 337; to Gevaerts, 15 September 1629
2. Ibid., p. 353; to Olivares, 14 December 1629
3. Ibid., p. 350; to Gevaerts, 23 November 1629
4. Ibid., p. 370; 13 January 1631
5. Ibid., p. 371; 13 January 1631
6. Ibid., p. 392; to Peiresc, 18 December 1634
7. *CDR*, VI, p. 96; to Jacques Dupuy, 26 December 1634
8. *Letters*, p. 393; 18 December 1634
9. *CDR*, VI, p. 97; to Jacques Dupuy, 16 January 1635
10. *Abregé de la vie des peintres* (Paris, 1699); English trans. (1750?), p. 252
11. *CDR*, VI, p. 228; to Philip IV, 27 February 1639
12. XXXVI, 20
13. Bonnaffé, 'Documents', p. 209
14. *CDR*, V, p. 375; 8 June 1631
15. *CDR*, V, p. 351, 21 December 1630
16. *Letters*, p. 371; to Woverius, 13 January 1631
17. De la Serre, *Histoire cvrieuse*, p. 69
18. *CDR*, V, p. 392; 16 July 1631
19. Ibid., VI, p. 35, 30 January 1633(?)
20. *Original Papers*, p. 177; to Sir J. Coke, 3 February 1633
21. *CDR*, V, p. 296; 1 June 1630
22. *Letters*, p. 369; October (?) 1630
23. Ibid., p. 372; to Pierre Dupuy, 27 March 1631
24. *Original Papers*, p. 244
25. Quoted in D. H. Willson, *King James VI and I* (1956), p. 271
26. *CDR*, VI, p. 200; frontispiece to *Legatus* by Marselaer, 6 March 1638
27. *Letters*, pp. 402–3; 16 March 1636
28. Sir William Davenant, *Britannia Triumphans* (1638), preface. See S. Orgel and R. Strong, *Inigo Jones: The Theatre of the Stuart Court* (1973), II, p. 662
29. *A Brief Discourse Concerning the Three Chief Principles of Magnificent Building* (1662), p. 40; quoted by Orgel and Strong, *Inigo Jones*, I, p. 16
30. Quoted by Rooses, *Rubens* (1904), p. 556
31. *Letters*, p. 393; 18 December 1634
32. *CDR*, VI, p. 237; to Philip IV, 29 August 1639
33. *Letters*, p. 408; to Sustermans, 12 March 1638
34. *Description de tous les Pays-Bas* (Antwerp, 1567), pp. 48–57; quoted by G. Parker, *The Dutch Revolt* (Harmondsworth, 1977), p. 27
35. *Odes*, I, 37; quoted by J. S. Held and D. Posner, *17th and 18th Century Art: Baroque and Rococo* (New York, 1971), p. 210
36. Pater Poirters, *Het Masker van de Wereldt afgetrocken* (Antwerp, 1646), p. 272; quoted by Rooses, *Rubens* (1904), p. 593
37. Cornelis de Bie, *Het Gulden Cabinet . . .* (Lier, 1661), p. 58; quoted by Held, 'Rubens and Titian', p. 286
38. *Letters*, p. 406; 25 July 1637
39. Ibid., p. 410; 2 April 1638
40. Count Ferdinand Harrach, 'Tagebuch' (unpublished); quoted by S. Alpers, *The Decoration of the Torre de la Parada*, *CRLB*, Part IX (Brussels, 1971), p. 27
41. *CDR*, VI, p. 172; Ferdinand to Philip IV, 31 January 1637
42. Ibid., VI, p. 175; to Philip IV, 30 April 1637
43. Ibid., VI, p. 191; to Philip IV, 21 January 1638
44. Ibid., VI, p. 220; to Philip IV, 30 June 1638
45. *Letters*, p. 411; 15 February 1639
46. *CDR*, VI, p. 227; to Philip IV, 11 December 1638
47. Ibid., VI, p. 228; to Philip IV, 27 February 1639
48. Ibid., VI, p. 234; 2 July 1639
49. *Original Papers*, pp. 214–15; to Edward Norgate, 4 February 1640
50. Ibid., p. 217; 24 March 1640
51. Ibid., p. 215; 25 February 1640
52. Ibid., p. 225; Abbé Scaglia to Gerbier, 13 May 1640
53. Ibid., p. 217; Gerbier to Inigo Jones, 24 March 1640
54. *Letters*, p. 404; to Peiresc, 4 September 1636
55. Quoted by Rooses, *Rubens* (1904), p. 571
56. *Letters*, p. 405; 4 September 1636
57. *Rubens Bulletijn*, II (Antwerp and Brussels, 1883), p. 167
58. *Letters*, p. 60; to Sir D. Carleton, 28 April 1618
59. Quoted by I. Lavin, 'The Sculptor's "Last Will and Testament"', *Allen Memorial Art Museum Bulletin*, XXXV (Oberlin, 1978), p. 39
60. *Letters*, pp. 410–11; 17 August 1638
61. Ibid., p. 413; 5 April 1640
62. Ibid., p. 412; 5 April 1640
63. Ibid., p. 415; 9 May 1640
64. Ibid., p. 294; to Gevaerts, 29 December 1628
65. Ibid., p. 168; to Pierre Dupuy, 22 January 1627
66. *Original Papers*, p. 228; 31 May 1640
67. Ibid., p. 229; 31 May 1640
68. Ibid., p. 230; 2 June 1640
69. *CDR*, VI, p. 306; to Moretus, 14 June 1640
70. Quoted by Rooses, *Rubens* (1904), p. 620
71. P. Genard, 'De Nalatenschap van Rubens', *Antwerpsch Archievenblad*, II (Antwerp, 1865), p. 168; quoted by Rooses, *Oeuvre*, I, p. 279
72. Quoted by Rooses, *Rubens* (1904), p. 629
73. *Original Papers*, p. 230; to William Murray, 2 June 1640
74. Ibid., p. 229; 31 May 1640
75. Ibid., p. 230; 2 June 1640
76. Ibid., p. 231; 2 June 1640
77. *CDR*, VI, p. 311; 23 September 1640

Bibliography

The bibliography is arranged in two parts. The first lists the basic works of reference which have been used throughout the book. The second describes books and articles relating to a particular work or theme, which have been grouped together to follow the order of the text. To make consultation easier page references to this volume have been inserted in the margin.

LETTERS AND DOCUMENTS

W. N. Sainsbury, *Original unpublished Papers illustrative of the Life of Sir Peter Paul Rubens* (1859)

M. Rooses and C. Ruelens, *Correspondance de Rubens et documents epistolaires concernant sa vie et ses oeuvres*, 6 vols. (Antwerp, 1887–1909)

R. S. Magurn, *Letters of Peter Paul Rubens* (Cambridge, Mass., 1955)

GENERAL STUDIES

J. Burckhardt, *Recollections of Rubens* (Basel, 1898); trans. (1950)

M. Rooses, *Rubens* (Philadelphia and London, 1904)

H. G. Evers, *Peter Paul Rubens* (Munich, 1942)

H. G. Evers, *Rubens und sein Werk: Neue Forschungen* (Brussels, 1944)

H. Gerson, *Art and Architecture in Belgium, 1600 to 1800* (Harmondsworth, 1960), pp. 70–108

M. Warnke, *Kommentäre zu Rubens* (Berlin, 1965)

W. Stechow, *Rubens and the Classical Tradition* (Cambridge, Mass., 1968)

M. Jaffé, *Rubens and Italy* (Oxford, 1977)

F. Baudouin, *Rubens* (New York, 1977)

K. Downes, *Rubens* (1980)

CATALOGUES OF PAINTINGS – GENERAL

M. Rooses, *L'Oeuvre de Rubens*, 5 vols. (Antwerp, 1886–92)

M. Rooses, 'L'Oeuvre de Rubens: Addenda et corrigenda', *Rubens Bulletijn*, V (Antwerp and Brussels, 1897–1910), pp. 69–102, 172–92, 279–330

R. Oldenbourg, *P. P. Rubens: Des Meisters Gemälde* (Berlin and Leipzig, 1921)

Corpus Rubenianum Ludwig Burchard (Brussels and London, 1968–)
 VII. D. Freedberg, *The Life of Christ after the Passion* (1984)
 VIII. H. Vlieghe, *Saints*, 2 vols. (1972)
 XIX. F. Huemer, *Portraits I* (1977)
 Other published volumes, abbreviated *CRLB*, are listed below under the relevant chapters.

J. S. Held, *The Oil-Sketches of Peter Paul Rubens: A Critical Catalogue*, 2 vols. (Princeton, 1980)

CATALOGUES OF PAINTINGS – COLLECTIONS

J.-A. Goris and J. S. Held, *Rubens in America* (New York, 1947)

A. Seilern, *Flemish Paintings and Drawings at 56 Princes Gate*, 2 vols. (1955); *Addenda (1969); Corrigenda & Addenda* (1971)

G. Martin, *National Gallery Catalogues: The Flemish School* (1970)

M. Varshavskaya, *Rubens' Paintings in the Hermitage Museum* (Leningrad, 1975)

M. D. Padron, *Museo del Prado: Catalogo de Pinturas*, I (Escuela Flamenca Siglo XVII) (Madrid, 1975)

Peter Paul Rubens, 1577–1640, exhibition catalogue by K. Demus and others (Kunsthistorisches Museum, Vienna, 1977)

Rubens e la pittura fiammiga del Seicento nelle collezioni pubbliche fiorentine, exhibition catalogue by D. Bodart (Palazzo Pitti, Florence, 1977)

Le Siècle de Rubens dans les collections publiques francaises, exhibition catalogue by J. Foucart and others (Grand Palais, Paris, 1977–8)

J. Kelch, *Peter Paul Rubens: Kritischer Katalog der Gemälde im Besitz der Gemäldegalerie Berlin* (Berlin, 1978)

W. A. Liedtke, *Flemish Paintings in the Metropolitan Museum of Art*, 2 vols. (New York, 1984)

CATALOGUES OF DRAWINGS – GENERAL

G. Glück and F. M. Haberditzl, *Die Handzeichnungen von Peter Paul Rubens* (Berlin, 1928)

J. S. Held, *Rubens, Selected Drawings*, 2 vols. (1959); 2nd ed. (1986)

L. Burchard and R. A. d'Hulst, *Rubens Drawings*, 2 vols. (Brussels, 1963)

CATALOGUES OF DRAWINGS – COLLECTIONS

A. M. Hind, *Catalogue of Drawings by Dutch and Flemish Artists . . . in the British Museum*, II (1923)

F. Lugt, *Musée du Louvre: Inventaire general des dessins des ecoles du nord: Ecole flamande* (Paris, 1949), II

H. Mielke and M. Winner, *Staatliche Museen Preussischer Kulturbesitz: Peter Paul Rubens Kritischer Katalog der Zeichnungen* (Berlin, 1977)

Die Rubenszeichnungen der Albertina, exhibition catalogue by E. Mitsch (Albertina, Vienna, 1977)

Rubens Drawings and Sketches, exhibition catalogue by J. Rowlands (British Museum, London, 1977)

Rubens ses maitres, ses élèves: dessins du Musée du Louvre, exhibition catalogue by A. Serullaz (Louvre, Paris, 1978)

CHAPTER I

6 F. Lugt, 'Rubens and Stimmer', *Art Quarterly*, VI (Detroit, 1943), pp. 99–114

7 J. Müller Hofstede, 'Zum Werke des Otto van Veen', *Bulletin Musées Royaux des Beaux-Arts de Belgique*, VI (Brussels, 1957), pp. 127–73

8 The early years: G. Glück, *Rubens, Van Dyck und ihr Kreis* (Vienna, 1933), pp. 1–45; J. Müller Hofstede, 'Zur Antwerpener Frühzeit von P. P. Rubens', *Münchner Jahrbuch der Bildenden Kunst*, 3e Folge, XIII (Munich, 1962), pp. 179–215; I. Q. van Regteren Altena, 'Het vroegste werk van Rubens', *Medelingen van de Koninklijke Academie voor Wetenschappen Letteren en schone Kunsten van Belgie*, XXXIV (Brussels, 1972), pp. 3–21; K. Belkin, *The Costume Book, CRLB, Part XXIV* (1978); J. S. Held, 'Thoughts on Rubens' Beginnings', *Ringling Museum of Art Journal* (Sarasota, 1983), pp. 14–27

8 Adam and Eve: M. Jaffé, 'Rubens and Raphael', in *Studies in Renaissance and Baroque Art Presented to Anthony Blunt* (1967), pp. 98ff.

CHAPTER II

11 Rubens in Italy: J. Müller Hofstede in *Peter Paul Rubens, 1577–1640: Katalog I* (Wallraf-Richartz Museum, Cologne, 1977), pp. 13–354

11 *Rubens a Mantova*, exhibition catalogue by U. Bazzotti and others (Palazzo Ducale, Mantua, 1977)

13 Rubens and the Antique: E. Kieser, 'Antikes im Werke des Rubens', *Münchner Jahrbuch der Bildenden Kunst*, N. F., X (Munich, 1933), pp. 110–37; V. Miesel, 'Rubens' Study Drawings after Ancient Sculpture', *Gazette des Beaux-Arts*, LXI (Paris, 1963), pp. 311–26; J. S. Held, 'Padre Resta's Rubens Drawings after Ancient Sculpture', *Master Drawings*, II (New York, 1964), pp. 123–41; H. Rodee, 'Rubens' Treatment of Antique Armor', *Art Bulletin*, XLIX (New York, 1967), pp. 223–30; M. van der Meulen, 'Observations on Rubens' Drawings after the Antique', *Ringling Museum of Art Journal* (Sarasota, 1983), pp. 36–45

16 Copies and reworking of drawings: M. Jaffé, 'Rubens as a Collector of Drawings', *Master Drawings*, II (New York, 1964), pp. 383–97; ibid., III (1965), pp. 21–35; ibid., IV (1966), pp. 127–48; A.-M. Logan, 'Reviews: Rubens Exhibitions, 1977–1978', *Master Drawings* XVI (New York, 1978), pp. 428–30

23 S. Croce in Gerusalemme altarpieces: M. de Maeyer, 'Rubens en de altaarstukken in het hospital te Grasse', *Gentse Bijdragen tot de Kunstgeschiedenis*, XIV (Ghent, 1953), pp. 75–87; J. Müller Hofstede, 'Rubens in Rom, 1601–1602: Die Altargemälde fur Sta. Croce in Gerusalemme', *Jahrbuch der Berliner Museen*, XII (Berlin, 1970), pp. 61–110

25 *Aeneas preparing to lead the Trojans into Exile*: E. McGrath in *Splendours of the Gonzaga* (Victoria and Albert Museum, London, 1981–2), pp. 227–9

26 J. L. Saunders, *Justus Lipsius* (New York, 1955)

31 The Holy Trinity altarpieces: C. Norris, 'The Tempio della Santissima Trinita at Mantua', *Burlington Magazine*, CXVII (1975), pp. 73–9; F. Huemer, 'Rubens and the Mantuan Altar', *Studies in Iconography*, III (Northern Kentucky University, 1977), pp. 105–44; E. McGrath in *The Splendours of the Gonzaga* (Victoria and Albert Museum, London, 1981–2), pp. 214–21

33 Philip Rubens and his brother's portrait: J. S. Held, *Flemish and German Paintings of the 17th Century* (Detroit Institute of Arts, Detroit, 1982), pp. 76–82; F. Huemer, 'Philip Rubens and his Brother the Painter', in *Rubens and his World* (Antwerp, 1985), pp. 123–8

34 N. de Grummond, 'The Study of Classical Costume by Philip, Albert and Peter Paul Rubens', *Ringling Museum of Art Journal* (Sarasota, 1983), pp. 78–90

34 Rubens' 'Notebook': M. Jaffé, *Van Dyck's Antwerp Sketchbook* (1966), I, pp. 16–47

35 E. Mandowsky, 'Two *Menelaus and Patroclus* replicas in Florence and Joshua Reynolds's Contribution', *Art Bulletin*, XXVIII (New York, 1946), p. 117

38 The Chiesa Nuova commission: M. Jaffé, *Peter Paul Rubens and the Oratorian Fathers* (Florence, 1959); J. Müller Hofstede, 'Rubens's First Bozzetto for Sta. Maria in Vallicella', *Burlington*

Magazine, CVI (1964), pp. 442–51; ibid., 'Zu Rubens' zweitem Altarwerk für Sta. Maria in Vallicella', *Nederlands Kunsthistorisch Jaarboek*, XVII (The Hague, 1966), pp. 1–78

46 *Rubens a Genova*, exhibition catalogue by G. Biavati and others (Palazzo Ducale, Genoa, 1977–8)

CHAPTER III

55 Relations with Archduke Albert: M. de Maeyer, *Albrecht en Isabella en de Schilderkunst* (Brussels, 1955); H. Trevor-Roper, *Princes and Artists* (1976), pp. 127–62

59 Portraits of Isabella Brant and Helena Fourment: H. Vlieghe, 'Some Remarks on the Identification of Sitters in Rubens' Portraits', *Ringling Museum of Art Journal* (Sarasota, 1983), pp. 106–10; R. an der Heiden, *Peter Paul Rubens und die Bildnesse seiner Familie in der Alten Pinakothek* (Munich, 1982)

61 F. Baudouin, *Rubens House: A Summary Guide* (Antwerp, 1977); ibid., 'The Rubens House at Antwerp and the Château de Steen at Elewijt', *Apollo*, CV (1977), pp. 181–8; E. McGrath, 'The Painted Decoration of Rubens's House', *Journal of the Warburg and Courtauld Institutes*, XLI (1978), pp. 245–77; J. Muller, 'Rubens's Emblem of the Art of Painting', *Journal of the Warburg and Courtauld Institues*, XLIV (1981), pp. 221–2; ibid., 'The Perseus and Andromeda on Rubens's House', *Simiolus*, XII (Amsterdam, 1981–2), pp. 131–46

67 M. Jaffé, 'Rubens as a Collector', *Journal of the Royal Society of Arts*, CXVII (1969), pp. 641–60; J. Muller, 'Oil-Sketches in Rubens's Collection', *Burlington Magazine*, CXVII (1975), pp. 371–7; ibid., 'Rubens's Museum of Antique Sculpture: An Introduction', *Art Bulletin*, LIX (New York, 1977), pp. 571–82; ibid., 'Rubens's Collection of Art' (to be published, Princeton, 1987)

70 The visits of Sperling and Golnitzius: M. Rooses, 'De vreemde reizigers Rubens of zijn huis bezoekende', *Rubens Bulletijn*, V (Antwerp and Brussels, 1910), pp. 221–4

78 W. Prinz, '*The Four Philosophers* by Rubens and the Pseudo-Seneca in Seventeenth Century Painting', *Art Bulletin*, LV (New York, 1973), pp. 410–28; M. Vickers, 'Rubens's Bust of "Seneca"?', *Burlington Magazine*, CXIX (1977), pp. 643–4

79 The Antwerp altarpieces: J. S. Held, 'Rubens' Designs for Sepulchral Monuments', *Art Quarterly*, XXIII (Detroit, 1960), pp. 247–70; C. Eisler, 'Rubens' Uses of the Northern Past: The Michiels Triptych and its Sources', *Bulletin Musées Royaux des Beaux-Arts*, XVI (Brussels, 1967), pp. 43–76; J. R. Martin, *Rubens: The Antwerp Altarpieces* (1969); F. Baudouin in *Rubens before 1620* (Art Museum, Priceton University, 1972), pp. 45–72; D. Freedberg, 'Rubens as a Painter of Epitaphs, 1612–1618', *Gentse Bijdragen tot de Kunstgeschiedenis*, XXIV (Ghent, 1976–8), pp. 51–71; T. L. Glen, *Rubens and the Counter Reformation* (New York and London, 1977). For a summary of Counter Reformation iconography, see A. Blunt, *Artistic Theory in Italy, 1450–1600* (Oxford, 1956), pp. 103–36

85 Willem van Haecht's Gallery of Cornelis van der Geest: J. S. Held, *Rubens and his Circle* (Princeton, 1982), pp. 35–64

86 The *Raising of the Cross*: S. Heiland, 'Two Rubens Paintings rehabilitated', *Burlington Magazine*, CXI (1969), pp. 421–6; J. R. Martin, 'The Angel from Rubens's "Raising of the Cross"', in *Rubens and his World* (Antwerp, 1985), pp. 141–6

95 J. Bialostocki, 'The *Descent from the Cross* in Works by Peter Paul Rubens and his Studio', *Art Bulletin*, XLVI (New York, 1964), pp. 511–24; M. Vickers, 'A New Source for Rubens's *Descent from the Cross* in Antwerp', *Pantheon*, XXXIX/2 (Munich, 1981), pp. 140–2

99 T. Buddenseig, 'Simson und Dalila von Peter Paul Rubens' in *Festschrift für Otto von Simson*, ed. L. Grisebach and K. Renger (Frankfurt, Berlin and Vienna, 1977), pp. 328–45; C. Brown, *Rubens: Samson and Delilah* (National Gallery, London, 1983)

103 M. Jaffé, 'Rubens's Portraits of Nicolaas Rockox and Others', *Apollo*, CXIX (1984), pp. 274–81

110 M. Lewine, 'The Source of Rubens' *Miracles of St Ignatius*', *Art Bulletin*, XLV (New York, 1963), pp. 143–7; G. Smith, 'Rubens' Altargemälde des Hl. Ignatius von Loyola und des Hl. Franz Xaver für die Jesuitenkirche in Antwerpen', *Jahrbuch der Kunsthistorischen Sammlungen in Wien*, LXV (Vienna, 1969), pp. 39–60

111 Rubens' designs for altar-frames: F. Baudouin in *Rubens before 1620* (Art Museum, Princeton University, 1972), pp. 73–91

111 A. Blunt, 'Rubens and Architecture', *Burlington Magazine*, CXIX (1977), pp. 609–21

118 Hunting pictures: D. Rosand, 'Rubens's Munich *Lion Hunt*: Its Sources and Significance', *Art Bulletin*, LI (1969), pp. 29–40; J. S. Held, *P. P. Rubens: The Leopards, 'Originale de mia mano'* (privately published, New York, 1970).

120 R. Baumstark, 'Notes on the Decius Mus–Cycle', *Ringling Museum of Art Journal* (Sarasota, 1983), pp. 178–86; ibid., *Liechtenstein: The Princely Collections* (Metropolitan Museum of Art, New York, 1985), pp. 338–55

123 G. Glück, *Die Landschaften von P. P. Rubens* (Vienna, 1940); L. Vergara, *Rubens and the Poetics of Landscape* (New Haven and London, 1982); W. Adler, *Landscapes, CRLB, Part XVIII* (1982)

131 H. Vlieghe, 'Het Portret van Jan Breughel en zijn gezin door P. P. Rubens', *Bulletin Musées Royaux des Beaux-Arts de Beligique*, XV (Brussels, 1966), pp. 177–88

133 H. Vlieghe, 'Erasmus Quellinus and Rubens's Studio Practice', *Burlington Magazine*, CXIX (1977), pp. 636–43

134 Rubens and Snyders: F. Kimball, 'Rubens' Prometheus', *Burlington Magazine*, XCIV (1952), pp. 67–8; A. E. Popham, 'A Drawing by Frans Snyders', *Burlington Magazine*, XCIV (1952), p. 237; M. Jaffé, 'Rubens and Snijders: A Fruitful Partnership', *Apollo*, XCIII (1971), pp. 184–96

138 Rubens and his engravers: F. van den Wijngaert, *Inventaris der Rubeniaansche Prentkunst* (Antwerp, 1941); *Peter Paul Rubens: Maler mit dem Grabstickel...*, exhibition catalogue by H. Robels, J. Heynen and W. Vomm (Wallraf-Richartz Museum, Cologne, 1977); *Rubens e l'Incisione*, exhibition catalogue by D. Bodart (Villa della Farnesina, Rome, 1977)

138 R. de Smet, 'Een nauwkeuriger Datering van Rubens' eerste Reis naar Holland in 1622', *Jaarboek, Koninklijk Museum voor Schone Kunsten* (Antwerp, 1977), pp. 199–218

138 J. S. Held, 'Rubens and Vorsterman', *Art Quarterly*, XXXII (Detroit, 1969), pp. 111–29

140 *Rubens and the Book*, exhibition catalogue, ed. J. S. Held (Chapin Library, Williamstown, 1977); J. R. Judson and C. van de Velde, *Book Illustrations and Title-Pages*, CRLB, Part XXI (1978), 2 vols.; J. S. Held, *Rubens and his Circle* (Princeton, 1982), pp. 166–84

146 C. Parkhurst, 'Aguilonius' Optics and Rubens' Color', *Nederlands Kunsthistorisch Jaarboek*, XII (Bussum, 1961), pp. 35–49; M. Jaffé, 'Rubens and Optics: Some Fresh Evidence', *Journal of the Warburg and Courtauld Institutes*, XXXIV (1971), pp. 362–6; J. S. Held, 'Rubens and Aguilonius: New Points of Contact', *Art Bulletin*, LXI (New York, 1979), pp. 257–64

148 E. Larsen and V. Hyde Minor, 'Peter Paul Rubens and the Society of Jesus', *Konsthistorisk tidskrift*, XLVI (Stockholm, 1977), pp. 48–54

150 J. R. Martin, *The Ceiling Paintings for the Jesuit Church in Antwerp*, CRLB, Part I (1968)

CHAPTER IV

161 J. Thuillier and J. Foucart, *Rubens' Life of Marie de' Medici* (New York, 1967); F. Hamilton Hazlehurst, 'Additional Sources for the Medici Cycle', *Bulletin des Musées Royaux des Beaux-Arts de Belgique*, XVI (Brussels, 1967), pp. 111–35; R. Berger, 'Rubens and Caravaggio: A Source for a Painting from the Medici Cycle', *Art Bulletin*, LIV (New York, 1972), pp. 473–7; D. Marrow, *The Art Patronage of Marie de' Medici* (Ann Arbor, 1982); R. an der Heiden, *Die Skizzen zum Medici-Zyklus von Peter Paul Rubens in der Alten Pinakothek* (Munich, 1984).

171 D. Dubon, *Tapestries from the Samuel H. Kress Collection at the Philadelphia Museum of Art: The History of Constantine the Great designed by Peter Paul Rubens and Pietro da Cortona* (1964); J. Coolidge, 'Louis XIII and Rubens: The Story of the Constantine Tapestries', *Gazette des Beaux-Arts*, LXV (Paris, 1966), pp. 271–92

174 C. Norris, 'Rubens and the Great Cameo', *Phoenix* (Amsterdam, August–September, 1948), pp. 179–88; M. van der Meulen, *Petrvs Pavlvs Rvbens Antiqvarivs: Collector and Copyist of Antique Gems* (Alphen aan den Rijn, 1975); O. Neverov, 'Gems in the Collection of Rubens', *Burlington Magazine*, CXXI (1979), pp. 424–32

178 M. van der Meulen, 'A Note on Rubens's Letter on Tripods', *Burlington Magazine*, CXIX (1977), pp. 647–52

179 *Rubens Diplomate*, exhibition catalogue by F. Baudouin (Château Rubens, Elewijt, 1962); C. V. Wedgwood, *The Political Career of Peter Paul Rubens* (1975)

182 J. S. Held, 'Rubens' "Triumph of the Eucharist" and the Modello in Louisville', *J. B. Speed Art Museum Bulletin*, XXVI, no. 3 (Louisville, 1968), pp. 2–22; C. Scribner, 'Sacred Architecture: Rubens's *Eucharist* Tapestries', *Art Bulletin*, LVII (New York, 1975), pp. 519–28; N. de Poorter, *The Eucharist Series*, CRLB, Part II (1978), 2 vols., and review by E. McGrath in *Art History*, IV (1981), pp. 474–9; C. Scribner, *The Triumph of the Eucharist, Tapestries designed by Rubens* (Ann Arbor, 1982)

188 R. Davies, 'An Inventory of the Duke of Buckingham's Pictures etc. at York House in 1635', *Burlington Magazine*, X (1907), pp. 376–82; C. R. Cammell, *The Great Duke of Buckingham* (1939); G. Martin, 'Rubens and Buckingham's "fayrie ile"', *Burlington Magazine*, CVIII (1966), pp. 613–18; J. S. Held, 'Rubens's Sketch of Buckingham Rediscovered', *Burlington Magazine*, CXVIII (1976), pp. 547–51; R. Lockyer, *Buckingham* (1981)

191 The inventory drawn up after Isabella Brant's death: E. Bonnaffé, 'Documents inedits sur Rubens', *Gazette des Beaux-Arts*, VI (Paris, 1891), pp. 387–91

192 Balthasar Gerbier: H. R. Williamson, *Four Stuart Portraits* (1949), pp. 26–60; L.-R. Betcherman, 'Balthazar Gerbier in Seventeenth-Century Italy', *History Today* (May, 1961), pp. 325–31; ibid., 'The York House Collection and its Keeper', *Apollo*, XCII (1970), pp. 250–9; D. Freedberg, 'Fame, Convention and Insight: On the Relevance of Fornenberg and Gerbier', *Ringling Museum of Art Journal* (Sarasota, 1983), pp. 236–56

193 Self-portraits: M. Jaffé, 'Rubens to Himself: The Portraits sent to Charles I and to N.-C. Fabri de Peiresc', in *Rubens e Firenze*, ed. M. Gregori (Florence, 1983), pp. 19–32

199 Isabella Brant's will: *Rubens Bulletijn*, IV (Antwerp and Brussels, 1896), pp. 154–88

202 Pontius's drawing of *Olivares*: E. Haverkamp Begemann, *Bulletin Museum Boymans*, V (Rotterdam, 1954), p. 15

203 T. Müller and A. Schädler, *Georg Petel, 1601–1634* (Munich, 1964); K. Feuchtmayr and A. Schädler, *Georg Petel, 1601/2–1634* (Berlin, 1973)

207 The Henry IV series: I. Jost, 'Bemerkungen zur Heinrichsgalerie des P. P. Rubens', *Nederlands Kunsthistorisch Jaarboek*, XV (The Hague, 1964), pp. 175–220

217 Rubens and the court of Philip IV: C. Justi, *Diego Velazquez and his Times* (1889), pp. 131–8; M. Volk, 'Rubens in Madrid and the Decoration of the King's Summer Apartments', *Burlington Magazine*, CXXIII (1981), pp. 513–29; J. Brown, *Velázquez* (New Haven and London, 1986), pp. 65–6, 189–90

219 J. S. Held, 'Rubens and Titian', in *Titian, his World and his Legacy*, ed. D. Rosand (New York, 1982), pp. 283–334; M. Volk, 'On Rubens and Titian', *Ringling Museum of Art Journal* (Sarasota, 1983), pp. 140–9

227 P. Bjurström, 'Rubens' "St George and the Dragon"', *Art Quarterly*, XVIII (Detroit, 1955), pp. 27–43; O. Millar, 'Rubens's Landscapes in the Royal Collection: The Evidence of X-ray', *Burlington Magazine*, CXIX (1977), pp. 631–5

229 *Peace and War*: R. Baumstark, 'Ikonographische Studien zu Rubens' Kriegs- und Friedensallegorien', *Aachener Kunstblätter*, XLV (Aachen, 1974), pp. 125–234; C. Brown, '*Peace and War*': *Minerva Protects Pax from Mars* (National Gallery, London, 1979); A. Hughes, 'Naming the Unnameable: An Iconographical Problem in Rubens's "Peace and War"', *Burlington Magazine*, CXXII (1980), pp. 157–64

Chapter V

235 The artist's will: E. Bonnaffé, 'Documents inedits sur Rubens', *Gazette des Beaux-Arts*, VI (Paris, 1891), pp. 204–10

242 J. Foucart, 'Un nouveau Rubens au Louvre: Hélène Fourment au carrosse', *Revue du Louvre*, XXVII (Paris, 1977), pp. 343–53

243 *Helena Fourment in a Fur Cloak*: J. S. Held, 'Rubens' *Het Pelsken*', in *Essays in the History of Art Presented to Rudolf Wittkower* (1967), pp. 188–92; J. Bialostocki, 'Reflections on Eroticism in some Rubens Pictures: Three Paintings in the Vienna Museum', in *Rubens and his World* (Antwerp, 1985), pp. 187–92

251 The Whitehall ceiling: P. Palme, *Triumph of Peace* (1957); O. Millar, *Rubens: The Whitehall Ceiling* (1958); J. S. Held, 'Rubens' Glynde Sketch and the Installation of the Whitehall Ceiling', *Burlington Magazine*, CXII (1970), pp. 274–81; D. J. Gordon, *The Renaissance Imagination* (Berkeley, Los Angeles and London, 1975), pp. 24–50; R. Strong, *Britannia Triumphans* (1980); J. Charlton, *The Banqueting House Whitehall* (rev. ed., 1983)

258 E. Haverkamp Begemann, *The Achilles Series, CRLB, Part X* (1975)

259 J. R. Martin, *The Decorations for the Pompa Introitus Ferdinandi, CRLB, Part XVI* (1972); E. McGrath, 'Rubens's "Arch of the Mint"', *Journal of the Warburg and Courtauld Institutes*, XXXVII (1974), pp. 191–217

268 The *Garden of Love*: G. Glück, *Rubens, Van Dyck und ihr Kreis* (Vienna, 1933), pp. 82–153

271 P. Fehl, 'Rubens's "Feast of Venus Verticordia"', *Burlington Magazine*, CXIV (1972), pp. 159–62

274 S. Alpers, *The Decoration of the Torre de la Parada, CRLB, Part IX* (1971)

279 C. White, 'Rubens and Old Age', *Allen Memorial Art Museum Bulletin*, XXXV (Oberlin, 1978), pp. 40–56

286 The recent X-rays of the *Moonlit Landscape* will be published by Mr Robert Bruce Gardner, to whom I am grateful for showing them to me.

Index

Photographic Acknowledgements

310